Eileen Agar//Stacy Alaimo//Heba Y. Amin//Michelle Antoinette//Bergit Arends//Erika Balsom//Karen Barad//Betty Beaumont//Louis Bec//Ron Broglio// Rachel Carson//Mel Y. Chen//Tacita Dean//Elizabeth DeLoughrey//T.J. Demos//Manthia Diawara//Chris Dobrowolski//Tarralik Duffy//Ann Elias//Marion Endt-Jones//Léuli Eshrāghi//Kodwo Eshun//Tatiana Flores// Vilém Flusser//Marietta Franke//Paul Gilroy//John K. Grande//Ayesha Hameed//Donna Haraway//Stefano Harney//Epeli Hau'ofa//Eva Hayward//Stefan Helmreich//Barbara Hepworth//Stefanie Hessler// Matthew Higgs//Klara Hobza//Luce Irigaray//Isuma// Zakiyyah Iman Jackson//Celina Jeffery//Melody Jue// Brian Jungen//Robin D.G. Kelley//Tania Kovats// Barbara Kutis//Sonia Levy//Max Liboiron//Lana Lopesi//Janine Marchessault//Chus Martínez//Ana Mendieta//Jules Michelet//Kasia Molga//Eleanor Morgan//Fred Moten//Astrida Neimanis//Celeste Olalquiaga//Saskia Olde Wolbers//Ralph Rugoff// John Ruskin//Allan Sekula//Shimabuku//Heather Anne Swanson//Pandora Syperek//Jan Verwoert// Sarah Wade//Ahren Warner//Marina Warner// Alberta Whittle//

Oceans

Whitechapel Gallery
London
The MIT Press
Cambridge, Massachusetts

Edited by Pandora Syperek and Sarah Wade

OCEANS

Documents of Contemporary Art

Co-published by Whitechapel Gallery
and The MIT Press

First published 2023
© 2023 Whitechapel Gallery Ventures Limited
All texts © the authors or the estates of the authors,
unless otherwise stated

ISBN 978-0-85488-304-2 (Whitechapel Gallery)
ISBN 978-0-85488-306-6 (Whitechapel Gallery
e-book)
ISBN 978-0-262-54534-1 (The MIT Press)
ISBN 978-0-262-37391-3 (The MIT Press retail
e-book)
ISBN 978-0-262-37392-0 (The MIT Press library
e-book)

A catalogue record for this book is available from
the British Library

Library of Congress Control Number: 2022947019

Whitechapel Gallery 10 9 8 7 6 5 4 3 2 1
The MIT Press 10 9 8 7 6 5 4 3 2 1

Commissioning Editor: Anthony Iles
Project Editor: Francesca Vinter and Evie Tarr
Design by SMITH
Gemma Gerhard, Justine Hucker, Allon Kaye,
Claudia Paladini
Printed and bound in Turkey

Cover, Edgar Cleijne and Ellen Gallagher
Painted glass slide with 3D modeling from *Osedax*,
2010 © Edgar Cleijne and Ellen Gallagher. Courtesy
the artists

Whitechapel Gallery Ventures Limited
77–82 Whitechapel High Street
London E1 7QX
whitechapelgallery.org

Distributed to the book trade (UK and Europe only)
by Thames & Hudson
181a High Holborn
London, WC1V 7QX
+44 (0) 20 7845 5000
sales@thameshudson.co.uk

The MIT Press
Cambridge, MA 02142
mitpress.mit.edu

Documents of Contemporary Art

In recent decades artists have progressively expanded the boundaries of art as they have sought to engage with an increasingly pluralistic environment. Teaching, curating and understanding of art and visual culture are likewise no longer grounded in traditional aesthetics but centred on significant ideas, topics and themes ranging from the everyday to the uncanny, the psychoanalytical to the political.

The Documents of Contemporary Art series emerges from this context. Each volume focuses on a specific subject or body of writing that has been of key influence in contemporary art internationally. Edited and introduced by a scholar, artist, critic or curator, each of these source books provides access to a plurality of voices and perspectives defining a significant theme or tendency.

For over a century the Whitechapel Gallery has offered a public platform for art and ideas. In the same spirit, each guest editor represents a distinct yet diverse approach – rather than one institutional position or school of thought – and has conceived each volume to address not only a professional audience but all interested readers.

Series Editor: Iwona Blazwick; Commissioning Editor: Anthony Iles; Project Editors: Francesca Vinter and Evie Tarr; Editorial Advisory Board: Erika Balsom, Gabriela Bueno Gibbs, Sean Cubitt, Neil Cummings, Sven Spieker, Sofia Victorino

THE SEA
IS
VERITABLY
A
GREAT
ARTIST.

Jules Michelet, 'The Milky Sea', 1861

Pandora Syperek and Sarah Wade
Introduction//Towards an Oceanic Art History

There must be something in the water. Oceans have been ubiquitous in artworks and exhibitions in recent years, coinciding with a surge of 'blue' scholarship as well as countless marine permeations into popular culture. As a global commons and a vital source for ensuring planetary health, oceans touch the lives of everyone and are as much historical, cultural and political entities as they are 'natural', providing generative channels for examining the urgent issues of the present moment. And yet this flood of activity does not emerge as suddenly as it may appear, but can be traced back to deeper histories concerning human relationships with the amorphous forces and forms that fall under the collective label 'the sea'. The predominately Euro-American fields of the blue humanities and critical ocean studies, which have proliferated since the literary scholar Steve Mentz coined the term 'blue cultural studies' in 2009,[1] were preceded by decades of analysis and poetry by writers from Oceania and the Caribbean Archipelago and Indigenous and postcolonial scholarship examining maritime journeys driven by colonisation and slavery. Meanwhile, new materialist meditations on oceans have precedents in earlier feminist critique. The sea has likewise been an enduring subject throughout historical and recent artistic practice, making it all the more surprising that visual art is relatively underrepresented in this burgeoning body of scholarship. This anthology foregrounds the unique contribution made by art and the visual to this 'oceanic turn', highlighting some of the diverse thinking and practices riding this recent wave and its varied genealogies.

To anthologise this topic presents a distinct challenge since oceans are physically and conceptually uncontainable, spilling into seas, canals, rivers, polar ice, mythologies, extreme weather events, climate crisis and more, infiltrating the lives of humans and nonhumans in manifold ways. There is a tendency in western European and settler-colonial traditions to view the sea, which is frequently feminised, as a sublime 'Other', at once monstrous and maternal. However, oceans are too integral to many Indigenous communities' ways of life and Earth's ecologies to be cast in isolation. As such, segregating oceans from other bodies of water as from human activity – even with conservationist intent – can have a colonising effect, replicating the disjuncture that the curator Candice Hopkins describes as 'what happens when you see land purely as a resource instead of as your home'.[2] As the environmental philosopher Stacy Alaimo has noted, conceptions of the deep sea as 'alien' are detrimental as this

'casts them beyond the reach of the human when, in fact, all marine zones suffer anthropogenic harms'.[3]

It is the negotiation of this perceived oceanic otherness on the one hand, and the experience of immersion and interconnectedness on the other, that brings together the texts in this book. Traversing painting, drawing, sculpture, printmaking, collage, photography, installation, performance, multimedia, model making, contemporary craft, electronic music, video, feature-length film, photo essay, performative lecture, children's animation, as well as artworks referencing and reworking the extensive literary history associated with the oceans from the Western canon to diasporic literatures, they demonstrate how art and curation, with their capacity for interdisciplinarity and multimodality, are uniquely equipped to address oceanic boundlessness.

Despite a campaign to 'Drop the S' to promote shared responsibility for the health of 'One Ocean',[4] the multiplicity of oceans and their communities' unique marine relations, histories, geographies and ecologies are shown to demand specific and situated responses. The intrinsic plurality of oceans has been addressed variously in exhibitions over the past decade, from the oceanic abundance of 'Oceanomania' (Monaco, 2011) and 'Aquatopia' (UK, 2013–14) to more localised and politicised perspectives as seen in Celina Jeffery's multi-sited 'Ephemeral Coast' project (Wales, Mauritius, Mexico and Canada, 2014–18), among others. Oceans' profuse material and metaphorical affordances have lent themselves to theoretical and curatorial models, as in Carolyn Christov-Bakargiev's 14th Istanbul Biennial titled 'SALTWATER' (2015) in homage to the Bosporus and the poetics and politics of knots and waves, the 'navigation' of trade and immigration routes as a model for curatorial practice in Koyo Kouoh's 'Streamlines' (Deichtorhallen Hamburg 2015-16), Stefanie Hessler's exhibition 'Tidalectics' (TBA21–Augarten, Austria, 2017), inspired by poet Kamau Brathwaite's eponymous concept, or the 2021 Shanghai Biennale, which paid tribute to Astrida Neimanis' influential hydrofeminist text *Bodies of Water* (2017). And so, although many exhibition catalogues have focused on literary and other disciplinary perspectives, curatorial projects that take the sea as a subject have been pioneering in their own right in both oceanic content and oceanic methodologies.[5] Recognition of the oceans' diversity and potential for multivocality has resulted in increased interdisciplinary collaboration in artistic and curatorial practice, extending beyond the confines of the art gallery to the science laboratory, the ship and the submersible, and engaging with diverse modes of display including the natural history museum and the aquarium, as well as the lingering imperialism of such ventures.[6] Projects such as *Forensic Oceanography* have furthermore intervened in surveillance and policy-making processes via a practice of critical cartography, documenting and interpreting

intergovernmental forces' accountability, for example, in the case of the 'left-to-die boat' that led to the deaths of 63 migrants aboard a stranded vessel.[7]

Display practices and other visualising technologies' central role in human relationships to the sea is explored throughout this book. The oceans and their inhabitants have taken on exhibitionary significance in and of themselves, from zoologist Ernst Haeckel's late nineteenth-century vision of the coral reef as a museum to contemporary artist Shimabuku's octopus tentacle that became an accidental 'exhibition in a refrigerator' in a spectacle of marine exoticism for the artist's non-Japanese housemate to rival the aquarium. Artworks considered here defy dominant models of visualising the sea, with imagery that is the direct opposite to the improbably clear, turquoise waters teeming with colourful sea life that have become a mainstay in nature programmes like *Blue Planet* (2001, 2017) as well as the anthropocentric, masculinist empiricism that persists even in more relational iterations such as *My Octopus Teacher* (2020).[8] Murky, debris-laden and populated largely by human technology, the submarine world in works by Klara Hobza and Armin Linke, discussed by Bergit Arends and Stefanie Hessler respectively, expose illusions of hyperrealism perpetuated by marine wildlife films since Jacques-Yves Cousteau. Rather than this ubiquitous blue, artists and theorists have described myriad marine shades since Homer's 'wine-dark sea' to creatively and conceptually respond to different contexts. These range from 'the brown water of the sea' in Ayesha Hameed's characterisation of J.M.W. Turner's *Slave Ship* (1840),[9] to Alaimo's 'violet-black ecology' concentrated on the ocean's depths,[10] from Barbara Hepworth's view of the Atlantic radiating 'pinks of strange hues' to the 'opalescent' white of Jean-Ulrick Désert's anti-colonial map of the Caribbean Sea, described by Elizabeth DeLoughrey and Tatiana Flores. Moreover, vision itself is often displaced as the dominant mode of engagement with the sea, as with Eva Hayward's examination of the immersive affect created by the aquarium in 'Sensational Jellyfish', Stefano Harney and Fred Moten's theory of hapticality as feeling through and with others originating in the slave ship in 'Fantasy in the Hold', or the manifold sonic reverberations of the sea in recent artistic practice. Sea creatures and artists alike remind us that 'the ocean is a sensorium',[11] with ways of knowing and experiencing that displace the ocularcentrism of the modern Western paradigm. Nevertheless, in various ways the texts here highlight the complex politics of visualising oceans and how these may (or may not) transcend commodity fetishism and scopophilia, from octopuses' and mermaids' collecting practices to exquisite glass models of marine invertebrates, from historical shipwrecks to media imaging of drowned migrants.

While referencing Neimanis' important work, our first section Bodies (In and Out) of Water expands beyond a new materialist 'epistemology of wet'[12]

to consider various states of physical and cultural immersion in oceans as well as the sea's paradoxical potential to both liberate and contain. Enactments of marine interiority in Kasia Molga's attempts to cultivate 'tiny ecosystems' in 'mini oceans' formed of her own tears, Ana Mendieta's imagined iteration of her *Silueta* series on the shore and Heidi Bucher's wearable *Bodyshells* (1972) (examined by Chus Martínez) offer corporeal scale and texture to the well-worn trope of the inhuman and expansive 'open sea' as well as the awesome cosmic processes described in Rachel Carson's opening text. The mobilisation of oceans to both uphold and dissolve restraints on colonised and gendered bodies is explored here by writers including Epeli Hau'ofa, Lana Lopesi and Luce Irigaray as well as artists such as Léuli Eshrāghi and Nadia Huggins, whose queering of oceanic encounters stirs gender troubled waters. Yet, it is also oceans' diffractive, fragmenting tendency that is shown to liberate, what John Ruskin recognises in 'The Harbours of England' when he characterises the sea, like the ship, as 'a thing that broke to pieces'. This sense of melancholy is carried through in Hepworth's account of the Cornish seascape set in the shadow of the Second World War and the prehistoric animal remains immortalised in Eleanor Morgan's limestone lithography plates. What emerges throughout this first section is the crucial relationality of bodies in, and sometimes out, of oceans, and how this overcomes the romantic mythos of the lone figure against the sea, a theme picked up again in following sections concerning maritime voyages and human relationships with the sea in a time of ecological crisis.

Aquatic Imaginaries explores artists' mythic and psychical associations with the sea. While for the surrealists the ocean was symbolic of the unconscious, as explored by Eileen Agar and Ann Elias, contemporary artists have reimagined its depths as sites of horror, regeneration and even banality with mythical beings and fictional worlds emerging from lived realities. The legend of the Black Atlantis envisioned by the 1990s Detroit techno act Drexciya as an underwater society originating from those who jumped or were thrown overboard in the Trans-Atlantic Slave Trade has informed numerous artists, including the Otolith Group (represented here by Kodwo Eshun) and Ellen Gallagher, whose delicate works on paper offer a feminised vision of the descendants of pregnant slaves and their entanglements with marine life. Artists have equally drawn from other mythologies to come to terms with the atrocities of the Middle Passage and their diasporic legacies, as in Alberta Whittle's invocation of the Pan-African water deity Mami Wata in a poem commissioned for this volume. Other artists upend notions of oceanic sublimity that have long lingered in Western culture through playful acts of domestication, such as Guy Ben-Ner's light-hearted re-enactment of Herman Melville's 1851 novel *Moby-Dick* in his kitchen sink, Shuvinai Ashoona's coloured pencil drawings that juxtapose Inuit mythology

and everyday life with James Cameron's *Titanic* (1997) and Marcus Coates' performance of becoming-selkie for the twenty-first century. In *Finfolk* (2003) Coates swaps the transformational seal skin for an unfashionable tracksuit and a sense of mystery for what Ron Broglio describes in *Surface Encounters* as 'knowing idiocy' as he ascends and descends into the sea and stutters and splutters by the shore. Such oceanic shapeshifters bridge land and water while providing form for fluid identities and ecologies as texts by Celeste Olalquiaga, Mel Y. Chen and Melody Jue make clear. Correspondingly, Brian Jungen explains how his sculpture *Shapeshifter* (2000), a giant whale skeleton articulated from plastic garden chairs, questions the fixity of scientific knowledge in the face of Indigenous cosmologies and stereotypes.

It is a truism that we know more about outer space than we do about the deep sea, despite the originary role oceans have played in human life. Yet, there has been a turn from anthropocentric conceptions of the sea as 'mother' and 'other' towards embracing its more-than-human connections. Alien Seas? interrogates the otherness of the ocean via its inhabitants. From the microbes that give seawater its 'mucousness' in Jules Michelet's 'The Milky Sea' to hard-to-classify coral, which, as Marion Endt-Jones notes, historically confused the categories of animal-vegetable-mineral; from the 'new communicative media' of Vilém Flusser and Louis Bec's *Vampyroteuthis infernalis* to the embodied visualising system of brittlestars examined by Karen Barad, the physiologies of aquatic lifeforms have often appeared otherworldly to humans. Foundational to evolutionary theories, marine invertebrates such as jellyfish have historically fascinated scientists and artists alike, but their fluidity of species and sex has fed into sexist and racist science as demonstrated by Marina Warner and Zakiyyah Iman Jackson writing respectively on the work of Dorothy Cross and Wangechi Mutu. Artists have frequently sought to overcome negative conceptions of radical difference, from Jean Painlevé and Geneviève Hamon's aquatic anthropomorphism in films beginning in the 1920s, to Ant Farm's multispecies endeavour *Dolphin Embassy* (1974), which as Janine Marchessault reminds us, was conceived as an 'aquaterrestrial' space to facilitate interspecies communication in a single 'coextensive superhabitat'. Such projects resist detached involvement with sea life to instead negotiate difference with a view towards reimagining continuities across species.

Following these contemplations of biological otherness and proximity, Crossings considers the oceans' geographical and political potential to both divide and connect, as vast surfaces to be traversed and unfathomable depths to be explored and exploited. Artists engage with these sites of colonial voyage and imperilled migration in the face of the past ideal of romantic exploration, at times with playful resistance. Here the ship surfaces as a transcultural icon

of oceanic crossing, a political microcosm, as argued for by Paul Gilroy and Allan Sekula, following Michel Foucault, for whom the ship was the 'heterotopia par excellence', a parallel space that since the early modern period represented 'the great instrument of economic development' and 'simultaneously the greatest reserve of the imagination'.[13] The various ways colonial and migratory crossings both forge and disrupt identities are explored in Gilroy's *Black Atlantic*, Lani Maestro's photographic *a book thick of ocean* (1993), which 'moves us beyond an identitarian politics of representation' according to Michelle Antoinette, and Isuma's filmic account of forced relocation. The inextricability of these movements from global economic powers is considered by Sekula and in Heba Y. Amin's mock speculative proposal to sink the Mediterranean Sea, while other texts navigate what Jan Verwoert labels here 'the genre of the "ocean romantic"'. The heroic narrative of ocean conquest and its basis in masculinism, anthropocentrism and good old-fashioned hubris is complicated in Tacita Dean's account of the real-life tragic example of Donald Crowhurst's failed voyage around the world, but also in Chris Dobrowolski's humorous retelling of his attempt to build a boat to escape art college. Both works are in dialogue with Bas Jan Ader's romantic-conceptual 1975 work *In Search of the Miraculous*, and the artist's disappearance at sea, as is Klara Hobza's durational performance *Diving Through Europe* (2009–2039). Although Hobza abandons the surface of the open sea to explore the depths of its connecting rivers and canals with humour and poignancy, through her endeavour the artist renders these waterways coextensive with the oceans they flow into and out of, while remaining acutely aware of the mortal risk these marine environments pose.

Anthropocene Oceans homes in on the mortal risks *humans* pose. The designation of a geological epoch that recognises human impact has gained traction in the arts and humanities beyond its original scientific premise, catalysing both creativity and critique.[14] Yet, before the 'Anthropocene' was proposed in 2000,[15] artists had been initiating environmental changes and critique through earthworks and land art at least since the 1960s. While Peter Fend and collaborators founded the Ocean Earth Development Corporation in 1980, a pioneering shift from land to sea was enacted two years earlier by Betty Beaumont, whose *Ocean Landmark* (1978–1980) recycled industrial coal ash waste to create an ecosystem that provided a habitat for marine wildlife as well as a sustainable fishery. This premonitory intervention on the ocean floor is notable for avoiding the spectacular monumentality characteristic both of its contemporary earthworks and of many recent sculptural interventions undersea.[16] Indeed, the monumentalisation of the global environmental crisis itself through the charismatic concept of the Anthropocene risks overshadowing specificities of site and circumstance and replicates the very anthropocentrism that is its cause.[17] Accordingly, the writing here responds to calls to 'break up

the Anthropocene' to encompass plurality, attend to inequalities and eschew human exceptionalism.[18] In this section texts by Hessler, Heather Anne Swanson and Sonia Levy, Jeffery, T.J. Demos and Max Liboiron demonstrate the intricacies of ocean ecology's entanglement with the infrastructures of capitalism and imperialism in relation to deep-sea mining, the circulation of so-called 'invasive species', the impact of coastal erosion on postcolonial nations, the Trans-Atlantic Slave Trade and Indigenous and anti-colonial science. The uneven distribution of the so-called Anthropocene already affecting individuals 'on the ground' is made clear by Manthia Diawara's fisherman and pebble collector and Saskia Olde Wolbers' semi-fictionalised oil-spill cleaner. Yet, subsequent feelings of futility and eco-anxiety are countered here by Erika Balsom's re-orientiation of Freudian 'oceanic feeling' towards a holistic ecological imaginary, Isabella Rossellini's humorous enactments of sea creatures' sex lives to raise awareness of overfishing and Donna Haraway's fantastically flamboyant reading of Christine and Margaret Wertheim's *Crochet Coral Reef* (2005-ongoing), an international participatory craft project uniting art, geometry and marine conservation.

The *Crochet Coral Reef's* championing of collective authorship, seen also in Isuma's 'cumulative'[19] approach of connecting to Inuit culture and histories and Shimabuku's multispecies collaborations with unwitting octopuses, marks a sea change from what Neimanis calls here the 'rather dry, if convenient, myth' of discrete individualism. This collaboratively edited volume presents a paradigm shift from a singular, 'aquatopian' vision of the oceanic sublime, towards one that is necessarily fragmentary. Texts grapple with the paradoxes of universality and heterogeneity, fluidity and texture, generativity and cataclysm that are inherent to the sea. The various social and ecological configurations presented here necessarily point towards multiple oceanic materialities, which as well as watery, are microbial (Helmreich), gelatinous (Michelet), frozen (Isuma) and geological (Carson and Morgan). Taking our cue from Nancy Tuana, who posits viscosity as encompassing a potential for resistance which the open possibilities of fluidity risk washing over, we thereby look to the critically generative potential of the oceans' multiplicitous and sticky material realities.[20] These recall for example Tiffany Lethabo King's theory of the black shoals, which as liminal formations between land and sea, signify 'a disruptive mechanism that interrupts and slows normative thought and violent knowledge production', thereby 'chafing and rubbing up against the normative flows of Western thought'.[21] Like the shoal, the various oceanic models presented here, including tidalectics, immersion and diffraction, all complicate the dualism of land and sea, physically, psychologically and politically. As with the divergence between shore and coast and the heterogeneous but unified archipelagic webs, as Lawrence Abu Hamdan

argues, borders are not lines but networks, 'layered spaces'.[22]

Such complex renderings of place likewise push beyond a simple chronology of the ocean as a space of modernity following earlier periods' conceptions of a vast empty waste.[23] In addition to its tidal time-telling, repositories of deep time, temporal slowing and infliction of 'time-madness', as in Crowhurst's sorry fate, alternative notions of time emerge, including the distinction between pre- and post-colonised time for island peoples and an aspiring future after 'Gregorian shame-time',[24] as well as the simultaneity of past-present-future in Afrofuturist visions explored here. As DeLoughrey observes of Caribbean discourse on oceanic immersion, 'linear models of time are distorted and ruptured'.[25] The defiance of '"rootedness" in static time and space'[26] elicited by oceans makes them useful for rethinking art's histories. This dynamic resonates with what Sekula identifies as the 'ambivalence, which allows the features of classical and romantic seascape to atrophy and hypertrophy at the same time', represented here by artists in different ways, for instance in Akomfrah and Mutu's use of montage. This shattering quality of the oceans, at once singular and multiple, gives rise to various figurations of identity and relationality, both historical and speculative. Consequently, oceans present multifarious opportunities to expunge and re-orient the art historical canon towards embracing plurality and difference.

1 Steven Mentz, 'Towards a Blue Cultural Studies: The Sea, Maritime Culture, and Early Modern English Literature', *Literature Compass*, vol. 6, no. 5 (2009) 997–1013. On the development and precursors to 'critical ocean studies' also see Elizabeth DeLoughrey, 'Submarine Futures of the Anthropocene', *Comparative Literature*, vol. 69, no. 1 (2017) 32–44.

2 Candice Hopkins and Asinnajaq, 'Ocula Conversation', *Ocula* (4 May 2019) (https://ocula.com/magazine/conversations/candice-hopkins-and-asinnajaq/).

3 Stacy Alaimo, *Exposed: Environmental Politics and Pleasures in Posthuman Times* (Minneapolis: University of Minnesota Press, 2016) 113.

4 www.oceanprotect.org/2019/09/19/drop-the-s-campaign-implementing-principle-one-of-ocean-literacy/

5 Pandora Syperek and Sarah Wade (eds.), 'Curating the Sea', special issue of *Journal of Curatorial Studies*, vol. 9, no.2 (2020).

6 For example, on the 'expedition' see Markus Reymann and Ute Meta Bauer, 'Trusting the Oceans', in *Thyssen-Bornemisza Art Contemporary: The Commissions Book*, eds. Daniela Zyman and Eva Ebersberger (Berlin: Sternberg Press, 2020) 20.

7 Charles Heller, Lorenzo Pezzani and SITU Research, 'Left-to-Die Boat', in *Forensis: The Architecture of Public Truth*, ed. Forensic Architecture (Berlin: Sternberg Press, 2014) 637–55.

8 Sophie Lewis, 'My Octopus Girlfriend', *n+1*, no. 39 (2021), available at www.nplusonemag.com/issue-39/reviews/my-octopus-girlfriend/

9 Ayesha Hameed, 'Black Atlantis', in *We Travel the Space Ways: Black Imagination, Fragments and Diffractions*, eds. Henriette Gunkel and Kara Lynch (Bielefeld: transcript Verlag, 2019) 109.

10 Stacy Alaimo, 'Violet-Black', in *Prismatic Ecology: Ecotheory Beyond Green*, ed. Jeffrey Jerome Cohen (Minneapolis and London: University of Minnesota Press, 2013) 233–251.

11 Territorial Agency, 'Oceans in Transformation', in *Oceans Rising: A Companion to Territorial Agency: Oceans in Transformation*, ed. Daniela Zyman (London: Sternberg Press, 2021) 46.

12 Astrida Neimanis, *Bodies of Water: Posthuman Feminist Phenomenology* (London and New York: Bloomsbury, 2017) 112.

13 Michel Foucault, 'Of Other Spaces', trans. Jay Miskowiec, *Diacritics*, vol 16, no. 1 (Spring 1986) 27. These ideas find precedent in C.L.R. James, *Mariners, Renegades and Castaways: The Story of Herman Melville and the World We Live In* (1953) (Hanover and London: Dartmouth University Press, 2001).

14 Jamie Lorimer, 'The Anthropo-scene: A Guide for the Perplexed', *Social Studies of Science*, vol. 47, no. 1 (2017) 121–2.

15 Paul J. Crutzen and Eugene Stoermer, 'The Anthropocene' *Global Change Newsletter*, no. 41 (2000) 17–18.

16 For example, in Jason deCaires Taylor's 'underwater museums' and Doug Aitken's 'underwater pavilions'.

17 Elizabeth M. DeLoughrey, *Allegories of the Anthropocene* (Durham, NC: Duke University Press, 2019) 192.

18 Steve Mentz, *Break Up the Anthropocene* (Minneapolis: University of Minnesota Press, 2019). See also Kathryn Yusoff, *A Billion Black Anthropocenes or None* (Minneapolis: University of Minnesota Press, 2018) and Zoe Todd, 'Indigenizing the Anthropocene', in *Art in the Anthropocene: Encounters Among Aesthetics, Politics, Environments and Epistemologies*, eds. Heather Davis and Etienne Turpin (London: Open Humanities Press, 2015) 241-54.

19 Asinnajaq, 'Isuma is a Cumulative Effort', *Canadian Art* (22 April 2019), available at https://canadianart.ca/features/isuma-is-a-cumulative-effort/

20 Nancy Tuana, 'Porous Viscosity: Witnessing Katrina', in *Material Feminisms*, eds. Stacy Alaimo and Susan Hekman (Bloomington: Indiana University Press, 2008) 188–213. Also see Kimberley Peters and Philip Steinberg, 'The Ocean in Excess: Towards a More-Than-Wet Ontology', *Dialogues in Human Geography*, vol. 9, no. 3 (2019) 293–307.

21 Tiffany Lethabo King, *The Black Shoals: Offshore Formations of Black and Native Studies* (Durham, NC and London: Duke University Press, 2019) 31.

22 Lawrence Abu Hamdan website (http://lawrenceabuhamdan.com/45th-parallel).

23 See Helen M. Rozwadowski, *Fathoming the Ocean: The Discovery and Exploration of the Deep Sea* (Cambridge, MA: Belknap Press of Harvard University Press, 2005) and Alain Corbin, *The Lure of the Sea: The Discovery of the Seaside in the Western World, 1750-1840*, trans. Jocelyn Phelps (Cambridge: Polity Press, 1994).

24 Eshrāghi, in this volume.

25 'Submarine Futures of the Anthropocene', op. cit., 33.

26 The Black Shoals, op. cit., 36.

I RIDE UPON THE OCEAN FLOOR,
I FLOAT WITHIN THE SEA.
THE WATERS ARE THE ONLY THING,
THAT EVER COMFORT ME.

Paul Thek, in Mariette Franke, '"Be Abstracted": On Paul Thek's Artistic Oeuvre', 1995

He had seen the sea feed her white flames on souls of men; and heard what a storm-gust sounded like, that had taken up with it, in its swirl of a moment, the last breaths of a ship's crew.

John Ruskin, 'The Harbours of England', 1856

BODIES (IN AND OUT) OF WATER

Rachel Carson
The Grey Beginnings//1951

> And the earth was without form, and void; and
> darkness was upon the face of the deep.
> —Genesis 1:2

Beginnings are apt to be shadowy, and so it is with the beginnings of that great mother of life, the sea. Many people have debated how and when the earth got its ocean, and it is not surprising that their explanations do not always agree. For the plain and inescapable truth is that no one was there to see, and in the absence of eyewitness accounts there is bound to be a certain amount of disagreement. So if I tell here the story of how the young planet Earth acquired an ocean, it must be a story pieced together from many sources and containing whole chapters the details of which we can only imagine. The story is founded on the testimony of the earth's most ancient rocks, which were young when the earth was young; on other evidence written on the face of the earth's satellite, the moon; and on hints contained in the history of the sun and the whole universe of star-filled space. For although no man was there to witness this cosmic birth, the stars and the moon and the rocks were there, and, indeed, had much to do with the fact that there is an ocean.

The events of which I write must have occurred somewhat more than 2 billion years ago. As nearly as science can tell, that is the approximate age of the earth, and the ocean must be very nearly as old. It is possible now to discover the age of the rocks that compose the crust of the earth by measuring the rate of decay of the radioactive materials they contain. The oldest rocks found anywhere on earth – in Manitoba – are about 2.3 billion years old. Allowing 100 million years or so for the cooling of the earth's materials to form a rocky crust, we arrive at the supposition that the tempestuous and violent events connected with our planet's birth occurred nearly 2½ billion years ago. But this is only a minimum estimate, for rocks indicating an even greater age may be found at any time.

The new earth, freshly torn from its parent sun, was a ball of whirling gases, intensely hot, rushing through the black spaces of the universe on a path and at a speed controlled by immense forces. Gradually the ball of flaming gases cooled. The gases began to liquefy, and Earth became a molten mass. The materials of this mass eventually became sorted out in a definite pattern: the heaviest in the centre, the less heavy surrounding them, and the least heavy forming the outer rim. This is the pattern which persists today – a central sphere of molten iron,

very nearly as hot as it was 2 billion years ago, an intermediate sphere of semi-plastic basalt, and a hard outer shell, relatively quite thin and composed of solid basalt and granite.

The outer shell of the young earth must have been a good many millions of years changing from the liquid to the solid state, and it is believed that, before this change was completed, an event of the greatest importance took place – the formation of the moon. The next time you stand on a beach at night, watching the moon's bright path across the water, and conscious of the moon-drawn tides, remember that the moon itself may have been born of a great tidal wave of earthly substance, torn off into space. And remember that if the moon was formed in this fashion, the event may have had much to do with shaping the ocean basins and the continents as we know them.

There were tides in the new earth, long before there was an ocean. In response to the pull of the sun the molten liquids of the earth's whole surface rose in tides that rolled unhindered around the globe and only gradually slackened and diminished as the earthly shell cooled, congealed, and hardened. Those who believe that the moon is a child of Earth say that during an early stage of the earth's development something happened that caused this rolling, viscid tide to gather speed and momentum and to rise to unimaginable heights. Apparently the force that created these greatest tides the earth has ever known was the force of resonance, for at this time the period of the solar tides had come to approach, then equal, the period of the free oscillation of the liquid earth. And so every sun tide was given increased momentum by the push of the earth's oscillation, and each of the twice-daily tides was larger than the one before it. Physicists have calculated that, after 500 years of such monstrous, steadily increasing tides, those on the side toward the sun became too high for stability, and a great wave was torn away and hurled into space. But immediately, of course, the newly created satellite became subject to physical laws that sent it spinning in an orbit of its own about the earth. This is what we call the moon.

There are reasons for believing that this event took place after the earth's crust had become slightly hardened, instead of during its partly liquid state. There is to this day a great scar on the surface of the globe. This scar or depression holds the Pacific Ocean. According to some geophysicists, the floor of the Pacific is composed of basalt, the substance of the earth's middle layer, while all other oceans are floored with a thin layer of granite, which makes up most of the earth's outer layer. We immediately wonder what became of the Pacific's granite covering and the most convenient assumption is that it was torn away when the moon was formed. There is supporting evidence. The mean density of the moon is much less than that of the earth (3.3 compared with 5.5),

suggesting that the moon took away none of the earth's heavy iron core, but that it is composed only of the granite and some of the basalt of the outer layers.

The birth of the moon probably helped shape other regions of the world ocean besides the Pacific. When part of the crust was torn away, strains must have been set up in the remaining granite envelope. Perhaps the granite mass cracked open on the side opposite the moon scar. Perhaps, as the earth spun on its axis and rushed on its orbit through space, the cracks widened and the masses of granite began to drift apart, moving over a tarry, slowly hardening layer of basalt. Gradually the outer portions of the basalt layer became solid and the wandering continents came to rest, frozen into place with oceans between them. In spite of theories to the contrary, the weight of geologic evidence seems to be that the locations of the major ocean basins and the major continental land masses are today much the same as they have been since a very early period of the earth's history.

But this is to anticipate the story, for when the moon was born there was no ocean. The gradually cooling earth was enveloped in heavy layers of cloud, which contained much of the water of the new planet. For a long time its surface was so hot that no moisture could fall without immediately being reconverted to steam. This dense, perpetually renewed cloud covering must have been thick enough that no rays of sunlight could penetrate it. And so the rough outlines of the continents and the empty ocean basins were sculptured out of the surface of the earth in darkness, in a Stygian world of heated rock and swirling clouds and gloom.

As soon as the earth's crust cooled enough, the rains began to fall. Never have there been such rains since that time. They fell continuously, day and night, days passing into months, into years, into centuries. They poured into the waiting ocean basins, or, falling upon the continental masses, drained away to become sea.

That primeval ocean, growing in bulk as the rains slowly filled its basins, must have been only faintly salt. But the falling rains were the symbol of the dissolution of the continents. From the moment the rains began to fall, the lands began to be worn away and carried to the sea. It is an endless, inexorable process that has never stopped – the dissolving of the rocks, the leaching out of their contained minerals, the carrying of the rock fragments and dissolved minerals to the ocean. And over the aeons of time, the sea has grown ever more bitter with the salt of the continents.

In what manner the sea produced the mysterious and wonderful stuff called protoplasm we cannot say. In its warm, dimly lit waters the unknown conditions of temperature and pressure and saltiness must have been the critical ones for the creation of life from non-life. At any rate they produced the result that neither the alchemists with their crucibles nor modern scientists in their laboratories have been able to achieve.

Before the first living cell was created, there may have been many trials and failures. It seems probable that, within the warm saltiness of the primeval sea, certain organic substances were fashioned from carbon dioxide, sulphur, nitrogen, phosphorus, potassium and calcium. Perhaps these were transition steps from which the complex molecules of protoplasm arose – molecules that somehow acquired the ability to reproduce themselves and begin the endless stream of life. But at present no one is wise enough to be sure.

Those first living things may have been simple microorganisms rather like some of the bacteria we know today – mysterious borderline forms that were not quite plants, not quite animals, barely over the intangible line that separates the non-living from the living. It is doubtful that this first life possessed the substance chlorophyll, with which plants in sunlight transform lifeless chemicals into the living stuff of their tissues. Little sunshine could enter their dim world, penetrating the cloud banks from which fell the endless rains. Probably the sea's first children lived on the organic substances then present in the ocean waters, or, like the iron and sulphur bacteria that exist today, lived directly on inorganic food.

All the while the cloud cover was thinning, the darkness of the nights alternated with palely illumined days, and finally the sun for the first time shone through upon the sea. By this time some of the living things that floated in the sea must have developed the magic of chlorophyll. Now they were able to take the carbon dioxide of the air and the water of the sea and of these elements, in sunlight, build the organic substances they needed. So the first true plants came into being.

Another group of organisms, lacking the chlorophyll but needing organic food, found they could make a way of life for themselves by devouring the plants. So the first animals arose, and from that day to this, every animal in the world has followed the habit it learned in the ancient seas and depends, directly or through complex food chains, on the plants for food and life.

As the years passed, and the centuries, and the millions of years, the stream of life grew more and more complex. From simple, one-celled creatures, others that were aggregations of specialised cells arose, and then creatures with organs for feeding, digesting, breathing, reproducing. Sponges grew on the rocky bottom of the sea's edge and coral animals built their habitations in warm, clear waters. Jellyfish swam and drifted in the sea. Worms evolved, and starfish, and hard-shelled creatures with many-jointed legs, the arthropods. The plants, too, progressed, from the microscopic algae to branched and curiously fruiting seaweeds that swayed with the tides and were plucked from the coastal rocks by the surf and cast adrift.

During all this time the continents had no life. There was little to induce living things to come ashore, forsaking their all-providing, all-embracing mother sea. The lands must have been bleak and hostile beyond the power of words to

describe. Imagine a whole continent of naked rock, across which no covering mantle of green had been drawn – a continent without soil, for there were no land plants to aid in its formation and bind it to the rocks with their roots. Imagine a land of stone, a silent land, except for the sound of the rains and winds that swept across it. For there was no living voice, and no living thing moved over the surface of the rocks.

Meanwhile, the gradual cooling of the planet, which had first given the earth its hard granite crust, was progressing into its deeper layers; and as the interior slowly cooled and contracted, it drew away from the outer shell. This shell, accommodating itself to the shrinking sphere within it, fell into folds and wrinkles – the earth's first mountain ranges. [...]

The epochs of mountain building only served to speed up the processes of erosion by which the continents were worn down and their crumbling rock and contained minerals returned to the sea. The uplifted masses of the mountains were prey to the bitter cold of the upper atmosphere and under the attacks of frost and snow and ice the rocks cracked and crumbled away. The rains beat with greater violence upon the slopes of the hills and carried away the substance of the mountains in torrential streams. There was still no plant covering to modify and resist the power of the rains.

And in the sea, life continued to evolve. The earliest forms have left no fossils by which we can identify them. Probably they were soft-bodied, with no hard parts that could be preserved. Then, too, the rock layers formed in those early days have since been so altered by enormous heat and pressure, under the foldings of the earth's crust, that any fossils they might have contained would have been destroyed.

For the past 500 million years, however, the rocks have preserved the fossil record. By the dawn of the Cambrian period, when the history of living things was first inscribed on rock pages, life in the sea had progressed so far that all the main groups of backboneless or invertebrate animals had been developed. But there were no animals with backbones, no insects or spiders, and still no plant or animal had been evolved that was capable of venturing onto the forbidding land. So for more than three-fourths of geologic time the continents were desolate and uninhabited, while the sea prepared the life that was later to invade them and make them habitable. Meanwhile, with violent tremblings of the earth and with the fire and smoke of roaring volcanoes, mountains rose and wore away, glaciers moved to and fro over the earth, and the sea crept over the continents and again receded.

It was not until Silurian time, some 350 million years ago, that the first pioneer of land life crept out on the shore. It was an arthropod, one of the great tribe that later produced crabs and lobsters and insects. It must have been something like a modern scorpion, but, unlike some of its descendants, it never wholly severed the ties that united it to the sea. It lived a strange life, half-

terrestrial, half-aquatic, something like that of the ghost crabs that speed along the beaches today, now and then dashing into the surf to moisten their gills.

Fish, tapered of body and stream-moulded by the press of running waters, were evolving in Silurian rivers. In times of drought, in the drying pools and lagoons, the shortage of oxygen forced them to develop swim bladders for the storage of air. One form that possessed an air-breathing lung was able to survive the dry periods by burying itself in mud, leaving a passage to the surface through which it breathed.

It is very doubtful that the animals alone would have succeeded in colonising the land, for only the plants had the power to bring about the first amelioration of its harsh conditions. They helped make soil of the crumbling rocks, they held back the soil from the rains that would have swept it away, and little by little they softened and subdued the bare rock, the lifeless desert. We know very little about the first land plants, but they must have been closely related to some of the larger seaweeds that had learned to live in the coastal shallows, developing strengthened stems and grasping, rootlike holdfasts to resist the drag and pull of the waves. Perhaps it was in some coastal lowlands, periodically drained and flooded, that some such plants found it possible to survive, though separated from the sea. This also seem[s] to have taken place in the Silurian period.

The mountains that had been thrown up by the Laurentian revolution gradually wore away, and as the sediments were washed from their summits and deposited on the lowlands, great areas of the continents sank under the load. The seas crept out of their basins and spread over the lands. Life fared well and was exceedingly abundant in those shallow, sunlit seas. But with the later retreat of the ocean water into the deeper basins, many creatures must have been left stranded in shallow, landlocked bays. Some of these animals found means to survive on land. The lakes, the shores of the rivers, and the coastal swamps of those days were the testing grounds in which plants and animals either became adapted to the new conditions or perished.

As the lands rose and the seas receded, a strange fishlike creature emerged on the land, and over the thousands of years its fins became legs, and instead of gills it developed lungs. In the Devonian sandstone this first amphibian left its footprint.

On land and sea the stream of life poured on. New forms evolved; some old ones declined and disappeared. On land the mosses and the ferns and the seed plants developed. The reptiles for a time dominated the earth, gigantic, grotesque, and terrifying. Birds learned to live and move in the ocean of air. The first small mammals lurked inconspicuously in hidden crannies of the earth as though in fear of the reptiles.

When they went ashore the animals that took up a land life carried with them a part of the sea in their bodies, a heritage which they passed on to their

children and which even today links each land animal with its origin in the ancient sea. Fish, amphibian and reptile, warm-blooded bird and mammal – each of us carries in our veins a salty stream in which the elements sodium, potassium and calcium are combined in almost the same proportions as in sea water. This is our inheritance from the day, untold millions of years ago, when a remote ancestor, having progressed from the one-celled to the many-celled stage, first developed a circulatory system in which the fluid was merely the water of the sea. In the same way, our lime-hardened skeletons are a heritage from the calcium-rich ocean of Cambrian time. Even the protoplasm that streams within each cell of our bodies has the chemical structure impressed upon all living matter when the first simple creatures were brought forth in the ancient sea. And as life itself began in the sea, so each of us begins his individual life in a miniature ocean within his mother's womb, and in the stages of his embryonic development repeats the steps by which his race evolved, from gill-breathing inhabitants of a water world to creatures able to live on land. [...]

Rachel Carson, extracts from *The Sea Around Us* (1951) (New York: Oxford University Press, 1961) 3–8 [footnotes omitted].

Epeli Hau'ofa
The Ocean in Us//1998

We sweat and cry salt water, so we know that the ocean is really in our blood.
– Teresia Teaiwa

In a previous essay, I advanced the notion of a much enlarged Oceania that has emerged through the astounding mobility of our peoples in the last fifty years.[1] Most of us are part of this mobility, whether personally or through the movements of our relatives. This expanded Oceania is a world of social networks that crisscross the ocean all the way from Australia and New Zealand in the southwest, to the United States and Canada in the northeast. It is a world that we have created largely through our own efforts, and have kept vibrant and independent of the Pacific Islands world of official diplomacy and neocolonial dependency. In portraying this new Oceania I wanted to raise, especially among our emerging generations, the kind of consciousness that would help free us from the prevailing, externally generated definitions of our past, present, and future.

I wish now to take this issue further by suggesting the development of a substantial regional identity that is anchored in our common inheritance of a very considerable portion of Earth's largest body of water, the Pacific Ocean. The notion of an identity for our region is not new; through much of the latter half of this century people have tried to instill a strong sense of belonging to an islands region for the sake of sustained regional cooperation. So far these attempts have foundered on the reef of our diversity, and on the requirements of international geopolitics, combined with assertions of narrow national self-interests on the part of our individual countries. I believe that a solid and effective regional identity can be forged and fostered. We have not been very successful in our attempts so far because, while fishing for the elusive school of tuna, we have lost sight of the ocean that surrounds and sustains us.

A common identity that would help us to act together for the advancement of our collective interests, including the protection of the ocean for the general good, is necessary for the quality of our survival in the so-called Pacific Century when, as we are told, important developments in the global economy will concentrate in huge regions that encircle us. As individual, colonially created, tiny countries acting alone, we could indeed 'fall off the map' or disappear into the black hole of a gigantic pan-Pacific doughnut, as our perspicacious friends, the denizens of the National Centre for Development Studies in Canberra, are fond of telling us. But acting together as a region, for the interests of the region as a whole, and above those of our individual countries, we would enhance our chances for a reasonable survival in the century that is already dawning upon us. Acting in unison for larger purposes and for the benefit of the wider community could help us to become more open-minded, idealistic, altruistic and generous, and less self-absorbed and corrupt in the conduct of our public affairs than we are today. In an age when our societies are preoccupied with the pursuit of material wealth, when the rampant market economy brings out unquenchable greed and amorality in us, it is necessary for our institutions of learning to develop corrective mechanisms such as the one proposed here, if we are to retain our sense of humanity and of community.

An identity that is grounded in something as vast as the sea should exercise our minds and rekindle in us the spirit that sent our ancestors to explore the oceanic unknown and make it their home, our home. [...]

1 Hau'ofa, Epeli, 'Our Sea of Islands', in *A New Oceania: Rediscovering Our Sea of Islands*, eds. Eric Waddell, Vijay Naidu and Epeli Hau'ofa, Suva: School of Social and Economic Development, University of the South Pacific. Reprinted in *The Contemporary Pacific*, vol. 6, no. 1 (1994) 147–16.

Epeli Hau'ofa, extract from 'The Ocean in Us', *The Contemporary Pacific*, vol. 10, no. 2 (Autumn 1998) 392–3.

Lana Lopesi
Beyond Essentialism: Contemporary Moana Art from Aotearoa New Zealand//2018

I will not pretend that I know her in all her manifestations. No one – not even our gods – ever did; no one does… no one ever will because whenever we think we have captured her she has already assumed new guises – the love affair is endless…
– Albert Wendt[1]

The ocean that Maualaivao Albert Wendt writes about has many names. It is called Te Moana Nui a Kiwa here in Aotearoa New Zealand,[2] the great ocean of Kiwa. Kiwa is also the name of the guardian of the ocean and son of Papatūnuku and Ranginui.[3] It is known as Moanākea in Hawai'i, which acknowledges it as a great ocean where the energy 'cannot be harnessed'.[4] Moana means ocean in the Sāmoa, Tonga, Niue and Tahiti languages. Scholars Ōkusitino Māhina, Kolokesa Māhina-Tuai and Tēvita Ka'ili have picked up on how the term *moana* centres Indigenous commonality, providing a way to discuss this part of the world.

What one calls the Moana, the other calls the Pacific Ocean – or *Mar Pacifico*, the name given to it in 1521 by Portuguese explorer Ferdinand Magellan. The 'Pacific Ocean' is the most commonly used term for referring to the vast expanse of ocean that makes up one third of the planet's surface area and hosts thousands of cultures and languages. *Mar Pacifico*, or the peaceful seas, is a Western term that subsequently degrades the peoples inhabiting it by identifying them as peaceful, tranquil and passive – Moana subjectivities that are not self-appointed.

The pervasive colonial myths derived from explorers such as Magellan, as well as Louis-Antoine de Bougainville and James Cook, are etched into our contemporary understanding of the Moana. These continental men struggled to make sense of a vast ocean by focussing on land masses, portraying them as beautiful and idyllic yet isolated and deprived. In the eyes of Cook, Aotearoa New Zealand was the 'farthest flung shore',[5] confirmation that oceanic peoples were outside the confines and corruption of Western civilisation. These accounts were accompanied by paintings and drawings by artists like Joseph Banks and Paul Gauguin, adding archetypes to the idyllic landscapes: the sexually receptive, beautiful dusky maiden; the innately good, uncivilised noble savage, not yet corrupted by Western civilisation.

With the invention of ethnographic photography, this imagery was distributed worldwide. From a voyeuristic standpoint, there could have been

something endearing about the depictions: the focus was on the beauty and physicality of the Moana. Even if the images seemed to at least partly acknowledge their humanity, the approach was dehumanising, belittling and exoticising Moana peoples while justifying imperial policies of domestication.[6] To this day Moana people struggle to assert and claim their humanity.

From the late eighteenth century the region became a place for conquer and conquest, with James King, a lieutenant on Cook's third voyage urging that Great Britain 'must take the lead in reaping the full advantage of her own discoveries'.[7] The British expansion into the Moana included the colonisation of Australia and Aotearoa, as well as what were named the British Western Pacific Territories. The colonial entity created in 1877 included Kiribati (1939–71), Cook Islands (1893–1901) and Niue (1900–01), the latter two both now self-governing in free association with New Zealand while Kiribati is now independent; Pitcairn Islands (1898–1952), still a British colony; Tonga (1900–52), which has always been staunchly independent; Tokelau (1877–1926), a dependent territory of New Zealand; Nauru (1914–21) now a trust territory administered by Australia; and Fiji (1877–1952), the Solomon Islands (1893 to 1971) and Vanuatu (1906–80), the three of which are now independent. The colonial entity also included the administration of Western Sāmoa by New Zealand after Germany ceded it post-World War I. This colonial myth of the vast Pacific Ocean or the South Seas separating tiny isolated islands has long been cemented in history. False borders were drawn across the ocean, and seafaring people became landlocked, their continent shattered into tiny pieces.

The colonial situation across the Moana, like many colonial 'situations', is complex. For starters, it is young. Cook's encounters occurred just 250 years ago; the region has been touched and divided by many empires (not just Great Britain), so that now decolonised, colonised and neo-colonised nations sit next to one another. It is easy to assume belittling colonial myths – the dusky maiden, noble savage, small deprived yet beautiful islands – are things of the past. Yet we should not underestimate the power of imperial depictions, both written and visual, within the dominant perception of the Moana region.

These myths spill over into our expectations of Moana contemporary art, dehumanising contemporary Moana peoples and trapping them within a certain era, set of concepts and aesthetics. Some contemporary artists are doing the important work of tackling these myths head-on by reappropriating and subverting them. A recent and prolific example is Lisa Reihana's *in Pursuit of Venus [infected]* at the 57th Venice Biennale, 2017, which remasters and digitises the French, scenic wallpaper *Les Sauvages de la Mer Pacifique* (1804) by Jean-Gabriel Charvet Cie and Joseph Dufour.

Imperialism means that Moana peoples, especially those within settler nations such as Aotearoa New Zealand, are not separated off from global technology and discourse. Be it in Tokelau, a small traditional island atoll, or the contemporary Los Angeles diaspora, both are Moana peoples with internet connections. We span the cosmopolitan to the tribal, not as a binary, but as a display of diversity and difference. As Professor of Indigenous Education at University of Waikato Linda Tuhiwai-Smith states, 'Decolonization is a process which engages with imperialism and colonialism at multiple levels',[8] and therefore looks like many things. Moana contemporary art practices today – like Moana peoples – are all-encompassing, varied and to an extent undefinable.

Smith's work has held a particular influence on contemporary art in Aotearoa New Zealand. In the seminal book *Decolonizing Methodologies* (1992) she writes that decolonisation encapsulates solutions from the 'time before', which she identifies as colonised time, and the 'time before that', or pre-colonised time, with decolonisation as present and perhaps also future time. Smith encourages thinking of both a pre-colonial time, in which Indigenous peoples had complete authority over their ideas, and Indigenous people's need to understand how colonisation occurred and 'what that has meant in terms of our immediate past and what it means for our present and future'.[9]

The Moana spans one third of the Earth's total surface area, including thousands of archipelagos, languages and distinct cultures. It is therefore impossible to provide a summary of the art practices across that expanse. Even while the focus here is on Aotearoa New Zealand, and local Moana art practices, these too are wide ranging and heterogeneous. Perhaps what decolonisation can really offer us is not just a speaking back to the empire, but a pathway to Moana peoples asserting diverse, multi-layered and complex subjectivities [...]

Since the Aotearoa population is strong at 22.3% Moana (including Māori peoples indigenous to Aotearoa and other Moana peoples in the diaspora), Moana art practices are contextually situated, and audiences are familiar with the content. Generally, Moana artists are no longer exoticised, but rather a common presence in contemporary art, enabling artists to be free of essentialising views.

However, these same privileges are not afforded to Moana artists (or even peoples) outside of this context. In part, this is because the pervasive colonial myths and escapist narratives of the Moana are still alive and well in the imagination of the European public. The sudden interest in Moana art in time for the 250-year commemoration of Cook's Pacific voyages, as seen in London's The British Library exhibition 'James Cook: The Voyages' (2018) and upcoming 'Oceania' (2018) at The Royal Academy of Arts, is somewhat curious. It is perhaps troubling that it takes commemorating a historical nemesis, as he is known in this part of world, to generate conversations around Moana contemporary art

practices. On the one hand, increasing the display of contemporary Moana art is exciting. On the other, one cannot help but see it as a contemporary display of the empire's spoils. Furthermore, what may be a celebration for the colonisers, is yet another reminder of the oppression and subjugation of Indigenous peoples as another notch on the belt of the empire. It is perhaps difficult to understand the ongoing impact and trauma caused by imperialism within the Moana from the distant location of London, but we must be critical of the limitations presented by these regional exhibitions.

Moving beyond the colonial celebrations of Cook and the myths he embedded in the impressionable European public, a wealth of Moana artists practice with critical rigour, aesthetic variety and astute commentary. [...]

How do you define contemporary Moana art? You don't.

1 Albert Wendt, 'Towards a New Oceania', *Mana Review*, vol.1, no.1, (1976) 49.

2 Aotearoa is the Te Reo Māori name for New Zealand. Te Reo Māori is the language of the Māori people, the Indigenous people of New Zealand. In this essay I use Aotearoa New Zealand to signal its multiple histories. Maualaivao is a title the Aiga Sa-Maualaivao of Malie conferred on Wendt as their highest ali'i title, in a ceremony in Sāmoa in 2012.

3 Papatūnuku (the earth mother) and Ranginui (the sky father) are key figures in Māori mythology.

4 B. Pualani Lincoln Meialua, 'Moanaākea', in *The Space Between: Negotiating, Place and Identity in the Pacific Culture*, ed. A. Marata Tamaira, (University of Hawaii: Honolulu, 2009) 143

5 Ron Brownson, 'Roundtable: Thinking Through Oceania Now', *Reading Room: A Journal of Art and Culture*, no.4, (2010) 91.

6 Linda Tuhiwai-Smith, *Decolonizing Methodologies: Research and Indigenous Peoples*, (London: Zed Books, 2012) 27.

7 James Cook and James King, *A Voyage to the Pacific Ocean*, vol. 3, (London: Champante & Withrow, 1793) ivii.

8 *Decolonizing Methodologies*, op. cit., p.21.

9 Ibid., 25.

Lana Lopesi, extracts from 'Beyond Essentialism: Contemporary Moana Art from Aotearoa New Zealand', *Afterall*, no. 46 (2018) 107–12, 115.

Tania Kovats
Oceans//2014

The exhibition 'Oceans' (2014) came together around a work that I've been wanting to make for some time called *All the Seas,* where I wanted to bring all the world's seas to one place. I knew I couldn't do this on my own so I would have to invite people into a kind of gathering, so the work became a participatory artwork where the invitation went out to ask people to send me water. During the time that this piece was being gathered I was also thinking about how to bring other works together around *All the Seas,* so it led me to reflect on how work I've made previously also has a connection to water and even some of the most solid, more geological sculptural works that I've made represent landscapes that have been formed by water, either through coastal erosion or river erosion, even to the point of thinking about when solid things were liquid.

Water is a really problematic material to try and make sculpture with. It's not a fixed thing unless you freeze it. But it's a very emotive element. People have a very particular sort of psychological response or emotional response to water, whether that's water in the landscape and their personal relationship with the sea, or being beside water, or just how we understand its significance for survival.

To make moving water still is a reflection as well on how water somehow represents our relationship with time, because the way water flows is also the way time flows. For me that's a very literal embodiment of those things. If you capture water and make it still, you've actually captured a moment, a bit like you might take a photograph, and that has been part of the invitation in *All the Seas.* I feel that when people have bottled up their bit of sea and sent it to me they've actually sent me a moment, either in their day, or in their holiday, or they've gone somewhere that's special to them and actually somehow encapsulated that. Probably every bottle has a story attached to it. I might not know all those stories and those stories won't necessarily be obvious to someone visiting the exhibition, but that sea of stories is woven into the work. [...]

Tania Kovats in conversation transcribed from *Tania Kovats, Oceans,* [DVD], Fruitmarket Gallery, Edinburgh, 2014.

Luce Irigaray
Marine Lover of Friedrich Nietzsche//1980

[...] Into the sea (you) are returned, to live your loneliness. And ten years, without weariness, you took pleasure *(jouis)* in your spirit. The sea used to carry you, but in no way troubled your fortune. You sought to become a child again, to climb ashore and drag your man's body once more.*

Why leave the sea? To carry a gift – of life. But it is to the earth that you preach fidelity. And forgetfulness of your birth. Not knowing if you descend from a monkey or a worm or if you might even be some cross between plant and ghost.†

Anxious to resolve this discord, you teach the superman: the meaning of the earth. But do you come from earth or sea to announce this news? Is it fluid depths or solid volume that engendered you?

Are you fish or eagle, swimmer or dancer, when you announce the decline of man? Do you seek to sink or climb? Flow out or fly up? And in your entire will for the sea are you so very afraid that you must always stay up so high?

Perched on any mountain peak, hermit, tightrope walker or bird, you never dwell in the great depths. And as companion you never choose a sea creature. Camel, snake, lion, eagle and doves, monkey and ass, and ... Yes. But no to anything that moves in the water. Why this persistent wish for legs, or wings? And never gills?

And when you say that the superman is the sea in whom your contempt is lost, that's fine. That is a will wider than man's own. But you never say: the superman has lived in the sea. That is how he survives.

It is always hot, dry, and hard in your world. And to excel for you always requires a bridge.

Are you truly afraid of falling back into man? Or into the sea? [...]

For there is no peril greater than the sea. Everything is constantly moving and remains eternally in flux. Hence with a thawing wind, bad fortune arrives. As well as salvation.

And in order for you to be pleasured, without always seeking pleasure *(jouissance)* anywhere else but in me, let the ice break up now. Let us be done with believing we need flints which only open up the solid shells of your ideas, or spurs to get your impassive things moving.

In me everything is already flowing, and you flow along too if you only stop minding such unaccustomed motion, and its song. Learn to swim, as once you danced on dry land, for the thaw is much nearer at hand than you think. And

what ice could resist your sun? And, before it disappears, perhaps chance will have the ice enflame you, dissolving your hardness, melting your gold. [...]

What a limitless world of appearances lies concealed beneath the great seas! If a man wants to delude himself, the sea will always lend him the sails to fit his fortune. And the (female) one and the other change places constantly without the one ever being really superior to the other. As they imperceptibly tint the whole with a skin of light that has the colour of the moment.

And because her depths are high, and deeper than imagined, anyone who finds in her the efflorescent source of his dreams rises very high, drawn higher than his highest day.

And when, in her abundance, she is not giving waters – those supple living envelopes for specular alchemy – she gives forth airs. And, according to the weather, she can become ice or restless waves. She is hard or melting at the whim of sun or wind.

And from her is born the very crystal that dream fixed in its transparent brilliance. Enigmatic fish, sleeping in her abysses and that even the wiliest fisherman will have trouble catching. Life beneath the sea is not fed upon honey even. Its own elements suffices it.

But the loftiest gaze does not penetrate thus far into her depths and is still unable to unfold all the membranes she offers to bathe his contemplations.

And whoever looks upon her from the overhanging bank finds there a call to somewhere farther than his farthest far. Toward an other ever more other. Beyond any anchorage yet imaginable. Any landing at the appearance of one of her strata.

As she unfurls, casting off all moorings. Her waves rolling again and yet again over one another. Stirring with strength as far as she extends.

And (she is) much deeper than the day ever conceived her to be. For days sets before touching the sea bottom. Before it can set anchor even at the last hour. The sea blushes at this setting sun that is forever tangent to sea swell but she still remains dark.

Anything that has not yet seen daylight hurtles into the abyss. Anything that remains unillumined is taken by the eye to be a chasm drawing a man to his destruction. And since he does not want to fall, he comes back at break of dawn to get a good look at things and thereby ensure himself a firm footing as he goes off again on his high-seas explorations. Expecting, further and later on, to come upon the shore of the furthest land.

But (he) keeps going on and keeps coming back, and never gets there. The sea is too deep. Hiding away from the final landfall. And anyone who wants her to send him back her deepest depths is lost. For one by one each of her surfaces takes its turn to shimmer. And the mirage falls into the gleaming abyss, endlessly.

The sea shines with a myriad eyes. And none is given any privilege. Even here and now she undoes all perspective. Countless and shifting and merging her depths. And her allure is an icy shroud for the point of view.

No rapture, no peril, is greater than that of the sea. And the man has still to come who will live that love out beyond the reach of any port. Letting go of his rock, his ship, his island, and even of that last drop of oil on the water, and all so that he can feel the intoxication of such vastness. [...]

*Again I am indebted to Walter Kaufmann's translation of the Prologue to *Thus Spoke Zarathustra*. After ten years in the mountains, Zarathustra announces to the sun that he 'must descend to the depths'. An old man says to him, 'Zarathustra has changed. Zarathustra has become a child. Zarathustra is an awakened one; what do you now want among the sleepers? You lived in your solitude, as in the sea, and the sea carried you. Alas, would you now climb ashore? Alas, would you again drag your own body?' (Friedrich Nietzsche, *The Portable Nietzsche, ed. and trans. Walter Kaufmann (New York: Penguin, 1976).* † See Kaufmann, *The Portable Nietzsche*, 125.

Luce Irigaray, extracts from *Marine Lover of Friedrich Nietzsche* (1980), trans. Gillian C. Gill (New York: Columbia University Press, 1991) 12–3, 37, 46–7.

Astrida Neimanis
Bodies of Water//2017

[...] To rethink embodiment as watery stirs up considerable trouble for dominant Western and humanist understandings of embodiment, where bodies are figured as discrete and coherent individual subjects, and as fundamentally autonomous. Evidence of this dominant paradigm underpins many if not all of our social, political, economic, and legal frameworks in the Western world. Despite small glimmers of innovation, regimes of human rights, citizenship and property for the most part all depend upon individualised, stable and sovereign bodies – those 'Enlightenment figures of coherent and masterful subjectivity'[1]– as both a norm and a goal. But as bodies of water we leak and seethe, our borders always vulnerable to rupture and renegotiation. With a drop of cliché, I could remind you that our human bodies are at least two-thirds water, but more interesting than these ontological maths is what this water does – where it comes from, where it goes, and what it means along the way. Our wet matters are in a constant process of intake, transformation, and exchange – drinking, peeing, sweating, sponging, weeping. Discrete individualism is a rather dry, if convenient, myth.

For us humans, the flow and flush of waters sustain our own bodies, but also connect them to other bodies, to other worlds beyond our human selves. Indeed, bodies of water undo the idea that bodies are necessarily or only human. The bodies from which we siphon and into which we pour ourselves are certainly other human bodies (a kissable lover, a blood-transfused stranger, a nursing infant), but they are just as likely a sea, a cistern, an underground reservoir of once-was-rain. Our watery relations within (or more accurately: *as*) a more-than-human hydrocommons thus present a challenge to anthropocentrism, and the privileging of the human as the sole or primary site of embodiment. Referring to the always hybrid assemblage of matter that constitute watery embodiment, we might say that we have never been (only) human.[2] This is not to forsake our inescapable humanness, but to suggest that the human is always also more-than-human. Our wateriness verifies this, both materially and conceptually.

Moreover, as Virginia Woolf reminds us, 'there are tides in the body'.[3] Or in the words of Syilx Okanagan poet Jeanette Armstrong, 'water is siwlkw' and *siwlkw* is 'coursing / to become the body' – 'waiting', 'over eons / sustaining this fragment of now'. Water extends embodiment in time – body, to body, to body.[4] Water in this sense is facilitative and directed towards the becoming of other bodies. Our own embodiment, as already noted, is never really autonomous. Nor is it autochthonous, nor autopoietic: we require other bodies of other waters (that in turn require other bodies and other waters) to bathe us into being. Watery bodies are gestational milieus for another – and for others often not at all like us.[5] Our watery bodies' challenge to individualism is thus also a challenge to phallologocentrism, the masculinist logic of sharp-edged self-sufficiency. Phallologocentrism supports a forgetting of the bodies that have gestated our own, and facilitated their becoming, as some feminist philosophers have long argued.[6] But crucially, this watery gestationality is also decidedly posthuman, where human reprosexual wombs are but one expression of a more general aqueous facilitative capacity: pond life, sea monkey, primordial soup, amphibious egg, the moist soil that holds and grows the seed. As themselves milieus for other bodies and other lives that they will become as they relinquish their own, our bodies enter complex relations of gift, theft and debt with all other watery life. We are literally implicated in other animal, vegetable and planetary bodies that materially course through us, replenish us, and draw upon our own bodies as their wells: human bodies ingest reservoir bodies, while reservoir bodies are slaked by rain bodies, rain bodies absorb ocean bodies, ocean bodies aspirate fish bodies, fish bodies are consumed by whale bodies – which then sink to the seafloor to rot and be swallowed up again by the ocean's dark belly. This is a different kind of 'hydrological cycle'. [...]

1 Donna Haraway, *The Haraway Reader* (London: Routledge, 2004) 48.

2 Rosi Braidotti, *The Posthuman* (Cambridge: Polity Press, 2013) 1; Donna Haraway, 'A Manifesto for Cyborgs: Science, Technology and Socialist Feminism in the Late Twentieth Century', *Socialist Review*, vol. 80 (1985) 65–108.

3 Virginia Woolf, *Mrs. Dalloway* (1925) (New York: Penguin Classic, 2000) 124.

4 Jeanette Armstrong, 'Water is Siwlkw', in *Water and Indigenous Peoples* (Paris: UNESCO, 2006).

5 Mielle Chandler and Astrida Neimanis, 'Water and Gestationality: What Flows Beneath Ethics', in Cecilia Chen, J. MacLeod, and Astrida Neimanis (eds.), *Thinking with Water* (Montreal and Kingston: McGill-Queen's University Press, 2013) 61–83.

6 See Luce Irigaray, *Marine Lover of Friedrich Nietzsche*, trans Gillian C. Gill, (New York: Columbia University Press, 1991) and Hélène Cixous and Catherine Clément (eds.), *The Newly Born Woman*, trans. Betsy Wing (Minneapolis: University of Minnesota Press, 1986).

Astrida Neimanis, extract from *Bodies of Water: Posthuman Feminist Phenomenology* (London: Bloomsbury, 2017) 2–3.

Kasia Molga
How to Make an Ocean//2023

In autumn 2019, I experienced a devastating loss. While mourning I cried many tears. At some point, I started to collect them in a small container while pondering the possibility of making something constructive out of my very sad grief. At the same time, the worldwide climate emergency was declared and eco-anxiety was recognised as a valid mental health condition. Then the pandemic arrived. A new, uneasy emotion entered my life with a sense of restlessness and unpredictability, amplifying already present anxiety. Tears then became a sort of remedy for me. During this time, I read *Flights* (2017) by Olga Tokarczuk, and in one short story the question is posed – how to make an ocean? It struck a strong chord with me because I spent my childhood travelling on the open sea and now I live by the coast, so the ocean is a huge part of my life. With so many collected tears, I started to wonder whether it was possible to cultivate marine life in them, constructing something life affirming out of devastating loss and deeply uncertain times.

I managed to get a residency in EMAP/EMARE (European Media Art Platform/ European Media Artist in Residence Exchange) with Ars Electronica to make this work happen. It was supposed to last three months. Instead, it lasted over 18 months and has evolved into a set of experiences, which together depict the

complexity of how me, my body, oceans and experiences of reality mediated via technology are interconnected.

How to Make an Ocean (2021) expands upon my passion to investigate how each of us, individually via our bodies, can care for and nourish the natural environment and connect with other-than-human organisms. It explores if human tears – a bodily 'waste' – can provide the basis for a marine ecosystem. What sort of species can I cultivate in my tears? How often do I have to cry to be able to grow them? How might different types of tears, from sadness or frustration or happiness, influence the condition of my mini oceans? What sort of stimuli do I need to make myself cry when tears are not present but are necessary to nourish my tiny ecosystems? And what sort of tools are needed to effectively collect tears, which is not easy at all?

It turned out that to create and sustain marine life takes a lot of time, especially in such unusual circumstances. I started experimenting with seawater, artificial tears and algae from my local beach. The beginning of my residency coincided with the world lockdown, so I had to create a makeshift bio lab in my studio. Marine systems have to be in a constant state of flow but my tiny tears in small containers were static, resembling pond water. I found out that algae can grow in such an environment. However, during my first experiment to cultivate particularly beautiful North Sea red algae in my tears, it lost its red colour after a few days. It was very disappointing, but after some research I learnt that this was due to lack of potassium. That inspired me to look at my diet and how it could affect the chemical composition of my tears while keeping a diary of what I ate. Due to the lack of access to medical labs in the pandemic I used chemical strips in an attempt to assess the presence of vital elements in my tears. I learnt that nitrogen, potassium and phosphorus are crucial for a healthy human diet and also for the development of healthy algae. This prompted me to consider how our own self-care of our bodies is important for the health of the living world.

Based on my newly acquired knowledge about the composition and value of tears, I designed a *Moirologist Bot*, a bespoke Artificial Intelligence which by assessing news headlines on ocean conditions every 15 minutes determines 'its' mood. Depending on this, it then selects a video with more or less intense emotional cues, visuals and music, in an attempt to induce some tears in the viewer. A moirologist is a professional mourner, a profession that doesn't exist anymore in Western society, but can still be encountered in some Indigenous cultures. The *Moirologist Bot* in *How to Make an Ocean* becomes a commentary on the impact of AI-curated news stories and digital spaces on our mental health and on how technology can obscure experiences of physical nature.

How to Make an Ocean was also an investigation into what makes us cry and why tears are important. According to scientists, only humans cry out of emotion. Tears often appear when we feel acute pain. We release a painkiller – natural opioids – through our tears. Sometimes we cry out of happiness. Sometimes we shed tears seeing other people crying in an act of deep connection and empathy. Crying gets rid of toxins generated in moments of stress. And tears can help us gain clarity to view things in better order and see the way out of some horrible situations or problems – such as ecological emergency and the Sixth Mass Extinction.

All of this contributed to building a selection of mini oceans, hosting a variety of algae. Each tear, whether my own or a contributor's, is enclosed in a tiny bottle noted with the reason for crying, the date and the type of algae. The collection continues to grow. And the sea – life-affirming water – continues to connect all parts of this narrative, just like it connects parts of the planet, weaving us all into one inextricably intertwined system.

Kasia Molga, 'How to Make an Ocean', a new text written for this book, adapted from an artist's talk for 'Artists/Oceans' online artist talk series, University of East Anglia, 10 February–3 March 2022.

Léuli Eshrāghi
Priority to Indigenous Pleasures//2021

[…] What does receiving and giving tactile pleasure have to do with non-colonial actions in the world? Archival research into colonial and Indigenous imaginaries of gender, sexuality, performance and wellbeing focused on the central Great Ocean archipelago of Sāmoa and neighbouring cultures has culminated in the materiality, colour, shimmering movements, and meditative practices that realise Indigenous existences in the installation *re(cul)naissance* (2020). An eight-limbed fe'e deity represented in ancestral and new motifs, on printed, iridescent lengths of fabric, reaches across the ancillary space of an old industrial shipyard. The lengths of fabric converge at a neon circle above a gold-gilded steel pool of water, in a ceremonial framework within which to honour precolonial human-animal kinship and cycles of life, pleasure, connection, survival, and thriving before death and the afterlife. Filtered into the installation, Wareamah's natural light is tempered within the space to reverse the notion of the 'Coming of the Light' that masks violent evangelisation undertaken by Euro-American missionaries around the world. Indigenous kinships

including multiple genders and sexualities, ceremonial-political practices, and visual cultural expressions are recovered from negatively connoted Western perceptions of savagery, deviancy, chaos and darkness.

To relate the possibility of our becoming water with becoming sensual gives us responsibility to become well and sovereign in relation with all life. Water is our primary ancestor in the Great Ocean, a third of this planet's surface, sustaining all life, yet underrepresented or erased from voicing perspectives in the majority of anthropocentric discourses and practices evolving out of an unenlightened, empire-hungry Europe. Situating Indigenous law-making capacity as preceding the invading settler governance is to recognise Indigenous legality through living beings breathing, surviving, thriving and worldmaking, in lakes, rivers and seas that embody the upholding of Indigenous truth. Indigenous truth can be articulated as kinship based on reciprocity and future-focused action, and inherently presupposes as much agency on the part of lakes, rivers and seas as on that of animals, birds, mammals and humans.[1] A break or interruption in the local, prior world of an Indigenous people's understanding of themselves creates an exception to belonging, relationality and hxstory: before we were Sāmoans, we were actors in ungendered kinship with all our relations in village-based polities, where the expression of sensual languages was prized and cherished.

I believe that recurring, ritualised proffering and accepting of each other's being in the sexual life of everyone can, when involving Indigenous persons, realise other temporalities. In order to relearn our roots, our ancestral-future knowledge, our guardian spirits, our god-goddesses, our animal relationships, we need to imagine or renew ourselves as fa'afafine, fa'atama, Two-Spirit, queer, trans, nonbinary, and much more. Teasing around cheeks, asses, pleasures, diving deep, eating, feeding, rimming, furrowing, sometimes with the added rush of poppers. I think we need to move our tongues, our bodies, get them to speak, propel, touch, be tender, so that we can become healthy, in heterogeneous brilliance. We will be even more sovereign, true, free after Gregorian shame-time.

1 [Footnote 4 in source] Stephen Turner, 'The Truth of Waters', Reading Room: A Journal of Art and Culture, no. 4 (2010) 116. Published by Auckland Art Gallery Toi o Tāmaki, Auckland.

Léuli Eshrāghi, extract from 'Priority to Indigenous Pleasures', in Sensing Nature: MOMENTA Bienniale de l'image 2021 (exh. cat.), ed. Audrey Genois (Montreal and Bielefeld: Kerber Verlag, 2021) 46–7.

Elizabeth DeLoughrey and Tatiana Flores
Submerged Bodies: The Tidalectics of Representability and the Sea in Caribbean Art//2020

[...] Although the perpetual circulation of seawater means that, in many ways, the ocean itself is not localised, we place this critical literature in conversation with Caribbean visual art, particularly because it acknowledges that bodies of water are marked by material and cultural histories as well as by human and nonhuman bodies.[1] We bring these conversations in relation to Caribbean poet/ historian Kamau Brathwaite's theory of 'tidalectics', an analytical method based on what he describes as 'the movement of the water backwards and forwards as a kind of cyclic . . . motion, rather than linear'.[2] Importantly, Brathwaite's theory foregrounds the diverse temporalities of oceanic space as well as the 'submerged mothers' that must be recuperated in regional history.

This (sub)oceanic turn was anticipated in the art of Tony Capellán, whose sculptural work features plastic objects washed ashore in Santo Domingo, Dominican Republic. With these objects, Capellán constructed installations that invoke the sea, its ecosystems, and the people that encountered it: a deeply humanised ocean constituted by plastic waste. Capellán's *Invaded Sea* (2015) visualises a seascape of gradient blues from the detritus of the ocean and the flooded tenements along the Ozama River. Installed on the floor, the accumulated plastic objects overwhelm the viewer with their material presence; made in the 1990s, Capellán's work marks the advent of the Plasticene well before the term Anthropocene had even been coined. Although the image they create is of the sea's surface, Capellán's installations probe the human-produced debris permeating the world ocean and its estuaries. Thus, waste – supposed to be 'flushed' away and rendered invisible to bourgeois consumers of art – suddenly 'invades' museum space. Immersion in this piece becomes invasion, an excess of the waste of capitalist consumption that challenges any notion of the sea as wilderness or 'pure nature', just as it contests gallery space as 'pure culture'.

Inspired by Capellán, our inquiry considers the animacy and materiality of the ocean's depths. This is vital in the Caribbean context, in which the tourism industry advertises a visual imaginary of 'seascapes' where turquoise waters and white sands appear as interchangeable blank canvases. In submerging, we recognise that the sea is a site of historical and contemporary trauma and drives the work of recuperating the lost bodies of history.

In 2017, the exhibition 'Relational Undercurrents: Contemporary Art of the Caribbean Archipelago' opened at the Museum of Latin American Art (MOLAA)

in Long Beach, California.[3] Curated by Tatiana Flores, *Relational Undercurrents* challenged the continental bias that tends to frame the discourse on Latin America and argued against the narrative of fragmentation and heterogeneity that characterises much critical commentary on the Caribbean. The exhibition located spaces of continuity and thematics of correspondence in the art of the Caribbean and, as such, was framed in terms of archipelagoes, building on a vital body of work in island studies and archipelagic thinking.[4]

Through this exhibition, we noticed that engagement with the ocean abounded in different media: video, sculpture, painting and photography. This tendency in art is not surprising, given that Caribbean literature and cultural practices have long engaged with the ocean as both dystopian origin and aquatopian future: a space of origins of the transatlantic Middle Passage or in crossing Kala Pani (black waters) rendering, to paraphrase Derek Walcott, 'the sea (a)s history'. To Brathwaite, Caribbean 'unity is submarine' and offers a more holistic mapping than the balkanisation caused by European colonial empires, leading Cuban author Antonio Benítez-Rojo to envision 'peoples of the sea'.[5] These oceanic imaginaries of unification must also be placed in dialogue with how migration crises position the Caribbean Sea as a space of loss and fragmentation for Cuban and Dominican *balseros* and Haitian *botpippel.* Caribbean, African and Indian diasporic work has an established intellectual genealogy engaging the histories of transoceanic terror, while blue humanities scholarship – thus far – has not really engaged with how the oceanic also produces racialised violence.[6] Our work builds on postcolonial and Caribbean studies scholarship and connects it to ecomaterialist and environmental humanities work to raise questions about how human bodies merge with more-than-human nature – a tidalectic method engaging a wide range of experiences and representations of the submerged body at multiple scales, recognising that the ocean can be understood as simultaneously planetary and deeply local. This is in keeping with Anthropocene work, which understands the ocean, like the planet, as a site of intimate phenomenological encounter (ontology) as well as an incommensurate 'planetarity'.[7] [...]

Tidalectic Diffractions

We define *tidalectics* as submarine immersion and oceanic intimacy constituted by an 'entangled ontology' of diffraction.[8] Building on the work of Donna Haraway and others, we engage a 'diffracted ethics' of the visual logics of oceanic representation that bring the artist, the artwork and the viewer into relation.[9] Knowledge making is often based on a visual logic: 'to see' and 'to perceive' connect visuality with epistemology. In an attempt to move beyond the simple representational logic of *reflection* (a mirroring between subject and

object), these scholars call attention to a different, less 'transparent' approach to meaning making that incorporates alterity and the limits of knowledge. To Haraway, 'Diffraction, the production of difference patterns, might be a more useful metaphor' than reflection or reflexivity because it denotes the bending of a line of sight, the way an object in the water, when viewed from above or below, is distorted.[10] Literally and metaphorically, it is a turning 'away from a straight line or regular path'.[11] 'Diffraction patterns record the history of interaction, interference, reinforcement, difference. [They are] about heterogeneous history, not about originals.'[12] To Karen Barad, 'diffraction may serve as a productive model for thinking about nonrepresentationalist methodological approaches'.[13] Non-representationalist methods consider the world from within rather than 'reflecting on the world from outside'.[14] Importantly, they insist on an immersive participation-engagement that demands accountability and praxis rather than distanced, neutral observation.

We begin with the tidalectic methods and diffractive ethics of Jean-Ulrick Désert's *The Waters of Kiskeya/Quisqueya* (2017), a hand-painted map of the Caribbean spread over nine folios of calfskin vellum. Kiskeya/Quisqueya, the Taíno name for the island of Hispaniola, today comprises Haiti (the artist's home country) and the Dominican Republic. The piece recalls an early modern *mappa mundi* with its leather support, gold leaf accents, Latin inscription, finely painted surface, and detailed renderings of landmasses, flora and fauna. Its naturalist rendering of the ocean includes sea creatures – real and fantastic – such as a kraken (giant octopus) submerging an eighteenth-century ship and detailed, often-taxonomic illustrations of fish and birds derived from the colonial archive.[15] The animated submarine representations invoke the advent of a transatlantic empire in which European cartographies of the ocean began to empty the space of life and replace it with the gridlines of longitude and latitude.[16] Désert's Caribbean Sea teems with nonhuman life.

This work must be seen in relation to the threat of a rising Anthropocene ocean and the history of representing the Atlantic as a space of wonder and terror. Désert, a Berlin-based Haitian-American, conceived of the map while on a residency in Venice, Italy, surrounded by rising waters, medieval illuminated manuscripts, and early modern maps of Venice and the Atlantic world.[17] Unlike the blue seas in the maps he consulted, *The Waters of Kiskeya/Quisqueya* depicts an opalescent, white Caribbean Sea with flora, fauna, and marine vessels sketched or xenographed onto the surface. The islands and continental territories are lightly outlined in green, and blue water only appears in the representations of the Atlantic and Pacific Oceans. The sea here is not a placid backdrop; the piece presents a terraqueous view that brings land and sea into tidalectic relation. The whiteness of Désert's Caribbean Sea captures and reflects

light; its iridescence partakes in the 'unsettled, reflective and bright surfaces' that Krista Thompson pinpoints as characteristic of African diasporic practices.[18] Rather than employing what Haraway calls the 'god trick' of the aerial view that characterised colonial Caribbean mapping,[19] *The Waters of Kiskeya/Quisqueya* demands that the viewer take in multiple, often diffracted perspectives at once through three horizontal spatial registers: the undersea, the land and sea surface, and the air. In the depths are black-and-white sketches of coral and fish, many of them rendered taxonomically. A seaplane, birds and a fish fly in the air. A cruise ship and yacht on the water replace the caravels of the past, signalling the condition of neocolonialism; historical vessels, including a sunken galleon, are also visible. As Stefan Helmreich points out, contemporary mapping technologies like Google Ocean visualise the ocean as bereft of all sea life;[20] Désert instead includes flying fish, enormous deep-sea oar fish, tiger sharks, squid, octopi, nautilus and various types of coral.

While transatlantic Renaissance cartography rendered foreign spaces as transparent and accessible to European viewers, Désert's map plays with legibility, demonstrating how cartography itself is bound up in spectral laws of light, often resulting in diffracted imagery. The map's surface, covered in mother-of-pearl pigment, reflects light back at the viewer and even resists photographic representation. The refracted lines drawn between images impart the sense that we are viewing this map partially underwater. This demands an immersive spectatorship, an ontological entanglement with the history of representing the Caribbean. Désert's work suggests that visually representing the Caribbean Sea necessitates the interplay of oceanic waves and waves of light that enable perception. According to Barad, both types of waves result in diffraction patterns that, from the perspective of physics and metaphor, are 'the fundamental constituents that make up the world'. In other words, the ocean's movement and our perception of it through light are determined by waves of diffraction.

Feminist theorist Astrida Neimanis has argued that 'water extends embodiment in time – body, to body, to body. Water in this sense is facilitative and directed towards the becoming of other bodies'.[21] But the bodies in Désert's map are diffracted and fragmented – the red lines that crisscross the sea represent the borders of each country's Exclusive Economic Zone (EEZ) and are drawn in 'blood red', as Désert describes.[22] In a medium that prioritises an orderly, 'objective', and 'neutral' aerial gaze, the employment of a diffractive aesthetic disrupts the authority of the map. As Désert notes, 'the seas are fractured and like broken glass [or] broken mirrors, there are refractions and distortions'.[23] Accordingly, the bodies of the fish drawn between these maritime borders are diffracted. This trope characterises much of the critical discourse

on the Caribbean about the violent 'irruption into modernity', in Édouard Glissant's words, created by colonisation, diaspora, slavery and indenture. The minimal use of vibrant colour in the cartography of a tropical region known for its exoticised representations is deliberate. The sea that falls into the region separated by borders is rendered pearlescent white instead of blue; the blood red lines that partition the sea suggest the violence of state territorialism, the history of mapping and the mastering aerial view, and the ongoing difficulties of determining EEZ borders in a region that shares a common sea. [...]

Intimacies of Submersion

Feminist theorists of submersion suggest that the element of liquid itself enables bodies to be merged with other bodies. But claiming the ocean as origin does not necessarily suspend or 'unmoor' the history of racialised and gendered bodies. We explore this tidalectic through the medium of photography in the work of two female artists who use self-portraiture as a kind of 'unmooring' of gendered binaries. They partake in a Caribbean feminist conversation, as noted by Annalee Davis, Joscelyn Gardner, Erica Moiah James and Jerry Philogene, regarding how 'the body can become a marker within a set of critical frameworks, which at its core yields emancipatory spaces'.[24] In María Magdalena Campos-Pons' composite photograph *Elevata* (2005), we see the ocean as abstracted cosmic space, where the artist's body, pictured from behind, hangs suspended as her long braids traverse the depths, tracing a path across a pictorial expanse that would be otherwise unfathomable. Campos-Pons, a Cuban artist who moved to the United States in the early 1990s, temporally condenses the traumatic voyage of the Middle Passage and more recent experiences of Caribbean migration northward. *Elevata* is composed of a grid of sixteen individually framed large-scale Polaroids that engulf the viewer, for whom the act of looking is akin to submergence. As in Désert's map, the component pieces create the whole, but the compositional fragmentation inherently evokes diffraction, suggesting interrupted trajectories and unresolved histories.

Interestingly, Campos-Pons' images were not created underwater; rather, she photographs gestural watercolours superimposed with sculptural spherical elements resembling planets – representing the ocean's vastness as a universal space even as it is firmly and tidalectically located in Caribbean bodies. 'Elevata', suggesting ascension, belies the downward orientation of the artist's head and hair, as though she is diving headfirst into the water – a movement that invokes the Middle Passage and more recent migrant deaths by drowning. The artist genders the oceanic body as female, as though her long, intertwined braids were in the process of becoming roots from which to grow and flourish. In fact, her braids call to mind the octopus tentacles of *The Waters of Kiskeya/Quisqueya,* a shared gendering of subject and place that merges the human with more-than-human others.

Similarly, the Vincentian photographer Nadia Huggins queers the Caribbean Sea by destabilising masculine and feminine binaries. Her photographic series *Circa No Future* (2014), which depicts local boys swimming near a rock in Indian Bay, establishes 'a link between an under-explored aspect of Caribbean adolescent masculinity and the freedom of bodies in the ocean'.[25] For Huggins, the ocean is a place of intimacy and play where, as Angelique V. Nixon points out, gender binaries are 'troubled' and made fluid[26] – especially crucial in the context of St. Vincent and the Grenadines, where due to colonial laws homosexuality is not only illegal but conflated with bestiality. Thus we can read this collapse of gendered and sexed bodies in relation to M. Jacqui Alexander's important claim that 'not just (any) body can be a citizen' in national contexts that proscribe heteropatriarchy.[27]

The ocean then becomes a space in which the land-based binaries of heteropatriarchy, and the relationship between artist and subject, are challenged. In these underwater and half-submerged photographs, Huggins herself is one of the swimmers. She uses an unobtrusive point-and-shoot rather than a camera with sophisticated technology, so as not to create distance between herself and the boys she photographs. Huggins builds a relationship to her subjects over time, and that sense of intimacy pervades the series. In some photographs, she is so close as to make the viewer feel like part of the inner circle, collapsing our distance and creating a tidalectic immersion that insists – drawing again from Barad – that we engage from within rather than 'reflecting on the world from outside'.[28]

The first time Huggins swam toward the boys, they assumed that she was also male and so behaved in an unconstrained manner; when they noticed she was female, they began 'posturing'.[29] Indeed, in a dramatic view captured from below, a boy poses in midair, one hand on his head with a bent elbow, the other arm stretched outward, his legs rotated and knees bent in the form of a plié. His feminine pose confirms the artist's observations that the boys are 'a lot less guarded' in the ocean than they would be on land.[30] Other images capture scenes of the boys swimming around the rock, fragments of their bodies, and bubbles generated as they hit the ocean. Says Huggins, 'it's a place so far removed from everything else going on in shore that they feel comfortable and safe with each other there, and . . . nobody's judging them'.[31]

Huggins probes the underwater world for unmapped Caribbean masculinities, invoking Brathwaite's 'submerged mothers'. On the one hand, the title of the series, *Circa No Future* (the text printed on one of the boys' shirts) evokes the challenges facing Caribbean men; on the other, her work suggests that water allows for a kind of merger with nonhuman others that is rendered maternal and comforting rather than terrifying. Huggins explains:

The ocean itself takes on a personality – that of the embracing mother providing a safe space for being – which is both archetypal and poignant. I am as much a subject as the boys for whom I provide solace. The boys become submerged in a moment of innocent unawareness. They emerge having proven themselves. The relationship between myself and the subject is also explored within this paradigm. The subjects are aware of me while posturing, but lose this cognizance when they sink into the water.[32]

Despite themselves, the boys' performance of masculinity dissolves in oceanic water. Huggins is particularly interested in their vulnerability as their bodies hit the water, and many of the photographs focus on the moment of submersion; air bubbles in some images obscure the boys' features and in others frame them.

Although the sea through Huggins' lens is nurturing, there is also a sense of uncertainty. Some images are cropped so that the boys appear decapitated. In one, where a swimmer's body is mostly submerged apart from his head, Huggins captures the effect of diffraction. The elongated underwater torso contrasts with the disproportionately smaller head peeking out against the rocks, a bodily diffraction seen in Désert's map and perhaps part of an ongoing conversation in Caribbean studies about masculinity in crisis. Per Haraway, diffraction 'does not map where differences appear, but rather maps where the effects of differences appear'.[33] An abstract amorphous plane that runs through the centre of the photograph compounds the 'effect of difference' as it separates water from air. The solid rock and the human body both disappear, replaced by a greyish-blue blur that spreads horizontally from edge to edge of the composition – the water that, given sea-level rise, will one day immerse us all. This rising of the Anthropocene ocean provides a new angle from which to interpret the phrase 'Circa No Future'. [...]

1 [Footnote 6 in source] This oceanic analysis and engagement with tidalectics is argued in Elizabeth M. DeLoughrey, *Routes and Roots: Navigating Caribbean and Pacific Islands* (Honolulu: University of Hawaï'i Press, 2007).

2 [7] Kamau Brathwaite, in Nathaniel Mackey, 'An Interview with Edward Kamau Brathwaite', *Hambone*, no. 9 (Winter 1991) 44; Edward Kamau Brathwaite, 'Submerged Mothers', *Jamaica Journal*, vol. 9, nos. 2–3 (1975) 48–9. Recent work has returned to his theory – see *Tidalectics: Imagining an Oceanic Worldview through Art and Science*, ed. Stefanie Hessler (Cambridge, MA: The MIT Press, 2018).

3 [10] *Relational Undercurrents* was on view at MOLAA from 16 September 2017–3 March 2018. A version of the exhibition travelled to several venues along the East Coast of the United States, ending its run in September 2019.

4 [11] Rutgers University's Center for Cultural Analysis held a yearlong seminar on archipelagoes, codirected by Yolanda Martínez-San Miguel and Michelle A. Stephens, in 2015. See https://cca.rutgers.edu/annual-seminar/past-seminars/308-archipelagoes.

5 [12] To Benítez-Rojo, 'the culture of the Caribbean . . . is not terrestrial but aquatic . . . [it] is the natural and indispensable realm of marine currents, of waves, of folds and double folds, of fluidity and sinuosity'. Benítez-Rojo, *The Repeating Island: The Caribbean and the Postmodern Perspective*, trans. James E. Maraniss (Durham, NC: Duke University Press, 1997) 11. DeLoughrey explores this aquatic discourse in *Routes and Roots* (2007).

6 [13] We note here a difference between the 'blue humanities' as it is inscribed by literary scholars and a more interdisciplinary body of work in critical ocean studies.

7 [14] Gayatri Chakravorty Spivak, *Death of a Discipline* (New York: Columbia University Press, 2003). Dipesh Chakrabarty troubles the universalist narratives of the Anthropocene and makes a compelling claim for a species-based universalism that is not ontological; see Dipesh Chakrabarty, 'The Climate of History: Four Theses', *Critical Inquiry*, vol. 35, no. 2 (2009) 197–222. DeLoughrey's *Allegories of the Anthropocene* builds upon this to argue for the necessity of allegory to telescope between scales.

8 [18] Karen Barad, *Meeting the Universe Halfway: Quantum Physics and the Entanglement of Matter and Meaning* (Durham, NC: Duke University Press, 2007) 89. See also Karen Barad, 'Diffracting Diffraction: Cutting Together-Apart', *Parallax*, vol. 20, no. 3, special issue on *Diffracted Worlds, Diffractive Reading: Onto-Epistemologies and the Critical Humanities* (2014) 168–87.

9 [19] Eva Hayward, 'Sensational Jellyfish: Aquarium Affects and the Matter of Immersion', *Differences*, vol. 23, no. 3 (2012) 161–96, 181.

10 [20] Donna J. Haraway, *Modest_Witness@Second_Millennium: FemaleMan©_ Meets_OncoMouse™: Feminism and Technoscience* (New York: Routledge, 1997) 34.

11 [21] Hayward, op. cit., 182.

12 [22] Haraway, *Modest_Witness@Second_Millennium*, op. cit., 273.

13 [23] Barad, op. cit., 88.

14 [24] Ibid.

15 [25] Some of the sketches are drawn from early naturalist renderings of the Bermuda 'sea serpent' (oarfish); one ship is reproduced from the work of French naturalist Pierre Denys de Montfort. For the history of ecology and empire, see Antonello Gerbi, *Nature in the New World* (Pittsburgh: University of Pittsburgh Press, 1986), and Richard Grove, *Green Imperialism: Colonial Expansion, Tropical Island Edens, and the Origins of Environmentalism, 1600–1860* (Cambridge: Cambridge University Press, 1995).

16 [26] See Philip E. Steinberg, *The Social Construction of the Ocean* (Cambridge: Cambridge University Press, 2001) 107.

17 [27] Email correspondence with artist, 14 November 2016.

18 [28] Krista Thompson, *Shine: The Visual Economy of Light in African Diasporic Aesthetic Practice* (Durham, NC: Duke University Press, 2015) 9.

19 [29] Donna J. Haraway, 'Situated Knowledges: The Science Question in Feminism and the Privilege of Partial Perspective', *Feminist Studies*, vol. 14, no. 3 (Autumn 1988) 575–599.

20 [30] Stefan Helmreich, 'From Spaceship Earth to Google Ocean: Planetary Icons, Indexes, and Infrastructures', *Social Research*, vol. 78, no. 4 (Winter 2011) 1226.

21 [32] Astrida Neimanis, *Bodies of Water: Posthuman Feminist Phenomenology* (London: Bloomsbury, 2017) 3.

22 [33] Email correspondence from Jean-Ulrick Désert, 16 September 2017.

23 [34] Ibid.

24 [52] Annalee Davis, Joscelyn Gardner, Erica Moiah James and Jerry Philogene, 'Introduction: Art as Caribbean Feminist Practice', *Small Axe Project*, vol. 21, no. 1 (March 2017) 35. This article chronicles a vital feminist history of Caribbean art and includes some of the works of Nadia Huggins discussed here.

25 [53] www.nadiahuggins.com/Circa-no-future. Within the region, the island of St. Vincent itself is not heavily touristed; most travellers move on to the luxury resorts on Bequia, which ensures that the local community has access to the sea for recreation, resulting in a different aesthetic of submergence than in more heavily trafficked islands.

26 [54] Angelique V. Nixon, 'Troubling Queer Caribbeanness: Embodiment, Gender, and Sexuality in Nadia Huggins' Visual Art', *Small Axe Project: Caribbean Queer Visualities* (2017) 102–113.

27 [55] M. Jacqui Alexander, 'Not Just (Any)Body Can Be a Citizen: The Politics of Law, Sexuality and Postcoloniality in Trinidad and Tobago and the Bahamas', *Feminist Review*, no. 48 (Fall 1994) 6.

28 [56] Barad, op. cit., 88.

29 [57] Conversation between Tatiana Flores and Nadia Huggins, 12 January 2019. See also a similar conversation in 'Troubling Queer Caribbeanness', op. cit.

30 [58] Ibid.

31 [59] Ibid.

32 [60] See www.nadiahuggins.com/Circa-no-future

33 [62] Haraway quoted in Hayward, op. cit., 162.

Elizabeth DeLoughrey and Tatiana Flores, extracts from 'Submerged Bodies: The Tidalectics of Representability and the Sea in Caribbean Art', in *Liquid Ecologies in Latin American and Caribbean Art*, eds. Lisa Blackmore and Liliana Gómez (New York and Abingdon: Routledge, 2020) 163–7, 172–4, [some footnotes omitted].

Ana Mendieta
Ideas para siluetas (Ideas for silhouettes)//1976-78

[...] En el mar: Hacer la silueta a la orilla - Dejarla que se llene de agua (y vacíe) y tambien llenarlo de sangre (o pintura roja y que se vacie en el mar y se esparza - Por largo tiempo documentar la erudcion [sic] de la figura [...]

[...] In the sea: Do the silhouette on the shore - Let it fill with water (and drain) and also fill it with blood (or red paint and empty into the sea and scatter - For a long time, document the erosion of the figure [...]

John Ruskin
The Harbours of England//1856

[…] Of one thing I am certain; [J.M.W.] Turner never drew anything that could be *seen*, without having seen it. […] [W]hen, of his own free will, in the subject of Ilfracombe, he, in the year 1818, introduces a shipwreck, I am perfectly certain that, before the year 1818, he had *seen* a shipwreck, and, moreover, one of that horrible kind – a ship dashed to pieces in deep water, at the foot of an inaccessible cliff. Having once seen this, I perceive, also, that the image of it could not be effaced from his mind. It taught him two great facts, which he never afterwards forgot; namely, that both ships and sea were things that broke to pieces. *He never afterwards painted a ship quite in fair order.* There is invariably a feeling about his vessels of strange awe and danger; the sails are in some way loosening, or flapping as if in fear; the swing of the hull, majestic as it may be, seems more at the mercy of the sea than in triumph over it; the ship never looks gay, never proud, only warlike and enduring. The motto he chose, in the *Catalogue of the Academy*, for the most cheerful marine he ever painted, the *Sun of Venice going to Sea*, marked the uppermost feeling in his mind:

> Nor heeds the Demon that in grim repose
> Expects his evening prey.

I notice above the subject of his last marine picture, *the Wreck-buoy*, and I am well persuaded that from that year 1818, when first he saw a ship rent asunder, he never beheld one at sea, without, in his mind's eye, at the same instant, seeing her skeleton.

But he had seen more than the death of the ship. He had seen the sea feed her white flames on souls of men; and heard what a storm-gust sounded like, that had taken up with it, in its swirl of a moment, the last breaths of a ship's crew. He never forgot either the sight or the sound. Among the last plates prepared by his own hand for the *Liber Studiorum*, (all of them, as was likely from his advanced knowledge, finer than any previous pieces of the series, and most of them unfortunately never published, being retained beside him

for some last touch – for ever delayed,) perhaps the most important is one of the body of a drowned sailor, dashed against a vertical rock in the jaws of one merciless, immeasurable wave. He repeated the same idea, though more feebly expressed, later in life, in a small drawing of Grandville, on the coast of France. The sailor clinging to the boat in the marvellous drawing of Dunbar is another reminiscence of the same kind. He hardly ever painted a steep rocky coast without some fragment of a devoured ship, grinding in the blanched teeth of the Surges, – just enough left to be a token of utter destruction. Of his two most important paintings of definite shipwreck I shall speak presently.

I said that at this period he first was assured of another fact, namely, that The Sea also was a thing that broke to pieces. The sea up to that time had been generally regarded by painters as a liquidly composed, level-seeking consistent thing, with a smooth surface, rising to a water-mark mark on sides of ships; in which ships were scientifically to be embedded, and wetted, up to said water-mark, and to remain dry above the same. But Turner found during his Southern Coast tour that the sea was *not* this: that it was, on the contrary, a very incalculable and unhorizontal thing, setting its 'water-mark' sometimes on the highest heavens, as well as on sides of ships; – very breakable into pieces; half of a wave separable from the other half, and on the instant carriageable miles inland; – not in any wise limiting itself to a state of apparent liquidity, but now striking like a steel gauntlet, and now becoming a cloud, and vanishing, no eye could tell whither; one moment a flint cave, the next a marble pillar, the next a mere white fleece thickening the thundery rain. He never forgot those facts; never afterwards was able to recover the idea of positive distinction between sea and sky, or sea and land. Steel gauntlet, black rock, white cloud, and men and masts gnashed to pieces and disappearing in a few breaths and splinters among them; – little blood on the rock angle, like red sea-weed, sponged away by the next splash of the foam, and the glistering granite and green water all pure again in vacant wrath.

So stayed by him, for ever, the Image of the Sea. [...]

John Ruskin, extract from 'The Harbours of England' (1856), in *The Complete Works of John Ruskin*, vol. 13 (Edinburgh: Ballantyne Press, 1904) 40, 42–4. [footnotes omitted].

Barbara Hepworth
The War, Cornwall, and Artist in Landscape 1939–1946// 1952

When war was declared in September 1939 I was in Cornwall where good friends had offered hospitality to the children. Early in 1940 we managed to find a small house and for the next three years I ran a small nursery school. I was not able to carve at all; the only sculptures I carried out were some small plaster maquettes for the second 'sculpture with colour', and it was not until 1943, when we moved to another house, that I was able to carve this idea, and also the first idea for sculpture with colour of 1938, both in a larger and slightly different form in wood.

[...] I remember expecting the major upheaval of war to change my outlook; but it seemed as though the worse the international scene became the more determined and passionate became my desire to find a full expression of the ideas which had germinated before the war broke out, retaining freedom to do so whilst carrying out what was demanded of me as a human being. I do not think this preoccupation with abstract forms was escapism; I see it as a consolidation of faith in living values, and a completely logical way of expressing the intrinsic 'will to live' as opposed to the extrinsic disaster of the world war.

In St. Ives I was fortunate enough to have constant contact with artists and writers and craftsmen who lived there, Ben Nicholson my husband, Naum Gabo, Bernard Leach, Adrian Stokes, and there was a steady stream of visitors from London who came for a few days' rest, and who contributed in a great measure to the important exchange of ideas and stimulus to creative activity. Looking back it seems to have been a period of great preparation which was later to show in the work of younger painters and sculptors. [...]

It was during this time that I gradually discovered the remarkable pagan landscape which lies between St. Ives, Penzance and Land's End; a landscape which still has a very deep effect on me, developing all my ideas about the relationship of the human figure in landscape sculpture in landscape and the essential quality of light in relation to sculpture which induced a new way of piercing the forms to contain colour.

A new era seemed to begin for me when we moved into a larger house high on the cliff overlooking the grand sweep of the whole of St. Ives Bay from the Island to Godrevy lighthouse. There was a sudden release from what had seemed to be an almost unbearable diminution of space and now I had a studio

workroom looking straight towards the horizon of the sea and enfolded (but with always the escape for the eye straight out to the Atlantic) the arms of land to the left and the right of me. I have used this idea in *Pelagos* (1946).

The sea, a flat diminishing plane, held within itself the capacity to radiate an infinitude of blues, greys, greens and even pinks of strange hues: the house and its strange rocky island was an eye; the Island of St. Ives an arm, a hand, a face. The rock formation of the great bay had a withinness of forms which led my imagination straight to the country of West Penwith behind me – although the visual thrust was straight out to sea. The incoming and receding tides made strange and wonderful calligraphy on the pale granite sand which sparkled with felspar and mica. The rich mineral deposits of Cornwall were apparent on the very surface of things; quartz, amethyst and topaz; tin and copper below in the old mine shafts, and geology and pre-history a thousand facts induced a thousand fantasies of form and purpose, structure and life, which had gone into the making of what I saw and what I was.

From the sculptor's point of view one can either be the spectator of the object or the object itself. For a few years I became the object. I was the figure in the landscape and every sculpture contained to a greater or lesser degree the ever-changing forms and contours embodying my own response to a given position in that landscape. What a different shape and 'being' one becomes lying on the sand with the sea almost above from when standing against the wind on a high sheer cliff with seabirds circling patterns below one; and again what a contrast between the form one feels within oneself sheltering near some great rocks or reclining in the sun on the grass-covered rocky shapes which make the double spiral of Pendour or Zennor Cove; this transmutation of essential unity with land and seascape, which derives from all the sensibilities, was for me a voyage of exploration. There is no landscape without the human figure: it is impossible for me to contemplate pre-history in the abstract. Without the relationship of man and his land the mental image becomes a nightmare. A sculpture might, and sculptures do, reside in emptiness; but nothing happens until the living human encounters the image. Then the magic occurs – the magic of scale and weight, form and texture, colour and movement, the encircling interplay and dance occurs between the object and the human sensibilities.

I used colour and strings in many of the carvings of this time. The colour in the concavities plunged me into the depth of water, caves or shadows deeper than the carved concavities themselves. The strings were the tension I felt between myself and the sea, the wind or the hills. The barbaric and magical countryside of rocky hills, fertile valleys, and dynamic coastline of West Penwith has provided me with a background and a soil which compare in strength with

those of my childhood in the West Riding. Moreover it has supplied me with one of my greatest needs for carving: a strong sunlight and a radiance from the sea which almost surrounds this spit of land, as well as a milder climate which enables me to carve out of doors nearly the whole year round.

Barbara Hepworth © Bowness, extracts from 'Statements by Hepworth in Six Autobiographical Sections in *Barbara Hepworth: Carvings and Drawings*, with an Introduction by Herbert Read, London 1952', in *Barbara Hepworth Writings and Conversations*, ed. Sophie Bowness (London: Tate Publishing, 2015) 66–8.

Eleanor Morgan
The Death Swamps (or a Pond within an Ocean)//2023

In the winter of 2018, I went on holiday to the quarries of Bavaria. The Christmas fairs were long gone. Instead, winter was marked by large wooden caskets in the market square that protected the statues inside from frostbite. One casket covered the man I had come to find, the eighteenth-century actor and playwright Alois Senefelder. He was the inventor of lithography, a process of printmaking that uses slabs of the local Solnhofen limestone as printing plates. The grain of the stone here is so fine that it can create images without any loss of detail. By the nineteenth and early twentieth century, lithography, literally 'stone writing', was adopted by most commercial printers in Europe to reproduce pictures, maps, posters and labels for beer bottles. It has since been replaced by digital and offset printing. Stone lithography, like other past printing inventions, made its way to the art school: a creative junkyard of print possibilities. Some art schools in Britain still have racks of the original Solnhofen plates, thicker than gravestones and too heavy to lift alone. These racks are libraries of images made over the decades, as each stone retains the image made by the last person to use it. A student draws onto a stone plate, seals it with gum arabic, and it can be ground down or reprinted by a student fifty years later.

I had travelled to the quarries in icy weather because the lithography stones had become increasingly more interesting to me than the prints I was making. Solnhofen limestone is a particularly romantic material, as it contains some of the finest fossils in the world, the most famous of which is the *Archaeopteryx*, the feathery link between dinosaurs and birds. The fossils in the local museum in Eichstätt are so detailed that they show not just prehistoric animals, but the final steps that these animals took before they died. During the Jurassic period, this area was an archipelago covered in lagoons. At the depths of these

was something that seems impossible: an underwater pond. The pond was made of highly salty water that collected in a crevice on the ocean floor with its own underwater surface and shoreline. It was toxic to organisms, shocking the system of any that passed too close. The fossils are a graveyard of animals that could not escape this briny pool, creatures that never met, from different times and ecosystems: an alligator, a dragonfly, a jellyfish, as if a giant press had slowly descended into the ocean, squashing space and time into a single print. One fossil in the museum captures the path of a prehistoric lobster in its final minutes. Its tracks start on the left of the stone plate where it had fallen onto the seafloor. It then walked backwards, dragging itself away from the salty pond. But halfway across the stone, it appears that it became disorientated and instead of moving away, it turned back. The shape of its body lies at the end of a curving line of marks that claw at the seabed.

When I talk to students about printmaking, I begin with the death swamp. I show a short clip from a David Attenborough documentary which shows eels attempting to escape an underwater brine pool in the ocean floor of the Orca basin. They tie themselves into knots, twitching and arching away. This, I say to the students, is what your printing plates are made from: hundreds of creatures that died millions of years ago when they were sucked into an underwater ocean pond. I am trying to add drama to the undramatic stones that are stacked under the sinks in the print workshop. But I am also falling into one of the traps of printmaking, of allowing the plates to become more interesting than the prints. A lithography plate is so smooth and flat, it is as if the print has already been pressed. The artist Vija Celmins, reflecting on the lithographs she made in the early 1970s, was asked whether she found lithography satisfying, 'Yes and no. It's a very flat kind of process. I was making pencil drawings at the time and the quality of line and the graphite sitting on the paper became a kick for me, and expressive in a way; it made the image come to life. But in lithography it seemed like you rolled a truck over it and flattened it back out again.'[1] Marks float on the surface of the stone, and the lithographic process squashes the life out of them, adding another layer of fossilised forms. Some of Celmins' lithographs are of the ocean, a landscape she has returned to repeatedly over her career using different printing processes. She says that these oceans are not the same. They are re-inscriptions; each time she draws the ocean it is for the first time, as if the number of potential ocean prints must be as infinite and changing as the ocean itself. Every view is subtly altered by the weather, the currents and the invisible creatures that pass below, so that, eventually, we might assemble these prints to create a 1:1 scale map of every possible ocean.

This is perhaps why I show the death swamp film to the students. I am trying to think about our actions on the world as insignificant in the face of the

unimaginable scale of geological time and material transformation. Yet, when we draw on lithographic plates, we are deliberately placing ourselves within a story that began millions of years ago. We can be rearrangers of stuff, shifting and assembling materials so that they might take a different path.

Like all printing plates, the images on a lithographic stone must be drawn backwards. This is the challenge of printmaking. If the portrait on your stone faces right, the portrait once you print it onto paper will face left. Alois Senefelder's contribution to printmaking is honoured in his gravestone, on which the inscription is written backwards and crouched at the base is a cherub holding a mirror up to his name. There is a link between death and printmaking which I circle around. The backwards thinking means that everything is the wrong way, like the world of the living mirrored in the world beneath.

1 Samantha Rippner, *The Prints of Vija Celmins* (New York: Metropolitan Museum of Art/Yale University Press, 2002) 17.

Eleanor Morgan, 'The Death Swamps (or a Pond within an Ocean)', previously unpublished, 2023.

Chus Martínez
Heidi Bucher: A Work Illuminated by the Senses//2022

[...] In January of 1832, Charles Darwin spotted a horizontal band of compressed seashells and corals thirty feet above sea level. The whole area looked as if it had once been under water. 'Why not now?' he asked himself. He thought about a recently published book he had brought along with him: the first volume of Charles Lyell's *Principles of Geology*, in which the Scottish geologist suggested that the Earth was gradually and continuously changing, with land rising in one area, falling in another.

What Darwin saw before him seemed to be direct confirmation of Lyell's theory. In 1972, Heidi Bucher realised a series of sculptural works titled *Bodyshells*, which she activated on Venice Beach, California. She had been interested in clothes and fashion before, in movement and in how the way we dress transforms our body, both in its external perception and the way we perceive it. These shells are definitely dresses – dresses that aspire to house bodies we cannot see. The works appear to be a philosophical interpretation of a shell: a large casing, slightly bottle-shaped ... these shell-vessels, created by a human, inspired by the sea, address the same questions raised by Darwin.

Two worlds biologically separated and two times – human time and geological time – reunited. These structures are called shells because shells are made of a marvellous substance: mother-of-pearl. The artist did some drawings using mother-of-pearl. Living in Los Angeles, it is easy to imagine her walks along the beach, collecting shells and wondering about their colours, their strength. Mother-of-pearl, or nacre, is a strong material with a very particular trait: iridescence. This iridescent material is the innermost layer of the shell, present only to the animal living inside – a coat of glossy and silky matter beneath the rough surface of the shell. However, Heidi Bucher's *Bodyshells* are neither rough, nor solid, nor strong. Why are the real shells so different from her *Bodyshells*?

It has recently been discovered that nacre is as resistant as concrete and that, like plastic, it can return to its original form if damaged, without losing its resistance. A shell has very particular structural peculiarities. It is composed of tightly packed aragonite crystals held together by proteins. These crystals are like tiny bricks whose complex disposition is also the origin of the beautiful colours we see. If these materials were completely smooth, we would see a plain – probably boring brown – colour. No wonder, then, that the forms created by Heidi Bucher were unable to replicate the shells. Actually, it was never her intention to do so. Her shells serve more as an ode-cum-manifesto: an ode to the simple sculptures one finds in nature, autonomous forms of life able to preserve and take care of organisms, durable and eternal, as is the dream of art; but also a manifesto, a way to express the complex and associative relationship between the depiction of women's bodies and the history of art. We are all familiar with the image of Venus standing on a shell, and the oft-repeated associations between the female genitals and shells. As a major producer of images, art history has not been indifferent to that bond. It is only fair to ask how women feel about such images, about this pairing of forms, about the 'motherhood' of shells, which 'give birth' to pearls, so to speak.

Heidi Bucher's *Bodyshells* may be an unconscious response to shame. The shells are exoskeletons that allow its inhabitants – the women-clams – to move, live and act without their bodies being revealed. Unlike the *Venus* of Sandro Botticelli, the women inside Heidi Bucher's shells do not need hair to cover their exposed bodies, none of which, in fact, are normally shaped. But even if they no longer resemble human female creatures, they may still feel vulnerable and exposed, given the images and practices pointing towards their genitalia in previous centuries. One thing is obvious: the bodies inside the shells on Venice Beach must be soft and vulnerable – or why else would they need shells? But why should we imagine them as human bodies? Simply because we know they are activated by dancers. But forget about the humans now inside them. The living forms inside these other forms may already have transcended

the question of gender, having grown weary of the impediment of the dual relationships imposed on us for centuries. The *Bodyshells* are merely empty vessels – or may, depending on the circumstances, be host to jinns.

It was not uncommon in previous centuries to imagine humans mutating into other shapes – walking sculptures, for example, soft forms that add organicity to the classical language of object and form making. Influenced by fashion, popular culture, dance and television, the *Bodyshells* are equally naïf and vulnerable in their nature. But besides these obvious traits, the artist was mesmerised by the unsettling expressiveness of shellfish. It may have been no more than a thought or a phrase, such as 'looking for a new direction', that propelled her towards exoskeletons and houses – simple forms that seem to offer a way to lend visibility to something existential, albeit no less gut-wrenching, in all its universality. […]

Chus Martínez, extract from 'Heidi Bucher: A Work Illuminated by the Senses', in *Heidi Bucher: Metamorphoses*, ed. Jana Bauman (exh. cat.) (Berlin: Hatje Cantz, 2022) 212–3.

THE ARTIST WAS MESMERISED BY THE UNSETTLING EXPRESSIVENESS OF SHELLFISH.

Chus Martinez, 'Heidi Bucher: A Work Illuminated by the Senses', 2022

DREXCIYA
RETURNED
TO THE
EIGHTEENTH
CENTURY
TO ENVISION
THE BLACK
ATLANTIC
AS A
LIQUID
GRAVEYARD.

Kodwo Eshun, 'Drexciya As Spectre', 2013

AQUATIC IMAGINARIES

Ann Elias
Mad Love//2019

[...] To liberate the mind and body, as well as thought and expression, through chance and automatic modes of thought and action, and to free the self from the constraints of rationalism was surrealism's manifesto. Which is why the sea, a shifting, unfathomable force of nature, was totemic for the movement and why the underwater was revered as a symbol of the unconscious. Allan Sekula named surrealism 'the last aesthetic movement to claim the sea with any seriousness'.[1] And his point reverberates through a survey of the most evocative works of art and literature in history, among them Max Ernst's *Forêt* (1927), René Magritte's *Collective Invention* (1934) and René Clair's *Entr'acte* (1924), a short, silent film in which a dancer, viewed from below in slow motion, appears weightless as her petticoats undulate like a jellyfish in water. There are the examples of Man Ray's use of underwater films by the biologist Jean Painlevé (1902–1989) for *L'Étoile de mer* (1928) and the inclusion by Georges Bataille of Painlevé's pictures of crustaceans in the journal *Documents*. Moreover, it was in Breton's essay 'Surrealism and Painting' (1928) that he wrote about 'the Marvels of the sea a hundred feet deep', and how only the 'wild eye' freed from habit can be fully receptive to the magical sensations of the outer limits of the world.[2]

Sometime before 1937, André Breton obtained an underwater photograph from Wide World Photos, the photo agency then owned by the *New York Times*.[3] Underwater photographs were only just beginning to appear in natural history publications. They were relatively rare, but a keen public waited to view them. In 1937, Breton published the news photograph in the pages of [his poetic prose work] *Mad Love*.

How did Breton, and for that matter, the *New York Times*, obtain the image? [...] A quick check of the digitised *New York Times* reveals the context in which the underwater photograph that Breton acquired was published. It featured in an article written in 1929 titled 'The Coral World beneath the Waves That the Williamsons Invaded'.[4] The photograph that Breton later labelled 'The Treasure Bridge of the Australian Great Barrier' was actually taken underwater at the Bahamas during an expedition there in 1929 organised by the Field Museum in Chicago in conjunction with the explorer, photographer and filmmaker John Ernest Williamson to collect corals, sharks and other fish for the museum's newly planned diorama scene of a Bahamian coral reef. [...]

The context of *Mad Love* offers clear answers for why Breton was attracted to Williamson's image. At a time before general audiences had developed a

visual vocabulary for looking at the underwater realm, Williamson's films and photographs ushered in a new paradigm of seeing. André Breton was excited about the once invisible world beneath the sea coming to light. Moreover, Williamson's image of the underwater had a strong connection with surrealist politics and aesthetics because the vision it offered was like an otherworldly dream-space. The photograph was a significant find for Breton because it embodied the cornerstones of surrealist aesthetics – dreams, the unconscious and the uncanny. It offered a vision that was opposite to the modern, metropolitan environments of Paris. If the experience of Paris was 'geometric', the scene of 'the Australian Great Barrier' underwater was an extravaganza of organic and natural wilderness of the type identified by Gavin Parkinson as 'antithetical to the habits, customs, restrictions, and laws that characterized modern Western society'.[5] The coral formations in Williamson's photograph that Breton published in *Mad Love* seem untamed and random. They invoke the suggestion of primordial mysteries surrounding the evolution of life on earth from the ocean, since it was commonly imagined that sea animals belonging to past ages would be found in the depths. The image suggests not only regression but also the idea of unbounded experience. For Breton, who saw himself at the frontier of art, here was an image that also suggested the frontier of physical and psychological worlds. [...]

1 [Footnote 2 in source] Allan Sekula, *Fish Story* (Düsseldorf: Richter Verlag, 1995) 51.

2 [3] André Breton, 'Surrealism and Painting', in *Surrealism and Painting*, trans. Simon Watson Taylor (London: Macdonald, 1972) 1.

3 [4] The history of the Paris office of the *New York Times* is discussed in John G. Morris, 'Henri Cartier-Bresson: Artist, Photographer and Friend,' *News Photographer*, no. 2 (September 2004). Available at http://archive.li/UJxNo (accessed 20 December 2017).

4 [8] Virginia Pope, 'In an Odd World of Coral and Fishes', *New York Times Magazine* (1 December 1929) 95.

5 [33] Gavin Parkinson, 'Emotional Fusion with the Animal Kingdom', in *The Art of Evolution: Darwin, Darwinisms, and Visual Culture*, eds. Barbara Larson and Fae Brauer (Hanover, NH: Dartmouth College Press, 2009) 268.

Ann Elias, extracts from *Coral Empire: Underwater Oceans, Colonial Tropics, Visual Modernity* (Durham, NC and London: Duke University Press, 2019) 29–31, 38–9 [some footnotes omitted].

Eileen Agar
Sea-deep//undated

This blue and grey painting is a rich and strange monument to the drowned inhabitants of the sea, the Birds, Bones and grotesque fingers and arms amidst curious rock shapes.

I didn't intend a representation, more an evocation and feeling for the idea or mood. For I take from what I see and turn it hopefully into what I think. So that my effort is towards an aesthetic of the painting itself, not towards something outside the painting. As [Paul] Cézanne said 'It is the eye which governs a painting not the brain or the intellect'.

I try to involve the spectator so that there are many associations, like ripples on a pond which suggest rather than proclaim it is the interpretation of reason and the unconscious, too much intellect flattens a painting.

Eileen Agar, note on her work *Sea-Deep*, undated (Tate Archive, TGA 9222/2/3/6). Available at www.tate.org.uk/art/archive/items/tga-9222-2-3-6/note-by-eileen-agar-on-her-work-sea-deep

Marietta Franke
'Be Abstracted': On Paul Thek's Artistic Oeuvre//1995

[...] The sense of process that was inherent in [Paul] Thek's path-like presentation of his exhibitions demanded a response on the viewer's part, an inner process that reflected the psychic dimension of Thek's art. What Thek learned especially from [Joseph] Beuys was how his oeuvre was at its most effective through unconscious channels despite the complex conceptual apparatus in which it was embedded. Thek used sand for the first time in his Stockholm exhibition to represent the ocean. This sea of sand remained a constitutive element of his exhibitions throughout the seventies. It represents the inner context for the artistic process, as exhibition process. While in Amsterdam in 1969, Thek wrote, 'I ride upon the ocean floor, I flual [float] within the sea. The Waters are the only thing, that ever comfort me.' In *A Fake Diary*, written that same year, Thek described how he loved diving into the water all the way down to the bottom, and then letting himself float motionless to the surface while watching the light become brighter and brighter. He compared

this movement to his artistic objectives, 'It pleases me to know that in my work I am able to go beneath the surface of things in order to continue the glorious human voyage in search of a final solution.' Thek's unforgettable *Fishman* (1968) figure is related to this psychical context. Thek described the encounter with the unconscious as the unconscious processes of the human psyche whose ineluctable polarity necessitates a 'lifelong voyage'. According to Jung, water, or the course of water, is the most common image of unconscious activity. [...]

Marietta Franke, extract from '"Be Abstracted": On Paul Thek's Artistic Oeuvre', in *Paul Thek – The Wonderful World that Almost Was* (exh. cat.), eds. Louise Neri and Barbera van Kooij (Rotterdam: Witte de With Center for Contemporary Art, 1995) 154.

Barbara Kutis
Playing *Moby Dick*//2020

[...] In videos created between 1999 and 2005, [Guy] Ben-Ner negotiates his role as an artist, father, and a man, thus articulating the artist-parent identity. In his videos, Ben-Ner exclusively employs his children, Elia and Amir, as his primary actors. He educates and guides them through their roles – both on screen and off, but he also mimics their actions and equally participates in the playful aspects of theatre. [...] Ben-Ner visually embraces this artist-parent identity, fully exploring the possibilities of an artistic fatherhood as seen in his video, *Moby Dick* (2001). This work, which features the artist and his daughter almost exclusively, highlights play as a medium of not only fantasy, but of education, and familial bonding. [...]

As an artist whose practice was based in the home, Ben-Ner reiterated the circumstances that several women artists experienced and still experience today: as they moved their studios into the domestic space and worked on their art projects while their children were sleeping or in school, they were perceived by critics and fellow artists as 'giving up' or being a 'dilettante'. However, the home studio provided artists a creative outlet, a means of creating art without neglecting their children and thus being – or being labelled – a 'bad mother'. [...]

Ben-Ner's choice to use the kitchen for most films visualises the domestic in a loaded manner. [...] In *Moby Dick*, the kitchen becomes a site of fantasy, a ship, and a place for play. The kitchen, however, still largely functions as the gendered space of the woman. It is a space that became the site of politics in 1959 thanks to the 'Kitchen Debate' between Vice President Richard Nixon and Soviet Premier

Nikita Khrushchev, in which the two leaders discussed the modern household innovations of the Americans. In response, women artists highlighted the kitchen within their work. These works were alternately read by critics as kitschy – for example Joan Brown's *Noel in the Kitchen* (1964) in which Brown's son Noel is depicted semi-nude in a 'funky' kitchen with a wobbly stack of pots and pans and two dogs; or critical, such as in Martha Rosler's *Semiotics of the Kitchen* (1975), in which Rosler critiques the stereotypes of the 'domestic goddess', cooking shows, and gendered space by violently animating the tools of [the] kitchen from A through Z. Rosler's exploration of the kitchen provides a unique correlation to Ben-Ner, as both artists restructure the space to explore identity and function. Rosler's use of the kitchen rests on a critique of female gender roles, whereas Ben-Ner employs it as a space for action, creation and play.

Visualisations of the kitchen are often transformed into avant-garde strategies when undertaken by male artists. [...] But as Cécile Whiting contends, not all male artists' appropriations of the domestic reinvigorated the space as an avant-garde subject.[1] [...] Thus, as an artist limited to the household and tasked with the care of his daughter, Ben-Ner's choice of setting seems to in some degree reinforce the kitchen as a feminine space and to allow interpretations of Ben-Ner assuming the primary domestic role in the home. Perhaps to counter this feminisation of the space and assert it as Ben-Ner's domestic-artistic domain, there is only one instance where an adult female appears within the kitchen, thus suggesting the artist's natural occupation in the role and space.

[...] In recreating the tale of Ishmael, Ahab, and his search for Moby Dick, Ben-Ner appropriates the most basic elements. The film begins with clips of Elia and Ben-Ner facing the camera, smiling and laughing, with the intertitle, 'Call me Ishmael', inserted in between the shots. Elia and Ben-Ner are twinned, both with nude torsos and missing their upper central incisors (Ben-Ner obscures his with a dark tape or paper); however, in the next sequence, Elia, is dressed in an oversized shirt and vest with her hair in pigtails and donning a moustache. She appears seated in the kitchen sink, which is now transformed into a bar at The Spouter Inn, in New Bedford Bay, where Ishmael (played by Ben-Ner) enters. The two converse as Elia, playing the role of the barkeep, pours him a drink, which Ishmael imbibes. Attracted to a black and white linocut of a whale, the conversation turns to whaling. Someone enters the kitchen bar, denoted by the text, 'Hi You', fearful of the approaching visitor, Ishmael draws a gun while the barkeep takes a bottle and breaks it over his head, rendering him unconscious.

Still located within the space of the kitchen, in the next scene the space has been transformed into the whaler on which Ishmael finds himself. A mast becomes positioned in the sink and is surrounded by plates, a reminder of the space's continued domestic function. Ropes are tied and placed diagonally

to suggest the system of supports and levies for the sails and other necessary whaling instruments. In accordance with this transformation of the kitchen, the freezer section of the refrigerator becomes a food depot, as we observe Ben-Ner's friend and colleague, the artist Boaz Arad, hauling in a water jug, bags of frozen vegetables, half a watermelon, and a large bottle of Coca-Cola. These modern conveniences mark, expose and reinforce the artifice of the entire scene and its place between art and life. That is, the items are likely actual items on the family's grocery list and will be consumed; it was merely the putting away of the items that became incorporated into the film. Similarly, when Ishmael is done storing the items, he closes the freezer door to reveal a series of family photos adorning its exterior. The lower portion, the camera later reveals, displays child-like drawings of a fish, a mermaid and a third image, likely to be Elia's own artistic contribution to the ship's décor – a sentimental reminder that this artistic space also functions as a domestic space.

As the ship is stocked and readied, the artist's family appears next to a palm tree that glides across the kitchen – Nava, turned away from the camera, holds Amir in her arms, as she and Elia wave goodbye, sending off Ishmael, the aimless wanderer. In the subsequent scenes, Ishmael introduces the members of the ship's crew: Pip, Queequeg and Ahab.[2] Pip (Elia's new role in the video) appears standing on the kitchen counter, eating a snack out of a paper cup with a spoon, while the other characters, Queequeg, the harpooner and cannibal, and Ahab, are portrayed by the artist in various guises. A series of non-narrative sequences follow, explicating the 'cabin fever' experienced by the crew members. Once Ahab appears on the deck (kitchen counter) the narrative resumes. Ahab offers a gold coin to the first to locate the whale and nails it on the mast for all to behold. Another series of non-narrative sequences aboard depict the antics of Pip and Ishmael, which is followed by Pip spotting the whale – Ahab gives her the prize and she immediately bites into it to reveal it is a chocolate coin in a gold wrapper – *Hanukkah gelt.* [...]

The vignettes that follow highlight the business of whaling, including the rendering of whale fat into oil (Ishmael stands on the kitchen counter with a large wooden spoon, stirring the contents of a very large stock pot cooking on the stove) and the presence of carcass eaters (sharks) in the sea surrounding the ship. Here, only the fins of the predators are shown as they glide around the kitchen floor.[3] This scene cuts to Elia in the bath, where the viewer observes Ben-Ner's hand lathering up her hair, cuts back to the predators in the kitchen, and then jumps to the shower, revealing Elia's hair has been coiffed into a shark fin. [...] In his role of Ahab, he stands on the deck with his amputated leg supported by a series of inadequate substitutes, a stack of glasses, a pitcher, a ladle (which he must hold to his stump), all before Ahab locates his prize, and spots the whale.

A series of quick scenes demonstrate the whale's movement. A stream of water bursts from the sea floor (in the kitchen), from a duplicated kitchen counter, and then again in the living room (another part of the sea). Ishmael lowers the boats; Queequeg throws his harpoon and then takes a boat with Pip away from the whaler.[4] Ahab similarly throws his harpoon, gets in his boat, and pulls the camera to him, suggesting that he has pulled in the beast. A text screen declares 'the end', but the addition of an ellipsis to the text denies its proclamation. The next scene shows Ahab on top of the duplicate kitchen counter, repeatedly stabbing into it, suggesting that he has taken his vengeance on Moby Dick, yet a blast of water spurts forth, blinds him, and he succumbs to the belly of the whale. The film cuts to the sequence of the shark fins again, with the camera again taking a predatory role – suggesting that the viewer has devoured and consumed the image, Ben-Ner and Elia. While literally referring to the events in Melville's story, reading the scene from the perspective of the artist-parent offers another meaning.

With the whale, in its embodiment as a non-functional kitchen counter and placed within another domestic setting – the living room – Ben-Ner suggests that trying to contain, capture and defeat domesticity is futile. Once a parent, one or both of the parents will become restricted to the space of the home, and possibly even be figuratively swallowed by it. The ambiguous relationship Ben-Ner demonstrated between masculinity and the home in *Berkeley's Island* has evolved into an ungendered conflict between allowing domesticity to rule one's life and fighting to transform it to one that allows functional things, like the kitchen, to become non-functional. [...]

Like the portions of Melville's novel that are unrelated to the plot's development and instead recount aspects of the whaling process, manufacture, and sale of goods, the many scenes of slapstick in Ben-Ner's film reveal little about the narrative of *Moby-Dick*, yet convey much about the playful and active fantasy life of a child. [...]

1 [17] Cécile Whiting, *A Taste for Pop: Pop Art, Gender and Consumer Culture* (Cambridge: Cambridge University Press, 1997) 65–8.

2 [44] Quotations refer to the text presented within the film, not Melville's text.

3 [45] These fins appear to be captured using stop-motion, evoking the style and techniques of the surrealist filmmaker, Jan Švankmajer.

4 [48] Notably, in Melville's original text, Queequeg dies, Pip becomes lost at sea, and Ishmael uses Queequeg's casket as a flotation device, becoming the only survivor.

Barbara Kutis, extracts from *Artist-Parents in Contemporary Art: Gender, Identity, and Domesticity* (Oxford and New York: Routledge, 2020) 66–70, 69, 76–8, 82 [some footnotes omitted].

Tarralik Duffy
According to Shuvinai//2021

[...] The Titanic goes down in soft strokes of pencil crayon. Standing before this imposing work with its clever and unexpected pops of colour, the event it depicts seems almost unalarming. Maybe it's because we all know what happens. James Cameron probably has a lot to do with this; he turned it into an epic romance, after all. The 1997 film was the first ever to reach the lofty billion-dollar mark and quickly became, up to that point, the most successful film of all time. As infamously as the Titanic sank to the depths of the sea, the film of the same name famously soared to the heavens. It is a piece of pop-culture history so deeply entrenched in our collective minds that the tragedy is tamed.

Sinking Titanic (2012), brought to life by the magical hand of Shuvinai Ashoona, is unmistakably inspired by one of the most sensational scenes in her favourite film; and though cataclysmic, it very nearly feels like a party. A rock band plays on amplified instruments as the so-called unsinkable ship begins its historic 'sink of shame' to the bottom of the ocean. A comical rainfall of tiny, rainbow-clad people, many with their arms outstretched in Christ-like poses, fall to their doom in a brilliant flourish.

As Inuit, ships were the alien invasion of our not-so-ancient times; their first appearance irreversibly changed our world, and we are forever entangled. From those wary days of first-contact whaler ships to the eagerly awaited sealift of today, there no longer seems to be a way to survive without their return. Ships play a critical role in our communities, bringing in much needed supplies from the outside world, and remaining an indispensable part of what keeps us going through the year. Canned goods, boxes upon boxes of crackers, biscuits and cereal, machinery, ski-doos, trucks and ATVs, furniture, mountainous rolls of toilet paper, cartons of cigarettes, and the long-awaited fresh pop to restock our empty shelves and eager souls.

Tales of our colonial past have become as much a part of our folklore as the qallupillut, ijirait, or shape-shifting angakuiit. Shuvinai no doubt has spent a lifetime listening to the stories of the ill-fated SS Nascopie, an Arctic supply ship belonging to the Hudson's Bay Company that met its ruin in the summer of 1947. The ship struck an uncharted reef at the entrance of Cape Dorset Harbour, now known (and long referred to by Inuit) as Kinngait.[1] It had remained stranded on the nearly vertical rocks for two months until a storm broke it in half and the bow of the ship sank. Three weeks later, another storm would finally sink what was left of the Nascopie to the bottom of the ocean.

In *Compositions (Titanic Plus Nascopie and Noah's Ark)* (2008), Shuvinai strangely and brilliantly weaves stories of past and present, intermixing local history, religious fables and pop culture. Much like the story of the Titanic, the ghost of the Nascopie is in rabid pursuit, whispering behind us, refusing to be forgotten. A massive, dark, tentacled hybrid creature swims with its feelers outstretched, swiftly giving chase toward the Inuit boating back to shore. In this image it is as though the spirit of the Nascopie has been released from the wreckage, doomed to lurk in the shallows and haunt the shores of Kinngait and the minds of its inhabitants forever.

Blessed are your eyes,
For they see: and your ears,
For they hear.
–Matthew 13:16

The world according to Shuvinai is full of colour and mystical detail, wonderfully weird and whimsical, tender and terrifying, gorgeous and grotesque in exquisitely unpredictable turns. Deliciously dark, disturbing and delicate, she shows us the possibility of infinite worlds not contained by our neoteric perceptions, and merges seemingly conflicting spheres into harmony. 'Like peeling away layers of a mountain, looking behind the doors and closing them back up again.'[2]

Shuvinai has eyes to see. Shuvinai's drawings cannot simply be described as imaginary worlds intermixed with reality. She possesses a remarkable paranormal discernment and an ability to see things that others simply cannot or have forgotten how to see. Ancient Inuit beliefs are replete with unusual beings such as those seen in Shuvinai's work. Although some dismiss them as thinly veiled allegories used to frighten children, to those who have encountered such beings, they are far from imaginary.

In *Creatures* (2015), the central character appears to be a dreaded qallupilluk – an amautik-wearing sea hag believed to kidnap disobedient children who play too close to the sea ice, tucking them away in the back pouch of her hooded garment and swimming back down into the depths of the ocean.[3] It is a particularly effective and terrifying tale, for the place of comfort most dear to an Inuk child is being in the warmth and safety of their mother's amautik.

The qallupilluk is surrounded by what might be nunamiuti (the spirits of the land), metaphysical creatures who shared the nuna with Inuit, or the tariaksuit, known as shadow people.[4] As their name suggests, they live in the shadows, hiding among the rocks and hills of the mossy Arctic tundrascape. These beings are believed to be around us frequently but are rarely seen by humans. It is the

fortunate few who have seen them. Although potentially hideous in appearance, they are not considered to be evil and are believed to help Inuit.

While tariaksuit might be seen by anyone, other beings could only be seen by the eyes of the angakkuq.[5] Gazing at this marvellous composition, infused with a touch of Shuvinai's keen sense of humour, one such creature seems to be hilariously wandering around wearing a diver's helmet and a pair of rubber dish gloves. Still, we are left to wonder whether these curious creatures are merely fantastical or perhaps something more rooted in reality than we dare acknowledge. [...]

1 Its Inuktitut name is Kinngait, but Inuit say it was previously known as Sikusilaq (CBC News, www.cbc.ca/news/canada/north/cape-dorset-votes-name-change-1.5200824?fbclid=IwAR0Evwjkvr DN3OY5phgnYOb192_4XvVJZveBA).

2 Shuvinai Ashoona, in *Ghost Noise* [DVD], dir. and prod. Marcia Connolly, 2010.

3 An amautik is a women's garment with a large hood and a pouch in the back to carry infants.

4 A quallupik is a terrifying creature or sea hag who lives in the sea and wears an amautik; in English, nuna translates to 'land'.

5 The angakkuq is the intellectual and spiritual figure among the Inuit, known to other cultures as a shaman or medicine man.

Tarralik Duffy, extract from 'According to Shuvinai', in *Shuvinai Ashoona: Mapping Worlds* (exh. cat.), ed. Gäetane Verna (Toronto: The Power Plant Contemporary Art Gallery and Munich: Hirmer, 2021) 63–8.

Kodwo Eshun
Drexciya as Spectre//2013

[...] Within the sonic fictions of post-war music, it is possible to discern the twin aquatopia and aquadystopia. From the prepared piano runs and groans that evoke the 'sullen aborted currents' of The Doors' 'Horse Latitudes' (1967), to the processed guitars that evoke the merman's descent to the ocean floor 'not to die but to be reborn' in '1983...(A Merman I Should Turn to Be)' by The Jimi Hendrix Experience (1968). From the spray, shimmer and lull of *Future Days* (1973) by Can to the multitracked guitars summoning the 'sea of possibilities' on 'La Mer(de)' (1975) by The Patti Smith Group, from the sustained guitars circling like gulls over becalmed tidal pools in 'Small Hours' (1977) by John Martyn to the electronic squirms and synthetic squeals of 'Aqua Boogie (A psychoalphadiscobetabioaquadoloop)' (1978) by Parliament, from the sliding stabs and tabla rhythms of 'Let's Go Swimming' (1986) by Arthur Russell and onto the submerged, granular melancholia of 'Broken Home' (2006) by Burial, what links these positions is a fascination with immersion and dissolution into the oceanic, the pacific, the tidal and the eruptive. These are psychoacoustic fictional spaces produced by the studio-sciences of reverberation, echo and delay, shaped by electronic effects and guitar processing pedals. And yet Drexciya's music, by contrast, is not immersive as much as it is enthralled by the idea of the depths of the ocean. The advent of Google Ocean only underlies the extent to which the abyssal plains of the Mariana Trenches remain a prospect more occluded than the Valles Marineris of Mars. The inhospitality of the ocean floor acted as a geographical image of thought in which allusions could be secreted in titles and impressed into runout grooves. Intimations of an underwater subcontinent populated by a species of insurgent amphibians named Drexciyans. The records released between 1992 and 1997 were conceived as episodes, or better still as locations from the aquadystopia of Drexciya. These records effectively infiltrated the functional demands of 1990s dancefloors. [James] Stinson and [Gerald] Donald used electro to insert an esoteric fiction throughout electronic entertainment culture. When *The Quest* emerged unexpectedly in 1997, it not only played a curatorial role by compiling the duo's singles onto a single album, it provided a conceptual premise for the groups entire *raison d'être*. The short statement printed on the back of the inside cover and an image of four maps each indicating a historical phase in the evolution of a world system. The statement and the maps revealed the allusions whose implications had accrued throughout the 1990s but which, remained as yet, unspoken. The statement read as follows:

Could it be possible for humans to breathe underwater? A foetus in its mother's womb is certainly alive in an aquatic environment. During the greatest holocaust the world has ever known, pregnant America-bound African slaves were thrown overboard by the thousands during labour for being sick and disruptive cargo. Is it possible that they could have given birth at sea to babies that never needed air? Recent experiments have shown mice able to breathe liquid oxygen. Even more shocking and conclusive was a recent instance of a premature infant saved from certain death by breathing liquid oxygen through its undeveloped lungs. These facts combined with reported sightings of Gillmen and swamp monsters in the coastal swamps of the South-Eastern United States make the slave trade theory startlingly feasible.

Are Drexciyans water breathing, aquatically mutated descendants of those unfortunate victims of human greed? Have they been spared by God to teach us or terrorise us? Did they migrate from the Gulf of Mexico to the Mississippi river basin and onto the great lakes of Michigan?

Do they walk among us? Are they more advanced than us and why do they make their strange music?

What is their Quest?

These are many of the questions that you don't know and never will.

The end of one thing ... and the beginning of another.

Out

–The Unknown Writer[1]

[...] The Drexciya myth articulated by the Unknown Writer was nothing less than a reimagining of the biopolitical atrocity of the Middle Passage. According to the text, it could be understood as the crucible for the adaptation, evolution and mutation of the human species. The Atlantic slave trade, in all its horror, constituted the birth, the origin and the condition of the making of African Americans. Where the great post-war composers of the 1960s and 1970s such as Max Roach and Pharoah Sanders had approached the critical question of the historical formation of African Americans from an ancestralist perspective, seeking to reconstruct a forgotten past via the continental locus of the present, Stinson and Donald replaced an aesthetics of Africanity with a poetics of mutation enforced by death. By charting the historical implications of cargo ships sailing across the Atlantic from Africa to Europe and America throughout the nineteenth and twentieth centuries in *The Black Atlantic*, Paul Gilroy proposed a transnationality of diaspora that dissolved the reconstructionist impulse of ancestralism. Drexciya returned to the eighteenth century to envision the Black Atlantic as a liquid graveyard. The effect was not to deny the veracity of the Transatlantic Slave Trade but to produce a speculation capable of generating degrees of temporal anomaly in the present.

Stinson and Donald's mythology proposed a form of chronological involution that effectively intervened into the condition of the posthuman as it was formulated during the 1990s. The 1990s witnessed a popular American preoccupation with the technical feasibility of the post-human. What was certain was its location in the future. What was in dispute was the position one assumed in relation to an imminent corporate future whose outlines could be discerned in the genomics laboratories of La Jolla headed by charismatic bio-entrepreneurs such as Craig Venter. Either as a distant horizon to be dreaded by critics such as Francis Fukuyama or hymned by libertarians such as Ray Kurzweil, a future was carefully assembling itself. Looking back on the twentieth century, [Alain] Badiou wrote that it is 'precisely today, with the advent of genetic engineering that preparations are underway for a real transformation of man, for the modification of the species'.[2] The Drexciyan myth complicated this consensual vision by declaring that post-human condition arrived from the past rather than from the future. It decoupled the idea of the posthuman from its utopian imperatives and its futurological teleology. Instead, the posthuman was situated retrospectively, as a condition that had already been operative since the Slave Trade. It was an accomplished project rather than a coming condition that could be allegorised in terms of alien abduction. The ships, after all, had landed long ago. The people had been abducted with the assistance of their enemies, transported by unfamiliar vehicles through alien waters. Their bodies had been stolen from them and redesigned as commodities for exchanges whose satisfactions were inseparable from terror. The descendants of those redesigned bodies walked upon the surface of the earth today. They walk across America. They are Americans: the descendants of mutants. Designed, manufactured products, their origins unknown, their destinations uncertain. Instead of aligning themselves with the Civil Rights project of affirming humanity, Stinson and Donald were seceding from the claims made in the name of the human. What preoccupied them was the unknown question of the rights of genetic, cultural, ontological mutation. The condition of mutation oscillated between mythology and historicity. [...]

On the inside cover of *The Quest*, four maps of migration routes can be seen. The first map was entitled 'The Slave Trade (1655–1867)', the second 'Migration Route of Rural Blacks to Northern Cities (1930s–1940s)', the third stated that 'Techno leaves Detroit, spreads worldwide (1988)'. The fourth and final one was titled 'the journey home (future)'. Instead of a map, it featured destination lines that emerge from South America and North America and travel towards the South Western Coast of Africa and beyond. Unlike flight maps, however, there was no arrow to indicate the direction of migration. It suggested a movement that failed to register on the old maps, a movement that demanded a new

geography tuned to what Gilroy called the 'processes of cultural mutation and restless discontinuity' that constitute the 'webbed network'[3] of the Black Atlantic. In *Freaks: Myths and Images of the Secret Self*, Leslie Fiedler argued that the 'myth of the mutant was better able to illuminate the family crisis of the late sixties than the clichés of the generation gap'.[4] Marshall McLuhan understood comics as a folklore of the industrial age and the appearance of Marvel Comic mutants such as The X-Men in the 1960s suggested a popular American folklore borne from the convergence of atomics, psychedelics and electronics. Although the myth of the mutant disappeared during the 1980s, it resurfaced in the 1990s in Japan with anime such as *Akira* (1988) and *Tetsuo* (1989) and in America with the emergence of Stinson and Donald's hydratic fiction. Their mythos opened a portal between the financial terror of eighteenth-century slavery and the abstract horror of market fundamentalism. It was a myth powerful enough to initiate listeners into the hidden continuities between atrocity, insurance and enslavement, insistent enough to perceive the persistence of credit, trade and death in the present.

Warhol once stated that Pop Art was a way of seeing. Once you grasped the optic of Pop, the totality of social reality appeared to be Pop and it proved impossible to return to a pre-Pop perspective. A pre-Pop world didn't exist anymore. Why would you want to return to a world that no longer existed? In the 1990s, Drexciya performed a similar function. Once you understood reality in terms of mutation it was impossible to return to a world before the posthuman. Impossible not to see capital as a machine that calculates the future at the point of the death it demands.

1 [Footnote 3 in source] The Unknown Writer, Drexciya, The Quest (Detroit: Submerge Recordings, 1997).

2 [4] Alain Badiou, *The Century*, trans. Alberto Toscano (Cambridge: Polity Press, 2007) 5.

3 [8] Paul Gilroy, *The Black Atlantic: Modernity and Double Consciousness* (London and New York: Verso, 1993) 29.

4 [9] Leslie Fiedler, *Freaks: Myths and Images of the Secret Self* (London: Penguin, 1981) 320.

Kodwo Eshun, extracts from 'Drexciya as Spectre', in *Aquatopia: The Imaginary of the Ocean Deep* (exh. cat.), eds. Alex Farquharson and Martin Clark (London: Tate Publishing, 2013) 141–6.

Robin D.G. Kelley
Ellen Gallagher's Confounding Myths//2013

That Oceanic Feeling

[...] In 1986, under the auspices of the Sea Education Association (SEA) in Woods Hole, Massachusetts, twenty-year-old Ellen Gallagher spent a semester aboard an oceanographic research vessel examining the migratory patterns of pteropods – microscopic wing-footed snails. She spent her nights catching the tiny creatures and part of her days drawing them.[1] Exactly a century and a decade earlier, twenty-year-old Sigmund Freud arrived in the Italian port of Trieste to begin work as a researcher at an experimental station for marine biology. Like Gallagher, he was fascinated with marine life and an accomplished draughtsman. He spent several years in Trieste, first dissecting eels in a futile search for testes, and then studying the nervous systems of fish.[2] He eventually grew weary of dead fish but left behind an impressive collection of drawings that inspired several works in Gallagher's *Watery Ecstatic* series. In these delicate, dream-like drawings made of cut paper on paper, watercolour, ink and oil, the grid writhes and bends organically or disappears altogether. We encounter the unfamiliar: exotic fish, eels, jellyfish, ancient sea creatures and strange vegetation, removed from the darkness of their habitat to laboratory or light-box whiteness; creatures entangled in love or struggle or both. We encounter the familiar: disembodied eyes, wigs and lips attached like barnacles, the masked and unmasked faces of African people.

The Africans represent the people of 'Drexciya', the main inhabitants of *Watery Ecstatic* and *Coral Cities*, as well as some of Gallagher's later works. Drexciya is a mythic black Atlantis at the bottom of the Atlantic Ocean founded by pregnant African women who leapt or were thrown from slave ships during the Middle Passage and gave birth to offspring capable of breathing underwater. The legend's creator[s] [were] [Gerald Donald and] the late James Stinson, founder[s] of the now defunct Detroit-based techno band of the same name. [Donald,] Stinson and artist Frankie C. Fultz imagined Drexciyans as water-breathing militants waging a perpetual war 'against planetary control systems incarnated in the Audiovisual Programmers'.[3]

Gallagher's Drexciyans are a far cry from the macho characters of [Donald and] Stinson's imagination. She populates her canvases with women protected by Afro wigs made of vibrant sea creatures and marine fauna; women with flowing coral hair; and jellyfish-like figures with African faces. Her Drexciya is less about war or revenge than about regeneration – hence the emphasis on the botanical,

biological and cellular nature of marine life. Jellyfish, for example, appear frequently in the work because some species can reproduce asexually by splitting in half. 'The overboard, drowned slaves', Gallagher explains, 'are carriers of ideas of regeneration and ideas of transhistorical nation' – ideas she discovered in the novels of Maryse Condé and the poetry of Aimé Césaire. In Césaire's 'Lost Body' ('Corps perdu'), a poem in which he imagines an underwater Utopia, 'the flaming torches of aurelian jellyfish' are life-giving. Indeed, it is possible to see Gallagher's Drexciya as a visual evocation of Césaire's 'Ode à Guinée' (1948), a poem about a mythic place, 'the heaven of black peoples', that culminates in the possibility of regeneration or rebirth. However, for Césaire rebirth means activating the 'Guinea' within, the ancestral land violently silenced, to plumb 'the astral depth of medusas'– which is to say, the depth of the racial unconscious.[4]

The idea of regeneration is sublimely rendered in Gallagher's 'Jungle Gym' from *Preserve*. When I wrote about the work a decade ago, I thought of it as a transformation of death into life, a literal reconstruction of 'the bones of our ancestors; bones rescued from the real Drexciya at the bottom of the ocean floor' rebuilt as 'a space of freedom and democratic play'.[5] What I missed then is the way in which its peculiar structure and texture mirrors the regenerative qualities of coral, or the interdependent life forms of the sea–molluscs, crustaceans, exotic seaweed and the tentacles of jellyfish. And yet, despite the peaceful elegance of these lifeforms, regeneration does not occur outside of history. These are the bones of disembodied Africans, conscripts for the fields and factories, black bodies cannibalised by a racial capitalism and its scientific jaws. Even in the realm of myth, modernity never leaves her sights. Drexciya is not Utopia. It blooms under siege, which is precisely why regeneration is so essential. […]

1 [Footnote 29 in source] Ellen Gallagher, Ichthyosaurus, Freud Museum, London, 28 July–11 September 2005 (www.freud.org.uk/exhibitions/ellen-gallagher-ichthyosaurus/ [URL updated]).

2 [30] Peter Gay, *Freud: A Life For Our Time*, (New York: Norton, 2006) 29–34.

3 [31] Kodwo Eshun, 'Drexciya: Fear of a Wet Planet', *The Wire*, no. 167 (January 1998).

4 [32] Aimé Césaire, 'Lost Body', in *Lost Body (Corps perdu): Poems by Aimé Césaire*, trans. Clayton Eshleman and Annette Smith (Paris: G. Braziller, 1986) 59; Aimé Césaire, *Solar Throat Slashed*, trans. by A. James Arnold and Clayton Eshleman (Middletown, CT: Wesleyan University Press, 2011) 142–5; Chris Bongie, *Islands and Exiles: Creole Identities of Post-Colonial Literature* (Stanford: Stanford University Press, 1998) 136.

5 [33] Robin D.G. Kelley, 'Fugitives From a Chain Store', in *Ellen Gallagher: Preserve* (exh. cat.), ed. Jeff Fleming (Iowa: Des Moines Art Center, 2001) 20.

Robin D.G. Kelley, extract from 'Confounding Myths', in *Ellen Gallagher: AxME* (exh. cat.) (London: Tate Publishing, 2013) 17–18.

Alberta Whittle
Lessons from Solariss//2023

I

Waters rise and still we hear the thrumming of the gong.

Treading through briny depths, Solariss' hands grip mine.
Silken hips command an ancient cadence until the tempo churns into
<div align="right">a sweet slow wine.</div>

Twin devotees bent at the waist,
palms open.
Beckoning to the heavens,
we are emptied of tears yet heavy with salt.

It is blood memory that binds us to her altar.
<div align="center">Crossing thresholds that promise healing,
Mami Wata trades prayers for wishes.</div>

She is never alone.
Forked tongues licking at her hair,
<div align="center">Orion and Sheeba
recollect the warping of time.
Coiled around her hips
as sinuous as a crescent moon,
these serpents cast rainbows.</div>

We pour libations,
call on ancestors,
feeling *spirit within.*

Mami Wata unsheathes my heart and opens the way.
My toes sink deeper under the spray.

Swallowed alive by the tides.
I don't need a death's head to know it is time for a reckoning.
Sinking deeper under indigo sheets,

sunlight becomes memory.

Tumbling into a question mark,
I devour chaos,
tasting its bitterness.
Spitting out grief,
I petition her.

She has pierced the skin separating *Other* worlds
and peeled them raw.

II

A yawning wave of dark, dark blood spills through Atlantic currents.
But even the sharks have grown tired of its scent.
They avoid it.
Stale,
even though multiplied daily
and grown fat,
this stain is no longer fresh.
It speaks of billy clubs,
bullets,
whips
and now tasers that hungrily replenish its borders.

In my throat, I choke on endless names of those who have crossed over before
their time.
Grandmothers,
Grandfathers,
Aunties,
Uncles,
Cousins,
Sisters,
Brothers,
Fathers
and Mothers
Mami Wata knew this ocean when it was luminescent, rippling with life.

Now a baptism, a rebirthing under briny swells,
cresting the waves,
I am bathed in her light.

Once again, I bury myself below the tide
trailing tears and bargaining,
questing for Mami Wata.

Alberta Whittle, 'Lessons from Solariss', a new poem written for this book, 2023.

Celeste Olalquiaga
The Missing Link//2002

[...] Attempting to account rationally for all phenomena, the 1700s and 1800s produced a mixture of science and fantasy that kept alive many of the old beliefs under the new guise of empiricism. In this vein, modernity recast those legendary aquatic creatures, mermaids, who underwent in the nineteenth century a peculiar transformation similar to the allegorical recovery of Atlantis, often assumed as their native kingdom and portrayed as an underwater palace with crystal walls. [...]

Promising to share their knowledge of all things, the Sirens of antiquity supposedly lured sailors to their destruction. If their spell failed when Orpheus played over their singing, they would jump into the sea in defeat and change into that endless source of oceanic camouflage, rocks. Nevertheless, Sirens were also intrinsically associated with the spirit (music being the classic vehicle for all higher enterprises) and were said to lead the souls on their way to heaven: Plato portrays them as holding the harmony of the world, and for the Egyptians they were symbols of wisdom. Christianity emphasised mermaids' sexual aspect, presenting them as evil temptresses and reducing their complex mix of material and spiritual attributes to its minimal expression. Celtic and Germanic folklore rescued mermaids in the Middle Ages, associating them with the gentler water nymphs and popularising the modern mermaid figure whose influence was felt all the way to Africa, where since the fifteenth century she has been known as 'Mami Wata', *mother of the waters.*[1]

Sirens and mermaids tend to grant wishes and even engage in pacts with humans. [...] Hans Christian Andersen's Little Mermaid (in the 1837 story by

that name) enters a similar pact, except that hers is with a wicked underwater witch who not only cuts out the adolescent princess' tongue to secure her exceptionally beautiful voice as payment for changing her tail into human legs, but does so at the price of excruciating pain, since the mermaid feels like she is walking on knives. Ultimately, the Little Mermaid's wish to obtain an immortal soul through human love can, and does, backfire: if she fails to inflame that love, she must die. Because her goodness is such that she forgoes the possibility of killing the desired prince and recovering her underwater life, the mermaid princess is transformed into a daughter of the air, becoming a candidate to win a soul as long as she puts in three hundred years of good deeds – surely a feat that few human beings could achieve.

It is perhaps their capacity to change back and forth between human and animal – or to be both at the same time – that has gained these mythical figures such suspicion and fear in Western culture, so given to fixed, patriarchal categorisations. The mermaids and Sirens of antiquity united in their proteiformity [changeability in form] both the spiritual and the material, the transcendental and the sexual. Their more recent transformation into human beings is only a rite of passage for their gaining a soul that had never before been at issue. In order to access the symbolic structure that gives meaning to this act in the West, mermaids must leave behind the amorphous space of the imaginary, where they can afford to have a hybrid condition, and assume instead the static form of a single species. In other words, they must split themselves and sacrifice an important part of their being, forfeiting their own complexity for a culture where it is read as an untenable duality.

Paradoxically, transformation, or the movement of life, is seen in Western culture as material and finite, while death, or the cessation of life, becomes the condition for an unlimited, albeit abstract and intangible, realm of being (redemption, the eternity of the soul), one happening at the expense of the other. [...]

While the reversal of the symbolic seems an impossible feat, the same is not true for its opposite, characteristic of all socialisation: the transition from the imaginary to the symbolic, represented by mermaids' ascension to land and their abilities to be (almost) fully integrated into the surface, albeit with disastrous consequences. [...] In *The Little Mermaid*, the mermaid princess pays for the parting of her tail into legs – which, more than walking or dancing, would allow her to have human intercourse and reproduce – with her voice. This unknowingly dooms her mission from the start, since her inability to breach the symbolic gap hinders her from fully performing as a human. Deprived of language, she cannot tell the prince that it was she who saved him from drowning, so he marries a human princess, believing her to be his real saviour.

Disney's contemporary adaptation of Andersen's story preempts this unhappy ending by transforming the tale into one of raging hormones and filial disobedience (that is, sexuality and rebellion), dismissing the wise grandmother, bearer of mermaid tradition, in order to elevate the figure of 'King Triton', the father of 'Ariel', whose authority has been challenged by his daughter's desire to marry a human. Throwing the whole underwater kingdom into disarray, Ariel appeals for help to the 'Sea Witch', a 'bad mother' who knows how to manipulate everyone's desires and whose uncontrolled sexuality is represented in the figure of a sleazy, voracious, overweight octopus with iron-clutch tentacles and a bosom and mouth that at one point take up the whole screen. Eventually defeated by Ariel's young human prince, the Sea Witch fizzles out and all her magic spells are broken. Having recovered her voice (which was 'contained', just like a special memory, in a magic bubble) and gained her father's approval, Ariel gets to keep her legs, marry the prince and stay on land.

Besides privileging the story's patriarchal implications, Disney's *Little Mermaid* displays an element which is barely present in the original version, but which establishes an interesting connection between Captain Nemo and herself, as well as with the consumer society they both represent: the collection. Like Nemo, Ariel roams shipwrecks foraging for treasures, although hers have barely any material value, while his finance the whole Nautilus enterprise plus a few campaigns of political destabilisation along the way. Yet both collections allow the characters to engage imaginarily in the worlds that so fascinate them: while Nemo fills the Nautilus with pearls, coral and hundreds of sea specimens in the name of research or finances, Ariel fills a huge underwater cave whose vertical formation reaches towards the surface, opening into a kind of submarine skylight, with the remains of human objects (glasses, vases, silverware, etc.) which she places in the interstices between the rocks, so that the cave-tower becomes a dizzying spiral of objects where the mermaid princess can get lost in her daydreams.

This replacement of an experience by its material symbol (instead of the symbol being a medium, or way of achieving, the sought experience, as in religious and magic rituals) emphasises the modern connection between objects and dreams which underlies all commodity fetishism, and which is at the heart of Disney's *Little Mermaid*. In this sense, the treasure cave episode is both a spin-off and a twist on the traditional mermaid stories where rather than collecting objects to enhance their daydreams, mermaids offer them for the fulfilment of others' wishes [...]

Mermaids' morphic change is intrinsically related to the fluidity of water, an element that acts both as a carrier – enabling the transmigration of souls,

as in the underground river Lethe – and as reflector, offering a looking-glass-like surface for the projection of the self. In turn, water, and particularly ocean water, responds directly to the changes of the Moon, ruler of tides and menstrual cycles, psychic phenomena and the unconscious. This tight symbolic unity, where the ungraspable versatility of the unconscious is represented in the liquidity of water, is perhaps nowhere more apparent than in mermaids. Both water and the Moon are metaphorically condensed in the mirror that, along with a comb, usually accompanies mermaid depictions, and that, although loaded with symbolic meaning, is often reduced to signifying feminine vanity.

In this sense, one of the most interesting but rarely discussed metamorphoses undergone by mermaids (in their earlier form as Sirens) is their transformation into rocks as a result of their failure to charm sailors. Here again rocks constitute a multifarious discourse, adding to their already kaleidoscopic status: given that the Moon is nothing but a rock, and one that reflects light at that, mermaids' fossilisation can be understood as their transformation into that lunar body which so determines them otherwise. At any rate, this is a paradoxical punishment since rocks, in the form of grottoes and caves, are not only mermaids' fabled abodes but their main connection to the surface world: mermaids usually appear sitting or lying on rocks, or represented by edifices like Mélusine's castle.[2]

Petrification, then, would seem only to perpetuate the mermaids' nature under a different guise: more than inert matter, rocks could be seen as an extension or continuation of mermaids' bodies – half above, half under the sea, holding in their crevices those secrets that can destroy men if they get too close. Perhaps those mermaid apparitions that were seen as fatal signs in antiquity might be better interpreted as warnings of the imminence of shipwreck – by hitting a shallow reef, for example – than as malicious acts of destruction cast upon unwary sailors by evil temptresses. […]

Petrification makes mermaids into metamorphic rocks – a transitional condition between states (i.e., molten and solid) that iterates the notion of the world as being in constant change instead of fixed polarities. Even though mermaids' return to animal form from rock is not part of their lore, in becoming rocks they are only entering a different manifestation of their being. As such, this is the last metamorphical twist in a long chain of transformations that led mermaids from their most ethereal and evanescent form – water nymphs – to the most concrete and permanent, passing through the in-between state of a mutant, sexual creature.

This turn of events is consistent with the fact that, as grantors of wishes or rescuers of drowning men, mermaids lack any agency for themselves, acting always in function of a male other. Like rocks or mirrors, which transmit energy

or give reflection but have no direct capacity for action, mermaids act as a vehicle for somebody else's desire. Their petrification further ratifies this passive identity by making them an indistinct part of the maritime panorama. Upon becoming rocks, mermaids give up their unique hybrid configuration for a primary organic state. In the end, it is their material aspect that carries the most weight. Perhaps this is why, of all their representations, mermaid images have been handed down through the ages in their most solidified form as statues and sculptures.

While as sea creatures mermaids symbolised the fantastic possibilities of the unconscious, as minerals they convey the ultimate fate of excessive metamorphosis: disapparition. It is as if so much going back and forth between species and elements, such an unbounded capacity for camouflage, finally rendered mermaids unable to form a stable identity of their own, remaining at the mercy of the very mutability that made them so special. This unstable reality is the key to why metamorphical creatures inspire such apprehension in the West: for a culture bent on fixed definitions and clearly delimitated categories, nothing is so threatening as a being that constantly transits between forms and states. [...]

1 [Footnote 6 in source] For the history of mermaid mythology see Meri Lao, *Las Sirenas: Historia de un símbolo* (Mexico D.F.: Ediciones Era, 1995) and Georges Kastner, *Les Sirènes: Essai sur les principaux mythes relatifs* (Paris: G. Brandus and S. Dufor Brandus, 1858). For a description and analysis of Mami Wata in African popular culture, see David Hecht and Maliqualim Simone, 'Mermaids and Other Things', in *Invisible Governance: The Art of African Micropolitics* (New York: Autonomedia, 1994) 56–75. According to some versions Mami Wata was taken to Africa by the inhabitants of Atlantis.

2 [12] According to Kastner, in Nordic mythology everything related to druidic stones, rocky clefts, caves and grottoes retains traces of mermaids. See *Les Sirènes*, 166.

Celeste Olalquiaga, extracts from *The Artificial Kingdom: On the Kitsch Experience* (Minneapolis: University of Minnesota Press, 2002) 238, 240, 242-51. [some footnotes omitted].

Ron Broglio
Surface Encounters//2011

[...] Much of [Marcus] Coates' artwork involves community. More specifically, he examines small or marginal communities through disrupting social conventions with animal worlds. While the role of community is clearly evident in his shaman rituals, in light of the role of animals and becoming, it is worth first turning to his earlier work, *Finfolk* (2003). In this video, Coates emerges from a sea bank dressed in athletic wear; he dances, gesticulates wildly, and spouts an inarticulate stream of words that sound something like a hybrid of Scottish, a Scandinavian language, and English cursing. When he spots a human family strolling along the quay, he zips up his coat and descends back into the water. Moments later, the family spots a seal bobbing in the ocean.

Coates is revising folklore about amphibious creatures who change form and interact with humans. According to Scottish folklore, the finfolk are mysterious shape-shifters who travel from their underwater world onto land in order to cause havoc. They are said to abduct humans and force them into servitude; they take young women and make them brides in their underwater world. The myth of finfolk is related to that of the selkie, a creature found in Icelandic, Irish and Scottish mythology. The Scottish word *sealgh*, or *seich* or *selk(ie)*, means 'seal'. These creatures take on human form by shedding their seal, or selkie, skins, and conversely become selkie by re-suiting into their skins. Many selkie stories are romantic tales of a lover knowingly or unknowingly marrying a selkie. In the fantasy film, *The Secret of Roan Inish* (1998), a farmer captures a selkie for a wife and locks away her sealskin in order to keep her in servitude and prevent her from returning to the sea. 'The Grey Selkie of Suleskerry' is one of many ballads collected by Francis James Child and printed in his Victorian collection, *The English and Scottish Popular Ballads*. Coates' athletic suit is a wry stand-in for the seal skin. Unlike in the legends, Coates as a finfolk is rather awkward on land: some moments he seems uncomfortably out of place, while at others he dances haphazardly on the shoreline. He is neither threatening like the finfolk nor seductive like the selkies.

Coates looks like an idiot; his words as a finfolk do not make sense: 'Frik frak fuk fuk fo', and on he goes; the storyline of the piece does not match the myths. In short, what is he doing out there, out on the quay, on the shoreline where the human-made walkway meets the beating of nature's waves? It is precisely this nonsense that is the fulcrum by which Coates leverages and jostles the human and animal worlds – a leveraging not through verticality of reason, but rather

by immanence and mixture between *Umwelts*. Recall Deleuze and Guattari on metamorphosis:

> It is no longer a question of resemblance between the comportment of an animal and that of a man ... The animal does not speak 'like' a man but pulls from the language tonalities lacking in signification; the words themselves are not 'like' the animals but in their own way climb about, bark and roam around, being properly linguistic dogs, insects, or mice.[1]

Coates puts out a very poor imitation of a seal designed to deflate metaphor and analogical comparisons. The work flattens meaning by baffling the viewer's ability to make sense of how the piece fits within analogy and within Scottish folklore. And yet the title insists that indeed this is *Finfolk*. The insistence of the title becomes its own ground and jabs at the hermeneutic circle, which grounds itself while erasing its tracks. If Coates looks foolish, if his yammering tells us nothing, and if the work itself remains inscrutable, it is all to the purpose of creating an 'asignifying intensive utilization of language'.[2] His words do not signify 'like' the animals, but do roam and bark and climb. Their value is in the intensity of the performance. The camera focuses on just his mouth frothing with spit, spitting out nonsense syllables, showing his not so-vicious teeth and tongue. The sounds become 'intensities overrun by deterritorialized sound or words that are following their line of escape'.[3] By the end of the work, the sounds and wild antics lead back to the sea and its dark veil from which Coates emerged. The whole of the video work is but a glimpse at the unintelligibility of the Other and a wonder at its wandering.

Throughout *Finfolk* the idiocy makes us laugh, but in this laughter we are caught: we stand within the hermeneutic circle that gets the joke, and outside the circle through a sympathy with the wayfaring seal-man who seems decidedly outside the social and hermeneutic circle. The sympathy is necessary to get the joke but is abandoned to be able to stand within the circle by which we laugh. The audience is on a quay – a borderline between the unintelligible waves of nature and the manmade banks hoisted against erosion of the landscape. The laughter becomes a moment of deterritorialisation (an abandonment of being inside or outside the social terrain) that works against reason and echoes the frothing, spitting mouth, and a signifying language of Coates the seal-man. Refusal to laugh acquiesces to the tyranny of reason; inability to laugh signals our own idiocy at not getting it, not being in the strange and stretched circle that contemplates human and animal worlding simultaneously. A laughter from the belly trumps the consumption of the world by reason. [...]

1 [Footnote 18 in source] Gilles Deleuze and Félix Guattari, *Kafka: Toward a Minor Literature* (Minneapolis: University of Minnesota Press, 1986) 22.

2 [19] Ibid.

3 [20] Ibid.

Ron Broglio, extract from *Surface Encounters: Thinking with Animals and Art* (Minneapolis and London: University of Minnesota Press, 2011) 108–12.

Mel Y. Chen
The Spill and the Sea//2012

[…] The titular character [in director Hayao Miyazaki's 2008 film], Ponyo, is a little fish (ambiguously raced) who desires to become a human and has strong affective ties to a little boy, Setsuke. She is not alone: she has a father, a kind of magician of the ocean who tends to its health by summoning potions which move and transform ocean matter, living or dead; a mother-goddess who seems almost metaphysical in form, but who makes occasional human-size departures; and a whole lot of little sisters who resemble her fish form, but are smaller in size, literally her 'little sisters'. They are her comfort and support when she is in the ocean. And this sea, as Miyazaki comments, 'is animated not as a backdrop to the story, but as one of its principal characters'.[1] Animation here works in multiple ways: both conjuring animacy and referring to the illustrated style and fantastical figuration of the film itself.

In Miyazaki's visual narrative, however, the distinction between land and sea is blurred: indeed, it is hardly a hostile relationship or, as in the case of the BP spill, primarily an economic one. The border between land and sea simply shifts upward in the wake of a tsunami-induced flood. Miraculously, despite the flood, death seems not what is at stake ('terror' and 'contagion' is displaced by 'magic', perhaps?), and the anxieties that exist are based on a disparate bunch of concerns, including electricity, protection for the elderly residents of the retirement home, and Setsuke's father being lost at sea. Ultimately, no one is killed; the big fish simply swim along what were formerly roads for automobiles; Setsuke's house remains above water; and the humans have simply remained buoyant, in boats, on the surface. Ponyo's little sisters are the ulterior oil plumes, animated little particles that have shared feelings. Collectively, they are affective matter.

I am reminded here of J. Jack Halberstam's work on animated movies featuring bees. Halberstam observes that animation films which centre on

bees display alternative political organisations despite not going so far as to observe, for instance, the matriarchal aspect of bee societies. That is, there are moments when more exact investigation of lived animal formations is generative. Halberstam nicely assumes this appropriability of reference not as a means of restoring final honesty to a signifier, but as a means toward political ends, suggesting that if mainstream animation filmmakers did study the lives of actual bees, bee fiction might do better than its currently middling job at representing a kind of feminist or otherwise progressive politics.[2] The case of Ponyo's little sisters presents an alternative political organisation of a hybrid posthuman-goddess-fish family which, in Miyazaki's configuration, is matriarchally structured and, unlike what human procreation predicts, involves a set of hundreds and hundreds of siblings, siblings that are not necessarily the less-autonomous 'little sister' deserving of protection.

Miyazaki's Studio Ghibli is known for being judicious about when it takes advantage of the convenience of computer-generated imagery (CGI) technologies, which Halberstam has observed is technology's latest imaginative feat in the representability of enormous collectivities ('hordes') and their accompanying political formations within animation. Ponyo's many little sisters, even if they were so numerous as to make up a 'horde,' were thus not multiply generated copies of a replicated single sister, launched at different points in her repeating dynamic smiling, speaking, and fluttering actions to induce the perception of difference and individuation. Rather, the supervising animator of the film, Katsuya Kondo, explained:

It wasn't enough just to have a lot of sisters onscreen. Each sister needed to move as an individual character. The scene in which the sisters rescue the half-fish, half-human Ponyo was divided into three stages – beginning, middle, and end – and the assistant animators drew each sister carefully. We didn't use any copies or CG, of course, because everything was drawn by hand this time. While the work was painstaking, it was easier to create the movements of an ensemble by hand than by CG, and we took on this task because we wanted to render those movements to our hearts' content.[3]

The technicality of Kondo's focus on mobility did not mitigate its sweetness to me, for the sisters were 'painstakingly' given life one by one to the animators' 'hearts' content.' The 'animation' of Ponyo was enriched by the multiple factors of animacy: sentience, movement, faciality, speech, and action upon something else – as well as the many imaginative animations dreamed up by each creator for which the final embodiment of a single sister was the culmination.

Animation is thus the end point of the setting-off of many different animacies; its careful consolidation of these animacies, particularly in the case of Ponyo, is what sets it apart.

In her attempt to transmogrify into a human, Ponyo enters intermediary stages where she sprouts chicken legs. She experiences her greatest exhilaration and exuberance at that in-between juncture: that chickenlike embodied site of interstitial land-water and fish-human, rather than a site of confusing or distressing liminality, yields an intensity easily read to viewers as pleasure. For Ponyo, the promise of humanness exists in spite of all that humans have done.

The fish/chicken/little girl is far from a binary logic; she is a blending that is partial and contingent and enacted across time, yet the blending is simultaneously robust and profound, effective and affective. Both air and seawater are the stuff of blends, the stuff of human, animal and godly mattering. If lungs no longer critically matter for breathing, then the material difference between air and water also dissolves. The air-seawater is also the stuff of sex, of the sensuous, sensible exchange of breath, fluids and parts; of meetings and interpenetrations which may be 'actual' or 'virtual', within which we need feel no particular responsibility to any exceptional organs; of reproduction, of penetration, of reception, of animacy itself.

[…] In the opening song to Ponyo, 'Umi no Okasan' (Mother Sea), the lyrics sing of lost unity and beckon a return to the family of countless siblings:

The sea lilies sway
In a world of blue
To brothers and sisters uncountable
We spoke in the bubbly, watery language of the sea
Do you remember when
So very, very long ago
We dwelt there together
Deep in the blue, blue sea?
The jellyfish, the sea urchins, the fish and the crabs
Were our family.[4]

The ending scenes of the film execute this new possible kinship between land and sea with the long-desired transmogrification of Ponyo into a human (albeit one who has a memory of being a fish) and the compacting of this transition by an agreement between a human (Sosuke), who agrees to care for her, and Ponyo's mother who commands the sea and makes the transition so. […]

1 [Footnote 6 in source] Hayao Miyazaki, *The Art of Ponyo: Ponyo on the Cliff by the Sea* (San Francisco: Viz Media, 2009) 11.

2 [7] J. Halberstam, *The Queer Art of Failure* (Durham, NC: Duke University Press, 2011).

3 [8] Miyazaki, op. cit., 116.

4 [9] Lyrics: Wakako Kaku and Hayao Miyazaki; music composition and arrangement: Joe Hisaishi; performance: Masako Hayashi; translation: Rieko Izutsu-Vajirasarn. Reported in Miyazaki, op. cit., 268.

Mel Y. Chen, extracts from *Animacies: Biopolitics, Racial Mattering, and Queer Affect* (Durham, NC and London: Duke University Press, 2012) 227–31.

Brian Jungen
In Conversation with Matthew Higgs//2004

Matthew Higgs [...] Could you say something about the origins of the recent sculptures of whale skeletons, which use mass-produced plastic garden furniture as their sculptural material?

Brian Jungen I was interested in how these ubiquitous, mass-produced white plastic lawn chairs came to 'infect' homes and gardens throughout the world. I started photographing them in different contexts and in different states of decay. I became interested in the chairs – as mass-produced global objects – as a potential sculptural material. With *Shapeshifter* (2000), the first whale skeleton piece, I wanted the work to allude to the context of the Natural History museum whilst simultaneously evoking a science-fiction-like aesthetic. When you first see *Shapeshifter*, especially from a distance, you immediately see the visual 'footprint' of what it represents: a diagrammatic representation of a whale's skeleton. But as you draw closer the work becomes almost a kind of spacecraft-like object, where you can't really identify its original point of reference. Instead you see these almost organic and somewhat alien-like shapes. The title *Shapeshifter* alludes to this process in which the sculpture seems to be in a kind of flux. The title alludes to science-fiction cinema and literature, but also to 'pulp' Indian legends: to the supernatural or mystical idea of a human being transformed into another form, like a werewolf for example.

Higgs A kind of alchemy?

Jungen In a way. The chairs are a petroleum product, which was once organic, yet as a result of the manufacturing process this material becomes inorganic. The use of the image of the whale – which might evoke notions of Greenpeace or of a species under threat of extinction – and the lawn chairs was in part an attempt to articulate a paradoxical relationship between the organic and the inorganic. Also I wanted to draw a parallel between the idea of a species under threat of extinction and the ongoing threat to aboriginal culture and traditions. [...]

Higgs Your work embraces and articulates tensions inherent between Indigenous and global cultures. Would it be useful to think of this tension as a kind of motivating principal?

Jungen Yes, definitely. I realise now that my upbringing in a remote part of Canada is, at least within the context of the art world, relatively unique. Certainly as a child the tension between being aware of my surroundings but also being exposed to the larger world via television informed my primary motivation to step outside of the world that was most immediately familiar. So even as a child I was exposed and conditioned by a rudimentary form of globalism. [...] [M]y approach to working with existing objects and altering them is directly related to a material sensibility I experienced in my childhood, the way my mother's family would use objects in ways that weren't originally intended, a kind of improvisatory recycling that was born out of both practical and economic necessity. Witnessing that resourcefulness continues to exert a deep influence on how I relate to the world as an artist.

Brian Jungen, extract from 'Brian Jungen in Conversation with Matthew Higgs', in *Brian Jungen* (exh. cat.) (Vienna: Secession, 2004) 27–9.

Melody Jue
The Floating World of Giant Kelp//2021

There are many stories about seaweeds fooling taxonomists. Since seaweeds are so plastic in form – able to vary their morphology according to the qualities of the ocean environment they have anchored to – it can sometimes be hard to tell whom is whom. Of these, perhaps the easiest seaweed to identify is giant kelp (*Macrocystis pyrifera*), whose scientific name attests to its poetics of form, a large-bladdered seaweed (*Macrocystis*) spiralling up to the surface of the ocean

like a plume of flame (*pyrifera*). This naming offers a striking thermal contrast between the evocation of fire and the cold waters where giant kelp grows best. What makes it uniquely distinctive are not only its large bladders, but also the ruffled surface of its blades (the leaf-like part of the kelp, which is technically an algae, not a plant). Even though giant kelp can stretch its blades, or balloon its bladders to huge round orbs as I have seen underwater at Anacapa Island, these ruffles give it away – an adaptation that may help them spread out and flap in the water, increasing nutrient uptake and catching more sunlight.

As part of an interview in the cookbook *Ocean Greens* (2016), seaweed curator and taxonomist Kathy-Ann Miller encourages you to 'think like a weed'. Even if you already know the species, it is helpful to imagine the environment of a specimen, including what kind of oceanic conditions may have influenced its morphology. This task of speculating what it is like to be giant kelp may benefit from a narrative form, like the second person voice. You might recall that the second person voice is one of the rarer narrative tenses, and used most frequently in cookbooks and how-to manuals (first you add a dash of salt … then you chill the soup …). While there are notable exceptions in fiction, such as Italo Calvino's *If on a Winter's Night a Traveller* (1979) and N.K. Jemisin's stunning short story 'Emergency Skin' (2019), it is more rarely found there. The second person voice is slippery – not unlike the feeling of running your hands over the surface of a giant kelp blade – because the pronoun 'you' famously breaks the fourth wall. It might mean you the reader, or a hypothetical you, or a you (singular or plural?) directed to a character in the text. You float(s) between these possibilities.

Perhaps the first thing you experience is a self-awareness of your own posture. The sunlight is tasty. You pull yourself up towards the sun, your stipes twisted into a rope that is strong but flexible. As a vertebrate you find it easy to empathise with this vertical position and straighten your spine, perhaps a bit stiff from sitting. Your holdfast has gripped and grown around a rock anchor. It is a mesh that looks like roots, except that the division of labour that manifests in terrestrial plants (leaves photosynthesise, roots absorb nutrients from the soil) does not apply here. As a macroalgae, you absorb nutrients throughout your whole body. The whole ocean is your soil, and your holdfast 'roots' are just the glue. Tiny nudibranchs like the purple and orange Spanish Shawl love to hang out here, like toe rings adorning your feet. Your many bladders also pull you towards the sun, little air-filled sacs that lift the column of your body. Unlike fish – who love the horizontal position – everything about you stretches up. Of course, you are also pulled back and forth by the lunar tides. Do you sway, or have sway? Round snails crawl up your column, taking up residence on your stipe (stem) as if they were extra bladders. You are a multi-story apartment

complex, home to a variety of tenants that stick and glue and graft to your blades. No matter – you have plenty of space, you make space, you unfold and unfurl at each geometric growing tip – a beautiful calculus that sometimes makes it to the cover of mathematics textbooks.

Perhaps you made a bad choice of rock. Perhaps you selected too small a holdfast – or one day, the force of the tides caught you, and as you pulled, your rock fragment dislodged from the whole. If you hadn't been tangled up with several neighbours into an accidental braid, you may have started the end of your life, that slow drift towards the shore. But now, here you are, balanced in perfectly neutral buoyancy, your body lifting up and a cluster of small rocks barely weighing you down. As a scuba diver approaches you with a fish-eye lens, she is surprised to encounter a science fictional scene: a cluster of rocks floating in front of her, as if escaped from gravity, as the plumes of your body spiral upwards.

In Japan, *ukiyo-e* means 'the floating world', a genre of woodblock art prints that portrayed many scenes of life, from history to landscapes, theatre, and erotica in the seventeenth through nineteenth centuries. Hokusai's famous *The Great Wave off Kanagawa* exemplifies this sense of suspension: a wave frozen at the moment of its break, just before it will bring foamy fingers crashing down on a slim boat. *The Great Wave off Kanagawa* anticipates what photographer Henri Cartier-Bresson would later call the decisive moment, the perfectly timed click of a camera shutter that captures something on the cusp of change: for example, a man leaping over a puddle, momentarily hanging in the air, the water perfectly mirroring his shadow. Hokusai's wave and Cartier-Bresson's man are both about to fall – a decisive moment that is closely tied to the experience of gravity, just before it pulls the subject down.

You too are in a moment of balance, but you are not about to fall. Unless you braid yourself into another bundle of giant kelp nearby, more properly anchored, you are getting ready to rise – your body a shaggy yellow carpet caught in the current, inexorably pulled to shore. As you grow your newest bladders, you inch ever closer to being carried up and away, tiny balloons lifting you into an atmosphere of ocean.

But not yet, not yet. For now, you are still part of the floating world.

Melody Jue, 'The Floating World of Giant Kelp' (2021), originally commissioned by artist Bryony Gillard for her creative research project *Unctuous Between Fingers*, (www.unctuousbetweenfingers. co.uk/contributions/melody-jue-floating-world).

THIS WAS MY OWN
APOLLO PROJECT.
I TOOK A LIVING
OCTOPUS
THAT I CAUGHT
MYSELF TO TOKYO.
THEN I BROUGHT IT
BACK, STILL ALIVE,
AND PUT IT INTO
THE SEA.

Shimabuku, 'With Octopus, 1990–2010', 2021

ALIEN SEAS?

Stefan Helmreich
Alien Ocean//2009

[...] If the wild and wondrous sea belongs to a zone of being beyond a steady and grounded self – if it belongs in part to what anthropologists call the order of the Other – today's microbial marine world can profitably be seen from the science fiction-spangled angle of the alien. If marine mascots have scaled down from the nineteenth-century whale to the twentieth-century dolphin to, now, the emerging microbe, it may not be surprising that the imagery aimed at apprehending this creature – neither charismatically mammoth nor wet and cuddly – reaches toward the sensationally odd and not-quite other.

I employ the figure of the alien because marine biologists so often invoke it as they describe the unfamiliar universe of marine microbes. Education-minded researchers, for example, appeal to the alien to invite kids to consider microbiology as a career: 'Being a microbiologist is like being an explorer in a vast, unseen world full of weird, alien-like creatures.'[1]

Alien associations abound when scientists speak of the strangeness of marine biota like hydrothermal vent microbes, the foreignness of invasive species, and the possibility that marine microbes might serve as models for extraterrestrial life forms (a connection brought into pop culture by James Cameron in a 2005 documentary about extremophiles called *Aliens of the Deep*). The word *alien* also flags the space-age imagery that informs scientific invocations of the term; not only are microbial realms often compared to outer space, but microbes inhabit contexts and scales – worlds, microcosms – inaccessible to prosthetic-free human experience, zones hard to apprehend as connected to our own forms of life. Microbes are life forms that exist at scales 'unperceived by ordinary human experience', in texts that push to their limits (genetic, metabolic, ecological) what biologists have imagined living systems capable of enduring or enacting.[2] Microbiologists often describe these creatures in a biotechnological idiom as devices solving engineering problems, devices deploying the logic of information processing to propagate their kind in extended, subaqueous webs. Microbes' status as novel scientific objects, and as objects of wonder and anxiety, makes science fiction an inviting vernacular in which to describe them.

The figure of the alien materialises, I contend, when uncertainty overtakes scientific confidence about how to fit newly described life forms into existing classifications or taxonomies, when the significance of these life forms for forms of life – and particularly, for secular, civic modes of governance – becomes

difficult to determine or predict. [...] Aliens are figures through which, as Kathleen Stewart and Susan Harding phrase it, 'the imaginary "them" [becomes] the surreal "us"'.[3] In other words, aliens are strangers, entities not yet – or not fully ever – friend or enemy, self or other. Stealing a phrase from Stuart Hall, the alien could be glossed as constituted by 'difference which is not pure "otherness"'.[4] Aliens are life forms whose place in our forms of life is yet to be determined. [...]

1 [Footnote 45 in source] Microbeworld: Discover Unseen Life on Earth (www.microbe.org).

2 [46] Colin B. Munn, *Marine Microbiology: Ecology and Applications* (London: BIOS Scientific Publishers/Taylor and Francis Group, 2004) xiv.

3 [48] Kathleen Stewart and Susan Harding, 'Bad Endings: American Apocalypsis', *Annual Review of Anthropology*, vol. 28 (1999) 294.

4 [51] Stuart Hall, 'Cultural Identity and Diaspora', in *Identity: Community, Culture, Difference*, ed. Jonathan Rutherford (London: Lawrence and Wishart, 1990) 229.

Stefan Helmreich, extracts from *Alien Ocean: Anthropological Voyages in Microbial Seas* (Berkeley and London: University of California Press, 2009) 15–17 [some footnotes omitted].

Vilém Flusser and Louis Bec
Vampyroteuthis Infernalis: A Treatise//1987

[...] Some octopods, such as *Octopus vulgaris*, are commonly known and even eaten. Others, such as *Octopus apollyon*, can grow to a length of ten metres and are rightly feared: their violent beak and sharp teeth, their muscular tentacles – arrayed with suckers – and the voracity of their expression lend them a diabolical appearance. Still others are all but unknown because they inhabit the abysses of the sea. Their body size exceeds twenty metres and their skull capacity exceeds our own. Such a species, difficult to classify, was recently caught in the Pacific Ocean: *Vampyroteuthis infernalis*.

It is not easy for us to approach it taxonomically, and not only taxonomically. Humans and vampyroteuthes live far apart from one another. We would be crushed by the pressure of the abyss, and it would suffocate in the air that we breathe. When we hold its relatives captive in aquaria – both to observe them and to infer certain things about *it* – they kill themselves: they devour their own arms. How we would conduct ourselves if dragged to its depths, where eternal darkness is punctured only by its bioluminescence, remains to be seen.

And yet the vampyroteuthis is not entirely alien to us. The abyss that separates us is incomparably smaller than that which separates us from extraterrestrial life, as imagined in science fiction and sought by astrobiologists. The same basic structure informs both of our bodies. Its metabolism is the same as ours. We are pieces of the same game, both constructed of genetic information, and we belong to a branch of the same phylogenetic tree to which its branch belongs. Our common ancestors dominated the beaches of the earth for millions of years, and it was relatively late in the history of life that our paths began to diverge – that is, when life 'decided' to advance away from the beach both toward the mainland and, in the opposite direction, toward the bottom of the sea. We and the vampyroteuthis harbour some of the same deeply ingrained memories, and we are therefore able to recognise in it something of ourselves. […]

Its Art
Both vampyroteuthes and humans acquire information in order to disseminate it to others, and this practice is not unique to us. In several other of the so-called higher species – mammals and birds, for instance – certain behavioural models, such as hunting and flying, are passed along from a mother to her young. However, the case of humans and vampyroteuthes is somewhat different. Unlike other animals, both of us endeavour to preserve information in our respective memories, to saturate these memories with more and more new information, and to impart them – thus enriched – to others. In the case of humans and vampyroteuthes, that is, the transmission of information is a cumulative process. In other words, humans and vampyroteuthes are historical animals, animals that have overcome their animality.

[…] The central problem of historical evolution is that of memory. Animals perpetuate transmitted information in gametes. The latter are practically eternal memories: they will persevere as long as there is life on earth. To transmit their acquired information, however, humans make use of artificial memories such as books, buildings and images. Because these are far less permanent than eggs or sperm, humans are therefore always in pursuit of more durable memories: *aere perennius* (more everlasting than bronze). They are aware that, after all of their artificial memories – all of their cultural artefacts – will have faded into oblivion, their genetic information, preserved in gametes and perhaps mutated by chance, will still remain. The biological is more permanent than the superbiological, and this truth is difficult for humans to accept. It is difficult because it is not as animals, but as superanimals, that humans want to achieve 'immortality'. Memory, the central problem of historical evolution, is also the central problem of art, which is essentially a method of fabricating artificial memories.

From the perspective of the vampyroteuthis, all of this has the look of a laughable error. How foolish can humans be to entrust their acquired

information to lifeless objects such as paper or stone? It is well known, after all, that these objects are subject to the second law of thermodynamics, that they will decay and necessarily be forgotten. In the vampyroteuthic abyss, where all is strewn with sedimentation and bathed in fluidity, the unreliable impermanence of lifeless objects is far more obvious than it is on the relatively dead surfaces of the continents, where sun-bleached bones can endure for millennia. And yet the laughable error that is human art should not simply be laughed at – assuming the vampyroteuthis is capable of laughter – but scrutinised as well.

When we attempt to express a novel experience or thought – when we aspire to render the unspoken speakable and the unheard audible – we do so as functions of artificial memory, as functions of lifeless objects. That is, our experiences and thoughts assimilate with lifeless objects to form inextricable unities. We experience and think, for example, as functions of marble, film strips, or the letters of written language. It is not the case that we first experience or think something and, subsequently, scour the vicinity for an object with which to record it. Rather, it is *already* as sculptors, filmmakers, authors – as artists – that we begin to experience and think. Material, lifeless objects (stones, bones, letters, numbers, musical notes) shape all of human experience and thought.

All objects are stubborn; being inert, they resist our attempts to '(in)form' them. Yet every object is stubborn in its own particular way: stones shatter when chiselled; cotton slackens when stretched; written language deforms thoughts with the stringency of its rules. To (in)form objects and transform them into memories, art engages in a constant struggle against the resistance of the objects themselves. During this struggle, humans have experienced and come to know the essence of certain objects (stones, cotton, language, for instance). Of course, this very experience provides us with even more new sets of information that, in their turn, come to be recorded in other artificial memories. Thus an ever-expanding feedback loop has developed, and continues to develop, between objects and humans – in other words, 'art history'.

The stubborn resistance of objects is aggravating to humans. It is as though humans are called from above to (in)form a specific object. There are humans whose calling it is to (in)form stones, others whose calling it is to (in)form language, and those who have missed their calling seem to be leading a false existence, a false *Dasein*. For the feedback loop – the relationship – between a specific object and a specific human is finely tuned and, over the course of its development, this relationship changes both the object and the human. To repeat, humans live as functions of their objects. Because of this fact, we tend to forget the purpose of art, which is to transform objects into memories from which other humans can extract information. Forgetting that they are engaged

in the transmission of acquired information to other humans, artists allow the objects themselves to preoccupy and absorb all of their attention. It is typical of humans to allow objects to absorb their existential interests. The result of this is a work ethic that threatens to turn objects not into communicative media but into the opposite, namely, barriers that restrict human communication. The creation of communicative barriers is, in the end, the laughable error upon which all of human art is based. Thanks to the perspective of the vampyroteuthis, it has finally come to our attention.

By observing the vampyroteuthis we are able to recognise an art of a different sort, one that is not burdened by the resistance of objects – by our error – but is rather intersubjective and immaterial. Its art does not involve the production of artificial memories (artwork) but rather the immediate inculcation of data into the brains of those that perceive it. In short, the difference between our art and that of the vampyroteuthis is this: whereas we have to struggle against the stubbornness of our materials it has to struggle against the stubbornness of its fellow vampyroteuthes. Just as our artists carve marble, vampyroteuthic artists carve the brains of their audience. Their art is not objective but intersubjective: it is not in artefacts but in the memories of others that it hopes to become immortal.

The production and dissemination of vampyroteuthic art – its epidermal painting, for instance – can be described as follows: It experiences something new and attempts to store this novelty in its memory, that is, to allot space for it among the other information stored in its brain. It then realises that this novelty is incongruous with its mnemonic structure, that it somehow does not fit. The vampyroteuthis is thus forced to reorganise its memory in order to accommodate it, and so its memory, shocked by this new information, begins to process it (what we humans call 'creative activity'). This creative shock permeates its entire body, overwhelming it, and the chromatophores on the surface of its skin begin to contract and emit coloured secretions. At this moment it experiences an artistic orgasm, during which its colourful ejaculations are encrypted into vampyroteuthic code. This exhibition captures the attention of its mate, whetting the latter's curiosity about the articulated novelty. Thus the mate is lured into copulation, which becomes a sort of conversation. During the course of this conversation, the novelty is inculcated into the partner's memory in order to be stored in its brain. Exactly how it spreads from there to other vampyroteuthes – how it manages to infiltrate the common vampyroteuthic conversation – cannot be accounted for here. In any case, that is precisely what happens: the newly acquired information is now a part of the vampyroteuthic conversation, and as long as vampyroteuthes exist, it will exist along with them. [...]

In the depiction of vampyroteuthic art presented above, we are able to recognise – it cannot be denied – elements of our own. Nothing about this creative and orgasmic deceit is alien to us. Not only is it not alien to us, but we have even begun to vampyroteuthise our art. We have begun, in other words, to stand defiant against the fundamental error of our art, to overcome our dependence on material objects, to renounce artefacts for an immaterial and intersubjective art form. Having lost faith in material objects as artificial memories, we have begun to fashion new types of artificial memory that enable intersubjective and immaterial communication. These new communicative media may not be bioluminescent organs, but they are similarly electromagnetic. A vampyroteuthic revolution is underway. […]

Vilém Flusser and Louis Bec, extracts from *Vampyroteuthis Infernalis: A Treatise* (1987), trans. Valentine A. Pakis (Minneapolis: University of Minnesota Press, 2012) 5–6, 60–61, 61–4, 65.

Karen Barad
Invertebrate Visions: Diffractions of the Brittlestar//2014

[…] 'Eyeless Creature Turns Out to Be All Eyes' announces the *New York Times*. An international team of material scientists, theoretical physicists, chemists and biologists were featured in the *Times* for their amazing finding that a brainless and eyeless creature called the brittlestar, an invertebrate cousin of the starfish, sea urchin and sea cucumber, has a skeletal system that also functions as a visual system. The ability of this critter to reconfigure the boundaries and properties of its body is prompting technology enthusiasts to reimagine what it means to be human. This multi-limbed sea creature is being enterprised up for new computer designs and telecommunications optical networks (giving new meaning to the AT&T slogan 'Reach Out and Touch Someone'). Summarising the results of a study published in the 23 August 2001, issue of the scientific journal *Nature*, Jonathan Abraham, the author of the *Times* article, continues: 'The brittlestar, a relative of the starfish, seems to be able to flee from predators in the murky ocean depths without the aid of eyes. Now scientists have discovered its secret: its entire skeleton forms a big eye. A new study shows that a brittlestar species called *Ophiocoma wendtii* has a skeleton with crystals that function as a visual system, apparently furnishing the information that lets the animal see its surroundings and escape harm. The brittlestar architecture is giving ideas to scientists who want to build tiny lenses for things like optical

computing.'[1] The researchers found that the approximately ten thousand spherically domed calcite crystals covering the five limbs and central body of the brittlestar function as micro-lenses. These micro-lenses collect and focus light directly onto nerve bundles that are part of the brittlestar's diffuse nervous system. Remarkably, the brittlestars secrete this crystalline form of calcium carbonate (calcite) and organise it to make the optical arrays. According to Alexei Tkachenko of Bell Laboratories, one of the authors of the study, 'The brittlestar lenses optimize light coming from one direction, and the many arrays of them seem to form a compound eye.' 'It's bizarre – there's nothing else that I know of that has lenses built into its general body surface', says Michael Land, who studies animal vision at the University of Sussex, Brighton.[2] [...]

In talking with the press, Joanna Aizenberg, a Bell Labs scientist and the lead author of the study, likens the brittlestar to a digital camera that builds up a picture pixel by pixel.[3] In this exchange, one quickly loses track of whether the digital camera is a metaphor for brittlestar vision or the reverse, especially as the metaphor begins to take on a strikingly material form:

'Instead of trying to come up with new ideas and technology, we can learn from this marine creature. ... The [calcitic] lenses surround the whole body, looking in all different directions and providing peripheral vision to the organism. ... This is the quality we all want to incorporate in optical devices, in cameras in particular. Instead of having one lens pointing in one direction, you could have thousands of lenses pointing in different directions. This will give you perhaps a 360-degree view of the whole space.'[4]

In summary, the remarkable finding of this international multidisciplinary team of scientists is that the brittlestar's skeletal system is composed of an array of micro-lenses, little spherical calcite crystal domes (on the order of tens of microns in diameter) arranged on its surface, which collect and focus light precisely on points that correspond to the brittlestar's nerve bundles, part of its diffuse nervous system, suggesting that the combined system seemingly functions as a compound eye (an optical system found in insects). [...]

The brittlestar's optical system is different in kind from the visualising systems that many science studies and cultural studies scholars are fond of reflecting on. The history of Western epistemology displays great diversity and ingenuity in the generation of different kinds of epistemological and visualising systems. (Plato's is not Descartes' is not Kant's is not Merleau-Ponty's is not Foucault's.) But as long as representation is the name of the game, the notion of mediation – whether through the lens of consciousness, language, culture, technology, or labour – holds nature at bay, beyond our grasp.

The brittlestar is not a creature that thinks much of epistemological lenses or the geometrical optics of reflection. The brittlestar does not have a lens serving as the line of separation, the mediator between the mind of the knowing subject and the materiality of the outside world. Brittlestars do not have eyes. They *are* eyes. That is, it is not merely the case that its visual system is embodied. Its very being is a visualising apparatus. The brittlestar is a living, breathing, metamorphosing optical system. For a brittlestar, being and knowing, materiality and intelligibility, substance and form entail one another. Its morphology – its intertwined skeletal and diffuse nervous systems, its very structure and form – entails the visualising system that it is. This is an animal without a brain. It does not suffer the Cartesian doubts of an alleged mind-body split. Knowing is entangled with its mode of being. Brittlestars are not fixated on the illusion of the fixity of 'their' bodily boundaries, and they would not entertain the hypothesis of the immutability of matter for even a moment. Dynamics is not merely matter in motion to a brittlestar when matter's dynamism is intrinsic to its biodynamic way of being. A brittlestar can change its colouration in response to the available light in its surroundings. When in danger of being captured by a predator, a brittlestar will break off the endangered body part (hence its name) and regrow it. The brittlestar is a visualising system that is constantly changing its geometry and its topology – autonomising and regenerating its optics in an ongoing reworking of bodily boundaries. *Its discursive practices* – the boundary-drawing practices by which it differentiates between 'itself' and the 'environment', by which it makes sense of its world – are *materiality enacted.* Its bodily structure is a material agent in what it sees/knows. Its bodily materiality is not a passive blank surface awaiting the imprint of culture or history to give it meaning or open it to change. [...]

1 [Footnote 2 in source] Jonathan Abraham, 'Eyeless Creature Turns Out to Be All Eyes', *New York Times* (4 September 2001).

2 [3] Michael Land quoted in John Whitfield, 'Eyes in Their Stars', *Nature* (2001). Available at www.nature.com/news/2001/010823/full/news010823-11.html.

3 [7] Whitfield, op. cit.

4 [8] BBC News Service, 'Can We Learn to See Better from a Brittlestar?' (16 December 2002).

Karen Barad, extracts from 'Invertebrate Visions: Diffractions of the Brittlestar', in *The Multispecies Salon*, ed. Eben Kirksey (Durham, NC: Duke University Press, 2014) 222, 224, 227–8 [some footnotes omitted]; originally published in Karen Barad, *Meeting the Universe Halfway* (Durham, NC: Duke University Press, 2007).

Marion Endt-Jones
A Monstrous Transformation: Coral in Art and Culture//2013

Coral Animals

[...] Whether coral should be attributed to the vegetable, mineral or even animal kingdom remained controversial among naturalists until the mid eighteenth century. In the end, it was Jean-André Peyssonnel from Marseille who proved once and for all in a series of essays presented to the Académie des Sciences in Paris in 1726 that corals are 'inhabited' and produced by small creatures, polyps, which he called 'insects' – then a common term for small invertebrates. The idea that the alleged plants were in reality 'zoophytes' or 'animal-plants' first came to him during excursions he took with coral fishermen off the coast of Marseille; back on shore, he substantiated his observations through a series of experiments in which he picked single polyps from their cups with his fingernail in order to slice them, plunge them into boiling water and douse them with acid liquids.[1] His discovery was so groundbreaking that it took some time for it to become accepted by fellow researchers and to catch on in the public imagination.

The notion of coral as a marine plant and a gemstone used for jewellery is still obstinately present in the public consciousness: as a marine organism that is eyeless, colony-building, reproducing sexually and asexually and living in symbiosis with photosynthetic microscopic algae, so-called zooxanthellae, it is extremely difficult to grasp. In his treatise on the *Corals of the Red Sea*, published in Germany in 1876, the zoologist and populariser of science Ernst Haeckel relates an anecdote which bears witness to the still prevailing confusion about the nature of coral. Triggered by the magnificent coral necklace worn by a lady during a social gathering, a dispute arose about the nature of the 'red gemstone'. While some wanted it understood as 'the rock-hard fruit of an Indian tree', others attributed it, like pearls, to the genre of 'sea plants'. A third group, getting closer to the truth, declared it a stony animal shell. Haeckel's assertions that the red, precious coral was in fact the inner skeleton of a composite animal colony, which had been abandoned by its inhabitants, caused considerable consternation.[2]

Aquarium Mania

As Haeckel suggested in *Corals of the Red Sea*, every single coral colony is, in fact, a small zoological museum.[3] The invention and spread of public and domestic aquariums in the middle of the nineteenth century allowed researchers and the

interested public to examine these 'miniature museums' up close – colourful living creatures in their natural habitat rather than pale, rigid specimens in actual museums or on the dissecting table.

In rapid succession, a series of natural history crazes swept through Victorian Britain (and, with a slight delay and less fervour, through continental Europe): studying and collecting the natural world was no longer reserved for experts and members of the academies and professional societies, but became a popular pastime accessible to young and old, rich and poor, and male and female alike. Thus the explosion of interest in the aesthetic and decorative qualities of sea shells ('*conchyliomanie*', as the French dubbed it) was eventually replaced by 'fern fever' (*pteridomania*), a passion for seaweeds, an obsession with orchids and a widespread craze for 'miniature oceans'.

Popularisers of natural history like Haeckel were partly responsible for introducing corals and other marine organisms like radiolaria and siphonophores – brought to life in Haeckel's beautiful drawings – to the public consciousness. In Great Britain, the naturalist Philip Henry Gosse's books on the habits and habitats of marine life, such as *A Naturalist's Rambles on the Devonshire Coast* (1853) and *The Aquarium: An Unveiling of the Wonders of the Deep Sea* (1854), were published in several lavishly illustrated editions aimed at a mass audience.

Although experiments with both fresh and saltwater tanks had been carried out before, Gosse was the first to use and establish the term 'aquarium' in 1854: 'The MARINE AQUARIUM ... bids fair ... to make us acquainted with the strange creatures of the sea, without diving to gaze at them.'[4] With their characteristic blend of scientific description, religious fanaticism and practical instructions for setting up and maintaining tanks in the home, Gosse's books firmly established the 'sea in the glass' as a parlour attraction and promoted 'rock-pooling' and 'anemonizing' as recreational activities for everyone. Different coral species, such as the honeycomb coral, Gosse explained, were ideal aquarium residents, not only because of their aesthetic appeal, but also because they attracted a 'variety of animals which make their abode in its ample winding chambers'.[5] The result was a lively, colourful scene, a moving work of art that never ceased to arrange itself into new formations and invited the onlooker's imagination to roam. Consequently, for the protagonists of *fin-de-siècle* novels and poems, such as Jean des Esseintes in Joris-Karl Huysmans' *Against Nature* (1884), the aquarium served as a springboard for an overflowing, decadent and narcissistic imagination.[6]

Whereas reef-building corals, known since Charles Darwin's theory of coral reef formation as virtuous architects tirelessly toiling for the common good, had been described as embodying industriousness and hardiness, sea

anemones and cold-water corals native to the seas around the British Isles struck the owners of and visitors to aquariums as rather odd. Even as George Henry Lewes assured the British public in 1856 that the sea anemone was a less expensive and troublesome pet to keep than a hippopotamus,[7] the creatures' voraciousness and reproductive habits were often perceived as repulsive and promiscuous; the grace and beauty of the 'animal-flowers' could not detract from their perceived monstrosity.

Occasionally, the 'sea monsters' managed to upset an entire household. Thus Gosse reports in his *History of the British Sea-Anemones and Corals* (1860) how the sight of a sea anemone devouring a young conger eel drove his little son to tears; the beast, which suddenly seemed to consist of nothing but a giant, cavernous mouth, becomes in Gosse's account the epitome of merciless gluttony.[8] Similarly, John Harvey, in his aquarium manual of 1858, describes an incident with a maid who screamed upon seeing the sea anemone tank: 'O pleassir, do come and look, the enemy ... is a turning hisself inside out!'[9] The marine zoologist Anna Thynne notes a similar episode in her research diary: returning to the house after a few days of absence, she found her madrepores surrounded by small piles of stones; her servants, flabbergasted by the creatures' asexual reproduction through splitting, had tried to stop them 'coming to pieces'.[10] The 'grotesque' natural characteristics of sea anemones and corals profoundly challenged the prevailing classifications of gender and species, playing into subliminal fears of a society whose belief in supposedly 'established truths' about origin, sex and religion had begun to falter in the light of modern developments. Like all fads, the aquarium wave ebbed away in the 1860s – but the desire to transport a slice of the ocean to the living room, or to experience a taste of wilderness in the safe surroundings of a 'shark tunnel', continues to the present day. [...]

1 [Footnote 5 in source] Jean-André Peyssonnel, 'Traité du corail, contenant les nouvelles découvertes...', *Philosophical Transactions of the Royal Society*, 47 (1751) 445–69.

2 [6] Ernst Haeckel, *Arabische Korallen: Ein Ausflug nach den Korallenbänken de Rothen Meeres und ein Blick in das Leben der Korallenthiere* (Berlin: Georg Reimer, 1876) 2.

3 [7] Ibid., 34.

4 [8] Philip Henry Gosse, *The Aquarium: An Unveiling of the Wonders of the Deep Sea* (London: Van Voorst, 1854) vii.

5 [9] Ibid., 121.

6 [10] Joris-Karl Huysmans, *Against Nature* (Oxford: Oxford University Press, 1998).

7 [11] George H. Lewes, *Sea-Side Studies at Ilfracombe, Tenby, The Scilly Isles and Jersey* (London: William Blackwood and Sons, 1858) 115.

8 [12] Philip Henry Gosse, *Actinozogia Britannica: A History of the British Sea-Anemones and Corals* (London: Van Voorst, 1860) 165–6.

9 [13] Quoted in Rebecca Stott, 'Through a Glass Darkly: Aquarium Colonies and Nineteenth-Century Narratives of Marine Monstrosity', *Gothic Studies*, 2.3 (2000) 307.

10 [14] Ibid., 307.

Marion Endt-Jones, extract from 'A Monstrous Transformation: Coral in Art and Culture', in *Coral: Something Rich and Strange*, ed. Marion-End Jones (Liverpool: Liverpool University Press, 2013) 15–17.

Pandora Syperek
The Blaschkas' Slippery Gender Models//2014

The *Physophora hydrostatica* (c.1876) that sits in a specially constructed foam storage vessel in the basement of the Natural History Museum in South Kensington is one of 182 glass models of marine invertebrates purchased by the museum from the father-son glassmakers Leopold and Rudolf Blaschka between the years 1866 and 1889.[1] Descending from its pinnacle, a series of transparent glass bells correspond to the ocean creature's gas-filled floating mechanisms. Outstretched finger-like protrusions of a soft apricot shade appear rubbery; in the animal these tentacles are capable of dangerous stings. Emerging from yet another layer of tentacles, tubular and whitish-hued, a cascading tangle of fine wire ending in delicate glass droplets is reminiscent of jewellery, although intended to emulate thousands of trailing polyps. The finely worked and naturalistic object – like the creature itself – appears fragile and otherworldly. However, the *Physophora hydrostatica* is not a singular animal, but a siphonophore colony: a superorganism comprising numerous, even thousands of tiny organisms living together in unity. Such astonishing deep-sea lifeforms captured the cultural imagination in the later decades of the nineteenth century, following the Challenger expedition of 1872–1876, which surfaced thousands of previously unknown species from hundreds of locations, and was momentous for natural history, and in particular evolutionary theory. Their centrality to material and scientific culture provided a context in which the Blaschkas implemented a business producing thousands of models of marine invertebrates to be purchased by museums and individuals.

A recent resurgence of interest in the models, evidenced in their re-display in both museums of natural history and exhibitions of contemporary art,[2] can be attributed to a sense of wonder and curiosity attached to their obsolescence in the face of modern technologies of visualisation. Like the animals to which they correspond, the Blaschka models are queer objects, difficult to grasp. They

skilfully and poetically freeze the life of the sea in glass, a process that for all its inherent material contradictions – between gelatinous, spineless aquatic creatures and brittle, static objects in the dry museum air – seems semi-intuitive. Lorraine Daston has referred to such objects that straddle art and science as 'chimeras', composites of different 'species'.[3] The hybridity of the marine models, however, extends beyond their objecthood – caught between ornament and biology, spectacle and pedagogy – to the anatomy of the creatures themselves. As well as appearing to transgress the established kingdoms of nature – siphonophores, jellyfish, sea anemones, sponges and coral were commonly called 'zoophytes', or 'animal-plants' – they also blurred boundaries of gender through hermaphroditism and asexual reproduction. Late-nineteenth-century evolutionary theory produced a hierarchy based on sexual division, with such hermaphroditic and asexual, 'simple' animals at the bottom and (white, European) man at the top. However, rather than mere representations of evolutionary relics, the genre- and gender-bending Blaschka models' 'anatomy' points towards radical implications.

The common explanation given for why the Blaschkas exclusively produced invertebrate models for so long was that, soft-bodied and aquatic, these animals were some of the most difficult to preserve.[4] Traditionally jarred in aseptic fluids, this method was not ideal for such ethereal bodies: the alcohol bleaches and distorts their tissues, resulting in opaque, rubbery specimens that literally bear a pale resemblance to the living creatures.[5] And yet, many scholars have taken this problem of representation at face value, labelling the models as 'specimens' or even 'reproductions'.[6] This elision of the model-making process is echoed in recent photography that fetishises the dazzling illusionism of the models, when 'in the flesh' they are extraordinarily fragile and surprisingly diminutive. In glass cases, on glass shelves, with no electric lighting, they would have been subtly uncanny, more treasures to be discovered than dramatic spectacles. This discrepancy mirrors what Stacy Alaimo has pinpointed as contemporary wildlife photography's tendency to portray jellyfish as glittering jewels, contrasting sharply against a background of black water, despite the translucent creatures' elusiveness in live encounter.[7] The Blaschka models exemplify the fluidity between artistic and scientific interests through their variety of sources and outputs. An early catalogue labelled the models 'ornaments for elegant living rooms', while the Blaschkas' consistent use of species' Latin names affirms their intent on scientific objectivity,[8] which as Lorraine Daston and Peter Galison note, was increasingly placed in direct opposition to the subjectivity that distinguished art.[9] The Blaschkas adapted their inherited jewellery-making techniques descended from fifteenth-century Bohemia to the unique problems of Victorian model-making.[10]

The transfer of interest from the ocean's flat littoral zone to its unfathomable depths in the late nineteenth century paralleled the paradigm shift from an emphasis on taxonomy in earlier natural history to new modes of looking and thinking through nature and biology within evolutionary models. Once Rudolf joined Leopold in the family business in 1876, the Blaschkas expanded their repertoire to include a variety of complex models of marine invertebrates, including siphonophores, jellyfish, squid, octopuses and sea slugs.[11] It was at this time that the glassmakers began to vary their sources. While Leopold's early sea anemones were based exclusively on drawings by Philip Henry Gosse, a natural theologist, he and Rudolf came to use the German zoologist and evolutionist Ernst Haeckel's illustrations for the Challenger reports, as well as the live and preserved animals themselves,[12] a move which indicates increasing concern for objectivity's ideal of 'purity of observation'.[13] Whereas Gosse's sea-life-filled scenes are a celebration of God's creation in all its ebullient glory, Haeckel's schematics feature a scopophilic penetration of notoriously enigmatic and alien forms with virtuosic execution. Here the organisms and their anatomy become diagrammatic principles stripped of their fleshly associations. Haeckel became famous equally for his lavishly intricate drawings of sea creatures, which heavily influenced art and design movements of the late nineteenth century,[14] as for popularising Darwin's theory of natural selection.

Invertebrates' bewildering anatomical processes and their potential connections to modern humans unsettled evolutionary theorists, who in turn denigrated them. In their 1889 tome *Evolution of Sex*, Patrick Geddes and J. Arthur Thomson called hermaphroditism a 'reversion' and asexual reproduction 'degenerate'.[15] Both forms signified biological obsolescence, as they elided the highly defined divisions of labour deemed essential to sexual division into male and female roles. These animals' lowly status was anthropomorphised according to Victorian ideology. The social Darwinist Herbert Spencer claimed that human societies mirrored the evolutionary 'advance from the simple to the complex': he directly compared Indigenous South Africans, as 'among the lowest races', to protozoa; 'savages not quite so low' to polyps; more 'lowly-organized tribes' to hydra and so forth.[16] This brand of social evolutionary theory placed white Western man at the apex of development, as illustrated in Haeckel's well-known evolutionary tree.

However, Darwin proposed that a 'coral of life' represented evolution more accurately than the popular tree model.[17] Like siphonophores, coral, with its branching colonies reproducing through both unisexual and hermaphroditic means, symbolises an alternative social model. Horst Bredekamp has argued that the anarchic nature of coral is fundamental to Darwin's processual and

changeable vision of natural selection, including fossilised/extinct branches and unanticipated regrowth.[18] Such a model not only overthrows natural theology's fixed taxonomical order, but also transcends the hierarchical narratives that derived from evolutionary theory. Elizabeth Grosz likewise suggests that out of a re-reading of Darwinian theory, one that rejects linear, teleological interpretations in favour of its central premises of unpredictability, randomness and dynamism, a new understanding of subjectivity and sexual relations can emerge. Far from a static, homogenising theory, Grosz sees Darwin's work as expounding the dynamic forces of difference which propagate life on earth, thereby decentring the human and destabilising the gender binary.[19]

Much like invertebrate anatomy's radical potential, the glass models embody an alternative mode of vision. The feature that most distinguishes the models from their referents – both animals and illustrations – is their medium. Isobel Armstrong argues that glass was a defining medium to nineteenth-century experience: a ubiquitous but invisible presence from the architecture and display cases of the Crystal Palace to the microscope lens.[20] Transparency marked the emergence of a new scientific and medical gaze, witnessed in modern imaging technologies such as x-rays,[21] as well as in popular spectacles such as the aquarium and the museum. Set within glass cabinets, the models acquired a triple glaze, from vitrine to glass model to microscopic marine invertebrate anatomy. They enacted a *mise en abyme* of seeing and seeing through in their dialectic of spectacle and transparency. However, in its combination of frozen liquid and 'petrified' breath blown glass is an 'ethereal substance',[22] a paradoxical, hybrid material. Like the model, as a third member to subject and object, glass negates dualism and impedes representation. While its visible transparency suggests water and its translucent inhabitants, this paradoxical nature also connects to the elusive, hermaphrodite organisms of the sea.

How we look at the Blaschka models can suggest an alternative mode of vision. In contrast to reflection's fixation on original and copy, Karen Barad posits the phenomenon of diffraction as embodying relational, entangled difference that makes it a useful tool for feminist analysis.[23] Rather than offering a mirror of or window onto the world, its objects and creatures taken as fixed and discrete, the Blaschka models with their complex ontological relationships to the animals, diffract and ensnare the gaze. Their insistent materiality disrupts what Mieke Bal calls the 'truthspeak' of natural history display and its goal of scientific veracity. The Blaschka models' repeated appearance in contemporary art exhibitions points to what Alaimo identifies as a renewed interest in the ecological aesthetics of animals she terms 'gelata'. She writes: 'Despite the

concurrent objectification and commodification of the gelata as artistic images for humans, these framings may nonetheless be a way to encircle them with care and concern.'[24] This sentiment potentially defies charges of fetishism in the Blaschka models. While the Blaschkas may appear to have crystallised siphonophores and their ilk in the sterile atmosphere of Victorian museum display, their material simulations present a generative counterpoint to reactionary views of degeneracy and evolutionary drag. [...]

1 As an expert on the Blaschka models, principal curator Miranda Lowe is responsible for their conservation and recent display in the museum. I thank Miranda for her generosity in showing me the stored models and sharing her extensive knowledge. This text draws on research supported by the Social Sciences and Humanities Research Council, Canada.

2 For example, *Rosemarie Trockel: A Cosmos* at the New Museum, New York, and Serpentine Gallery, London (2012–13), *Aquatopia* at Nottingham Contemporary and Tate St. Ives (2013-14) and *Curiosity: Art and the Pleasures of Knowing* at Turner Contemporary, Margate, and other venues (2013–14).

3 Lorraine Daston (ed.), *Things That Talk: Object Lessons from Art and Science* (New York: Princeton University Press, 2004) 21.

4 Ruthanna Dyer, 'Learning Through Glass: The Blaschka Marine Models in North American Post Secondary Education', *Historical Biology*, vol. 20, no. 1 (2008) 31.

5 Nigel Monahan, Julia Sigwart and Catherine McGuinnesss, *Blaschka Glass Models* (Dublin: National Museum of Ireland, 2006) 4.

6 C. Giles Miller and Miranda Lowe, 'The Natural History Museum Blaschka Collections', *Historical Biology*, vol. 20, no. 1 (2008) 51–62.

7 Stacy Alaimo, 'Jellyfish Science, Jellyfish Aesthetics: Posthuman Reconfigurations of the Sensible', in *Thinking with Water*, ed. Janine MacLeod, Cecilia Chen and Astrida Neimanis (Montreal: McGill-Queens University Press, 2013) 141.

8 Julia Sigwart, 'Crystal Creatures: Context for the Dublin Blaschka Congress', *Historical Biology*, vol. 20, no. 1 (2008) 7.

9 Lorraine Daston and Peter Galison, *Objectivity* (Cambridge, MA: Princeton University Press, 2007) 75.

10 Susan M. Rossi-Wilcox, 'Notes: The Discovery of Leopold Blaschka's First Glass Models of Plants, 1860–1862', *Journal of Glass Studies*. vol. 37 (1995) 146.

11 In the 1880s–90s, the Blaschkas added a variety of microscopic organisms such as radiolaria, and enlarged anatomical dissections to their catalogue, before they signed an exclusive contract to produce Harvard University's collection of glass flowers.

12 Meechan and Reiling, op. cit., 19.

13 Daston and Galison, op. cit., 161.

14 See Marsha Morton, 'From Monera to Man: Ernst Haeckel, *Darwinismus*, and Nineteenth-Century German Art', in *The Art of Evolution: Darwin, Darwinisms, and Visual Culture*, ed. Barbara Larson and Fae Brauer (Hanover, New Hampshire: Dartmouth College Press, 2009) 59–91.

15 Patrick Geddes and J. Arthur Thomson, *The Evolution of Sex* (London: Walter Scott, 1889) 71, 169.

16 Herbert Spencer, 'Progress: Its Law and Cause' (1857), in *Essays: Scientific, Political, and Speculative* (London: Williams and Norgate, 1868) 16–20.

17 Darwin, notebook B, 20 and 26, quoted in Julia Voss, *Darwin's Pictures: Views of Evolutionary Theory, 1837–1874*, trans. Lori Lantz (London: Yale University Press, 2010) 90.

18 Horst Bredekamp, *Darwins Korallen. Frühe Evolutionsmodelle und die Tradition der Naturgeschichte* (Berlin: Wagenbach Verlag, 2005) 17–20. My thanks to Sandra Rehme for her translation from the German.

19 Elizabeth Grosz, *Becoming Undone: Darwinian Reflections on Life, Politics, and Art* (Durham, NC: Duke University Press, 2011) 3–4.

20 Isobel Armstrong, *Victorian Glassworlds: Glass Culture and the Imagination, 1830–1880* (Oxford: Oxford University Press, 2008) 11.

21 José Van Dijck, *The Transparent Body: A Cultural Analysis of Medical Imaging* (Seattle: University of Washington Press, 2005) 5.

22 Armstrong, op. cit., 5.

23 Karen Barad, *Meeting the Universe Halfway: Quantum Physics and the Entanglement of Matter and Meaning* (Durham, NC: Duke University Press, 2007) 72.

24 Alaimo, op. cit., 155.

Pandora Syperek, adapted from '"No Fancy So Wild": Slippery Gender Models in the Coral Gallery', in *Framing the Ocean, 1700 to the Present: Envisaging the Sea as Social Space*, ed. Tricia Cusack (Aldershot: Ashgate, 2014) 239–51.

Zakiyyah Iman Jackson
Genealogical Mutations in the Works of Wangechi Mutu//2020

[...] Kenyan-born, Brooklyn-based Wangechi Mutu is known for her mixed-media collages featuring ink and paper drawings or watercolour paintings of gelatinous black female figures. Mutu's works are set in fecund, imagined landscapes, exploring postcolonial paradoxes and technological possibilities. [...] Mutu's technique of collage – the alternation of discordant juxtapositions with seamless transitory states – catalyses the irresolute becoming of what [Gilles] Deleuze calls assemblage.[1] Mutu's collages invite viewers to reflect on their aesthetic judgments as the perceived harmony or discordance of elements is undergirded by historically situated taxonomies and typologies (often scientific). More to the point, Mutu's collages reveal the extent to which Western

science and visual art share and mutually constitute what is a racialised, gendered and sexualised imperial economy of aesthetics, desire and affect. [...]

What we find in Mutu's visions of zoology and botany is a return, not so much a recapitulation but rather a mutation of German biologist Ernst Haeckel's foundational aestheticised evolutionary theory. In the history of Western imperialism, geologists, archeologists, surveyors and mapmakers (among others) employed ink and watercolour media for taxonomising 'foreign' people and environments as well as to generate an artistic industry that documented European 'discoveries' for scientific and popular consumption – these two domains, the popular and the scientific, never quite being separate. In privileging watercolour and ink drawing as media of critique, I will demonstrate that Mutu turns the medium against the very taxonomical imagination that gave rise to its prominence as a technology of representation. Mutating the aesthetic philosophy and artistic practice subtending Haeckel's evolutionary thought, Mutu's art highlights the efficacy of randomness, offering something other than the foundational and prevailing antiblack depictions, created by Haeckel and his contemporaries.

Haeckel was a preeminent architect of scientific taxonomical thinking. He described, named and illustrated thousands of species before placing them in a genealogical tree, guided by the aim of relating all life forms. Additionally, Haeckel identified the cell nucleus as the carrier of hereditary material; described the process of gastrulation; and was an important, if controversial, contributor to embryology.[2] He provided initial formulations of concepts such as anthropogeny, phylum, phylogeny and stem cells. Haeckel even established an entire kingdom of creatures, the Protista – representing them visually in stunning detail, in what are now canonical images in the history of Western visual culture. Haeckel was a scientist of well-known theoretic and artistic acumen. In 1866, he coined the term 'ecology', the study of relations among organisms and their environment.

By the end of the nineteenth century, Haeckel was possibly the world's most famous evolutionary theorist. According to Haeckel's biographer, philosopher and historian of science Robert J. Richards, more people at the turn of the century were carried to evolutionary theory on the torrent of Haeckel's visually arresting and theoretically rich publications than through any other source, including those authored by Darwin himself.[3] Known internationally as a promoter and populariser of Darwinian theory, Haeckel's own expertise lay in marine invertebrate biology. To this day, no other investigator has named as many creatures – radiolaria, medusa, siphonophores, sponges – as Haeckel.[4] Drawing inspiration from the Romantic Naturphilosophie of Goethe, Humboldt and Schleiden – thinkers who insisted that the understanding of organic forms

required not only theoretic consideration but aesthetic evaluation as well – Haeckel honed his considerable artistic talent in keeping with these principles, illustrating all of his books by brush or ink, believing that a proper assessment of the development and function of organic forms necessitated a studied attentiveness to their artistic qualities.[5] [...]

Haeckel believed that his theory of recapitulation, which he termed the 'biogenetic law', was evidenced in an inherent and apparently transparent progressivist taxonomic order, captured in his succinct axiom, 'ontogeny recapitulates phylogeny'. Haeckel's cardinal principle held that the embryo of a species goes through the same morphological stages as the phylum went through in its evolutionary history; thus, the embryo in its development chronologically passes through the successive morphologies of its nearest and most distant ancestors. In the case of the human embryo, one begins as a single-celled organism, just as biologists presume life on earth began in a unicellular mode; upon passing through a stage of gastrulation, a cuplike form is produced, similar (Haeckel believed) to a primitive ancestor that plied the ancient seas; then, the embryo takes on the structure of an archaic fish with gill arches and then that of a primate, before acquiring the form of a specific human being.[6]

[...] Haeckel's signature articulation of progress in evolution asserted directly that the telos of evolution was evidenced in an observable and, Haeckel maintained, progressivist hierarchy of the races. Haeckel maintained that the laws of nature revealed their evolutionary aims and organisational structures in a graduated achievement of civilisation. Haeckel surmised that the role of the scientist was to hone skills of discernment necessary for delineating the metrics and scales given by nature. Believing it possible to relate all of humanity according to relative degree of intellectual and cultural advancement, Haeckel's metrics placed human 'races and species' in a stem-tree that ranged from 'simple' to 'complex' forms and societies. [...]

What I claim is that imperialist racist rationale drove a demand for a material basis of scientific evidence *in general* and was the engine of species designations in both humans and nonhumans. The pursuit of an observable and comparative basis of racial taxonomy and typology is central to the rise of empirical science, an organising principle, not a matter merely incidental to it. In light of a dauntingly elusive material basis for their imperial rationale, speculative theories concerning mental traits would allow recapitulationists to rely more on products of the mind than on physical criteria for ranking in a matter now relieved from the constraints of data: paleontologist and zoologist E.D. Cope argued, 'Some of these features have a purely physical significance, but the majority of them are . . . intimately connected with the development of the mind.'[7] Founder of Social Darwinism Herbert Spencer claimed that 'the

intellectual traits of the uncivilized' recur in 'the children of the civilized'.[8] Lord Avebury (John Lubbock), the English leader of child study, compared '[m]odern savage mentality to that of a child', stating, 'As we all know, the lowest races of mankind stand in close proximity to the animal world. The same is true for infants of civilized races.'[9] Of course, that the purportedly immaterial – mind, mentality, morality, intelligence, character, personality traits, moral faculties – as embodied practices have a quotient of materiality is actually an inconvenience to measurement's rationale because matter does not conform to the dictates of racial logic.

Claims of knowledge of the so-called *immaterial* properties of the 'savage', 'the uncivilized' and 'the lowest races of mankind' relied upon the imperial expedition and its – literary and visual – representational maps for navigation, which commonly maintained a coextensive relation among African humans, animals and territories. [...]

In the early 1870s, Charles Wyville Thomson, a naturalist at the University of Edinburgh, proposed an expedition to sound the oceans of the world in order to discover the chemical composition, temperatures and depths of their various waters as well as survey their marine life. A fighting ship was dispatched by the Royal Navy, HMS *Challenger*, as the research trip was fully within the purview of the military. The ship was graphically depicted in paint and ink. Upon removal of most but not all of its guns, the ship was fitted with dredging and other equipment needed for the accomplishments of the expedition's goals. In December 1872, the three-mast ship with Captain George Nares and his crew of two hundred men aboard, along with six scientists headed by Thomson, embarked on a three-and-a-half-year voyage. In all, the ship travelled to the Canary Islands, Brazil, the Cape of Good Hope, Australia, New Zealand, Fiji, the East Indies, Japan, the Sandwich and Society Islands, Chile and Argentina before returning to England in May 1876. An international team of chemists, physicists and marine biologists were commissioned and charged with the task of describing the composition of seas, the seabeds and the animals procured. Haeckel, by then already an established systematist, was asked to work on cataloguing the radiolarian[s], medusae, siphonophores, and sponges. Ten years, 1,803 pages, and 140 plates later, Haeckel completed his *Report of the Radiolaria*, which detailed systematic relations, morphology, the locality where taken (latitude, longitude and the nearest land), the abundance of creatures, the depth and temperature of the waters, and the nature of the sea bottom. Haeckel's *Challenger* research formed the basis of his taxonomical system of radiolarian[s]–in large measure still in use today.[10]

Haeckel also initiated approximately twenty solo expeditions, a number that Richards notes seems 'almost superfluous for the sheer purpose of acquiring

new materials and for advancing a career', as after 1870 Haeckel had solidified a reputation as a premier researcher and could have obtained organisms through the work of other naturalists or assistants. The acquisition of new materials would always be a justification, but with Haeckel there was usually more at stake.[11] For scientists like Haeckel, the 'danger' and 'hardship' of 'exotic travel' potentially served as a means of sealing the importance of any discoveries made:

> The model of great voyages of the past suggests that any findings or new ideas derived from a journey would have their significance elevated by the degree of difficulties suffered during the excursion. The assumption is easy: that the importance of results achieved would be commensurate with dangers chanced.[12]

And, in fact, as Richards notes, Humboldt and Darwin had made their intellectual fortunes by 'exotic' travel, a context Haeckel was well aware of; the hazard of great danger and hardship in 'alien travel', or at least the appearance of it, set the standard for scientific greatness and paved the path to immortal fame.[13] Haeckel's ambition and appetite for adventure impelled him to the western coast of Africa and the Canary Islands in search of 'biological riches' and the land of supreme beauty he had read about as a youth in the evocative travel writings of his hero Alexander von Humboldt.[14] Moreover, Richards has noted that Karl Haeckel, Ernst's father, had a keen interest in 'geology and foreign vistas'; similarly, his son devoted himself to the travel literature of Humboldt, Goethe and Charles Darwin, 'which set the deep root of a lasting desire for adventure in exotic lands'.[15] Richards' observation that young Haeckel's dreams arose out of reading works like Daniel Defoe's *Robinson Crusoe* invites not only a recollection of the historical intermingling of science and travel literature – in other words, the uneven imperial representational politics authorising claims to scientific 'discovery' – but also prompts a reopening of the question of the roles of aesthetics, literature and visual art in empirical racial science in particular. Haeckel never set sail toward any new research horizon without his sketchbooks and canvasses, and 'during his last travels, the implements of the aesthetic life became even more important than his microscopes, dissecting blades, and spirits of wine'.[16] [...]

Haeckel's commitment to 'exotic' and idealised depictions of forms would play a decisive role in persuading readers of the evolutionary theory behind Haeckel's art. Haeckel is canonised as an artist largely due to his lush drawing of Cnidaria in his *Art Forms in Nature*. The seductive appeal of Haeckel's theory lay mainly in the splaying of 'untamed nature'.[17] Haeckel's exploitation of Kantian metaphors linking femininity and sublimity can be gleaned in his choice to

name the 'Discomedusae' after the black(ened) sexed myth of the Medusa, also known for her venomous lethal sting and looks that could turn a man to stone.[18]

Mutu is known to borrow freely from marine biology, zoology and botany but in a manner that gathers critical attention and directs it toward gendered aesthetics that imply facile connections between female bodies, femininity and nature. Her collaged figures' conspicuous made-ness, their artificiality, is embraced and integral to their beauty. As Malik Gaines and Alexandro Segade put it, her figures 'do not fear technology, because they are made of it'.[19] *One Hundred Lavish Months of Bushwhack* alludes to Haeckel's canonical gelatinous figures in a manner that problematises colonial hierarchies of sex/gender, and in so doing, reveals that the iterative aspects of culture are 'mutational, autopoetic, performative'.[20] *One Hundred* figures both the enormously weighty aspects of hierarchies of sex/gender as well as their precarity, as a much larger figure rests upon the genuflection and exploitation as well as caprice of one much smaller. The two chimerical figures are sheathed in mottled skin, one light and one dark, and framed by a sparse grassland and ominous cloud that is either lifting or moving closer. The central and much larger golden figure has spiralling leopard-printed horns, hippopotamus heads for hands, and an exploding foot releasing motorcycle fragments – or perhaps flying motorcycle shrapnel is what initially caused the rupture. The larger golden figure's blasted head, seemingly burst open by a hurled motorcycle, and the accompanying bleeding stump are suggestive of an ongoing conflict. From her perched vantage point, the golden woman's oversize *discomedusae*, or sea anemone-reminiscent skirt, obscures the darker feminine figure that sustains her – the shadowy figure adorned with a flower behind her ear, narrowly holding off her plunging stiletto or perhaps lifting her, exposing the golden figure to harm's way.[21] In *One Hundred*, the black(ened) myth of Medusa is inherited mutationally; her petrifying gaze takes on new gendered meanings, even suggesting alterations to meaning itself. In other words, in the process of reinscription – the replication of historical metaphors – the structures of meaning that license Medusa's racialised sexed metaphoricity, informing Haeckel's 'Discomedusae', become mutational. However, this mutation is not attributable solely to 'artistic genius' but exceeds subjectivist claims – mutation relying as it does on the meeting of fortuity and the autopoesis of a system. Mutation is that radical alteration in the interstice of chance and design, 'a process that is not "ours" because it necessarily involves a degree of randomness'; in other words, mutation exploits the unpredictable and the limits of human control.[22] Thus, mutation, given its implied randomness, cannot be narrativised or, more precisely, can be narrativised only by subordinating its 'unpredictability' to the bias and parallax inherent in human perspective.[23] In the words of R.L. Rutsky, 'Mutation, one might say, serves

to figure a notion of change that seems to have taken on an uncanny life of its own.'[24] [...]

1 [Footnote 7 in source] Art historians and art journalists have typically approached this work via the disciplinary protocols of art history and framed Mutu's work as principally indebted to European artists such as Dadaist Hannah Höch. For instance, A *New Yorker* article on Mutu opens with 'The Nairobi-born, Brooklyn-based artist, forty-one, is a modern-day Hannah Höch, deftly braiding the satirical, the political, and the decorative in her collages' (*New Yorker*, 'Wangechi Mutu'). On occasion her work has been put in conversation with African diasporic artists like Romare Bearden but almost never with nonblack women [...] artists of colour like Frida Kahlo and Ana Mendieta, despite Mutu repeatedly citing their influence. See Deborah Willis, 'Wangechi Mutu', *Bomb* (28 February 2014).

2 [9] Robert J. Richards, *The Tragic Sense of Life: Ernst Haeckel and the Struggle over Evolutionary Thought* (Chicago: University of Chicago Press, 2008). Rather than call Haeckel's falsification of evidence into question, Haeckel biographer Robert J. Richards invites and performs a re-evaluation of the nature of Haeckel's transgressive act – arguing that the Romantic *Naturphilosophie* of Goethe, which valued the elevation of archetypal forms over realist representation, was the source of Haeckel's inspiration, and thus he did not strive to deceive readers. Richards contends that others have evaluated Haeckel based on present standards of academic honesty and empiricist methodology – standards not embraced by, or unavailable to, Haeckel. As a result of ahistoricist critiques and misrecognitions, Richards argues, a fuller acknowledgement of Haeckel's importance for the history of evolutionary theory has been obscured, making way for a far too easy dismissal of Haeckel as anti-Jewish, and even proto-Nazi, in the work of some historians, biologists and religious critics of evolutionary theory. [...] That said, while I am persuaded by Richards' reassessment of Haeckel's politics concerning Jewishness, there remains a profound racist legacy imbuing Haeckel's evolutionary theory in general and his recapitulation theory in particular. Assessing the implications of his indisputable antiblack racism, as his artistic legacy surfaces in the work of Mutu, is the central animating question informing my engagement with Haeckel in this chapter.

3 Ibid., xviii.

4 Ibid., xviii.

5 Ibid., 8–9.

6 Ibid., 502.

7 Edward Drinker Cope, *The Origin of the Fittest: Essays on Evolution* (New York: D. Appleton, 1887) 293.

8 Herbert Spencer, *The Principles of Sociology*, vol. 6 (New York: D. Appleton, 1895) 89.

9 John Lubbock (Lord Avebury), *Origin of Civilisation and the Primitive Condition of Man* (London: Longmans, Green and Company, 1870) 4.

10 Richards, op. cit., 75–7.

11 Ibid., 213.

12 Ibid., 214.

13 Ibid., 215.

14 Ibid.,173.

15 Ibid., 20.

16 Ibid., 60, 215.

17 Ibid., 214.

18 [12] For a reading of how Medusa was racially marked in nineteenth century archaeology and in psychoanalysis see: Ranjana Khanna, *Dark Continents: Psychoanalysis and Colonialism* (Durham, NC: Duke University Press, 2004). My thanks to Eva Hayward for bringing this text to my attention.

19 Malik Gaines and Alexandro Segade, 'Tactical Collage', in *Wangechi Mutu: A Shady Promise*, ed. Douglas Singleton (Bologna: Damiani, 2008) 146.

20 [13] R.L. Rutsky, 'Mutation, History, and Fantasy in the Posthuman', *Subject Matters*, vol. 3 no. 2 (2007) 108.

21 [14] See Chelsea Mikael Frazier's 'Thinking Red, Wounds, and Fungi in Wangechi Mutu's Eco-Art', in *Ecologies, Agents, Terrains*, eds. Christopher P. Heuer and Rebecca Zorach (New Haven: Yale University Press, 2018) 167–94, for a more sustained reading of this work, particularly as it relates to fungi and the ecological.

22 Rutsky, op. cit., 103.

23 [15] Ibid., 107.

24 Ibid., 103.

Zakiyyah Iman Jackson, extracts from *Becoming Human: Matter and Meaning in an Antiblack World* (New York: New York University Press, 2020) 167, 169–171, 172, 173–74, 175–180 [footnotes edited].

Jules Michelet
The Milky Sea//1861

The water of the Sea, even the purest, examined when you are far away from land, and from all possible ad-mixture, is somewhat viscous; take some between your fingers, and you find it somewhat ropy and tenacious. [...]

The marine plants and animals are covered with this substance, whose mucousness gives them the appearance of a coating of jelly, now fixed, anon trembling, and always semi-transparent. And nothing more than this contributes to the fanciful illusions presented to us by the world of waters. Its reflections are irregular, often strangely variegated, as, for instance, on the scales of fish and on the molluscæ, which seem to owe to it the exquisite beauty of their pearly shells.

It is that which most attracts and enchains the interest of the child when he first sees a fish. I was very young when I first saw one, but I still remember how vividly I felt the impression. That creature with variously coloured lights

flashing from its silvery scales, threw me into an astonishment, a fascination, a rapture, which no words can describe. I endeavoured to catch it, but found that it could no more be held than the water which glided through my small weak hand. That fish seemed to me to be identical with the element in which it swam, and gave me a confused idea of animated, organised and surpassingly beautiful water.

A long time after, in my maturity, I was scarcely less impressed when on a sea beach I saw, I know not what of shining and transparent substance, through which I could clearly see the sand and pebbles. Colourless as crystal, slightly, very slightly solid, tremulous when ever so slightly touched, it seemed to me as to the ancients and to [René Antoine Ferchault de] Réaumur, that which Réaumur so graphically named it – *gelatinised water.*

Still more forcibly do we feel this impression when we discover in the early stage of their formation the yellowish white threads in which the sea makes her first outlines of the fuci and algæ which are to harden and darken to the strength and colour of hides and leather. But when quite young, in their viscous state, and in their elasticity, they have the consistence of a solidified wave, all the stronger because it is soft. What we now know of the generation and the complex organisation of the inferior creatures, animal or vegetable, contradicts the explanation of Réaumur and the ancients. But all this does not forbid us to return to the question which was first put by Jean Baptiste Bory de Saint-Vincent; viz: What is the mucus of the Sea? That viscousness which water in general presents? Is it not the universal element of life? [...]

In the early ages of our world, innumerable volcanoes exerted a submarine action far more powerful than they exhibit now. Their clefts and their intermediate valleys allowed the marine mucus to accumulate in places, and to be electrified into life by the warm currents. No doubt the *mucus* affected those parts, fixed itself there and worked and fermented to the utmost of its young power. Its leaven was the attraction of the substance for itself. The creative elements, originally dissolved in the sea formed combinations, leagues, I had well nigh written marriages. First appeared, merely elementary lives – death following almost inseparably, indistinguishably, upon young life; and other lives following close upon, and nourished by, those wrecks and spoils, had firmer hold on life, became preparatory beings, slow but sure creators, which, thenceforth, began beneath the waters that eternal labour which, even in our own day and beneath our own scrutiny, they still continue.

The sea nourishing them all, gives to each that which best suits it. Each draws from that great nursing-mother, in its own fashion, and for its own especial behoof, that which it most needs, must have, to make it what we see of naked, or of shelled, of seeming vegetable, or of fierce, vigorous, and pugnacious life. And

whether in life or in death, whether building actively or passively decomposing, they clothe the sad nudity of the virgin rocks, those daughters of the volcanic fires from which flaming and sterile, they were hurled from the planetary nucleus.

Quartz, basalt, porphyry and semi-vitrified flints, each and all receive from these minute labourers a new, a more graceful, and a more fecund garb; from the fecund maternal milk (for such we must call the mucus of the Sea) they absorb and restore, and thus build up, and secure, and fructify, and beautify, this, our habitable earth. It is from these more favouring localities that have arisen our primal species.

These works must have been commenced among the volcanic isles and islets, in the depths of their Archipelagoes, in those sinuous windings, those peaceful labyrinths where the tides enter timidly and gently, warm and sheltered cradles for the newly-born.

But the bolder strength of the fully-expanded flower, is to be sought for in, for instance, the vast depths of the Indian Gulfs. There, the Sea is veritably a great artist. There she gives to the earth its most adorable forms, lively, loving and lovable. With her assiduous caresses she rounds or slopes the shore, and gives it those maternal outlines, and I had almost said the visible tenderness of that feminine bosom on which the pleased child finds so softly safe a shelter, such warmth, such saving warmth, and rest.

Jules Michelet, extracts from *La Mer* (New York: Rudd and Carleton, 1861) 114–6, 125–7.

Ralph Rugoff
Fluid Mechanics//2000

[...] Through his imagery, narration, and use of music, [Jean] Painlevé delights in presenting his subjects as uncanny hybrids that, for all their foreignness, call to mind things close to home. Sometimes this tendency is evident in the creatures he chooses to film, the seahorse, with its vertical posture (unique among aquatic vertebrates), is bound to conjure bipeds, and in *The Seahorse*, Painlevé's narration playfully pushes the point by describing its 'slightly affected air of dignity', or the way its pouting lower lip 'gives it a slightly embarrassed air, transformed into anxiety by the highly mobile eyes'. In another filmic portrait, the vampire bat is introduced after an extended commentary on its myriad human and mythological attributes. Even the octopus, 'creature of horror', is pointedly rendered with a recognisable detail, the narrator of *The Love Life of*

the Octopus informs us that 'this simple mollusk's eye, like those of the higher animals, boasts folds serving in the guise of eyelids'. No wonder that sleepy expression looks so uncannily familiar!

Painlevé's playful use of hybrid images extends beyond this kind of ironic anthropomorphism. His film on Pantopoda prompts viewers to wonder whether these eight-legged creatures are crustaceans or spiders, and in his stylish meditation *Hyas and Stenorhynchus*, he shows us clumps of walking underwater vegetables, which turn out to be crabs enjoying a fashionable promenade in seaweed camouflage. That ultimate hybrid, the hermaphrodite, is celebrated in *Acera or The Witches' Dance*, with its scenes of mollusc sex chains in which the middle creatures in a given row of fornicators function as both male and female.

Ultimately, however, the anthropomorphic proves to be Painlevé's most fertile playing ground. Yet his anthropomorphism is hardly in the vein developed much later by Walt Disney's 'live action' nature films, which continued a long literary and mythological tradition of projecting human values and emotions onto cuddly critters. To the contrary, in Painlevé's hands anthropomorphism is a tool that subverts the narcissistic self-portrait we so readily impose on our animal friends. Often as not, like a mirror, his films hold up to us seemingly familiar grotesqueries such as the vampire bat's peaked snout, ceaselessly quivering in the throes of a lascivious frenzy, as if to say, 'Identify with that!'

Though Painlevé mischievously calls our attention to minor similarities of appearance between certain creatures and humans, his films are much more deeply engaged with studying what the narrator of one film calls the 'grace and terror of gestures'. Among these are 'gestures' that we can hardly resist reading in human terms: seahorses for instance, linking their tails as if holding hands, or the vampire bat bestowing its deadly kiss on a hapless guinea pig, which it slyly approaches like a coquettish Quasimoto. On one level, moments such as these seem to function in the films mainly as amusing interludes breaking up the dry scientific accounts of an animal's biology, but they also serve to create an uncanny effect as they prompt us to try to reconcile the irreconcilable: the utterly strange appearance of such creatures with our own familiar mannerisms. Consequently, Painlevé's films often proceed according to an alternating rhythm of seduction and repulsion as we are invited to identify with a particular aspect of a given creature, only to have it revealed a moment later just how monstrously different this other life form actually is.

Far more commonly, though, we are asked to focus on movements that seem less familiar. From the convulsive throes of a male seahorse in labour to the sixteen tentacles of mating octopi whooshing within gravity-free grace or

the gently unfolding fanlike 'caress' of the spirograph, Painlevé's films feature a fabulous litany of jerking, thrusting, jittering, twittering, flopping, flapping, floating, swishing, limping, wiggling, jiggling, pulsing, and convulsing organisms and organs. The flowing ease made possible underwater gives many of these movements a ballet-like grace, and the appeal to the delight we take in watching movement of all kinds – a facility evident in infants as well as in those elderly people one sees in older urban neighbourhoods leaning out of tenement windows to watch the hustle and bustle below.

Painlevé's films often accentuate the dancelike spectacle of underwater motion through the use of orchestral soundtracks, which are often loosely synced-up with the subjects' rhythmic actions. A scene in *Acera or The Witches' Dance* rivals anything in *Fantasia*: accompanied by a Pierre Jansen score, molluscs rise and fall in the water in a choreography of weightlessness, resembling flying mushrooms as their cloaks flap up and down their pear-shaped bodies. *Freshwater Assassins* features a more frenetic style of dance, as tiny transparent carnivores (dragonflies, planorbids and hydrophilic beetles) engage in ferocious orgies of violence, pulsating to a hot jazz soundtrack featuring tunes by Louis Armstrong and Duke Ellington, among others. Inevitably their rhythmic thrashing conjures a mad nightclub scene, and we are prompted to wonder whether our urbane pastimes are as exclusively human as we tend to assume (indeed, when the narrator of *Acera or The Witches' Dance* remarks of his subjects that 'as with other animals, dance is a way to find a partner', the entire Western nightclub scene starts to seem like a mollusc throwback). [...]

Painlevé's films, then, do not simply substitute human characteristics for animal ones in portraying his subjects so much as they mix up our categories of human and animal. [...] [I]ndeed, the dreamlike quality of his underwater circus derives in part from the giddiness we experience before the mind-boggling otherness of the creatures he documents, the phantasmagoria of their endless forms and transformations. This aspect of his films occasionally serves as a corrective to our anthropomorphic impulses: confronted with intimate closeups of the vibratory cilia of a sea urchin's triple-jawed *pedicellariae,* we tend to marvel at their utter bizarreness. Simple identification is out of the question, however; more likely, our own prized uniqueness may suddenly seem a little less secure, given its context in this dizzying theatre of metamorphosis. [...]

Ralph Rugoff, extracts from 'Fluid Mechanics', in *Science is Fiction: The Films of Jean Painlevé,* eds. Andy Masaki Bellows and Marina McDougall, with Brigitte Berg (Cambridge, MA and London: The MIT Press and San Francisco: Brico Press, 2000) 50–52, 54, 55.

Eva Hayward
Sensational Jellyfish//2012

Ctenophora, Greek *kteis*, 'comb', and *pherō*, 'carry'. Commonly known as 'comb jellies', their ciliated bodies scatter light into rainbow effects. A provocation from the deep? Moving through movements of seawater, ctenophores are all motion, all flux. Sparkling, glittering, twinkling, these hermaphroditic jellies are voracious predators that prowl the wet darkness of oceanic space. Some have 'teeth', fused bunches of cilia that allow them to 'bite' their food, while others resemble swimming sacs with a cavernous mouth to engulf prey whole. We terrestrial, vertebrate, upright *Homo sapiens* do not easily identify with flexible and fungible ctenophores. Even our infantile drive to return and regress – the compulsion to invaginate space and time – does not prepare us for their differences. And yet, these ctenophores do compel us, attracting our ocularcentric selves as if our eyes were their intended audience and our gaze invented for their fluid light, their fluiluminality.

Captured ctenophores feed and swim in the artificial movements of the Monterey Bay Aquarium in California: large circular aquariums (kriesel tanks) produce continuous currents that follow the circumference of the tank. Freed from moon-driven surges and raging storms, these captivating captives travel along new currents that are partly mechanical, partly economic and partly affective. Our grouping eyes are touched by the ctenophore's teasing dazzle. Prismatically, their kinesthetic bling is registered visually and haptically, which draws our attention to the construction of their enclosure. Refracting light through seawater and acrylic, the aquarium seduces spectatorial senses, immersing us among these invertebrates. Expressively dense: spaces, beings, forces and lights conjugate each other into ever-ramifying patterns of resonance. Light, here, is rendered literal and material, not transcendental, through refractions and diffractions; light is of the world, not extraterrestrial, a going-on-together rather than a solitary force. [...]

I enter a large, circular space with azure walls and marine blue floors. The ceiling is remarkable. My gaze shifts from the horizontal to the vertical; here, what is above me matters as much as, if not more than, what is in front of me. The space aims to make every organ function as an eye. Swimming around the perimeter of the overhead space, thousands of anchovies flash their scales in the light, making me aware of effulgence and iridescence, and also placing me under water, literally and visually.

Another sign: 'The sea is as near as we come to another world.' I move to my left, into a darker space where a sign tells me: 'Sixty miles out – you make your first

encounter with the "Drifters".' All are alien allusions; all propose that I am entering a different place, a place of difference, and a place of first contacts.[1] [...]

I have been drawn to the Monterey Bay Aquarium, trying to sort out the poetics of the 'Drifters' display, a display of jellyfish, in the Outer Bay exhibit. It is markedly different from the common habitat exhibits at the aquarium, which attempt to provide visitors with an authentic marine experience. [...] [T]ypically, they give us what Ralph Acampora calls a 'zoöscopic' experience, a totalising view that conceals meaningful human-animal encounters at the price of reinvigorating anthropocentrism.[2] Acampora writes, 'The very structure of the human-animal encounter is disrupted, and the interaction that is sought – encountering the animals – becomes impossibility [sic] as the "real" animals disappear and the conditions for seeing are undermined.'[3] The effect of presentation is elided by the metaphysics of representation such that '[n]ot only can we as spectators not truly see the animals; but we cannot be seen by them. We are just as invisible – at least in terms of being encountered and approached as the animals we are – as the animals we expect to see (but cannot find) in the zoo'.[4] Captivity produces animals against themselves. As a qualified noun, as adjectival, the captive animal only hints at its noncaptive self, and therefore, according to Acampora, the zone of species contact is mediated by an interruption that voids actual encounter.

Although Acampora is attending to the function of the gaze as opposed to a particular look, I wonder: how does captivity function for eyeless, pelagic, fleeting lives? Does face-to-face 'seeing' matter for organisms of a radically different scale and for whom 'eyes' are light receptors rather than picture makers? Non-captive jellyfish already resist identification, already populate our surreal, which disrupts the familiar relays of representation that cause Acampora's captives to be lost to the real. Moreover, and of central concern in this essay, if captivity is always mediated, always eliding the face-to-face encounter that Acampora describes, then how can we see mediation as a dynamic of encounter, even an ethical one? We may not encounter 'real animals', but I want to suggest that we do encounter the conditions of encountering 'real animals'. And by 'encounter', I mean not necessarily contact or direct meeting but rather a sensuous rapport or energetic cadence.

Yet and still, Acampora is right to worry, since aquariums engage a story of looking, as Jane Desmond describes it, with deep roots in 'imperialism and the process of nation building' that constitutes 'a contemporaneous sense of what their observers are by showing them what they are (supposedly) not'.[5] The aquarium has been presented as a stage, an unspoiled garden in nature, a hearth for learning human self from animal other, and a clarification of the ontological and epistemological disorders of nature and culture. At their worst, aquariums use captive animals to evoke an anthropocentric sanitary zone, a generative and informative force in the purification of Western civilisation. [...]

I am not suggesting that the Monterey Bay Aquarium, and more specifically the 'Drifters' exhibit, does not share in this 'civilising' history – it clearly does. But I want to sound out other resonances at work in these jellyfish displays: differences in display technologies; variations in viewer experience and perception; and alterations in cross-species encounters. Might jellies sensuously matter in their displays, such that questions about their agential force must be asked? Additionally, how are aquarium-goers shaped and reshaped by the immersive space of the displays, the movements and corporeality of the nonhumans, and the flows of capital? Do these jellies, technologies and people exceed the aquarium's promise of immediacy? How do the various bodies of the display space (organic or inorganic) exist simultaneously not only as fixed or immutable but also as differentiated and always already constitutive – and as Karen Barad teaches us, always dynamically enacted and already materially configured? To answer these questions, I turn my attention to the expressiveness of sensation, display technologies, and the animals themselves. Studying the refractory forces of water and aquarium designs, the diffracting patterns of hermaphroditic comb jellies, and the sensuousness of immersion and encounter, I want to suggest that the rhetoric of animal domination is not the only discourse at work in aquarium displays, or at least in the 'Drifters' display. Perhaps – I pose this speculatively – what is at play in this gelatinous zone is a return of the repressed, a turning toward the monstrous oceanic but updated for a technoscientific postmodernity and anticipating a sci-fi futurity. [...]

And just for a moment, immersed in this liquid light and aurally wet space, in my flesh, I imagine myself breathing in water. I am moved deeply and touched throughout; my bodily senses and my sense of my body stir. Sensitised, I am in a primal time, when my own gill arches ache and then breathe. It is not an act of regression, not a womb-wish, but a recollection of evolutionary lifelines, of our own fishier days, or perhaps a future of new bodily sensations we are yet to feel – not posthuman but more than human – an embodiment we are yet to be.

Although the perimeter of the tanks is circular, the front transparent wall is flat. The back, seemingly opaque wall is indeterminate. The acrylic of these tanks produces an osmotic space wherein fluid moves through semipermeable partitions to equalise pressure across the membrane; that is, the liquid interior of the tank and the airy darkness in front of the glass meld into each other, equalising the pressures exerted by each interior's inhabitants. Through diffuse backlighting and the water's own distortion of light, I cannot see where the back wall begins or ends. The tanks appear to have no depth. The jellies seem to occupy the same space as me rather than the familiar animal display space of over there.

What is remarkable about the shape of this jellyfish display is that the luminosity that passes through the wall is not unidirectional. This display

does not easily define who is looking at whom, suggesting that we, not unlike the jellies, are on show under the microscopic view of the display. The distinction between inside and outside is, if not materially, at least symbolically blurred. More important, inner and outer are sensually blurred. Between my physiological and affective responses of 'here' and 'there', there is continuity, not primordial division. This should not be read hierarchically: my embodiment is of the display space; I am at once the space's subject, its substance and its partner. I, an oversized observer, am undulating with the drifters, both here and there, both sensing and sensible, both subject and object of the display. [...]

Deep-sea diving? Immersion? Yes, the exhibit attempts to authenticate itself as a simulated dive. Walking air-breathers feel plunged into dark fathoms without the safety of air tanks. In the immersion of the 'Drifters' display, multiple sensory registers temper the apparatus of seeing: sound, tactility, movement and proximity.

Immersion conveys the experience of being totally inside a world, a state of mind, cultural and historical forms, and intellectual rumination. Immersion is used as a trope of engagement associated with a variety of media. Roland Barthes' description of leaving a darkened movie theatre into daylight is the well-known evocation of the transitional experience in the levels and foci of consciousness. This state of absorption is temporary and partial. Disavowal, or 'I know it's not real, but nevertheless ...', is the formula for the splitting of belief in the unreality and reality scenes. Thus, even though our actual surroundings might be occluded or apparently frameless, we do not mistake virtuality for reality. Nor is the engagement of our bodies and psyches in immersive experiences ever total; even diving requires technological support around the body. Immersion, then, is not unreality or reality; rather, it is awareness divided between being conscious enough both to engage an interface and to experience the rapture of the deep. More a somatic trope than the metaphysics of identification, immersion produces cohabitation rather than mere representation. [...]

Pulsing along the thread of captivated anthropocentrism, blooms of jellyfish have found new economies, currents and pathways through which to make more of themselves and their own post-Cnidarian trajectory, however provisional and open ended. If we think about aquarium displays not merely as examples of human domination; if we consider jellyfish as successful colonisers of the world's oceans and recognise their alterity to vertebrates, their ability to flourish in extremes, we might imagine that the aquarium space has become yet one more venue of their colonisation, without deleterious effects to their ocean numbers – as opposed to marine mammals, where captivity is a vastly more consequential enterprise. [...]

In some ways I think Desmond is right. Ongoing cruelty toward animals, species extinction and ecological devastation offer good evidence for her case. There is no question that the jellies in the 'Drifters' exhibit are marketable figures that embody

all kinds of movements in capital. Jellies are produced as profoundly different from – even alien to – observers, and this difference is fashioned as markedly beautiful. Certainly the immersivity of the exhibit bends toward spectrality, motion and simulation. Nonetheless, I wonder if there are modes of captivity here that do not rely on total domination as the only modality of power? And if power is more discursive than anthropocentric, might the anthropocentric project of identification or reflectivity – that animals are really reflections of us – be the wrong framework for thinking about not only immersion but also cross-species encounters? [...]

The 'Drifters' display, with all its evocative labour, gelatinous movements and human trajectories, is experienced viscerally rather than intellectually, sensuously rather than conceptually. Ctenophore sensations bound by the immersive refrain of the 'Drifters' display, its framing/screening of encounter, invites bodies, or more precisely sensuous bodies, to resonate. As such, the aquarium space invents new sensations – deep-sea drifting and shimmering for upright, opaque hominids – that are sent further adrift through experience in yet unknown expressions. Visitors, for instance, borrow the ctenophore's diffractive capacity as dazzle (sensation) for the purpose of proliferating new sensations, future sensations. These renewed sensations of people and jellies are the conditions for future possibilities of sensorial interchange, an unleashing of yet unknown potentialities, of planetary encounters yet to come. [...]

The ctenophores in the 'Drifters' exhibit form a space enfolded into enactments and encounters, transfiguring the labour and capacities of humans and nonhumans and animals and nonanimals. Ctenophore iridescence is partly about understanding the ambivalent, powerful and elusive ways that ecology is composed through histories of interaction, relationality, interconnection and materiality. Theirs is not a calculus of speech acts, subaltern or agential; it is a relational matter. It is not simply about who has agency, as if it were a substance to be owned. As an aquarium-goer, my attention and sensuous reach are solicited by the ctenophores in the display, a display that instrumentalises the jellies diffracting cilia and solicits my senses. These specific organisms in this specific ecology make me adapt to them just as my entrance fee ensures that their lifeway becomes one of the substrates of biocapitalism. [...]

The jellies and the aquarium-goers are both immersed in the same environment – differently, of course: one can leave, the other lives and dies there, and yet in fundamental ways the space sensuously enacts futures for both of us. The lifeway of the jellies has become embedded in the aquarium: reproduction (sexual and asexual), predation, and drifting all take place within the aquarium's acrylic walls. They are watched over, they are protected, they are fed, and their human stewards sometimes destroy them. The display is not just an uncritical prophylactic that only overstimulates the senses; it is not a

substitute or representation of some real experience. When we are immersed as observers, as aquarium-goers, we are not only immersed in virtuality; we are immersed in deep marine technoscience worlds, and through that immersion we experience a vibratory, percussive, expressive improvisation of becoming more than ourselves (jellies and humans). We become part of the histories and trajectories, movements of fluiluminality, of fluid light, which the ciliary combs of ctenophores trace. Encounter is not on any one set of terms, jellies' or humans', but on a set of contingent terms. [...]

So, yes, these are captive beings – what they 'know' about their captivity one cannot be sure of – and their captivity makes local economies work. Whether we decide that captivity for these invertebrates is ethical or not, what is at play in this display is more than a politics of domination – literally more. Light, space, perception, and bodily (human and nonhuman) and technological sensoria are brought into conjunction in ways that matter so that they make sensation sensible, or sense-able. We both, with our fleshy differences, are affected by the exhibit, by its constraints, its possibilities, its convergences. We have a future together, sharing in local ecosystems that are under intense commercial and environmental pressure. We are interferences in the histories – past, present and future – that define the Monterey Bay Aquarium and its local and global communities. [...]

1 [Footnote 2 in source] The parallel between jellies and aliens is further emphasised by the Monterey Bay Aquarium's video production, *Jellies and Other Ocean Drifters*, narrated by Leonard Nimoy, who played the alien Mr. Spock on *Star Trek*. Throughout the narration, Nimoy compares jelly life forms with the unimaginable forms seen during Spock's travels on the *Enterprise*. 'We are on an expedition to investigate a confederation of strange life forms. From earlier observations we know that these creatures live in a habitat so inhospitable to humans that even with protective suits we can venture forth only for brief periods and only to the edge of the habitat.' One might say that aliens have always been here beneath the ocean's waters. For further discussions about alien oceans, the outerspace of underwater, see [Stefan] Helmreich's *Alien Ocean*.

2 Ralph Acampora, 'Zoos and Eyes: Contesting Captivity and Seeking Successor Practices', *Society and Animals*, vol. 13, no. 1 (2005) 83.

3 Ibid, 71.

4 Ibid, 71.

5 Jane C. Desmond, *Staging Tourism: Bodies on Display from Waikiki to Sea World* (Chicago: University of Chicago Press, 1999) 144.

Eva Hayward, extracts from 'Sensational Jellyfish: Aquarium Affects and the Matter of Immersion', *Differences: A Journal of Feminist Cultural Studies*, vol. 23, no. 3 (2012) 160–163, 164–5, 167–8, 172, 184, 185–6, 187 [some footnotes omitted].

Marina Warner
Passionate Cruces: The Art of Dorothy Cross//2005

[...] Medusae (2003), an ambitious multi-limbed work of research, film and mixed-media artefacts, was undertaken in collaboration with her [Dorothy Cross'] brother Tom Cross, a zoologist, and it explores one of the most despised species in the universe, as well as one of the most ancient and least understood: jellyfish were on this earth 550 million years ago, 500 million years before *Homo sapiens*. Dorothy Cross finds jellyfish 'overwhelmingly beautiful' but they are, she admits, 'terribly alien' with their viscous, trailing, slimy shapelessness, their occasionally fatal sting, their seemingly monstrous lack of brain or faculties or face. Smogairle Roin is the Irish word for a jellyfish and it means 'spit of the seal'. Jellyfish were given their name, 'medusae', by [Carl] Linnaeus, after one of the three Gorgons, who was afflicted with snakes for hair and given the baneful power of turning to stone anyone who looked at her. In the Renaissance, Medusa's severed head symbolised the defeat of unruly, discordant rebellion: political unrest taking the form of a female monster. Grand Duke Cosimo de' Medici commissioned Benvenuto Cellini to make the sculpture of the hero Perseus trampling her mangled body while holding up her head as a trophy. Caravaggio's *Medusa* (1597) also revels in violence and gore, showing the blood splashing up from the victim's neck as she screams in agony at the very moment of death; this terrifying image is painted on a shield, in order to act as a defensive emblem, like the demonic guardian of a threshold, and repel anyone who approaches the warrior. But the Medusa's repulsiveness has above all strongly sexual associations, and so belongs among those symbolic female bodies Dorothy Cross has enfolded in her symbolic repertory. When Linnaeus named the jellyfish after the Gorgon, he led the way towards Freud's celebrated castration theory, when he identified the head of the Medusa with the sight of the mother's genitals and pubic hair, and its petrifying effect on a boy. However far-fetched this may seem, the Linnaeus-Freudian association gives an insight into the terror invoked by jellyfish. Some phenomena – tentacular, buggy, creepy-crawly, primordial things such as squid and spiders and crabs and jellyfish – act as *foyers de songe* (dream hearths) and incubate fantasies.

Tom and Dorothy Cross travelled widely to make *Medusae:* they are both excellent swimmers (Tom coached Dorothy when she swam in the Ireland team), so together they were able to experiment at close quarters with their subjects. Tom focussed on *Chironex fleckeri*, the deadliest jellyfish of all, responsible for more deaths in Australia than sharks or crocodiles, and analysed

the jet propulsion that powers their rapid movement. Dorothy made the video *Jellyfish Lake*, a dream-like, lyrical piece which shows her drifting, naked and mermaid-like, through galactic shoals of gently pulsing, frilled *Aurelia aurita* and *Mastigias* jellyfish in their unique lagoon habitat in Palau, Micronesia. Swimming so gracefully through their glinting, winking bells and fronds, she seems to cross the boundary of species and to have become a sea creature herself. At the same time, she brings about a transformation of the beholder's sensibility: the flotilla of jellyfish still belongs to the category of disturbing things, but she has unsettled our response and changed the story.

Medusae tackles a phenomenon that by analogy with slime and deliquescence usually provokes abhorrence, and reconfigures 'the logic of our imaginary' about these animals, about pleasure and disgust.[1] Dorothy Cross is insisting in this work on her own creatureliness, and on the creatureliness of the human; she is refusing to shudder at any living thing; she is recovering an aesthetic of wonder before the assumed vile body of the jellyfish. *Medusae* refashions and transvalues an animal body and its processes, as it journeys through the cycle from spawning to decay. There is not a little identification when she says, speaking of jellyfish: 'It's a defiant animal.'

In another yet more profound way, the communion of medusae and artist strikes at conventional aesthetics, especially sculptural. For jellyfish are loose, fluid invertebrates. However, repugnantly fleshy and slimy as they might strike us, they are paradoxically almost disincarnate: 98% water, only 2% animal. They have no being outside their element, and so exist in harmony with the sea, almost emanations of its currents and eddies. Consubstantial with water, they embody contingency and interdependence, announcing the reciprocity of our relations as living creatures with the stuff in which we survive. The fringes of the jellyfish cannot be reconstructed outside the sea; the animals are so insubstantial that a shadow on the bottom is often the only sign of their presence. Such lightness makes them a sculptor's paradox: sculpture here has done with the column and the skeleton, the scaffold and the rock. They belong in the symbolic category of the wet, slippery, inchoate feminine, primordial and chaotic, and in this set up an order of beauty at variance with classical orders of architecture, pillar, statue, monument and their embodiment of masculine authority. But Dorothy Cross has discovered in them beauty and decorum: she laid out jellyfish she had found in the sea near her home on hand trimmed and embroidered white handkerchiefs such as a Victorian lady like Maude Delap would have kept in lavender scented presses; the creatures, drying out, left the shadow of their form in a sepia residue on the cloth; this is nature's own drawing, *acheiropoieton* or 'made without hands' like a miraculous story of the holy shroud. [...]

1 [Footnote 8 in source] Roger Caillois uses this phrase in his study of the octopus, an animal related to the jellyfish in mythopoeic qualities. See [Roger Caillois,] *La Pieuvre, Essai sur la logique de l'imaginaire* (Paris: 1973).

Marina Warner, extract from 'Passionate Cruces: The Art of Dorothy Cross', in *Dorothy Cross* (Dublin: Charta, 2005) 31–2, 37.

Janine Marchessault
Dolphins in Space, Planetary Thinking//2017

[...] The Dolphin Embassy received funding from the Rockefeller Foundation and was featured in an exhibition at the San Francisco Museum of Modern Art. It was established as a non-profit foundation that eventually relocated to Australia when Ant Farm disbanded in 1978 after a fire destroyed their studio at Pier 40 in San Francisco. From this period until his sudden death in 2003, [Doug] Michels kept developing the Dolphin Embassy concept, working with ecologist Alexandra Morphett and others. By 1987, it had evolved into a space project, renamed Project Bluestar, a joint dolphin-human space station in earth orbit with a 250-foot-diameter sphere of water at its heart, 'ultrasonically stabilized' and surrounded with research laboratories in a ring like Saturn's. The objective was to create 'the first think tank in space, a research lab dedicated to the study of the mind's newly expanded horizons, to the investigation of thought liberated from earth's gravitational ties'. This proposal presented an image of dolphins in space operating computers in a sphere of water 'to nurture the growth of new non-earth-bound ideas by inventing an atmosphere in which the dimensions of weightless thinking can be expanded, observed, and understood'. Project Bluestar, Michels wrote, would 'harbor the broadest possible range of inquiry, from the artistic to the psychological to the cybernetic, not merely the narrow experimentation of space engineering typical of its predecessors'.[1]

Michels' new proposal pushed the Embassy into utopian science fiction that was perfectly in keeping with [Dr. John C.] Lilly's ideas about dolphin communication – a belief that dolphins were descended from extraterrestrials and had special psychic abilities. In order to promote Bluestar, Michels and Morphett developed a proposal for a feature film called *Brainwave*, 'a pre-enactment of life aboard the Embassy that concludes with a collective human experience of transspecies telepathy'.[2] As [Tyler] Survant points out, Michels'

interest in parapsychological phenomena expanded Ant Farm's engagement with technology to encompass a broader framework that included 'the body's potential as a biological machine'.[3] Indeed, as a proposal, Embassy/Bluestar lines up with some of the most utopian ideas about the planetary consolidation of all living matter. After relocating to Australia, Michels devoted himself to dolphins, to educating people about dolphins, and to raising money for Bluestar. In 2003, Michels died in Australia while doing research on a seacoast site for a film about a group of human whalers who had formed a long-time alliance with a local population of orcas for mutual aid in whale hunts between 1850 and 1930. This extraordinary story is told in the small museum at Eden Bay, Australia.[4]

Let me turn now to the idea of the Embassy as diplomacy. The architecture for the Embassy proposed by Ant Farm is without location; floating in the ocean, it eschews national boundaries. The Embassy also features *Oceania*, a sea craft conceived by Michels in 1976 to bring more mobility to the structure, allowing researchers to meet dolphins further out in the ocean. As a place for friendly and equitable exchange, the Embassy completely reconfigures land-based political institutions. It is a hybrid space – some sections of the station are wet, some are dry, some designed for humans, others for dolphins. It is what Ant Farm calls 'aquaterrestrial', which lends a different semantic register than we are used to with terrestrial architectures, creating 'a planetary agora' made, as Survant surmises, 'not of two habitats distinct in space, but of a new, coextensive superhabitat'.[5]

This 'superhabitat' is perhaps the place for diplomacy in the twenty-first century. As Isabelle Stengers has argued, while the work of the diplomat is always tied to a local problem,[6] it must take place outside the confines of the natural world, beyond what is known, away from established conventions in the context of artifice – what the Greek agora was before it hardened into convention with established scripts of behaviours. Peace, Stengers insists, must be an invention, not a renunciation. It requires the construction of an ecology that is not 'natural' or usual, but dynamic, responsive and always in process, where every member is recognised as belonging to an *umwelt* (which defines distinct phenomenologies of perception) and also invited into an *oikos* (a political ecology constructed through the act of diplomacy, where enemies can encounter one another). Acts of peace, bringing two warring sides together, require imagination, not abstention.

[...] As part of a collaborative project with the architecture group WORKac, Curtis Schreier revised the design of the Dolphin Embassy for submission to the Chicago Architecture Biennial 2015. WORKac interpolated Schreier's drawings to devise 3.C.City: Climate, Convention, Cruise, a tetrahedral roving city-at-sea

not bound by national borders that 'proposes a new symbiosis between ecology and infrastructure, public and private, the individual and the collective'.[7] The architectural model for the ecstatic space of 'aquaterrestrial' communion retains but expands upon the Embassy's original utopian mandate to bring cetaceans into a global conversation that now includes climate change. [...] [T]he new proposal for the Dolphin Embassy offers a matrix directed primarily toward an expanded discussion and creative interface to include the heterogeneity of life that makes up the biosphere. [...]

1 [Footnote 74 in source] Doug Michels, 'Blue Star Human Dolphin Space Colony, 1987', ZKM's Space Place (http://www.orbit.zkm.de/?q+node/248, last updated 15 Apri 2006).

2 [76] Tyler Survant, 'Biological Borderlands: Ant Farm's Zoöpolitics', *Horizonte* no. 8 (Fall 2013) 61.

3 [77] This also lines up with Embassy muse John C. Lilly's like-minded telepathic experiences with dolphins. Survant, 'Biological Borderlands,' 58, 61.

4 [79] Danielle Clode, *Killers in Eden: The True Story of Killer Whales and Their Remarkable Partnership with the Whalers of Twofold Bay* (Sydney: Allen and Unwin, 2002).

5 [80] Survant, op. cit., 58.

6 [81] Isabelle Stengers, in Bruno Latour and Pasquale Gagliardi (eds.), *Les atmosphères de la politique*, conference proceedings (Paris: Seuil, 2006) 136.

7 [86] WORKac statement for the 2015 Chicago Biennale (http://work.ac/chicago-biennale/).

Janine Marchessault, extracts from *Ecstatic Worlds: Media, Utopias, Ecologies* (Cambridge, MA: The MIT Press, 2017) 225–9 [some footnotes omitted].

Shimabuku
With Octopus, 1990–2010//2021

1. Exhibition in a Refrigerator

In 1990 I was living in San Francisco. My roommate was from Kentucky, and just after he moved in, he begged me, 'Please don't put fish in the refrigerator. And whatever you do, don't put any octopus in there!'

At the time, I said, 'OK', but the more I thought about it the stranger it seemed. 'Why can't I put what I like in the refrigerator? It partly belongs to my roommate but it also belongs to me.'

One day I bought some smelt at a supermarket in Japan Town. I also bought an octopus leg wrapped in plastic. I put it in the refrigerator while my roommate was away. Shortly after he came home, he noticed the smelt and octopus in the refrigerator. As soon as he found it, he yelled, 'Ugh!' I wondered if he would get mad, but all he did was call a friend on the telephone.

The friend, who lived in the neighbourhood, came over immediately, and both of them took turns opening the refrigerator over and over, saying, 'Ugh!' each time. They seemed to be having fun.

This was an exhibition in a refrigerator. From that time on, I have had a special relationship with the octopus.

2. Octopus Road Project, 1991

While driving from San Francisco to New York, from the Pacific Ocean to the Atlantic Ocean, I started wondering, 'Has an octopus from Akashi, a city on the Seto Inland Sea, ever travelled to the Japan Sea?'

After returning to Japan, I took an octopus from Akashi to the Japan Sea. I imagined that this would be a major endeavour for an octopus, something like travelling in outer space for a human, so I thought I should do something difficult along with it. So I decided to walk from the Seto Inland Sea to the Japan Sea.

I mentioned my plan to various people, and someone I barely knew, Takamine Tadasu, asked to go with me. We started the walk from the beach in Kobe. Though it was almost the end of summer, it was still a very hot day. I thought that the octopus would also be hot, so I put some ice in a cooler filled with seawater. Later, after studying octopus life, I realised that this was the wrong thing to do. Because of changes in the water condition, the octopus turned belly up and died.

I wondered what to do and discussed it with Takamine, but we decided to go ahead and take the dead octopus to the Japan Sea.

We continued walking all day for four days, crossing mountains and rivers. One night we slept in the bushes on a traffic island on a road where a bike gang was racing up and down. On another night, a typhoon blew in and we had to take refuge in a campground storage room. The octopus in the cooler eventually began to decompose because of the heat, and changed to a pink blob that gave off a terrible smell.

Both of us had blisters on our feet and our bodies were sore all over when we finally arrived in Maizuru on the Japan Sea Coast. We put the octopus that had turned into a pink blob into the Japan Sea. The pink goo spread out for a moment on the surface of the water and then quickly sank to the bottom.

3. Studying About Octopi

I felt bad about making the octopus die in the Octopus Road Project. So I decided to learn more about these creatures so that next time I could make a journey with a living octopus. I talked to experts working in aquariums and read books, and I discovered some amazing things.

The octopus likes clean seawater and is very sensitive to changes in water conditions, especially changes in water temperature. Therefore, to keep an octopus in an aquarium, you have to have an oxygen supply and lots of filters and maintain the right temperature. It is difficult to keep an octopus alive, and even in public aquariums they often die. However, an octopus seller in the Akashi fish market told me, 'If you put them in sea water they should be all right for at least three days.'

The lower the temperature of the water in the tank, the less oxygen the octopus consumes, thus easier to look after. However, even in the ocean, when the temperature drops below 0 degrees, octopus can die. At Akashi, every few decades or so, the water drops below 0 degree and all octopi dies out.

The part of the octopus that looks like the head is actually the body. So it is put together in a different order than other animals: body, head and legs. And the reproductive organ of the male octopus is found on the end of one of the eight legs.

There are stories about the octopus coming up on land and in coastal villages in Japan, people say things like 'an octopus stole the sweet potatoes from the field' or 'an octopus carried away the chicken's eggs.' I have heard that people on the coast of Italy say similar things, for example, 'An octopus stole the tomatoes from the garden.' Does this mean that an octopus likes little round things?

'During evolution, the octopus once tried living on land, but the squid has never come out of the water. That is why the octopus can move along a surface without water, but the squid cannot.' After discussions with friends, we were convinced that it must be true. The octopus is full of possibilities.

4. Encounter Between an Octopus and a Pigeon

If gravity disappeared from the earth, an octopus and a pigeon could meet on equal terms. Fighting with gravity. 1993, Nagoya City Art Museum

This project started when I met a girl who was a Korean national resident in Japan sitting next to me on a plane from London. She was wearing a pretty pink coat. Although we had met accidentally, we began talking about various things and eventually we began talking about our ideas of marriage.

She said, 'I couldn't even think of marrying someone unless we had the same culture and interests, so I will probably marry another resident Korean.' I said, 'I don't know who I will meet in the future or who I might fall in love with. It is possible that I will marry someone who is not Japanese.'

In spite of our different opinions, we kept talking about this after all the other passengers around us had fallen asleep. Still disagreeing, we arrived in Seoul. I changed planes to go to Osaka and she changed to a flight for Tokyo. It seemed strange that the person who had just been sitting next to me was now flying toward Japan just as I was but in a different part of the sky. It occurred to me that if the power of gravity suddenly disappeared, an octopus and a pigeon could meet on a more equal basis.

I had an opportunity to do an exhibition at the Nagoya City Art Museum. There were many pigeons in the park around the museum, so I decided to arrange a meeting between an octopus and a pigeon. I brought the octopus from Akashi.

I placed an aquarium in an open atrium-like space on the basement level of the museum. I put the octopus into the aquarium with proper attention to water temperature, water quality and oxygen level. There was a stairway from this open space up to the ground level and the park. Since the octopus had come from as far as Akashi, I thought that it was not too much to ask the pigeon to come down these stairs. So I took some bread and set out to get a pigeon.

I tore up the bread and made a trail of bread pieces from the park to the stairs. I got pigeons to come halfway down the stairs, but they would not go all the way to where the octopus was. I tried many times, but it just didn't work. As I was walking around the park with the bread in my hand, a pair of dogs followed me.

They ate up all the bread on the stairs, came down to the water tank, and put both paws on the edge of the tank. Thus, there an encounter took place between some dogs and the octopus. The brown dog seemed very interested in the octopus but the white dog seemed frightened and pulled back. I don't know what the octopus thought or felt. It just kept moving around at the same slow pace.

5. An Octopus Becomes a Star, 1993

I took the octopus that had met the two dogs in Nagoya back to Akashi. I took it to the edge of the water to return it to the sea. It seemed reluctant to go back and just moved its legs nervously. It was night. I picked up the octopus and threw it out over the ocean in the night sky. A friend who was with me took a picture. The flash went off. When the picture was developed, the octopus looked like a star.

6. On the Beach in Zurich, 1993

I visited a toy shop along the stone pavement in Zurich.

Looking around the shop for some time, I found a cardboard box in the corner. In it were plastic animals and creatures of different kinds. Soon I found myself playing on the floor of the shop.

First I grasped an octopus to make it crawl on the floor. It looked alive. Side by side with the octopus, I placed a gorilla, a tiger, a shark, and then a dolphin, a giraffe, a rhinoceros and a dinosaur.

A donkey in the bottom of the box looked at me, so I put it in front of the octopus. Their eyes met, and appeared to have been looking at each other since long time ago.

It seemed that all happened on the beach. I felt as if I looked at the happenings on the beach from a distance.

7. Then, I Decided to Give a Tour of Tokyo to the Octopus from Akashi, 2000

This was my own Apollo Project. I took a living octopus that I caught myself to Tokyo. Then I brought it back, still alive, and put it into the sea.

Would the octopus be pleased to receive the gift of a trip to Tokyo? Or would it be annoyed?

Most people act as if they are glad to receive a present, but are they really? I never know.

I don't know if the octopus I took to Tokyo was happy to go or not. It is certain that he escaped the fate of being caught in the fisherman's octopus pot, sold to the fish market, and eaten.

Also, he was probably the first octopus in history to go to Tsukiji, the big fish market in Tokyo, and come back alive. The octopus returned to the ocean at Akashi in good health.

What does the octopus remember about this event? Is he talking to his fellow octopuses at the bottom of the ocean about his trip to Tokyo? Or has he gotten inside an octopus trap with the idea that he might be able to go to Tokyo again?

In any case. I am not going to stop giving gifts.

Shimabuku, extract from 'With Octopus, 1990–2010', in *Shimabuku: The 165-Metre Mermaid and Other Stories* (exh. cat.), eds. Célia Bernasconi and Shimabuku (Monaco: BOM DIA BOA TARDE BOA NOITE/Nouveau Musée National de Monaco, 2021) 162–75.

I highly recommend breathing underwater. It changes your perspective on life altogether.

Klara Hobza, 'Diving Through Europe (2009–2039): In Conversation with Bergit Arends', 2023

CROSSINGS

Paul Gilroy
The Black Atlantic as a Counterculture of Modernity//1993

[...] I have settled on the image of ships in motion across the spaces between Europe, America, Africa, and the Caribbean as a central organising symbol for this enterprise and as my starting point. The image of the ship – a living, micro-cultural, micro-political system in motion – is especially important for historical and theoretical reasons that I hope will become clearer below. Ships immediately focus attention on the middle passage, on the various projects for redemptive return to an African homeland, on the circulation of ideas and activists as well as the movement of key cultural and political artefacts: tracts, books, gramophone records and choirs. [...]

Ships and other maritime scenes have a special place in the work of J.M.W. Turner, an artist whose pictures represent, in the view of many contemporary critics, the pinnacle of achievement in the English school of painting. Any visitor to London will testify to the importance of the Clore Gallery as a national institution and of the place of Turner's art as an enduring expression of the very essence of English civilisation. Turner was secured of the summit of critical appreciation by John Ruskin, who, as we have seen, occupies a special place in [Raymond] Williams' constellation of great Englishmen. Turner's celebrated picture of a slave ship[1] throwing overboard its dead and dying as a storm comes on was exhibited at the Royal Academy to coincide with the world anti-slavery convention held in London in 1840. The picture, owned by Ruskin for some twenty-eight years, was rather more than an answer to the absentee Caribbean landlords who had commissioned its creator to record the tainted splendour of their country houses, which, as Patrick Wright has eloquently demonstrated, became an important signifier of the contemporary, ruralist distillate of national life.[2] It offered a powerful protest against the direction and moral tone of English politics. This was made explicit in an epigraph Turner took from his own poetry and which has itself retained a political inflection: 'Hope, hope, fallacious hope where is thy market now?' Three years after his extensive involvement in the campaign to defend Governor Eyre,[3] Ruskin put the slave ship painting up for sale at Christies. It is said that he had begun to find it too painful to live with. No buyer was found at that time, and he sold the picture to an American three years later. The painting has remained in the United States ever since. Its exile in Boston is yet another pointer towards the shape of the Atlantic as a system of cultural exchanges. It is more important, though, to draw attention to Ruskin's

inability to discuss the picture except in terms of what it revealed about the aesthetics of painting water. He relegated the information that the vessel was a slave ship to a footnote in the first volume of *Modern Painters*.[4]

In spite of lapses like this, the New Left heirs to the aesthetic and cultural tradition in which Turner and Ruskin stand compounded and reproduced its nationalism and its ethnocentrism by denying imaginary, invented Englishness any external referents whatsoever. [...]

Similar problems appear in rather different form in African American letters where an equally volkish popular cultural nationalism is featured in the work of several generations of radical scholars and an equal number of not so radical ones. We will see below that absolutist conceptions of cultural difference allied to a culturalist understanding of 'race' and ethnicity can be found in this location too.

In opposition to both of these nationalist or ethnically absolute approaches, I want to develop the suggestion that cultural historians could take the Atlantic as one single, complex unit of analysis in their discussions of the modern world and use it to produce an explicitly transnational and intercultural perspective.[5] Apart from the confrontation with English historiography and literary history this entails a challenge to the ways in which black-American cultural and political histories have so far been conceived. I want to suggest that much of the precious intellectual legacy claimed by African American intellectuals as the substance of their particularity is in fact only partly their absolute ethnic property. No less than in the case of the English New Left, the idea of the black Atlantic can be used to show that there are other claims to it which can be based on the structure of the African diaspora into the western hemisphere. A concern with the Atlantic as a cultural and political system has been forced on black historiography and intellectual history by the economic and historical matrix in which plantation slavery – 'capitalism with its clothes off' – was one special moment. The fractal patterns of cultural and political exchange and transformation that we try and specify through manifestly inadequate theoretical terms like creolisation and syncretism indicate how both ethnicities and political cultures have been made anew in ways that are significant not simply for the peoples of the Caribbean but for Europe, for Africa, especially Liberia and Sierra Leone, and of course, for black America.

It bears repetition that Britain's black settler communities have forged a compound culture from disparate sources. Elements of political sensibility and cultural expression transmitted from black America over a long period of time have been reaccentuated in Britain. They are central, though no longer dominant, within the increasingly novel configurations that characterise another newer black vernacular culture. This is not content to be either dependent upon or simply imitative of the African diaspora cultures of America and the Caribbean. [...]

Turner's extraordinary painting of the slave ship remains a useful image not only for its self-conscious moral power and the striking way that it aims directly for the sublime in its invocation of racial terror, commerce, and England's ethico-political degeneration. It should be emphasised that ships were the living means by which the points within that Atlantic world were joined. They were mobile elements that stood for the shifting spaces in between the fixed places that they connected.[6] Accordingly they need to be thought of as cultural and political units rather than abstract embodiments of the triangular trade. They were something more – a means to conduct political dissent and possibly a distinct mode of cultural production. The ship provides a chance to explore the articulations between the discontinuous histories of England's ports, its interfaces with the wider world.[7] Ships also refer us back to the middle passage, to the half-remembered micro-politics of the slave trade and its relationship to both industrialisation and modernisation. As it were, getting on board promises a means to reconceptualise the orthodox relationship between modernity and what passes for its prehistory. It provides a different sense of where modernity might itself be thought to begin in the constitutive relationships with outsiders that both found and temper a self-conscious sense of western civilisation.[8] For all these reasons, the ship is the first of the novel chronotopes presupposed by my attempts to rethink modernity via the history of the black Atlantic and the African diaspora into the western hemisphere. [...]

1 [Footnote 27 in source] Paul Gilroy, 'Art of Darkness: Black Art and the Problem of Belonging to England', *Third Text*, no. 10 (1990). A very different interpretation of Turner's painting is given in Albert Boime's *The Art of Exclusion: Representing Blacks in the Nineteenth Century* (London: Thames and Hudson, 1990).

2 [28] Patrick Wright, *On Living in an Old Country* (London: Verso, 1985).

3 [29] Bernard Semmel, *Jamaican Blood and the Victorian Conscience* (Westport: Greenwood Press, 1976). See also Gillian Workman, 'Thomas Carlyle and the Governor Eyre Controversy', *Victorian Studies*, vol. 18, no. 1 (1974) 77–102.

4 [30] John Ruskin, Modern Painters, vol. 1 (London: Smith, Elder and Co., 1860), sec. 5, ch. 3, sec. 39. W.E.B. Du Bois reprinted this commentary while he was editor of The Crisis; see vol. 15 (1918) 239.

5 [32] Peter Linebaugh, 'All the Atlantic Mountains Shook', *Labour/Le Travail*, vol. 10 (Autumn 1982). This is also the strategy pursued by Marcus Rediker in his brilliant book *Between the Devil and the Deep Blue Sea* (Cambridge: Cambridge University Press, 1987).

6 [33] 'A space exists when one takes into consideration vectors of direction, velocity and time variables. Thus space is composed of intersections of mobile elements. It is in a sense articulated by the ensemble of movements deployed within it.' Michel de Certeau, *The Practice of Everyday Life* (Berkeley and London: University of California Press, 1984) 117.

7 [34] See Michael Cohn and Michael K. Platzer, *Black Men of the Sea* (New York: Dodd, Mead, 1978). [...]

8 [35] Stephen Greenblatt, *Marvellous Possessions: The Wonder of the New World* (Oxford: Oxford University Press, 1992). See also Mary Louise Pratt, *Imperial Eyes: Travel Writing and Transculturation* (London and New York: Routledge, 1989).

Paul Gilroy, extracts from *The Black Atlantic: Modernity and Double Consciousness* (London and New York: Verso, 1993) 4, 13–15, 16–17.

Ayesha Hameed
Two Ships/Time Travel/Bodies Under the Sea//2019

[…] To the left is a diagram of the Brookes slave ship hold storage first published in 1788. Thomas Clarkson used this image in his campaign against transatlantic slavery. In the nineteenth century the Brookes image and others like it were used to create mass awareness of conditions for slaves onboard ships, which in turn spearheaded the abolitionist movement.

To the right is an image of migrants on a boat that arrived on the North coast of the Mediterranean. Other boats sailing on this route are not as lucky, where more often than not they capsize and run out of fuel, or are turned back.

The state often willfully turns away from rescuing boats like these. Migrants on these small boats have not been jettisoned from the boats they are sailing on, but their journeys are no less violent and perilous. The boats fall under the threshold of state responsibility, where, as Lorenzo Pezzani states, there is a systematic looking away or ignoring of these ships by states surrounding the Mediterranean.[1] Looking away from overcrowded ships on the Mediterranean is as much of a death sentence as a jettison.

The middle passage finds its afterlife in the crossing of the Mediterranean by 'adventurers': migrants crossing from sub-Saharan Africa into the European Union. To cross the Mediterranean is called 'to burn', as migrants burn their papers to make the crossing on fragile ships.[2] This highlights the centrality of documents in contemporary migration and the legal implications of living and travelling without papers. The 'adventurer' as a figure highlights the aleatory nature of making this journey where the inextricable combination of natural and human forces adds to the peril of their journey. Its plantations are detention centres, camps and biometric regimes. Its Atlantis lies in the infinitely receding horizon of their destinations – what right-wing rags decrying the desire to arrive at the UK as a quest for Eldorado – another mystical and lost land.

These two images placed together suggest a relationship between two histories. Though placed at the end, the juxtaposition of these two images are what catalyse this project. This juxtaposition of histories is hardly novel, with voices on the left and right connecting these two journeys in mainstream news:

*

IT IS APRIL 13, 2015.
AND. IT IS APRIL 19, 2015.

This link was dramatically apparent in the aftermath of the capsizing of two migrant ships, which resulted in the deaths of over twelve hundred people. These two incidents were linked to the middle passage in news articles by both pro- and anti-migration advocates. On the right, anti-immigrant groups made a link by comparing traffickers to eighteenth century slave traders. Figures like Italian Prime Minister Matteo Renzi dubbed this [a] new slave trade, driven by exploitative traffickers.[3]

On the left, those advocating for migrants, made the connection to the middle passage by drawing attention to the scale of death and conditions on the boat and calling attention to the fact that this journey is voluntary and that the wars migrants fled were the making of the very same countries that they were approaching for asylum.

*

IT IS MARCH 2015.

Another media blast turned its gaze to the bottom of the sea. The Smithsonian Museum announced the discovery of the San Jose, a capsized slave ship off Cape Horn that *went down with slaves on board.*[4] Discovering a ship that sank with slaves on board was vital to the Smithsonian. Finding a ship full of slaves would be the first discovery of its kind. The discovery of the San Jose was kept under wraps for two years so that the Smithsonian could make absolutely sure that they were right about its human cargo, and so that scavengers off the South African coast did not steal parts of the ship or its contents. It wasn't hard to hide though as the water churned around the remnants like 'swimming in a washing machine', a storm underwater, making the ship's parts hard to preserve as well.[5] The ship, hauled to the Smithsonian's National Museum of African American History and Culture, remains nominally the property of Iziko Museum in South Africa.[6]

What identified this ship as a slaver was the presence of ballast in the form of iron blocks. Iron bars were also the standard to trade for slaves –

thirteen bars being the going price for a man, nine for a woman.[7] Human cargo is unstable, as it is living and moving, and so requires ballast as counterweight – both then and now. Obviously, ballast is missing on boats crossing the Mediterranean. One of the main causes of ships capsizing on the Mediterranean is the absence of ballast. Passengers rush to the side of the boat when a possible rescue ship is sighted, and it is very easy for the boat to tip. The instability of the water and storms that surround the ship is matched by the conditions on board and the unique quality of the passengers who are treated as cargo in both instances.

The story of the recovery of the San José is a strange combination of prurience and thrilling detective work, it sits poorly on one's conscience. What fuels the desire to find a ship that went down with slaves on board? What is the appeal of looking at such a ship? The desire to see is an implicated one.

*

IT IS SEPTEMBER 2, 2015.

Alan Kurdi, a two-year old child attempting, with his family, to flee to Canada, drowned off the Turkish coast and washed up on shore. Images of this child circulated vociferously in the media and on the internet. The image of Kurdi, neatly dressed, face down as if in sleep became a meme, and was turned into a vector-based illustration. It turned (for a moment) the tide of mainstream media and public opinion on the influx of migrants. It was an image that turned into a diagram and once abstracted became a rapidly proliferating catalyst for change. It prompted the Canadian government under Justin Trudeau to pledge to sponsor 25,000 Syrian refugees to Canada.[8] A few months later the artist Ai Wei Wei bewilderingly recreated the pose of Kurdi's corpse on the beach.

Weeks earlier in his blog *How to See the World,* Nicholas Mirzoeff brought attention to another set of images of drowned migrants.[9] Collected by the artist Khaled Barakeh, they were images of bodies in the swirl of Mediterranean waters. There is something sublime and majestic in these photos, where the violence of the image is inextricable from its pull. This is a gesture that combines the same forces that J.M.W. Turner's *Slavers* draws from, where the violence of the act depicted spills onto the seascape, and where the boundaries between the dead and the sea are incoherent and blurred. The pull of both Turner and Barakeh's images lies in how that sense of horror evoked by the floating dead is transposed onto a turbulent sublime nature – swirling seascapes, saturated with colour. This sense of witnessing these state sanctioned massacres cannot be separated from the enervating pleasure of looking at nature in revolt. It is a

witnessing that is tinged with prurience and voyeurism. These images are of the same stock; one begets the other.

Mirzoeff decried how social media like Facebook took down Bourakeh's images and called this censorship.[10] These images needed to be seen, he said. But do they? Maybe we need no images here.

1 Lorenzo Pezzani, 'Mapping the Sea: Thalassopolitics and Disobedient Spatial Practices', in Ines Weizman (ed.), *Architecture and the Paradox of Dissidence* (New York: Routledge, 2013) 152.

2 Yto Barrada, 'Artist Project/A Life Full of Holes', *Cabinet*, no. 16, 'The Sea' (Winter 2004/2005) (www.cabinetmagazine.org/issues/16/barrada.php).

3 'Italian PM Matteo Renzi Condemns "New Slave Trade" in Mediterranean', BBC News (19 April 2015) (www.bbc.com/news/world-europe32374027).

4 Roger Catlin, 'Smithsonian to Receive Artifacts from Sunken 18th-Century Slave Ship', *Smithsonian Magazine* (31 May 2015) (www.smithsonianmag.com/smithsonianinstitution/sunken-18th-century-slave-ship-found-south-africa180955458/?no-ist).

5 Helene Cooper, 'Grim History Traced in Sunken Slave Ship Found Off South Africa', *The New York Times* (31 May 2015) (www.nytimes.com/2015/06/01/world/africa/tortuous-history-tracedin-sunken-slave-ship-found-off-south-africa.html?_r=0).

6 Ibid.

7 Corey Malcom, 'Trade Goods on the *Henrietta Marie* and the Price of Men in 1699–1700', presented at the Society for Historical Archaeology Conference on Underwater Archaeology, Atlanta, Georgia (January 1998, updated October 2003) 5.

8 'Refugee Crisis, Drowned Syrian Boy Shift Focus of Election Campaign', CBC News (3 September 2015) (www.cbc.ca/news/politics/syria-migrantscanada-drowned-migrants-leaders-respond-1.3213878).

9 Nicholas T. Mirzoeff, 'The Drowned and the Sacred: To See the Unspeakable', *How to See the World: Visual Activism in an Uncertain World* (29 August 2015), (http://wp.nyu.edu/howtoseetheworld/2015/08/29/auto-draft-73).

10 Ibid.

Ayesha Hameed, extract from *Black Atlantis*, performance script, in *We Travel the Space Ways: Black Imagination, Fragments and Diffractions*, eds. Henriette Gunkel and Kara Lynch (Bielefeld: transcript Verlag, 2019) 120–5.

Stefano Harney and Fred Moten
Fantasy in the Hold//2013

Hapticality, or Love

[...] Never being on the right side of the Atlantic is an unsettled feeling, the feeling of a thing that unsettles with others. It's a feeling, if you ride with it, that produces a certain distance from the settled, from those who determine themselves in space and time, who locate themselves in a determined history. To have been shipped is to have been moved by others, with others. It is to feel at home with the homeless, at ease with the fugitive, at peace with the pursued, at rest with the ones who consent not to be one. Outlawed, interdicted, intimate things of the hold, containerised contagion, logistics externalises logic itself to reach you, but this is not enough to get at the social logics, the social poesis, running through logisticality.

Because while certain abilities – to connect, to translate, to adapt, to travel – were forged in the experiment of hold, they were not the point. As David Rudder sings, 'how we vote is not how we party'. The hold's terrible gift was to gather dispossessed feelings in common, to create a new feel in the undercommons. Previously, this kind of feel was only an exception, an aberration, a shaman, a witch, a seer, a poet amongst others, who felt through others, through other things. Previously, except in these instances, feeling was mine or it was ours. But in the hold, in the undercommons of a new feel, another kind of feeling became common. This form of feeling was not collective, not given to decision, not adhering or reattaching to settlement, nation, state, territory or historical story; nor was it repossessed by the group, which could not now feel as one, reunified in time and space. No, when Black Shadow sings 'are you feelin' the feelin'?' he is asking about something else. He is asking about a way of feeling through others, a feel for feeling others feeling you. This is modernity's insurgent feel, its inherited caress, its skin talk, tongue touch, breath speech, hand laugh. This is the feel that no individual can stand, and no state abide. This is the feel we might call hapticality.

Hapticality, the touch of the undercommons, the interiority of sentiment, the feel that what is to come is here. Hapticality, the capacity to feel though others, for others to feel through you, for you to feel them feeling you, this feel of the shipped is not regulated, at least not successfully, by a state, a religion, a people, an empire, a piece of land, a totem. Or perhaps we could say these are now recomposed in the wake of the shipped. To feel others is unmediated, immediately social, amongst us, our thing, and even when we recompose religion, it comes from us, and even when we recompose race, we do it as race

women and men. Refused these things, we first refuse them, in the contained, amongst the contained, lying together in the ship, the boxcar, the prison, the hostel. Skin, against epidermalisation, senses touching. Thrown together, touching each other, we were denied all sentiment, denied all the things that were supposed to produce sentiment, family, nation, language, religion, place, home. Though forced to touch and be touched, to sense and be sensed in that space of no space, though refused sentiment, history and home, we feel (for) each other. [...]

Stefano Harney and Fred Moten, extract from *The Undercommons: Fugitive Planning & Black Study* (Wivenhoe: Minor Compositions, 2013) 97–8.

Isuma
One Day in the Life of Noah Piugattuk//2019

Historical Background

By the early 1960s, like Denmark and Norway, Canada is a 'minor' Cold War country sharing its circumpolar arctic region with the world's two super-powers, the United States and the Soviet Union. This undifferentiated chain of national mainlands and offshore islands, forming a ring around the Arctic Ocean and its north pole, itself mostly frozen solid permanently except for the southern edges that melt in the short arctic summers, is occupied almost exclusively by Indigenous peoples with common ancestries and languages.

Despite continuous Indigenous habitation for at least four millennia, both land and sea are claimed by the five national states in a continuous tension, with its many disputed borders made more ambiguous by the fact that these lands are generally treated and governed as if they were 'uninhabited'.

In May 1961, when Boss arrives at [Noah] Piugattuk's remote seal-hunting camp on the ice near Kapuivik, the word 'uninhabited' means simply that no one lives there except Inuit – like Piugattuk's clan of men, women and children going about their normal business of living as their ancestors have done since Moses crossed the Sinai – with a scattered handful of qallunaat like Boss sent to trade, manage or control them.

Despite being thousands of kilometres from the centres of twentieth-century information, knowledge and national power, both Piugattuk and Boss, in their own ways, understand more than most southern Canadians, Americans or Russians about the global political and military complexities being played out in the arctic landscape around them, including the bizarre mystery of Strategic

Air Command bombers carrying armed nuclear weapons flying high overhead as Inuit hunt seals, walrus and caribou like their ancestors.

From the earliest European exploration, this circumpolar arctic was coveted for its vast potential wealth, first for its whale oil and baleen, and then for its fox fur trade. Whaling and fur-trading brought the first whites to the region, mostly as seasonal visitors but occasionally over-wintering in semi-permanent stations.

As in southern regions of the colonial New World, national conflicts over colonised territory were also common in the arctic, as Canadian, American, Danish, Basque or Siberian whalers would hunt wherever they found the most plentiful whale-hunting grounds. In the 1890s, the first semi-permanent whaling station was established in the eastern arctic by a Connecticut whaling captain, George Comer, who began overwintering in Repulse Bay, on the western side of Hudson's Bay, leading to Canadian fears that the United States might claim sovereignty over Canada's arctic coastline. In the 1920s, triggered by an incident in which an Inuit hunter killed a qallunaat trader who had lost his mind and was threatening Inuit (see *The Journals of Knud Rasmussen),* Canadian 'sovereignty' was established in north Baffin Island with a permanent police presence of one RCMP officer. [...]

In May 1961, when Boss arrives by dogteam to Piugattuk's seal-hunting camp on the ice near Kapuivik, the Cold War and its MAD doctrine of mutually assured destruction are at their peak. Nuclear-armed SAC bombers are in the air constantly flying from arctic air bases attached to DEW [Distant Early Warning] Line sites; within a year the Cuban Missile Crisis would bring the world to the brink of mass nuclear destruction carried out by missiles and planes flying over the polar arctic; and Canada's concern for the national sovereignty of its northern region, threatened not only by Soviet attack but by American control, was greater than ever before.

This all adds up for Inuit.

To Inuit, Boss is the Government's man; as such he represents the violent threat of military force, the kind of unthinkable force Inuit have heard of for years. Inuit listened to Priests' short-wave radios during the Second World War when thousands or millions of qallunaat from different tribes and territories shot and blew one another up with bombs for years, never stopping until one side or the other is completely wiped out.

As Government man, Boss wears a hand-gun on his belt. All the time. He walks around town wearing a pistol. Even under his caribou outer clothing, Inuit know Boss is wearing his hand-gun. What is a hand-gun for? What kind of animal can he hunt with a hand-gun? [...]

Isuma, extracts from *One Day in The Life of Noah Piugattuk* (screenplay by Norman Cohn, 2019) 44–5, 49.

Available at www.isuma.tv/noah-piugattuk/script-english

Allan Sekula
Fish Story//1995

[...] What one sees in a harbour is the concrete movement of goods. This movement can be explained in its totality only through recourse to abstraction. [Karl] Marx tells us this, even if no one is listening anymore. If the stock market is the site in which the abstract character of money rules, the harbour is the site in which material goods appear in bulk, in the very flux of exchange. Use values slide by in the channel; the Ark is no longer a bestiary but an encyclopedia of trade and industry. This is the reason for the antique mercantilist charm of harbours. But the more regularised, literally containerised, the movement of goods in harbours, that is, the more rationalised and automated, the more the harbour comes to resemble the stock market. A crucial phenomenological point here is the suppression of smell. Goods that once reeked – guano, gypsum, steamed tuna, hemp, molasses – now flow or are boxed. The boxes, viewed in vertical elevation, have the proportions of slightly elongated banknotes. The contents anonymous: electronic components, the worldly belongings of military dependents, cocaine, scrap paper (who could know?) hidden behind the corrugated sheet steel walls emblazoned with the logos of the global shipping corporations: Evergreen, Matson, American President, Mitsui, Hanjin, Hyundai.

Space is transformed. The ocean floor is wired for sound. Fishing boats disappear in the Irish Sea, dragged to the bottom by submarines. Businessmen on airplanes read exciting novels about sonar. Waterfront brothels are demolished or remodelled as condominiums. Shipyards are converted into movie sets. Harbours are now less *havens* (as they were for the Dutch) than accelerated turning-basins for supertankers and container ships. The old harbour front, its links to a common culture shattered by unemployment, is now reclaimed for a bourgeois reverie on the mercantilist past. Heavy metals accumulate in the silt. Busboys fight over scarce spoons in front of a plate-glass window overlooking the harbour. The backwater becomes a frontwater. Everyone wants a glimpse of the sea. [...]

To the extent that transnational capital is no longer centred in a single metropole, as industrial capital in the 1840s was centred in London, there is no longer 'a city' at the centre of the system, but rather a fluctuating web of connections between metropolitan regions and exploitable peripheries. Thus the lines of exploitation today may run, for example, from London to Hong Kong, from Hong Kong to Shenzhen, from Taipei to Shenzhen, from Taipei to Hong Kong and Taipei to Beijing, from Beijing to Hong Kong and from Beijing to Shenzhen, and perhaps ultimately from a dispersed and fluid transnational block of capitalist

power, located simultaneously in London, New York, Vancouver, Hong Kong, Singapore, Taipei and Beijing, drawing ravenously on the rock-bottom labour costs of the new factories in the border city of Shenzhen and in the surrounding cities and countryside of Guangdong province in southern China. The ability of Taiwanese manufacturers to move rapidly from production in Taiwan to production in Guangdong or Fujian province is largely a function of the unprecedented physical mobility of manufactured goods and machinery. Shoes made one month in Taiwan are suddenly made a month later in Guangdong at greatly reduced cost. The shoes are identical, only the label registers the change. And even labels can be falsified when import restrictions are to be circumvented. The flow of cargo to Japanese or North American or European markets is never interrupted. A ship leaves Hong Kong with its forty-foot steel boxes full of sneakers, rather than Keelung or Kaohsiung.[1]

The key technical innovation here is the containerisation of cargo movement: an innovation pioneered initially by United States shipping companies in the latter half of the 1950s, evolving into the world standard for general cargo by the end of the 1960s. By reducing loading and unloading time and greatly increasing the volume of cargo in global movement, containerisation links peripheries to centres in a novel fashion, making it possible for industries formerly rooted to the centre to become restless and nomadic in their search for cheaper labour.[2] Factories become mobile, ship-like, as ships become increasingly indistinguishable from trucks and trains, and seaways lose their difference from highways. Thus the new fluidity of terrestrial production is based on the routinisation and even entrenchment of maritime movement. Nothing is predictable beyond the ceaseless regularity of the shuttle between variable end-points. This historical change reverses the 'classical' relationship between the fixity of the land and the fluidity of the sea.

The transition to regularised and predictable maritime flows initiated by steam propulsion was completed a century later by containerisation. If steam was the victory of the straight line over the zigzags demanded by the wind, containerisation was the victory of the rectangular solid over the messy contingency of the Ark. As we will see, containerisation obscures more than the physical heterogeneity of cargoes, but also serves to make ports less visible and more remote from metropolitan consciousness, thus radically altering the relationship between ports and cities.

The story is of course more complicated than this. It would be difficult to argue that the pioneers of containerised shipping had a vision of the global factory. Their innovations were responses to the internal competitive demands of the shipping industry, but these demands were, by their very nature, of an international character. Historically-militant seagoing and dockside labour had to be tamed and disciplined: the former had to be submitted to the international search for

lower wages, the latter subjected to automation. Ships themselves had to be built bigger and differently and by workers earning relatively less than their historical predecessors. International capital markets had to be deregulated and tariff boundaries circumvented or dissolved by fiat or international agreement, but these legal changes follow rather than precede containerisation. NAFTA and GATT are the fulfilment in international trade agreements between transnational elites of an infrastructural transformation that has been building for more than thirty years.

Indeed, it can be argued further that the maritime world underwent the first legally mandated internationalisation or 'deregulation' of labour markets with the invention by American shipowners and diplomats of the contemporary system of 'flag of convenience' registry in the late 1940s. At the time, American trade unionists concerned about the decline of the US merchant fleet complained about 'runaway ships', drawing an analogy with the 'runaway shops' of the textile industry then relocating from New England to the non-union South.[3] Little did they imagine that within three decades factories would follow ships to a more complete severing of the link between ownership and location. The flag of convenience system, which assigned nominal sovereignty to new maritime 'powers' such as Panama, Honduras and Liberia, allowed owners in the developed world to circumvent national labour legislation and safety regulations. Crews today are drawn primarily from the old and new third worlds: from the Philippines, Indonesia, India, China, Honduras and Poland, with Asians in the majority. Seagoing conditions are not infrequently as bad as those experienced a century ago.[4] The flag on the stern becomes a legal ruse, a lawyerly piratical dodge. To the victories of steam and the container, we can add the flag of convenience: a new ensign of camouflage and confusion, draped over the superficial clarity of straight lines and boxes.

My argument here runs against the commonly held view that the computer and telecommunications are the sole engines of the third industrial revolution. In effect, I am arguing for the continued importance of maritime space in order to counter the exaggerated importance attached to that largely metaphysical construct, 'cyberspace', and the corollary myth of 'instantaneous' contact between distant spaces. I am often struck by the ignorance of intellectuals in this respect: the self-congratulating conceptual aggrandisement of 'information' frequently is accompanied by peculiar erroneous beliefs: among these is the widely held quasi-anthropomorphic notion that most of the world's cargo travels as people do, by air. This is an instance of the blinkered narcissism of the information specialist: a 'materialism' that goes no farther than 'the body'. In the imagination, e-mail and airmail come to bracket the totality of global movement, with the airplane taking care of everything that is heavy. Thus the proliferation of air-courier companies and mail-order catalogues serving the professional, domestic and leisure needs of

the managerial and intellectual classes does nothing to bring consciousness down to earth, or to turn it in the direction of the sea, the forgotten space.

Large-scale material flows remain intractable. Acceleration is not absolute: the hydrodynamics of large-capacity hulls and the power output of diesel engines set a limit to the speed of cargo ships not far beyond that of the first quarter of this century. It still takes about eight days to cross the Atlantic and about twelve to cross the Pacific. A society of accelerated flows is also in certain key aspects a society of deliberately slow movement.

Consider, as a revealing limit case, the glacial caution with which contraband human cargo moves. Chinese immigrant-smuggling ships can take longer than seventeenth-century sailing vessels to reach their destinations, spending over a year in miserable and meandering transit. At their lowest depths, capitalist labour markets exhibit a miserly patience. […]

1 [Footnote 2 in source] See Xianming Chen, 'China's Growing Integration with the Asia-Pacific Economy', in *What Is in a Rim? Critical Perspectives on the Pacific Region Idea*, ed. Arif Dirlik (Boulder: Westview Press, 1993) 89–119.

2 [3] I owe this insight to Stan Weir.

3 [4] Rodney Carlisle, *Sovereignty for Sale: The Origins and Evolution of the Panamanian and Liberian Flags of Convenience* (Annapolis: Naval Institute Press. 1981) 112.

4 [5] See Paul K. Chapman, *Trouble on Board: The Plight of International Seafarers* (Ithaca: ILR Press, 1992).

Allan Sekula, extracts from *Fish Story* (1995) (exh. cat.) (2nd edn, Düsseldorf: Richter Verlag, 2002) 12, 48–50.

Heba Y. Amin
Operation Sunken Sea//2018

Operation Sunken Sea is an attempt to flip a historical narrative and to place myself at its centre as a radical act. I recently discovered Atlantropa, which was a proposal for a giant engineering project to drain the Mediterranean Sea, devised by a German architect named Herman Sörgel in the 1920s. He believed that uniting Europe and Africa as one continent could create the resources needed to rival the economic power of Asia and the Americas. It was a techno-utopian idea, typical of the early twentieth century, when people really believed that technology could solve the world's problems – or Europe's at least.

When I looked into Atlantropa further, I discovered that many other people had proposed similar ideas at around roughly the same time. Jules Verne was one of the first; his last novel, *Invasion of the Sea*, is about French colonisers who channel the Mediterranean into the Sahara Desert and run up against North African tribes. Shortly after it was published in 1905, a few other French and German geographers devised their own versions. Ultimately, they all use Africa's resources to rebuild Europe's strength. Of course, none of them are pitted as colonial projects; they're portrayed as projects of peace and as a coming-together of the two continents, which is funny.

I became really fascinated by these ownership claims to the Mediterranean Sea, which carries so many histories and belongs to so many cultures. Who were these megalomaniacal men who felt that it was theirs to control? Where does that entitlement come from, and what does it feel like? I thought it'd be interesting to replicate that viewpoint, but from the other side. What would happen if these projects were proposed by an African Arab woman who used the exact same logic and the same constructs – how would that read?

I wanted to embody these men. I'm plagiarising their ideas, drawings and plans, and I'm restaging their portraits, putting myself in their place. In turn, I am claiming their stories and erasing them from history. I recently gave my inaugural speech in Malta, where *Operation Sunken Sea* was first staged in the exhibition 'Dal Bahar Madwarha' ('The Island is What the Sea Surrounds') for Valletta 2018, and I've been researching dictators' speeches, trying to understand their mannerisms, gestures and language. I believe that a masculinist, patriarchal spirit is fundamental to these colonialist projects and attitudes.

The installation itself has a bureaucratic, old-world feel, with dictatorial motifs and props mixed in. The flags that flank my desk are emblazoned with the project's insignia, which is derived from a map of the Mediterranean Sea by Persian geographer Al-Istakhri in a tenth-century Islamic manuscript. Many of these old manuscripts illustrated the sea as a positive space and everything around it as negative. It was wonderful to discover this reversal. It also speaks so well as to why so many artists in the Middle East have research-based practices. We suddenly have access to many archives we couldn't access before, and we can now investigate our own histories and do our own anthropological studies. For those of us who have been colonised, I believe this is how we break the stronghold – by rewriting history.

Heba Y. Amin, 'Heba Y. Amin discusses her work in the 10th Berlin Biennale for Contemporary Art' (as told to Juliana Halpert) *Artforum* (June 2018). Available at www.artforum.com/interviews/heba-y-amindiscusses-her-work-in-the-10th-berlin-biennale-for-contemporary-art-75675

Michelle Antoinette
Fluid Encounters: Lani Maestro's *A Book Thick of Ocean*//2014

The stories I want to tell are never stories in the way I expect them to be. They always take different forms and shapes much like the fluid ocean does.[1]

[...] Lani Maestro's a *book thick of ocean* formed part of the 'Crossing Borders' exhibition component of 'The Third [AsiaPacific Triennial of Contemporary Art]' (APT 3), which encompassed artists of crosscultural life and artistic experience. [...] The book itself is five-hundred pages long, with an identical black and white photograph of the ocean printed on each page. It is presented lying open on an oak table, inviting the viewer to turn its pages. While, at first, engagement with the work seems quite simple, the interaction gradually becomes highly meditative. The constant ebb and flow of the sea is made still through the photograph, capturing this beautiful moment in the life of the ocean for our contemplation. As we find our gaze drawn into the photograph, stillness is turned into movement as we imagine drifting with the waves that carry this ocean; in this sense, the work becomes one of healing and calm but also contemplation and reflection. In the process of absorbing a particular image of the ocean, repeated over and over again, a meditative response is induced; echoing [Walter] Benjamin,[2] there is no 'original' representation here, on account of the incessant reproducibility of the photograph. Rather, we undertake 'a voyage into the erasure of repetition [...] a paradoxical nothingness'.[3] [...]

Maestro tends to resist the idea that her Philippine cultural background might be a principal motivation for understanding her art practice and discourages the utility of race and ethnicity in defining her art:

> We have a fear of not knowing, of things that we do not easily identify and we are always looking for a frame to refer it to. I think my work resists any kind of representation in that it is difficult to speak of the complexities of the world as event. My interest in addressing issues of power relationships in my art practice have become more freeing as I address my own identity as something that is not fixed.[4]

If there is a direct source of inspiration for *a book thick of ocean* it might be Maestro's vivid memory of contemplating the ocean as a child in the Philippines: 'When I was young [...] I just went to visit my mom who lived by the ocean and

sat in front of the sea for hours and hours. It was very healing.'[5] Elsewhere, we learn that the work 'exists as an object of mourning for the death of Maestro's Nany, her heart mother'.[6] [...] We might thus deduce that cultural memory is manifested *in a book thick of ocean* via the visual metaphor of ocean, of seas surrounding the Philippines and the personal memories they hold for the artist.

There is also the ocean's symbolic suggestion of cultural oscillation and disjuncture, common to artists working 'in-between' cultures. With regard to the latter, when she returned to the Philippines in the period after the lifting of martial law in 1981, Maestro came to the conclusion that she did not feel at home in the Philippines, but nor did she in Montreal:

> I was confronted upon returning from the Philippines with feelings of alienation and confusion, a loss of identity and no sense of belonging. I come from the Philippines and live in Canada, but I don't feel like I belong to either place.[7]

While likely drawing on personal experiences linked to her past in the Philippines and her subsequent life experiences abroad, Maestro's art is foregrounded in more profound philosophical questions about identity and difference, the self and the other, and the unpredictable 'unfolding of new subjectivities'[8] in the art-making process. [...]

Obvious visual markers of cultural affiliation – potentially delimiting/foreclosing audience engagement by evoking a didactic identitarian politics – are absent in much of Maestro's art practice, allowing the artist to contemplate the complexity of her own subjectivity through her art, at the same time as allowing viewers to explore their own. As with much of Maestro's art, *a book thick of ocean* activates a reflection and questioning of *difference*: i.e. Derridean or Kristevan *différance* in its broad philosophical sense – 'what do we see when we begin to look at the other within ourselves?'[9]

It is in this sense that *a book thick of ocean*, much like other artwork by Maestro, moves us beyond an identitarian politics of representation (nation, ethnicity, Asianness, etc.) to more philosophical considerations about the self and the other and the relationship between them. [...]

In its allusion to the ocean of her childhood, Maestro's *a book thick of ocean* is potentially a reminder of the fluid waters surrounding the Philippines and the archipelago of Southeast Asia more broadly. But, as she herself tells us, this work is less about identifying the Philippines and more about the complexities of identity-in-becoming – not only of the artist's becoming but also of our own in affective and self-reflexive relation to her artwork. In this sense, *a book thick of ocean* is possibly about oceans everywhere but possibly, too, the invocation of a vast space of repeating, endless void in which to contemplate our being in the

world is of little relevance to Oceanic things and is, rather, a personal revelation of the human condition and spirit. [...]

1 Lani Maestro, quoted in press release for 'dream of the other (*rêve de l'autre*)', installation exhibition at Galerie La Centrale, Montreal, Canada, April 1998.

2 [Footnote 135 in source] Walter Benjamin, 'The Work of Art in the Age of Mechanical Reproduction' (1936), in *Illuminations*, ed. and intro. Hannah Arendt, trans. Harry Zohn (London: Jonathan Cape, 1970) 219–53.

3 [136] Stephen Horne, 'Because of Burning and Ashes: A Few Works by Robert Frank and Lani Maestro', in *Image and Inscription: An Anthology of Contemporary Canadian Photography*, ed. Robert Bean (Toronto: Gallery 44 Centre for Contemporary Photography, YYZ Books, 2005) 181–9.

4 [139] Lani Maestro, as quoted in Thérèse Bourdon, 'The Art of Letting Go,' *The Concordian* (26 October 2005).

5 [140] Michelle Antoinette, personal communication with Lani Maestro, 27 September 1999. Linked with this, the artist explains the significance of the French title of the artwork: 'un livre en plein mer' (a direct inversion of the English) evokes the idea of 'the book out in the ocean field, that which facilitated mourning philosophically [...] *mer* is "mother" in French.' Antoinette, personal communication with Maestro, 16 March 2014.

6 [141] Keith Wallace, 'The Beauty of Rupture: Artists of Asian descent and Canadian identity', *ART AsiaPacific*, no. 24 (1999) 70.

7 [143] Dana Friis-Hansen, Jeff Baysa, Alice Guillermo and Patrick Flores (eds.), *At Home and Abroad: 20 Contemporary Filipino Artists* (exh. cat) (San Francisco: Asian Art Museum of San Francisco, 1998) 51.

8 [144] Lani Maestro, 'Locus', in *Locus: Interventions in Art Practice*, ed. National Commission for Culture and the Arts (Manila: National Commission for Culture and the Arts, 2005) 251.

9 Ibid, 250.

Michelle Antoinette, extracts from *Reworlding Art History: Encounters with Contemporary Southeast Asian Art after 1990* (Amsterdam and New York: Editions Rodopi, 2014) 58–65, 67.

Tacita Dean
Teignmouth Electron//1999

The Postcard

In 1968, Donald Crowhurst was one of nine competitors who entered the *Sunday Times* Golden Globe Race to be the first to circumnavigate solo non-stop around the world. He was a family man with a struggling business and no professional sailing experience, but his determination to enter and to win set him on a path of delusion that swept up others and trapped him into leaving in an unfit boat, ill prepared and afraid. Crowhurst's story is as much about his bravado and the politics of a small provincial town as it is about epic voyages and heroism.

When you catch the train to Penzance on what used to be called the Cornish Riviera, you pass through a stretch of Devon where the cliff has broken away to form stacks along the coast, and the railway track borders on the sea. The train never stops at the station there, and is often moving too fast for you to make out its name. I was always fascinated by the thought of this place and I at last found myself there, because this was Teignmouth, the town where Crowhurst set out from, and his intended home port for the race.

I was looking for a postcard which I was sure had been produced to commemorate the event. I wanted some physical proof of the story: a token that would connect the man to the place. We went first to a newsagent but they had never heard of him and told us to try the docks. We wandered to a concrete jetty where a group of men were loading sand onto a trawler. I tapped the glass and asked a man in the security box. He told me to try Fred Tooley, who used to be on the Council. Fred Tooley was sitting in the dockers' cafe. He remembered Crowhurst very well, and thought he did have a couple of those postcards somewhere. If he could find them, and had two, he'd let me have one. We arranged to meet him later in a pub on the front where he was working as a bouncer.

We walked up to the Council offices: a house set in a park on the hill that looked out to sea. We had to start thinking about spending the night in Teignmouth and here was a row of 'bed & breakfasts' that afforded a view of the docks.

Crowhurst's voyage was inextricably caught up with the affairs of Teignmouth Council. He became a tool for their Publicity Committee, and after he had found financial support for the construction of his trimaran locally, he named it *Teignmouth Electron* after the town. From what I can gather, he probably loved being the darling of Teignmouth in these few hectic months prior to his departure, but gradually this local pride became too much to bear, and

in those agonising days when he was desperately trying to get ready to leave, he must have despised the bunting on the quay, and the dignitaries preparing to wave him off. They stood between him and his way of escape. He must have known there was no getting out of it then, and that he was trapped by his own bravado, and by their zealous civic pride. [...]

Donald Crowhurst took 16mm film, made tape recordings and kept logbooks. He got mid-way into the Atlantic before realising he would not survive one day in the Roaring Forties let alone make it around the world. Something happened here; rather than give up, he set about faking his journey. First by estimating mathematically his supposed position and faithfully recording it in a different logbook, and then by breaking off radio contact so as not to betray himself by continually transmitting through Portishead. He hung around the Southern Atlantic, avoiding the shipping lanes, and at one point put ashore for repairs at Rio Salado, a tiny settlement on the coast of Argentina, which was against the rules of the race. After a while he just started vaguely to guess his sight readings and make more and more incoherent entries in his logbook, immersing himself in Einstein's theories on relativity and his own private discourse on God and the Universe.

Meanwhile, the world believed he was making great headway. His press agent in Teignmouth, Rodney Hallworth, became so exasperated with the radio silence that he vastly exaggerated Crowhurst's progress. By June 1969, when Crowhurst's fictional Journey collided with his real position in the Atlantic, and he could once again radio through Portishead, he learnt he was officially winning the race. The BBC radioed through arrangements to meet him off the Isles of Scilly.

But Crowhurst no longer knew where he was. He had lost all track of time and developed an obsessive relationship with his faulty chronometer, the instrument that measures Greenwich Mean Time on board. He began to suffer from 'time-madness', a familiar problem for sailors whose only way of locating their position is through zealous time-keeping. Once his sense of time became distorted, he had no further reference point in the shifting mass of grey ocean. Overwhelmed by the enormity of his deceit and his offence against the sacred principle of truth, what he believed to be his 'Sin of Concealment', Crowhurst 'resigned the game' and appears to have jumped overboard with his chronometer, just a few hundred miles from the coast of Britain.

It took some time for Crowhurst's deception to be revealed. When they found the abandoned trimaran in the Atlantic, the newspapers talked of an accident, while Clare, his wife, believed he was still alive: 'I am confident my husband is alive. I feel it.'[1] When the logbooks were eventually examined, the anguish of his real journey was serialised in the broadsheets.

For many, Donald Crowhurst is just a cheat who abused the sacred unwrittens of good sportsmanship. But for some it is more complicated than this, and he is seen as much as a victim of the Golden Globe as the pursuer of it. His story is about human failing; about pitching his sanity against the sea; where there is no human presence or support system on which to hang a tortured psychological state. His was the world of acute solitude, filled with the ramblings of a troubled mind. [...]

1 [Footnote 3 in source] Front page of *The Times*, (11 July 1969).

Tacita Dean, extracts from *Teignmouth Electron* (London: Book Works, in association with the National Maritime Museum, 1999) n.p.

Jan Verwoert
Bas Jan Ader: *In Search of the Miraculous*//2006

1. Existential Conceptual Art

In the fall of 1973 Bas Jan Ader took a night-time walk through Los Angeles, from the Hollywood hills down to the Pacific Ocean. He recorded this walk with a series of 18 black and white photographs entitled *In Search of the Miraculous (One Night in Los Angeles)*. Starting beside a highway at dusk and arriving by the sea at dawn, Ader is shown traversing the urban sprawl at a determined but unhurried pace, often visible only as a silhouette in a dark alley, or shot from behind against a panorama of city lights. Like subtitles on a movie image, Ader wrote the lyrics of the Coasters' 1957 song 'Searchin'' line by line on the bottom of the photos, and thereby linked the romantic iconography of the solitary wanderer to a commodified version of the quest for the sublime in the guise of an old pop song about the search for love. In 1974 Ader decided to continue this work and turn it into a three-part conceptual piece. His plan was to realise the quintessential sailor's dream, to cross the Atlantic in a one-man yacht, document the voyage and then close the project with a third work, a walk through Amsterdam at night that was to mirror the Los Angeles piece.

In April 1975, as a prelude to the Atlantic crossing, Ader presented the 1973 photographic piece in the eponymously titled show 'In Search of the Miraculous' at the Claire Copley Gallery in Los Angeles. Printed on the invitation card to the exhibition was an image of a vintage-looking black and white photograph taken on board a sailing ship rocking through rippling waves, across which the show's

title was printed in elegant italics. On the opening night a group of Ader's students from the University of California in Irvine sung traditional shanties to piano accompaniment. The performance was photographed and recorded on tape. During the show the images were projected as slides on a carousel, the music played from the taped recording and the lyric sheets displayed on the wall. In July 1975 Ader announced the Atlantic crossing in a bulletin published by his Amsterdam gallery Art & Project, in association with Claire Copley and the Groningen museum in Groningen, Holland – Ader's native town, where all three parts of the project were to be shown after its completion. The bulletin contained the sheet music to the shanty *A Life On The Ocean Wave* and a black and white photograph of Ader on his tiny boat, facing away from the camera towards the horizon as if about to set course for the open sea. Here the title of the piece was given as *In Search of the Miraculous (Songs for the North Atlantic: July 1975–)*. On the 9th of July 1975 Ader set sail from Cape Cod to cross the Atlantic in his one-man yacht, Ocean Wave.

In Search of the Miraculous is the consequent realisation of an idea, the idea of the romantic tragic hero on a quest for the sublime. In this cycle of works Ader first isolates and objectifies this idea by boiling it down to its essential features: one individual, silent and alone, approaches the limits of society and culture where the city borders on nature at the coastline, and goes beyond this limit into the unknown by travelling across the ocean on a boat by himself. This is an odyssey that is, by definition, both an experience of what lies beyond normal life and a form of homecoming, as Ader will be going back to the land he comes from. Ader then puts the idea into practice with highly economical means, through a series of performances with a clear-cut outline, documented through photographs and texts. All excess information is stripped away from the idea. No stories are told about the background of any of the actions Ader performs. Only an announcement, the documentation and some of the material (the music sheets) used in the process are presented. Although he performs the walk and the crossing, Ader downplays this personal involvement in the work by presenting himself as merely a figure with few discernible character traces: a man whose features are barely visible, whether photographed on a boat at sea, or walking through LA at night. The particular personal identity of both of these figures remains more-or-less irrelevant to the piece. Seen from a conceptual point of view, Ader (as well as his collaborators) simply plays a role in order to realise an idea. The entire cycle of *In Search of the Miraculous* is thus characterised by the particular way in which Ader uses the means of conceptual art – the purposeful reduction of art to the staging of a specific idea – to frame a key motif from the culture of Romanticism, that of the wandering tragic hero on a quest for the sublime.

The concise conceptual underpinnings of the work are met by a sensibility for the intertextual filiation of ideas as Ader extracts the motif of the romantic

tragic hero on a quest for the sublime from popular images or songs, and thereby places it in a framework of cultural references. *In Search of the Miraculous (One Night in Los Angeles)*, for instance, plays on the iconography of a solitary traveller that may initially have been derived from Caspar David Friedrich's paintings of lonely wanderers facing sublime landscapes, and which by 1975 had been filtered through into the romantic pop imagery of beatnik road movies. Thus, by subtitling the images of his nocturnal wanderings with the lyrics of the Coasters' song, Ader links a historic visual idiom of romanticism to the modern vernacular of pop culture. The song breaks down the motif of the romantic quest into a set of simple phrases and then repeats them: 'Gonna find her / Gonna find her / Well now if I have to swim the ocean you know I will / and if I have to climb a mountain you know I will / and if she is hiding up on blueberry hill / am I gonna find her still / you know I will cause I've been Searchin' / oh yeh Searchin' my goodness / Searchin' everywhich way.' The combinatorial effect of placing these words with Ader's images of a night-time walk is highly ambiguous. On the one hand the absurdly formulaic character of the lyrics foreground the derivative nature of the images and thereby makes the entire work seem like a practical study on the rhetorics of romantic representation. On the other hand, the genuine experience of a night-time walk, which the images clearly communicate, fills the empty formula of the song-text with new meaning. You feel that the beauty of the idea of the romantic quest might in fact lie in the simple truth that in order to find love you have to travel. Through the ambiguous interplay of text and image the integrity of the romantic idea is thus simultaneously dismantled as pure rhetoric and restored as a true experience.

The choir performance and the plan to cross the Atlantic push this critical ambiguity even further. Here Ader goes beyond the citation of particular images or words towards the evocation of an entire genre: the world of stories, songs, films and fashion that surround the motif of the sailor as romantic hero. Perhaps it can be called the genre of the 'ocean romantic'. Just as the songs that the choir intonates can be understood as stock examples of the musical genre of the shanty, so the photographs Ader uses for the invitation card and bulletin can be seen as tokens of a particular type of photography, as they contain only the absolute minimum of visual characteristics needed to identify them as romantic representations of sea travel. What further serves to frame these themes as genre motifs and create a certain distance towards them is Ader's conceptual choice to select motifs and media that are, if not openly nostalgic, at least decidedly uncontemporary. This decision can be traced through all the works of the cycle: instead of citing the lyrics of a then-contemporary pop song, Ader chooses a formulaic and arguably corny tune from the 1950s, as well as the highly evocative but hopelessly antiquated form of the shanty. Instead of colour

photography, Ader takes black and white images and uses slides instead of film. Significantly, the performances themselves stage untimely actions: crossing LA on foot in place of taking a car; singing shanties in a choir instead of playing pop in a band; and, above all, attempting to go across the Atlantic in a one-man yacht instead of taking a plane. These are all ways of acting and representing that are at odds with the customs of the modern world, and deliberately so.

Ader invokes the idea of the romantic quest through genre representations and untimely acts. He thereby makes it clear that the only way to access this idea today may be through second-hand motifs gathered from the stocks of a prefabricated romanticism. Yet, the twist in his work is that he takes these second-hand motifs and tries them out for real. In this sense, the *In Search of the Miraculous* cycle could be understood as a conceptual experiment. By wandering through LA from dusk until dawn, by staging a shanty choir and by trying to cross the ocean alone Ader puts the idea of the romantic quest to the test in order to see what it is worth and to experience what it feels like to act out an un-contemporary idea. To search for the potential truth of the romantic idea in the face of its obvious commodification may seem quixotic. But this is where the experimental character of the work makes all the difference. Ader does not insist on the validity of the romantic idea or deny its erosion like a stubborn traditionalist. Instead he acknowledges and actively foregrounds the fact that the motifs through which this idea manifests itself today are historical, rhetorical and commodified. The experiment lies precisely in the attempt, against these odds, to find out if the idea has any meaning or not. At the same time Ader brings his doubts into play by framing his experience as an experiment conducted on a set of abstract cultural terms, the outcome of which – a series of conceptual artworks – may arrive at a hypothetical, but not a final, claim of truth. Ader's work encompasses and moves between desire and doubt, experience and speculation, and it does so with a certain lightness. This attitude manifests itself, for instance, in the melancholic humour with which Ader traces the romantic sublime in the banalities of the Coasters' lyrics, and thereby proves that the sublime and the banal are today each other's flipside.

Yet, this thought-experiment is not just a mind game, for, by putting himself in the position as test person, Ader makes an existential investment in the work. He invests both his desires and doubts into the process, and ultimately puts his life at stake in the attempt to cross the Atlantic single-handedly. Ader prepared well for the voyage and was already an experienced sailor, having sailed from Morocco to Los Angeles in 1962. However, the crossing ended tragically: after three weeks at sea radio-contact with Ader's boat, the Ocean Wave, broke off and in April 1976 its wreck was discovered off the Irish coast. Ader himself was missing and his body was never found.

How is it possible to continue to talk about a work that ended so abruptly with the death of the artist? By attempting to cross the Atlantic Ader put the role of the romantic tragic hero to the test by living out one of the last remaining dreams of the romantic quest our society holds dear – the fantasy of the solitary sailor who transcends the limits of society in an encounter with sublime nature. In the end, through his disappearance and death, Ader came to embody this role of the romantic tragic hero in an unexpected and irrevocable way. The work is *about* the idea of the tragic and is itself a tragedy. Therefore, to speak about the work as if nothing happened and to treat it simply as a conceptual piece would mean to betray the existential loss it entailed. However, to portray it solely as a work sealed by the artist's death and therefore to disregard its speculative conceptual dimension would equally do neither the work nor Ader himself justice. In this sense, to create a cult around the disappearance of the artist seems wrong. In fact, one of the most problematic aspects of contemporary subcultures is its maintenance and glorification of the cult of a romantic heroic death. The long unholy lineage from James Dean, Brian Jones, Janis Joplin and Jimi Hendrix through to Ian Curtis and Kurt Cobain in this sense reaffirms the general misconception that artists can gain ultimate authenticity, can prove that they were for real and not just performing, only if they go beyond their work and make that extra sacrifice of their own life. The art world may be more discreet in its cults, yet the work of artists who die an untimely death – artists such as Wols, Eva Hesse or Blinky Palermo – is often treated as if it were exceptionally auratic.

To confuse the artist as a person with the role he assumed when he explored the motif of the tragic romantic hero would be, in the case of Ader, especially problematic. To credit him with a cult authenticity would be to effectively discredit the key concerns of his work that lie precisely in the critical conceptual exploration of the very terms of romantic authenticity. It is, after all, one of the merits of Ader's work that it disentangles the concept of the romantic act from its coercive ties to a belief system, and thereby makes it possible to reconsider the idea, intellectually as well as emotionally. To do justice to Ader, therefore, would mean to respect the liberating way in which he moves freely between the general idea and the specific experience of the romantic quest, and avoid suffocating the work under the heavy cloak of heroic authenticity. Nonetheless, the existential dimension of *In Search of the Miraculous* needs to be taken seriously. […]

2. Staging Grand Emotion

[…] It is precisely because of the suggestive openness of their conceptual form that Ader's works create a sense of the sublime. They preserve, through their cool form, the abstract character of the idea, even in the moment of its actual realisation and thus never exhaust its meaning. Framed as conceptual works,

a lonely walk through LA to the Pacific at night, the recital of shanties and the solitary crossing of an ocean become gestures that point towards infinity as an idea that eludes rational comprehension, and therefore becomes the object of yearning: By foregrounding this evocative, suggestive and open-ended quality of the conceptual gesture, Ader shows how deeply indebted conceptual art is to the aesthetics of the sublime and how it could be therefore understood as an art form dedicated to the 'search of the miraculous'. [...]

3. The Need for Tragedy

[...] Insofar as *In Search of the Miraculous* is a conceptual work based on intertextual references, it suggests a reading of Ader's disappearance as an allegory of the tragic desire for the sublime. Insofar as the attempted ocean crossing is essentially an action carried out in real life, however, its fatal outcome disrupts the abstract form of allegory. From this point of view it is simply a tragedy. These two perspectives may be impossible to reconcile. Yet, Ader's own approach to tragedy may open up a way to connect them. [...]

Jan Verwoert, extracts from *Bas Jan Ader: In Search of the Miraculous* (London: Afterall Books, 2006), 1–9, 14–15, 47 [footnotes omitted].

Chris Dobrowolski
Seascape Escape//2014

One afternoon during my first year, I found myself in the Ferens Art Gallery in Hull. The gallery has a large maritime collection and I was looking at a nineteenth-century painting of a small rowing boat being tossed about on the sea. I wasn't really doing research I was just moping around feeling sorry for myself and contemplating what I should do next. I had probably had another tutorial earlier that day. Quite often when a tutor has no real input to give to a student, the last resort is to give a list of names of artists who do similar work. It's a well-meaning gesture but doesn't really help to find a fulfilling line of personal enquiry. I felt that everything I did had been done before.

We were often told at college that we were learning the visual language but, as students in our early twenties with limited life experience, we didn't have anything worth saying with it. The art college wasn't far from the River Humber and, if you went out of the back door and through the old town you came to Drypool Bridge. This took you over the River Hull, down some steps to a path by

the old flour mill. The path turned left to follow an inlet which was the entrance to the old Victoria Dock. Here it joined a road that followed a line of very old industrial buildings that fronted the River Hull and led to the Buoy Yard where there was a footbridge that crossed over a slipway onto an area called Sammy's Point. Here the River Hull entered the River Humber. The whole area was a bit run down. The grass was overgrown and the city felt a long way away. I went there because it was a great place to get away from things and find a bit of solitude.

The river Humber is over three miles wide at this point and, although sometimes this walk gave me time and space for contemplation, at other times it just accentuated my sense of isolation and depression. When I thought back to my time on the foundation course, I not only remembered the phrase 'inner need' but also 'doing it for real'. It was all about connecting with something on a more fundamental level and challenging our commitment to the subject. We had to 'do it for real' if we were to be taken seriously as artists and have any integrity. I found myself on the north bank of the River Humber in Hull thinking: 'What do I need to do next? What's my motivation?'

The answer, I concluded, was to get the fucking hell out of Hull!

I could have just left the course and gone home but that would have been giving up. Instead, on my next trip to Sammy's Point, I started to collect driftwood. I figured that, if I could get a lot, this time I could build one big boat and, if it was big enough, I could get in it and physically escape from art college.

I knew almost nothing about building a full-size boat so the toy boats I had made the term before became my model. I didn't always interpret them correctly. I thought the keel on the toy boats was designed to stop them from tipping over. It isn't. It's there to keep the boat going in a straight line so that it can sail at an angle to the wind but this basic ignorance didn't deter me at all. I just scaled up what I saw on my toy boats and found a big section of steel to act as my keel (although I thought I was making a counterbalance). I knew I would have problems launching a boat with a piece of metal sticking out so I set about inventing a way to make it retractable. I didn't know about retractable keels used on small sailing dinghies that come up and into the boat via a slot, so I fixed the steel onto the bottom of the boat with chains that acted as a kind of hinge. The other end of the keel was connected at an angle of ninety degrees by ropes that ran from the tip of the keel to two old sash window pulleys connected to either side of the boat. With these ropes I could lower and then hold the keel rigid once the boat was in deep enough water.

My other boat-building experience came from making model ships in bottles. When I was a teenager, my aunt gave me a ship-in-a-bottle kit. It was pretty basic and consisted of a lump of wood that had to be whittled into a boat shape, some cotton (the rigging), a piece of muslin (the sails), glue, instructions and a bottle. Fortunately, my greatest asset, then as now, was my patience. The rigging on a ship

in a bottle has to work pretty much like a real boat. When the model is put into the bottle, all the strings that elevate the masts and sails are extended so that they come all the way out through the neck of the bottle. The hull of the boat is just big enough to get through the neck of the bottle and, when all the sails are erected, it is this that gives the impression that the model couldn't possibly have got into the bottle. A good ship-in-a-bottle has a lot of detail; a tiny anchor, ladders and everything else that a real boat would need but in miniature. I just scaled things up.

A technique I learnt in the life-drawing room when 'scaling up', was to hold a pencil or thumb up to the subject from a distance and then bring it down onto the paper to create approximate proportions. I did this with my boat and its relationship to the River Humber. I would often walk down to the river and look out across the water holding up my finger and thumb, imagining the distance between the two was my boat about halfway across the river. On some days, with the tide on the turn, the water was surprisingly calm. On other occasions it could be quite windy with large waves breaking in mid-stream. It was on a day like this that I looked out across the river, panicked and thought, 'I need a bigger boat'.

Some tutors encouraged us to make sculpture in an 'intuitive' way and I like to think that my random scaling up of the boat against the River Humber was indeed intuitive but this all took much longer than I had anticipated. It was the last term of my year and it was becoming apparent that I would not finish the boat before the end of term. This was vital because I needed to get the boat launched before the weather changed. If I waited until September, just before the autumn Equinox, the water would be too rough for an escape attempt so I moved my part-built boat into the college yard. I devised ways to do most of the construction with hand tools so that I didn't rely on electricity and, when college shut for the summer, I still had access to my boat. Every day I cycled to college, climbed over the fence and carried on building. I was lonelier than ever and, to cap it all, I was breaking into college to work on a boat whose function was to help me escape from art college.

One evening, I took a route home through the municipal gardens in front of the college and stopped to read a small monument that had caught my eye. It was dedicated to Robinson Crusoe who had, apparently, set out on his travels from Hull. Here it was, immortalised in bronze, outside the Queen's Gardens Café. A monument to a fictitious character's imagined relationship to Hull. In recognition, I called my boat 'Friday'.

Eventually some of the technicians discovered me in the college yard, took pity and connected me to the power supply so I could speed things up with power tools. By late August, the boat was finished. The caretaker offered to move it with the college van and trailer and, with the help of the technicians and a small group of students, we took the boat to the river. The boat was lowered into the water and, to everyone's amazement, it floated.

If I was going to escape from Hull in a boat, then the first obstacle was the river Humber. I knew very little about building a boat but I knew even less about sailing one. When you start doing a conspicuous project, however, it often attracts people who are keen to give advice and I picked up a few bits of knowledge along the way. One friend of a friend even lent me some life jackets.

Some of the other advice I received was less practical: 'If you are about to change direction in a sailing boat you have to say "lee-ho" to warn the crew that the boom will swing across the boat.'

This was probably good advice for a racing dinghy but a bit pointless in a boat made from driftwood. All I really wanted to know was how to get it across the estuary in one piece and, eventually, with the help of a few handbooks, I pieced together all the information I needed. The plan was to get the boat into the water just as the tide was coming in and cross the river going upstream with the tide, aiming to get about halfway across before the tide changed and went out again. At this point, I planned to change direction and head for anywhere on the southern bank as I went downstream with the tide, crossing the river in a kind of 'V' pattern. The river was about three or four miles wide at this point and, with the right weather conditions, I thought I could make it.

I wasn't totally 'foolhardy', to quote the local newspaper. I had made an arrangement with the pilot launch at the end of the pier. The main function of the pilot launch was to transport navigational pilots onto the ships as they made their way up and down the river. Its other function was as a safety vessel in case of emergency. The crew had invited me and a couple of friends on board one afternoon for a cup of tea that had turned into a drinking session. We all got a little drunk and at the end of the evening, the two-man crew said they would probably follow me all the way across the Humber when the day arrived. I was going to be perfectly safe.

The day arrived with a relatively calm wind blowing in the right direction so I rushed down to the river to get the boat ready to go. I didn't realise at the time, but I had picked possibly the worst conditions; a spring tide doing 5 knots. I had no idea what 5 knots was like, but I was about to find out. I had also underestimated how long it would take to get the boat ready to sail, we would have to work fast.

I had two other people in the boat with me; Paul Slater, a print student, and Eddie Weldon, a painting student. Eddie was my best friend at art college and had come back to Hull from his parent's farm for a few days to help me. Once we were in the water, the first task was for the 'crew' to help me lash all the rigging to the boat. I had made the mast removable so a lot of ropes needed tying. When we finished, I ran over to the pilot launch to let them know we were about to leave but they weren't the men we had got drunk with a few days before. I assumed they had been briefed, however, and quickly went back to the boat. By this time, the tide was going

out instead of in. Oblivious to this, we launched and, as we drifted off downstream, I spotted the pilot launch going upstream in the opposite direction. We didn't see them again for the rest of the morning. By now, there was no wind and the sails just hung limply. We still had the oars I had made, however, and there was a point at which we could have turned around, rowed back and admitted defeat. We didn't. Very quickly, we drifted too far and had no choice but to carry on down river.

Documentation – Sound

I had an old cassette tape recorder in the boat with us. I thought it would give an interesting audio documentation of the event and capture the ambient sounds of our adventure. As it turned out, the cassette became a bit like the black box flight recorder that you get in an aeroplane. The sound quality wasn't brilliant, a lot of what could be heard was tape hiss interspersed with the sound of water sloshing around in the boat. [...]

The first thing of note is a conversation between the three of us that has a kind of self-congratulatory feel about it. A big wave had just swept up the river, I don't know where from, maybe a ship that had passed by a long way off. It felt quite big to us and we felt as if the boat had been picked up and dropped about three or four feet in the air. We were a little worried but then, as we had obviously ridden it successfully it felt like a little test that we had passed. I thought my large piece of steel underneath had obviously done its job and on the cassette tape you can hear Eddie say: 'We did it alright, if we can get through that we can get through anything.'

This was met by lots of positive noise from Paul and me.

At this point, while we are still congratulating ourselves, it is possible to hear Eddie say: 'We are going to hit this buoy.' [...] Although it was doing five knots, to us, floating as far out as we were, it didn't seem that fast. With no immediate point of reference there were moments when I wondered if we were moving at all. Occasionally we would look at the riverbank in the distance and see some familiar landmark go past and remind ourselves that we were in fact moving. Everything was a novelty to us, here we were the three of us, floating along in a thing that had only a short time ago been lots of separate lumps of wood, we had never seen a buoy in the river, up close before and it was becoming clear that they're really big. When we saw the buoy approaching Paul said:

'Quick, get the cine camera out.'

Documentation – Film

We had an old Super 8 cine camera on board. This was the late 1980s and, although video cameras existed, they were expensive and it wasn't easy to get hold of one. I'd have had to go to the AV Loans Department to book the college

media equipment and, in the circumstances, I didn't think they would lend it to me. Super 8 cine cameras were, by comparison, very cheap and I managed to find one at a car boot sale for 50p. The camera cost less than the film inside and, in the event of an accident, I could afford to lose it. [...]

Our camera was so cheap and the viewfinder so tiny that we were finding it hard to fit anything in. It wasn't the ideal camera for a 12ft boat. The film begins with a shot of Eddie's ear, the back of Paul's head, a shot up a nose. The buoy presented a chance to film something far enough away to fit in the frame. I remember going to the front of the boat to begin filming the buoy and, suddenly, I had my first experience of what 5 knots was like. As I filmed the buoy through the tiny viewfinder, I noticed that it was getting bigger very quickly. The next words on the cassette tape are: 'Get the oar out.'

We still hadn't grasped how fast we were going so I was instructed to lean out with the oar to push us away. This was when I had my full-on encounter with the true meaning of '5 knots'. It's a bit like running as fast you can into a brick wall with a garden cane in your hands. Retrospectively, I was very proud that when the boat smashed into the buoy, it stayed in one piece and I had 'done it for real'. As the bow slammed momentarily against the obstacle, the rear of the boat, still in the slipstream, kept going. It swung around and, slowly, started to point in the opposite direction. At this point on the recording you can hear someone say: 'Lee Ho'.

By this time, we had floated a few miles downstream and were drifting past George Dock, the main port of Hull. The captain of a tugboat, the Lady Joan, had just finished docking a ship and seen us floating past. We were flying the skull and cross bones and the captain said later that he had never seen pirates on the river Humber before and thought he should come and investigate. As he got closer, he realised we were in difficulty and offered to throw us a rope. I tied the rope to the front of Friday and we were pulled alongside the Lady Joan. Like most tug boats, the Lady Joan had enormous tractor tyres tied all along the side and we held onto these and clambered up onto the deck to safety.

It was all a bit of an anti-climax. The project, for me, had a romance about it. After I found out about Robinson Crusoe, I thought I was fulfilling my destiny. I was 21, the right age for an adventurous rite of passage. College tutors had told us that we didn't have anything worth saying and all I had done was float downstream a bit and get rescued. Apart from the collision with the buoy, there hadn't been the kind of intensity that made me feel truly alive. [...]

Chris Dobrowolski, extract from *Escape* (Colchester: Jardine Press, 2014) 10–19.

Klara Hobza
Diving Through Europe (2009-2039): In Conversation with Bergit Arends//2023

In 2009, after having spent her formative years in the United States, Klara Hobza returned to her place of origin wondering how to find her way back into this place that had become estranged to her. Taking the train to visit her grandmother, she observed the river Elbe, contemplating European rivers and their relationship to place, history, violence and myth. She decided to learn to scuba dive to find out more. Once learning of a waterway connecting the North Sea with the Black Sea, she embarked on her Endeavour of *Diving Through Europe.*

Klara Hobza I had never scuba dived before, but I became obsessed with making my fantasy of *Diving Through Europe* into reality. At first, I attempted to train in a regular diving school, but everybody refused to teach me for this particular Endeavour. Around the same time, I was invited to exhibit in Istanbul, and the curator wished to host *Diving Through Europe.* I politely declined, as Turkey was not on my route. (My river connection goes: Netherlands – Germany – Austria – Slovakia – Hungary – Croatia – Serbia – Bulgaria – Romania, if I take the Danube – Black Sea canal, otherwise also Moldova – Ukraine.) I offered that perhaps in 30 years, once I had arrived at the Black Sea, I could consider diving to the Bosporus as a sort of appendix for her exhibition. But she didn't want to wait that long. She kept insisting. Then I thought of how interesting the Bosporus as a body of water was and how rich in metaphor it could be as a training ground. Also, I was still trying to find the right training instructor to prepare me for the dive. We agreed to find me a Jedi Master in Istanbul, and to stage the results of that encounter as the training chapter of *Diving Through Europe.*

It would have to be training for no visibility, high stress diving, the opposite of looking at colourful fish, which was not easy to find. Finally, a school replied: 'We always dive in coral reefs, however, there is one man: Namik Ekin, a retired military diver. He once dived from Istanbul to Cyprus Island, 35 hours non-stop underwater, eating underwater, sleeping underwater. He is holder of twelve Guinness World Records and a fourth-degree black belt in Judo. Namik trained United States Navy SEALs and is the eighth of 22 children.' – 'Please, I need to meet this man!' They called and within one minute he wanted to speak to me. 'I heard what you are doing. Tomorrow morning we meet, we have Turkish tea, I will make a training program for you. Then I am going to teach you how to eat a banana underwater.' I had found my Jedi Master.

Bergit Arends A sense of humour is characteristic of your work. But what looks like the slapstick performance of eating a banana underwater is actually really important for you to carry out the *Diving Through Europe* project, which makes difficult demands on you during this long-term performance. Underlying this is the question of how to be a human being in a marine habitat – to breathe, to eat and to live within the element of water. There is always a messiness or porosity between different habitats and how to be within those and, in a way, different species relations as well. In your project there is a sense of becoming within another habitat, a way of being within a non-terrestrial environment, which is ultimately an environment on which humans rely but in which they cannot survive. You are protected by a full-body neoprene suit, a diving mask and you carry your external supply of oxygen. Obviously eating bananas and drinking underwater is not just about food and water intake, but requires negotiating the medium of air. What do you do with those fundamental challenges?

Hobza Yes, the banana-eating practices become mental training. The danger of diving is to get nervous. A lot of dangerous situations can be easily averted, if you keep your wits about you and react with slow, controlled movements. However, we humans are not used to restricted breathing and that's why people get really nervous and mess up underwater. Eating underwater is a simple exercise to break the habit of breathing while eating. It gets you used to making smart decisions while holding your breath. I highly recommend breathing underwater. It changes your perspective on life altogether.

Arends The idea of the Endeavour is really at the heart of this work, as is the lived experience of this performative sculpture. At the outset the Endeavour of *Diving Through Europe* is very abstract, like following a map of the river Rhine with a finger, noting major cities and ports on the way, marking a beginning and an end point. But then the reality becomes quite other, a physical experience that you later represent visually. Part of your process, the aspect of absolute immersion, reminds me of the eighteenth-century phrase 'on the spot'. Used by travelling artists or expedition artists it conveys a mode of landscape representation in which 'true' knowledge of the natural world is based on direct observations in the field. The term signals the importance of in situ observations to compose a landscape image and to construct authoritative knowledge about distant places. These types of observation contributed to a European iconographic inventory of the world. How does your project unfold in the twenty-first century?

Hobza On one hand there is this simple premise – to go from the North Sea to the Black Sea. On the other hand, there is the actual doing and witnessing: the

live encounters surprise me with so many things that I couldn't predict, providing valuable material to work with. Then there's my symbolic resistance against our society's invention and enforcement of economic efficiency. It's important to me that the Endeavour is set to occupy 30 years. Going from A to B as quickly or successfully as possible is something a world record breaker might do. One might admire that, but I don't think that you would get any complex images or narratives out of it. The obstacles give substance to the raw material of the work.

Once I was diving by the Erasmus Bridge in the city centre of Rotterdam, Netherlands, and as I came out of the water the guys from the control tower had just arrived to start their shift. They asked me what I was doing and my mind started racing because we were surrounded by all these signs saying 'Do Not Jump In'. I was wondering how I was going to talk myself out of this, standing in front of them, dripping into my own puddle. I couldn't tell them that I had just fallen in as I had all my scuba diving gear. So, I relied on their sense of adventure and imagination, and I answered them honestly. I said, 'As a matter of fact, I'm diving through Europe.' They were so impressed that they took me along to show me what *they* were doing, showing off by lifting and lowering the Erasmus Bridge. So there I was, standing in Rotterdam's central water traffic control tower in all my gear, still dripping, watching them raise the city's bridges and coordinating ship traffic on all the monitors. These types of encounters keep showing me that people connect with this Endeavour emotionally through the language of inner images. We forget about our professional functions and other supposed roles in life and interact as humans.

Arends Improvisation and being open to social interactions along the way is really significant. However, these improvisations ultimately don't throw you off course, as it were, but enrich the Endeavour. We have talked about you diving and being inside the element of water. But importantly, you are within waterways that are main trade and traffic routes. You have had close encounters with shipping vessels.

Hobza One day I had decided to take a detour through a smaller channel to get out of the big channel with the container ships. There, the water became very murky, but I enjoyed being immersed in this spectacle of browns, greens, yellows, at times even neon greens. I had one person on the shore helping me and holding a camera. I had told her to hold the camera very still that day, so we could bring across this introverted feeling. At one point I had the strong intuition that I should dive up to see what's up there and where I was. As soon as I hit the surface, I heard her voice yelling my name – she had been yelling all along, but I didn't hear her underwater. I looked in the other direction and there was a huge container ship pushing straight towards me. The suction of the turbines had not yet reached the surface of the water, so I was able to swim away. I swam really fast. In retrospect I

realised the reason the spectrum of colours was shifting so markedly: I had been inside the propeller's currents, pulling me to where I would quickly become a diver smoothie. That's when I started employing a compass.

I know for sure that I don't want to die on this Endeavour. Besides all the usual reasons for averting death, it would be very bad for the project. Any complexity would then be flattened to the mere fact that I acted recklessly, which is not my intention.

Arends Your navigation on the river and its technosphere filled with vessels, bridges and communication centres, then relies on observing colour changes and turbulences within the water combined with an instrument that points to your location. You have not only a somatic experience of the seascape, but seek reassurance and mitigate risk by using a compass.

Hobza Exactly, and due to experiences like this I thought maybe I should do a new kind of cartography, one that's more representative of my physical and emotional states while diving. The techniques of perspective that we employ for picture making above water for example, become irrelevant underwater. There is no such thing as an x-y-z axis when without gravity and in constant movement. In that case, the pace of breathing for example, becomes my measure for proportion and perspective. Also, emotional states are far more vital for one's survival while diving. Drawing this kind of subjective and emotional mapping I found far more helpful for my orientation in diving through Europe.

Klara Hobza, 'In Conversation with Bergit Arends: Diving Through Europe (2009-2039)', a new text written for this book, adapted from an artist's talk for Artists/Oceans online artist talk series, University of East Anglia, 10 February – 3 March 2022.

Ahren Warner
The sea is spread and cleaved and furled//2020

The sea is spread and cleaved and furled, i say. You've said that before, she says, you're starting to repeat yourself.

The sea is spread and cleaved and furled, i say. By the relentless heft of a tanker, she says.

Yes, by the relentless heft of a tanker, i say, and by the small diesel-powered skiff we've borrowed for the day, and filled

with Antipodean millennials and crates of Mythos, until its hull sits a little lower than the Albanian gent who rented it to us

would like. That's true, she says. And by our own bodies, i say. You mean by your own body, she says.

i do, i say, the sea is spread and cleaved and furled by the stuttering heft of my own body, by the whip and flicker

and chunk of my own legs, and by the spread and drag of my oddly spindly arms that heave the weight of my recalcitrant heart

through the waves. I know, she says. i swim like a sad hippo, i say. Without grace, she says.

Yes, i say, but with the plump, grey surety of getting my own way.

[...]

Ahren Warner, extract from *The sea is spread and cleaved and furled* (London: Prototype, 2020) 49.

think about the **FISH**, the land, and your relation to them. You don't have to be kin with the **FISH** (though some of us are), but neither should you be thinking of the **FISH** primarily as a specimen or scientific object.

Max Liboiron, 'Pollution is Colonialism', 2021

ANTHROPOCENE OCEANS

Betty Beaumont
In Conversation with John K. Grande: Culture Nature Catalyst//2004

Betty Beaumont's underwater *Ocean Landmark* (1978–80) project, an interdisciplinary intervention, is a public artwork that most people will never have the opportunity to see, as it is in the Atlantic Ocean. Created by a process of coal ash recycling off the coast of New York, it is a kind of public art that changes the world we live in by transforming the ecology of the fish habitats near Fire Island. Since its inception, the habitat has encouraged fish and vegetation to thrive in an area of the ocean floor once devoid of such life. Still in production, Beaumont's *Decompression* cyber project will enable the public to experience the *Ocean Landmark* using a variety of technologies. [...]

John K. Grande Art can often be segregated from the flow of life and from real living environments. Human creation is placed at a higher level than ontological processes of birth, life, decay, death and rebirth.

Betty Beaumont The first industrial revolution is now officially over. And another one is beginning to take form. It is in this space, this gap or cusp between these revolutions, that my work has taken place over the past thirty-three years. It is in this new transformative space that I will continue to work. It is a political space that has the potential of aligning and integrating how we support life economically and ecologically. To imagine this space, it is vital we change our belief systems. I am suggesting a cultural transformation that will encourage our community to consider nature as an integral part of the human value system.

Grande Your ambitious and farsighted *Ocean Landmark* project was unlike most art practice at the time. It remains a landmark work, and actually involved creating a living underwater ecology that is sustainable.

Beaumont At the end of the 1970s I wanted to do a project that combined metaphor with underwater farming. The result was *Ocean Landmark*, which exists underwater and is made of five hundred tonnes of processed coal waste, a potential pollutant transformed into a productive new ecosystem in the Atlantic off Fire Island. It was during the first OPEC-constructed oil shortage that I became interested in energy. I was concerned with the consequences of

converting oil power plants to coal use. Today more than 50% of our electricity comes from coal. Coal is a fossil fuel: the transformed remains of plants that have been underground at high temperature and great pressure for millions of years. It is mined, burned in a flash, and then its ashes are thrown away.

Ocean Landmark is not meant to encourage the use of fossil fuels. While fossil fuels are used they generate tons of waste material. Ocean Landmark considers stabilised coal waste as a new material and plans for its sustainable future.

Renewable energy such as solar and hydrogen-cell technology are energy sources that we must embrace. While investigating the Atlantic Continental Shelf, a dream emerged: to build an underwater 'oasis' that would be a productive, flourishing site in the midst of an area of urban blight caused by ocean dumping. The work was inspired by the potential of the continental shelf and a team of scientists experimenting with coal waste looking for ways to stabilise this industrial by-product in water. I watched their test site for a year before proposing to use their materials to create an underwater sculpture in the Atlantic Ocean. In researching Japan's construction of artificial reefs, I discovered that a certain shape and size block or structure placed underwater will attract a particular kind of fish, which will then reside there to eventually be harvested as food.

The Ocean Landmark project developed over time with the participation and cooperation of biologists, chemists, oceanographers, engineers, scuba divers, industry and myself. We dove for a season and found a site just off Fire Island about forty miles from New York City's harbour. It was selected for its close proximity to shore and potential for fishing. Seventeen thousand coal fly ash blocks or bricks were fabricated and shipped to the site. Ocean Landmark started to change when it was installed on the continental shelf. It has since developed into a thriving marine ecosystem and continues to evolve. The work is listed as a 'Fish Haven' on the NOAA (National Oceanographic and Atmospheric Administration) 'Approach to the New York Harbour' coastal navigational chart. Ocean Landmark is a realised artwork that suggests a new industry, which makes use of recycled coal waste with the potential to revitalise the coastal fishing industry.

Ocean Landmark is an historical precedent for today's art and science collaborations. There have been no images of the artwork. Underwater photography is not useful in imaging the entire 'body' of work because of the limited visibility of the underwater site. I plan to work with multimedia technologists to image this work in its life-giving, mature condition and in its entire form.

Grande I believe your ongoing Decompression cyber project will allow people to experience the living underwater Ocean Landmark and Living Laboratory.

Beaumont Decompression (2000) is an in-progress cyberworld created by electronically collaging multiple stories and images of the contiguous worlds of technology, science and art. *Decompression* will image *Ocean Landmark* in its life-sustaining form. The technologically mediated images of this underwater oasis will be dynamic. As *Ocean Landmark* is a flourishing ecosystem, *Decompression* will develop into *Living Laboratory*, a thriving information system in cyberspace. Modelled on virtual environments in which the user's perception and spatial position affect their experience of the space, *Living Laboratory* will be a dynamically changing art space with an architecture that combines technologically mediated images and diverse virtual perceptual displays. The realised *Ocean Landmark*, a model for ecological equilibrium in the invisible underwater world, is an interdisciplinary project that for two decades has resided in the domain of the imagination. By visualising *Ocean Landmark*'s invisible realm, *Living Laboratory* will elucidate and elaborate on virtual perceptual models of different ways of experiencing information within a contemporaneous context.

Global positioning satellite technology will locate *Ocean Landmark*, and images will be created through the use of underwater remote sensing and side-scan sonar. Its progression as a sustaining environment for marine life will be codified in the images of the continuously evolving underwater sculpture. Audio recordings of the reverberations of underwater biological growth, water tones, sonic fish noises, and the timbre of breathing underwater with compressed air will also be part of the project. Images and audio that define the broader continental shelf site will be obtained from a variety of sources. *Decompression* offers access to *Ocean Landmark* while simultaneously being a new work of art. As our oceans become overfished to near depletion of specific species, activists might use the cyberspace laboratory to articulate the underwater project as an intervention that would effect policy and revive the offshore fishing industry. While bringing together environmental scholarship and activism, this cyberspace work is also a new work of electronic art that will evolve to be sited in museum and gallery venues as an interactive media installation. [...]

Betty Beaumont and John K. Grande, extracts from 'Culture Nature Catalyst', in *Art Nature Dialogues: Interviews with Environmental Artists*, ed. John K. Grande (Albany: State University of New York Press, 2004) 151–3.

Celina Jeffery
From the Shore to the Coast: Curating the Front Line of Climate Change//2020

[...] In 1951, marine biologist and environmental activist Rachel Carson addressed the significance of healthy ocean life systems and famously described the 'edge of the sea' as a 'strange and beautiful place', an ancient world that continues vivaciously and mysteriously into the present. An 'elusive and indefinable boundary', the intertidal zone is where the elements meet: earth, wind and water constantly merge to form vibrant and dynamic ecosystems.[1] The 'edge of the sea' is an 'ecotone', a blending of two ecosystems, and one of the most fertile on the planet that has allowed for productive and compelling exchanges between communities of biological life. As land and sea constantly mutate in never ending cycles of ebb-and-flood tides, resilient communities of humans have grown alongside nonhuman life in abundant and fleeting exchange.[2] Yet, with every oil spill, major storm or hurricane, the mutability of the coast is once again apparent, and the shore reveals itself once more.

There is now much evidence to suggest that ocean and coastal ecologies, and the many who rely on them, are not only facing collapse but also hold particular pertinence to understanding future ecological catastrophe.[3] The Intergovernmental Panel on Climate Change (IPCC), the UN organisation that assesses the science of climate change, has brought particular attention to the long-term impacts of sea rise, stating that the next century will bring a continued rise of sea water that will 'remain elevated for thousands of years'.[4] The report underscores the connections between a vast array of oceanic ecosystems that are now warmer, more acidic and less fecund, all caused, in some part, by human activity. Coastal areas, and particularly their Indigenous communities, will incur the worst of these effects, as the IPCC argues: 'Human communities in close connection with coastal environments, small islands (including Small Island Developing States), polar areas and high mountains are particularly exposed to ocean and cryosphere change, such as sea level rise, extreme sea level and shrinking cryosphere'.[5] Attesting to the most overt indicators of climate change – the melting of Arctic ice and the bleaching of coral – the report has become something of a wake-up call, urging for immediate, large-scale and coordinated action to cut emissions and conserve marine ecosystems.

As the climate crisis and global warming raise sea levels, and as more intense storms become more common and visible features of life in coastal communities, the possibilities of building interconnections between the global

ocean crises and coastal identities that embody regional concerns became a starting point for 'Ephemeral Coast'. Its nine exhibitions and multiple film screenings, panel discussions, talks and publications have investigated the connections between coastal ecologies, culture and its discourses through the lens of curating. The idea of the 'ephemeral' condition was a guiding curatorial strategy informing my choice of artists, locations and conversation between locations. The exhibitions trace the ephemerality of coastal edges, places, people and marine species that are bound in a series of evolving relationships concerning transformation and, at times, erasure. The exhibitions also sought to create interventions in coastal regions that engage with historical processes of occupation and decolonial resistance. Conceptually, 'Ephemeral Coast' has involved tracing the idea of the ephemeral as an aesthetic and conceptual register of loss and mutability of the coastal shore. [...]

Oceanic warming, contamination, acidification and overfishing are primary factors of what geologists referred to as the Anthropocene – a term originally coined by the biologist Eugene Stoermer in the 1980s, and then formalised nearly twenty years later with the Nobel prize-winning atmospheric chemist Paul J. Crutzen. Crutzen and Stoermer described the human dominance of biological, chemical and geological processes on Earth as being so significant that they should be deemed as comprising a new geologic epoch that replaces the Holocene with the Anthropocene.[6] These scientists declared that a new geological era had begun – the 'age of humankind' – marked by the mid-twentieth-century alteration of biophysical systems on Earth by the release of carbon and nitrogen, and proposed that humans are now living in the phase of the Anthropocene known as the 'Great Acceleration'.[7]

The Anthropocene as a discourse is changing rapidly across the sciences, arts and humanities, and has evolved into a highly contested term with a narrative that is expanding, or more aptly, pluralising within the cultural sphere.[8] Critical ocean studies scholar Elizabeth M. DeLoughrey calls attention to how the humanities reads the Anthropocene through narrativised allegories and, especially, visualised stories that resist universalising the ocean and call attention to Black and Indigenous voices.[9] She argues, 'Claiming to speak of an enormous system such as climate requires multiple narrative and visual registers, as well as scales'.[10] Blue humanities literature specialist Steve Mentz also disputes the singular and monocultural notion of the Anthropocene and argues for a consideration of its pluralisation, one that 'seeks justice and embraces difference'.[11] Furthermore, Mentz rejects the technocratic, patriarchal citing of the Great Acceleration and states that humankind has been remaking the nonhuman environment from its inception.[12] The feminist scholar Astrida Neimanis has also challenged the Anthropocene discourse – troubling the

term for perpetuating the man-versus-nature dualism that it supposedly seeks to overturn. Neimanis' concept of 'bodies of water' emphasises the need to address the complexities of the local, while engaging with ecological voices that are diverse and more than human.[13] Meanwhile, the cultural geographer and theorist Kathryn Yusoff similarly calls for the Anthropocene to be closely tied to the 'collision of human and inhuman histories' that 'haunts the present' and opens an 'epochal rift' into the future.[14] The 'Oceanic Turn', as it has come to be known, then leads to a kind of thinking of the edges of the Anthropocene ocean as a littoral place bound in a series of evolving and interrelated relationships, which are particular and also embodied.

[...] While the concept of the Anthropocene was not a starting point for 'Ephemeral Coast', the project's development inevitably interacted with the surrounding cultural and scientific discourses. The art critic and curator Lucy Lippard argues that 'place is experienced through the filter of culture and history'; she makes a significant argument towards examining the complex particularities of regions.[15] Ursula Heise, an environmental literature and extinction specialist, also argues that ecological awareness is best articulated from localisms that have a globalist perspective tied to territories and systems.[16] It was from such a premise that 'Ephemeral Coast' situated itself, with exhibitionary locations in Wales, Mauritius and Canada, and expeditionary practices in Baja California Sur, Mexico. My reasoning behind the selection of locations was as follows: they identified specific bioregions that are experiencing extreme coastal deterioration or destruction. Cumulatively, the curatorial process involved recognising the global parameters required to address how aspects of the world's coastal edges are being re-mapped. Erosion, loss and the possibilities for reconnection were constant themes, but were articulated through particular regionalisms.

[...] 'Edge Effects' was an exhibition in Mauritius that I curated, which sought to reframe coastal climate change as not just a scientific problem but one that is deeply interwoven into the histories of colonialism and the current need to transform the economies of consumption and exploitation of the shore. 'Edge Effects' comprised film screenings in galleries, an exhibition in an historical monument and site-specific work on the shoreline of Le Morne, a peninsula of historic colonial significance in the south-west of the island. 'Edge Effects' thus examined the collection and repurposing of oceanic plastic detritus as an aspect of coastal pollution, yet more critical to the project was the emphasis on placing these more recent incursions within the context of broader, historically charged discussions of species interaction and extinction.

The exhibition was situated mainly in La Citadelle, a military fort built by the English soon after their arrival on the island in the early nineteenth century,

completed after several years of construction by Indian indentured labourers in 1840.[17] Overlooking the capital city of Port Louis and the harbour, with a 360-degree view, the site had become the main source of defence, replete with cannon guns, which are still situated on the grounds. Today, this same panorama is a major tourist attraction, with enormous cut basalt stones that form part of its construction covered with encrusted sea salt, while its interior is rarely open to the public. The exhibition was situated throughout this large building, proposing some connections with the histories of colonialism that effectively 'created' Mauritius and that continue to shape its environmental challenges.

[...] The exhibition considered coastal anthropogenic disturbances and their impact upon small-scale subsistence fishing communities. Coastal fishing is well developed in Mauritius and, though regulated with some fishing reserves, approximately 2,800 fishermen's catches in 2016 exceeded the maximum sustainable yields. In her filmic installation, co-produced with local activist Stefan Gua, Diana Heise (then a research fellow in Mauritius) explored how artisanal fishing methods – in contrast to net fishing, which causes major marine depletion – offer a more ethical approach. Thus, the film focused on the sustainability of the Mauritian lagoon, its reef culture and its inevitable decline through an extensive examination of the movement and interaction of the reef within the water, capturing at close range the lagoon's hybridity. In a parallel performance, Heise planted mangrove seeds in a remote area of Le Morne, a historic site known as the home of the 'Maroon republic' for its violent historic clashes between the marooned slaves and the British and French colonisers. Mangroves are an essential stabiliser of the coastal intertidal zone in the Southern Hemisphere, acting as a buffer to storm surges and providing food and shelter for fish and other organisms.[18] Mauritius has experienced exponential coastal development, primarily because of tourism; in addition to the effects of global heating, this has caused mangrove forests to decline dramatically. Heise's planting of seeds was considered an act of climate resistance in Mauritius, the United States and Wales, where she continued the project with an elaborate seed-planting endeavour and a letter-writing campaign to the US Senate Committee on the Environment and Public Works.

Originally from Mauritius, Shiraz Bayjoo is an artist who engages with the complex legacies of colonialism within the Indian Ocean and the critical potential of authoring postcolonial narratives. As a result, histories of coastal 'encounters' feature as a dominant motif within his work and often as a premise for discussions of colonial occupation. In turn, the vivid luminosity of the Indian Ocean acts as an important visual marker of place, territory and belonging within Bayjoo's work. For 'Edge Effects', Bayjoo produced a series of stunningly luminous paintings of coral reefs based upon illustrations from the colonial era,

including Charles Darwin's reef drawings of Mauritius. Darwin arrived in Mauritius on 29 April 1836, describing it as a 'harmonious island [...] adorned with an air of perfect elegance'.[19] He was interested in the arrangement of coral reefs in the Mascarene region, and in 1842 published a series of maps of reefs, some of which Bayjoo used as the basis of his *Ocean Miniature Series* (2016). Here, details of the morphology of these 5000-year-old reefs around Mauritius and other regions in the West Indian Ocean, sit in a sea of turquoise and create an alternative classificatory system based upon incandescence and luminosity. A second work, the video installation *Sea Shanty* (2016), points to another kind of oceanic cartography – systems of colonial voyage and domination in Mauritius – further intertwining the narratives of colonialism and coastal decline of ecosystems through the black-and-white panning of the coastline, moving across traditional, sustainable dwellings to coastal concrete block-buildings.

The coral lagoon reefs, barriers, fringes and atolls in this region were once so abundant that they were considered a pristine natural wonder, but the impact of rapid deforestation combined with the concentration of sugar plantations during the colonial era and the intense anthropogenic impact of the past twenty-five years have now rendered these ecosystems severely endangered. [...]

'Edge Effects' used 'ephemerality' as a central concept to consider ideas of the vulnerable, exploited, disappearing or disoriented coastal spaces, people and species, bound in a series of evolving relationships. It considered the centrality of food – especially to poorer Creole coastal communities – for whom fish and shellfish are still a dominant source of protein, now under threat due to tourism, development and its associated overfishing, as well as climate change. The exhibition explored how large-scale commercial fishing industries, which are considered one of the greatest pressures on marine ecosystems, cause significant damage to local communities (human and more-than-human alike). It also mined the realities of a colonial past to discuss a future confounded by aggressive degrees of ecosystem breakdown and species extinction, and sought to create stories that connect the two.

When contextualising the histories, concepts and scientific parameters of loss at work in these exhibitions, Thom Van Dooren's stories of extinction and ecological dependency through, in part, an awareness of the historic impacts of capitalism and colonialism, are perhaps most pertinent. He begins with the Dodo, a bird native to Mauritius, which was probably extinct by the eighteenth century due to the impact of colonial occupation from the late 1590s onward. Indeed, the Dodo was 'the first species whose extinction was conceded – in writing – to have been caused by humans'.[20] Van Dooren claims that current generations are overseeing the loss of so many species on the planet, perhaps because they have yet to fully grasp and 'respect the significance of the

intimately entangled, co-evolved, forms of life with which we share this planet'.[21] These entangled experiences and moments in time among humans, more-than-humans and ecosystems at large become markers of various ecological incursions (the birth of agriculture, livestock domestication, genetic modification and selective breeding in produce, and so on). 'Edge Effects' thus sought to reconsider the Anthropocene as less of an epoch and more of a boundary event – in which the boundaries of temporality and disciplines are contravened to acknowledge their transience or 'ephemerality'. Together, they explore stories of ecological change and entangled perspectives – of vulnerable and troubled spaces, people and species, bound in a series of interconnected relationships that constitute the boundary's shifting edge. [...]

1 Rachel Carson, *The Sea Around Us* (London: Unicorn, 2014) 1–2.

2 Ibid., 1–5; John R. Gillis, 'Seacoasts in History: An Interview', *Historically Speaking*, vol. 14, no. 2 (2013) 15–17.

3 Irus Braverman and Elizabeth R. Johnson, *Blue Legalities: The Life and Laws of the Sea* (Durham, NC: Duke University Press, 2020) 1–3.

4 IPCC (Intergovernmental Panel on Climate Change), 'Summary for Policymakers', in *Special Report on the Ocean and Cryosphere in a Changing Climate* (2019) 324. Available at www.ipcc.ch/srocc/, accessed 10 June 2020.

5 Ibid., 5.

6 Paul J. Crutzen and Eugene Stoermer, 'The "Anthropocene"', *Global Change Newsletter*, no. 41 (2000) 17–18 Available at www.igbp.net/download/18.316f1832132347017758000141/13763 83088452/NL41.pdf

7 Will Steffen, Paul J. Crutzen, and John R McNeill, 'The Anthropocene: Are Humans Now Overwhelming the Great Forces of Nature?', *Royal Swedish Academy of Sciences*, vol. 36, no. 8 (2007) 617.

8 See Stacy Alaimo, 'Your Shell on Acid: Material Immersion, Anthropocene Dissolves', in Richard Grusin (ed.), *Anthropocene Feminism* (Minneapolis: University of Minnesota Press, 2017) 89–120; Steve Mentz, *Break Up the Anthropocene* (Minneapolis and London: University of Minnesota Press, 2019); and Zoe Todd, 'Indigenizing the Anthropocene', in Heather Davis and Etienne Turpin (eds), *Art in the Anthropocene: Encounters Among Aesthetics, Politics, Environments and Epistemologies*, (London: Open Humanities Press, 2015) 241–54.

9 Elizabeth M. DeLoughrey, *Allegories of the Anthropocene* (Durham, NC: Duke University Press, 2019) 8, 139, 175.

10 Ibid., 176.

11 Mentz, op. cit., 2.

12 Ibid., 4.

13 Astrida Neimanis, *Bodies of Water: Posthuman Feminist Phenomenology*, (London: Bloomsbury Academic, 2017) 15.

14 Kathryn Yusoff, 'Anthropogenesis: Origins and Endings in the Anthropocene', *Theory, Culture & Society*, vol. 33, no. 2 (2018) 3–28.

15 Lucy Lippard, *Undermining: A Wild Ride in Words and Images Through Land Use Politics in the Changing West* (New York and London: New Press, 2014) 670.

16 Ursula K. Heise, *Sense of Place and Sense of Planet: The Environmental Imagination of the Global* (New York and Oxford: Oxford University Press, 2008) 221–37.

17 Uma Kothari, 'Geographies and Histories of Unfreedom: Indentured Labourers and Contract Workers in Mauritius', *Journal of Development Studies*, vol. 49, no. 8 (2013) 1042–57.

18 Veronique Greenwood, 'To Save the Corals, First Save the Mangroves', *National Geographic* (11 February 2015). Available at www.nationalgeographic.com/ news/2015/2/150210-mangrove-protect-coral-bleaching-science/

19 Charles Darwin, *Voyage of the Beagle* (1839) (New York: Meridian, 1996) 419.

20 Thom Van Dooren, *Flight Ways: Life and Loss at the Edge of Extinction* (New York: Columbia University Press, 2014) 3.

21 Ibid., 5.

Celina Jeffery, extracts from 'From the Shore to the Coast: Curating the Frontline of Change', *Curating the Sea*, eds. Pandora Syperek and Sarah Wade, *Journal of Curatorial Studies*, vol. 9, no. 2 (October 2020) 232–3, 233–5, 238, 238–239, 239–241.

Heather Anne Swanson and Sonia Levy
A (Highly) Partial Field Guide to British Canals//2021[1]

Ballast

Ballast refers to any substance added to a vessel to improve its stability. For centuries, countless materials, including stones, iron bars and old cannon balls, have been used to make ships more sure and manoeuvrable. Although transport goods can be used as ballast, when ships lack heavy cargo, their mariners seek out these alternative sources of onboard weight. From the 1870s, water – held in onboard tanks – gradually began to replace other types of ballast. For mariners and shipping companies, water is more convenient and cost-effective: with the advent of pumps, it does not require substantial labour to load and unload, and it is readily available at all times. But for aquatic ecologies, ballast water has been a source of disruption, scrambling assemblages of species by rapidly transferring once regionally-specific water dwelling organisms around the world. In England, more than half of introduced aquatic animals and plants are likely attributable to shipping, either via ballast water or ship's hulls. While there are new

international regulations around ballast water treatment and management, they are not fully effective.[2]

Corbicula Fluminea

Meet the creature who launched this collaborative project and who appears several times in the film. Across Asia, *Corbicula fluminea* is called the golden clam, prosperity clam, or good luck clam, but in European conversations, it is most often given the common moniker of 'the Asian clam', emphasising its 'exotic' and 'foreign' origins. Such naming practices – along with wider debates about invasive species – are often intertwined with xenophobic vocabularies and suppositions. Yet the multidimensional problems bound up with such species should not be ignored. It is important to notice how *C. fluminea* have led to impoverishment of many of the new environs in which they have been deposited, in some situations causing changes in biogeochemistry and declines in other species of clams. Yet at the same time, their ability to rapidly filter turbid and debris-laden water can provide environmental benefits.

Much remains unknown about both their basic biology and ecological effects. Their filtering process is among the most complex, adaptable and efficient among clams: they can feed through both their feet and siphons, ejecting pellets of coagulated sediments (called pseudofeces) that sink to the bottom of the water column. These feeding processes are visible within the film.

With a remarkable ability to inhabit a wide-range of temperatures, conditions, and waterways, *C. fluminea* flourish in canals. The film shows the work of Loughborough University researchers who are investigating the filtering abilities of the clams, with special attention to how the speed at which they siphon out suspended particles may render the waters in which they dwell less cloudy, or turbid. Professor Paul Wood, Dr. Simone Guareschi, and PhD student Sarah Evans, all of Loughborough University, very generously shared their knowledges of *C. fluminea* with us and helped to shape our explorations of canal worlds.

Creatures of . . .

This phrase echoes the work of historian Virginia Anderson, who used the phrase 'creatures of empire' to examine how animals were deployed and transformed within North American settler colonial projects. We extend her general sensibilities toward empire and more than human worlds to focus specifically on the generative and creative forces of structural and infrastructural projects.[3]

Dikerogammarus Villosus

These so-called 'killer shrimp' were not unusually aggressive predators in the Ponto Caspian region where they evolved. While they were known for shredding

their prey and for sometimes killing organisms that they do not consume, they were not ecologically dominant and were just another member of the region's life webs. After the Rhine-Main-Danube canal was completed in 1992, boat traffic instigated their rapid long-distance dispersal. Subsequently, the new habitats to which they were transported sparked the shrimp to develop more aggressive behaviours with outsized effects on food chains.

In these new places, they consume large quantities of aquatic insect larva and lead to marked declines in other freshwater crustaceans. While these shrimps are not easily visible in the film (some can be glimpsed in-between the clusters of Zebra mussels), they were frequently found during its research and sampling and are thus present within it.

Dreissena Polymorpha

Also known as Zebra mussels, *Dreissena polymorpha* were initially located in the lakes of southern Russia and Ukraine, but are increasingly widespread in Europe and North America. Since the nineteenth century, European canal-building has fostered their spread, as they tend to cling to ships. Although they first arrived in England 200 years ago, their numbers have dramatically increased in the past 20 years. They thrive in altered habitats, frequently clustering on and clogging water intake pipes, to the annoyance of infrastructure maintenance workers, and their population increases can adversely affect other mussel species. They are the most prominent crustaceans on the concrete and brick surfaces and underside of boats shown throughout the film.

Ecological Globalisation

The film and overall project attempt to grapple with questions about the arrangements and processes we refer to as 'ecological globalisation'. We ask how practices of trade, development and management remake landscape ecologies by connecting geographically distant places. As ships and planes move growing quantities of goods, they connect ecological regions that have had little biological exchange between them. Supply chains typically transport more than they intend: aquatic species (like the introduced organisms presented in the film and this guide) have travelled in ballast water, grass species in packing crates, and insects on nursery plants. At the same time, infrastructures of transportation and production themselves transform lands and waters, as canals, roadways and industrial complexes create radically different habitats. How do we better understand the spatial and historical enfoldings of such processes – and their effects on more-than-human worlds? For us, the relations of British imperial trade, the creation of inland waterways, and introduced species are a key site from which to consider the challenges of ecological globalisation.[4]

Elodea Canadensis (Canadian Waterweed)

This aquatic plant appears in many of the canal images. *E. canadensis* was only found in North America until the nineteenth century, when trade practices began to spread it widely around the world. The plant was actively introduced to new lands as it became a highly popular aquarium and garden pond decoration; it was further transported to new environments by boats and fishing equipment, often coming to thrive in slower-moving waters, such as ponds, canals and ditches. *E. canadensis* rapidly expands into new areas because it reproduces vegetatively, by sprouting from plant fragments rather than by pollination and seeds. Due to its especially rapid growth, *E. canadensis* causes a variety of problems, it often displaces other plant species, leading to single-species patches with lower biodiversity. Ironically, while it is prized for its ability to add oxygen to fish tanks, in outdoor waters, *E. canadensis* often does the opposite, as its dense strands further reduce water movement and foster anoxic conditions that can kill invertebrates and fish. Today, it is found across Britain and Ireland.[5]

Eutrophication

Eutrophication is an emblematic example of how industrial processes seep into the world's metabolism. When waterways are flooded with nutrients, especially nitrogen and phosphorus, they can lead to rapid growth in aquatic plants and communities of microalgae giving waters a vivid green hue. Such bursts of growth can choke off light, deplete dissolved oxygen, and alter pH levels. Such processes can shift the dynamics of aquatic webs, triggering harmful algal blooms. These massive changes can kill fish and cause long term disruptions for ecological communities. Common causes of eutrophication include agricultural run-off and sewage discharges. Canals frequently suffer from eutrophication not only because such altered waters often flow into them, but also because canals – in contrast to rivers – are sluggish and slow-moving, meaning that inputs tend to accumulate.[6]

The most significant cause of eutrophication is the dramatic increase in fertiliser use, beginning in the nineteenth century and exponentially accelerating in the second half of the twentieth century. The turn to fertilisers – part of agricultural intensification projects – also displaced peasants, drove urbanisation, and created a burgeoning working class with few choices other than wage labour. If urban human waste is not collected, but instead flushed out to sea, it breaks the relationships of people and soil, extracting the wealth of rural soils and concentrating it in cities. Soils are either depleted or dosed with repeated applications of external nutrients to maintain their fertility. Marx – who was deeply interested in the implications of fertilisers – analysed these processes as part of his work on what he termed the 'metabolic rift'.[7]

The dynamics of fertilisers extend to the questions of global trade at the heart of this art-research work. Britain has long sought nutrients to fertilise its fields from abroad, including with nitrogen-rich bird guano from Peru and phosphate rock from Nauru and Christmas Island. In both cases, from the mid nineteenth century onward, these highly extractive industries were enacted through exploitative contracting and transoceanic industrial imaginaries.[8] While nitrogen can now be synthesised, phosphate cannot, leading to concerns about global shortages. At present, large suppliers of phosphate include Morocco, China, the US and Russia.[9] [...]

Suez/Lessepsian Migration
Canals have played an outsized role in the transformation of aquatic ecologies. One example is the mass migration of organisms from the Red Sea to the Mediterranean, due to the opening of the Suez Canal in 1869. As a consequence of a slight difference in elevation, about 300 Red Sea-dwelling species have been swept into Mediterranean habitats unaccustomed to their presence with wide-ranging ecological effects. Only a handful of species have been transferred in the opposite direction against the direction of flow. Named for Ferdinand de Lesseps, the founder of the Suez Canal Company, the Lessepsian migration emerges from an effort to pierce narrow pieces of land to reduce transit costs. Writing in 1890, J. Stephen Jeans, a British newspaper owner and industrial booster, phrased it this way:

In the eyes of engineers, the defects of natural geography were made to be corrected by their skill, experience, and ingenuity. Hydraulic engineers are the high priests of science, whose mission it is to publish the banns of marriage[10] between seas and oceans, and complete the nuptials in a way that no man may put asunder. By their sacerdotal functions, the Mediterranean has been married to the Red Sea, the Caspian to the Black Sea, the North Sea to the Atlantic, the Adriatic to the Archipelago, and the Atlantic almost to the Pacific. The importance of these alliances to the trade, the wealth, the intercourse, the facility of intercommunication, and the general convenience of the world, not to speak of strategical and political considerations, affecting individual nations, can hardly be over-estimated.[11]

Although initially worried by the French Suez Canal construction project at a time when Britain dominated other routes to the East, Britain soon colonised Egypt and established both military and commercial dominance over the canal until the Suez Crisis and British retreat from the canal zone in 1956.

'Trade is the golden girdle of the globe…'
These lines are excerpted from the poem 'Charity', published in 1782 by William Cowper, a well-known and critically acclaimed English writer.[12]
 While this excerpt ostensibly extolls the virtues of transoceanic commerce, the full poem – a noted antislavery text – positions this description of exchange as a prelude to a discussion of the moral unacceptability of the trade in human beings. […]

1 *A (Highly) Partial Field Guide to British Canals: Introducing some processes and beings* was produced to accompany Creatures of the Lines online screening on st_age commissioned by TBA21–Academy. *Creatures of the Lines* (2021), a film by Sonia Levy in collaboration with Heather Anne Swanson. Commissioned by Radar Loughborough, produced with the support of Radar Loughborough, Aarhus University Ecological Globalization Research Group, and Aarhus University Interacting Minds Centre 2021 Seed Funding.

2 [Footnote 1 in source] For more information specifically about England, see N. Clare Eno, Robin A. Clark and William G. Sanderson, *Non-native Marine Species in British Waters: A Review and Directory* (Peterborough: Joint Nature Conservation Committee, 1997). While more recent texts can also be found online, this report provides an accessible overview. To learn more about ballast water and related issues, see, Sarah A. Bailey, 'An Overview of Thirty Years of Research on Ballast Water as a Vector for Aquatic Invasive Species to Freshwater and Marine Environments', *Aquatic Ecosystem Health & Management*, vol. 18, no. 3 (2015) 261–8, as well as Ian C. Davidson, Christopher Scianni, Mark S. Minton and Gregory M. Ruiz, 'A History of Ship Specialization and Consequences for Marine Invasions, Management and Policy', *Journal of Applied Ecology*, vol. 55, no. 4 (2018) 1799–1811.

3 [2] See Virginia DeJohn Anderson, *Creatures of Empire: How Domestic Animals Transformed Early America* (New York: Oxford University Press, 2004).

4 [3] See more about the concept and affiliated research project here: https://projects.au.dk/ecoglobal

5 [4] http://invasivespeciesireland.com/species-accounts/established/freshwater/canadian-waterweed

6 [5] For a more detailed description of eutrophication, see: www.nature.com/scitable/knowledge/library/eutrophication-caus- es-consequences-and-controls-in-aquatic-102364466/

7 [6] See John Bellamy Foster, *Marx's Ecology: Materialism and Nature* (New York: NYU Press, 2000).

8 [7] A text which specifically inspired our thinking around the nutrient-related ecological impacts of British imperialism is: Brett Clark and John Bellamy Foster, 'Ecological Imperialism and the Global Metabolic Rift: Unequal exchange and the Guano/Nitrates Trade', *International Journal of Comparative Sociology*, vol. 50, no. 3–4 (2009) 311–34.

9 [8] See Marjolein de Ridder, Sijbren de Jong, Joshua Polchar and Stephanie Lingemann, 'Risks and Opportunities in the Global Phosphate Rock Market' (The Hague: The Hague Centre for Strategic Studies (HCSS), 2012) (www.phosphorusplatform.eu/images/download/ HCSS_17_12_12_ Phosphate.pdf).

10 [9] [Ed. note] 'The banns of marriage, commonly known simply as the "banns" or "bans", are the public announcement in a Christian parish church, or in the town council, of an impending marriage between two specified persons.'

11 Quote from: J. Stephen Jeans, *Waterways and Water Transport in Different Countries with a description of the Panama, Suez, Manchester, Nicaraguan, and Other Canals* (1890) (London and New York: E. and F. N. Spon, 2018) (www.gutenberg.org/ebooks/56560).

12 For more on Cowper and his poetry, see: www.poetryfoundation.org/poets/william-cowper

Heather Anne Swanson and Sonia Levy, *A (Highly) Partial Field Guide to British Canals: Introducing Some Processes and Beings* (2021) (https://admin.stage.tba21.org/wp-content/uploads/2021/12/A-Highly-Partial-Field-Guide-to-British-Canals.pdf).

Max Liboiron
Pollution is Colonialism//2021

[...] Civic Laboratory for Environmental Action Research (CLEAR) is the land-based, feminist and anticolonial environmental science lab I direct with between five and twenty-five collaborators. In CLEAR, we mostly count plastics. These plastics are often in the gastrointestinal tracts of animals caught for food, but we also sample plastics in water, in sediments, in ice and snow, and on shorelines.

[...] In a scientific laboratory, protocols are the scripts you follow to keep your controls controlled, your science replicable, and your findings valid. Step 1: Tie back your hair and put on gloves to avoid contamination. Step 2: Rinse the outside of the specimen bag in water before placing it in the sieve. Protocol also refers to guidelines for conduct during ceremony: bring the hosting Elder tobacco (loose cigarette tobacco will do, but leaf tobacco is better) in a red cloth bundle for the paarantii kaayash ooshchi;[1] present it in your open left hand and let the Elder take it from you. In both science and ceremony, protocols reinforce and perpetuate what is meaningful and right in an activity.[2]

Protocol can manifest in small ways. In one of CLEAR's protocols, for instance, we do not wear earbuds or headphones when we dissect fish, since they are L/land and it's rude to tune out your relations. Sometimes protocol manifests in more notable ways, like redirecting hundreds of thousands of dollars of federal grant monies to Indigenous-led research instead of settler-led research on Indigenous Land.

Feminist scholar Helen Longino (unmarked) proposes that 'we focus on science as practice rather than content, as process rather than product, hence,

not on feminist science, but on doing sciences as a feminist'.[3] So, too, with anticolonial science, where we focus on doing science with an orientation to good L/land relations. The thing about protocols is that they are orienting technologies, pointing us toward certain futures that are good and right and true, rather than merely describing a series of actions or processes. The following protocol is excerpted from CLEAR's lab book:

> Processing the stomach:
> 1. Do not wear earbuds to listen to music while processing, as this separates you from the animal, who deserves your full attention and respect. You can play music from a speaker, and singing is particularly welcome.
> 2. Take a moment to think about the samples and where they came from.
> 3. Fill in the spreadsheet with the fish code (ex. ph13, ncced18–01), today's date, the location the fish was caught, size, and sex if it is not already filled in. This will require you to look at the sample collection sheets or other documentation. Fill in your name, the date on the contamination control, and how you are feeling.[4]
> 4. Before opening each gut, wash your hands, backwash the sieve, and wipe down the tools, microscope lens & plate, and Petri dishes you will use. This will mitigate (not eliminate!) microfibres that have settled on tools through atmospheric deposition.
> 5. Stack the wide-grid sieve (if processing big guts) on top of the 5mm sieve on top of the 0.425mm sieve in the sink. The top sieve will catch the larger items and make visual inspection of the finer sieves easier. [...]

Even before we touch the fish guts, there are already several moments of orientation in these few moments of protocol: think about the fish, the land, and your relation to them. You don't have to be kin with the fish (though some of us are), but neither should you be thinking of the fish primarily as a specimen or scientific object. While the protocol asks a lab member to consider the fish or rinse the sieve, the lab member is also expected to think of other ways to respect the fish and reduce contamination – to become attuned to these relations and comport themselves accordingly, extending the protocol into new spaces to uphold the spirit of the script.

Whatever the scientific or ceremonial paradigm, protocols are enactments of our values and guiding principles, and they instruct us in how to reproduce what is good, whether that good is objectivity (sigh[5]) or good L/land relations, whether you're a settler with land relations or an Indigenous person with Land relations or something else. Sometimes protocols are prescriptive, and sometimes they are about the maintenance of everyday life, but they are always

orienting you toward a particular horizon and away from others. They are reproductive technologies [...]

1 [Footnote 29 in source] Question: Hey, why don't you italicise the Michif ? Answer: Because you italicise foreign languages and that would be English, not Indigenous languages. Italicising a whole book minus these lines would be annoying. But I did think about it.

2 [30] Kyle Powys Whyte, Joseph P. Brewer and Jay T. Johnson, 'Weaving Indigenous Science, Protocols and Sustainability Science', *Sustainability Science*, vol. 11, no. 1 (2016) 25–32; Kim TallBear, 'Standing with and Speaking as Faith: A Feminist-Indigenous Approach to Inquiry', *Journal of Research Practice*, vol. 10, no. 2 (2014) 1–7.

3 [31] Helen E. Longino, 'Can There Be a Feminist Science?', *Hypatia*, vol. 2, no. 3 (1987) 52.

4 [32] Adding feelings to our data entry is a relatively new protocol for CLEAR and came about when we read *Data Feminism* which highlights how data is often disembodied. Not only does our data entry and work attempt to highlight fish bodies but also the bodies of those doing the data entry. While we're not quite sure what we're going to do with this data, I've found it to be a source of surprise and generosity when I'm going through lab data and I see students are happy, struggling, or bored. It helps me take care of lab members (including reminding them to go home when they're sick) and helps us figure out where our practice and protocols are bogging down. Catherine D'Ignazio and Lauren F. Klein, *Data Feminism* (Cambridge, MA: The MIT Press, 2020).

5 [33] For a primer on how objectivity is a value-based concept that changes over time as Western societal values change, see Lorraine Daston, 'Objectivity versus Truth', *Daimon Revista Internacional de Filosofía*, no. 24 (2001) 11–22.

Max Liboiron, extracts from *Pollution is Colonialism* (Durham, NC and London: Duke University Press, 2021) 116, 122–4.

Stefanie Hessler
Seabed Mining in Armin Linke's 'Prospecting Ocean'//2019

[...] Darkness envelops the first scene of the main film in Armin Linke's exhibition 'Prospecting Ocean'. Sounds of distant splashing water, the damp noise of industrial work, and the screeching of a door opening and closing are audible as the camera focuses on a moving light, the only visible entity in the scene. The light shifts ever so slightly, bobbing in response to what we can only assume are waves, while the rest of the screen is dark. Cut, and we see an image on a screen, its graph-like dotty shape produced by a digital device used to gauge the bathymetry in the sea. With

this sequence, Linke introduces viewers to the technologically-mediated world of oceanography, situated at the intersection of science and industry, and the hardware and software used to penetrate the sea. Much of the 56-minute video depicts interior spaces, which may contradict viewers' expectations of the vast blue expanses that may come to mind when thinking of the oceans.

The video is comprised of interviews with representatives of the companies that advance deep-sea mining, shots of a geographer explaining the law of the sea, and scenes filmed at the UN, where international agreements affecting the future of the oceans are negotiated. It is only toward the end of the video, at minute 41:00, that outside, or natural, spaces are shown. The camera zooms in on a woman carving a wooden rod in a hut on Karkar Island in Papua New Guinea, a man mows the lawn in a landscape of palm trees as a chicken walks across the grass, another man weaves a mat from leaves as he sits on the ground, hunched over. Rather than suggesting an anthropological gaze on the Other, removed from capitalist and technological advances, the scenes that follow depict the grassroots opposition of the local community of Karkar Island, who fight the planned deep-sea mining operations off their shores. A group of approximately thirty people sits in the shade of the trees holding up banners with slogans such as 'Ban Sea Bed Mining' and 'Join the Alliance'. Speaking through a megaphone, a woman proclaims that foreign companies come to Papua New Guinea to exploit the land, a land which 'is not their land'.[1] As the protest progresses, viewers learn that 24,000 people across the country signed a petition against seabed mining. It also becomes clear that this petition will most likely not be heard, since, the protesters explain, the government is seeking short-term profit in providing their territorial waters as testing ground for ocean extractions to international corporations. […]

In 2011, the Canadian company Nautilus Minerals Inc. was granted an initial mining license. This will make Papua New Guinea the first country in whose territorial waters seabed mining will take place. The distinction between territorial and international waters is important. In a scene in Linke's video, Donald Rothwell, Professor of International Law with a specific focus on the law of the sea at the College of Law at the Australian National University in Canberra, explains the difference between law that applies to the Exclusive Economic Zone (EEZ) of a country, and laws stipulating the rights and limitations in what is defined as the 'area beyond national jurisdiction'.[2] While the former is under each country's jurisdiction, the latter is designated 'common heritage of mankind',[3] from which no single nation shall profit exclusively. Mining is currently only permitted according to specific countries' jurisdiction in their respective EEZ, but not in international waters. The International Seabed Authority (ISA), a UN arm located in Kingston, Jamaica, is tasked with the administration of international waters beyond national jurisdiction.

Administration here does not mean ensuring protection. The authority has already begun to distribute claims to sponsoring nations for purposes of exploration, and soon also exploitation. [...]

In terms of the oceans, relations with the observed area no longer come into being by accessing it physically, but instead depend on visual technologies. The telescope eliminates direct contact with the seen. Cameras utilised on land and underwater record these environments, extracting visual information from their site of origin. This information, collected at a remove, is utilised to intervene in the seabed not only in order to observe, but also to extract from it with the help of robotic intermediaries. And, in subjugating the ocean to representations deriving from a patriarchal-colonial history, these systems reinscribe these visions and their accompanying exploitations.

Linke's work exemplifies to viewers how these image-making techniques are put to use. Integrated into remotely operated vehicles (ROVs), many of these technologies were originally developed for military purposes. Alvin, the first manned deep-sea submersible, which was used for wide-ranging observations and data collection, was built by the General Mills Electronics Group in Minneapolis and operated by the Woods Hole Oceanographic Institution in 1964 on behalf of the United States Navy. Scientific reality here is constructed with the help of technological apparatuses enhancing and enabling human perception. Developed by interdisciplinary teams of roboticists, engineers and marine scientists, the camera captures depths at the ocean floor that are otherwise impossible for human observers to access. At a distance, in control rooms on vessels or on land, scientists use computers to analyse the images transferred back to them from the ROVs.

If mapping defines what matters within a modern episteme, so does visibility. Parameters of maps and measures define what is seen or noticed in the first place, and technologies help us notice that which we subsequently value. We might say that the tools making things visible bring them about in the first place. [Karen] Barad shows with her analysis of the fetal sonograph that technology 'does not simply map the terrain of the body'[4] – or, in our case, the ocean – but 'it maps the geopolitical, economic, and historical factors as well'.[5] In short, the technology is an integral part of making something matter. The thing depicted gains political significance, which has material, political, and ethical consequences. [...] In our case, visibility can make the ocean both protectable and exploitable. [...]

In [Linke's] video, we can see how techno-scientific apparatuses are deployed to overcome not only the purported distance between the water surface and the ocean floor, but also to divide life from nonlife. The ROV retrieves a specimen from the seabed and isolates it from its surroundings. It seems as if the sample taken from the deep sea can be studied separately from its surroundings, and that the effects of its absence from the ecosystem it formed

a part of, are insignificant. The modernist idea that knowing is isolable from its specific material context is incontestably present in these scenes. [...]

A tool is not only the technology or object, but the moral, economic, and political choices that bring it into being. As such, we must understand the effects of deep-sea mining that tools have enabled both in an immediate way, defined by sediment being moved around, but also in the way that these interventions will change moral, political, and cultural positions. In addition to questions of space and place, the temporal aspects must be considered. [...]

If deep-sea mining is changing the topology of the seabed, producing wider resonating effects, we can speak of it as a form of architecture. Feminist theorist Elizabeth Grosz argues that we need to rework the apparent divide between human-made architecture and nature.[6] As long as we consider architecture as a cultural paradigm, 'nature' and affordances upon which it relies remains unacknowledged and the nature-culture divide is reinforced. In thinking of nature as exceeding the passivity of a resource, we retire notions of it as a non-agential other.

The definition of architecture could also be expanded to the molecular level, as in human creations of nuclear fissions as an intervention in the molecular architecture. Seabed interventions are, like 'architectural' interventions on land, exercises of power, physical and ideological. [...]

1 [Footnote 24 in source] Armin Linke, *Prospecting Ocean* (2018).

2 [26] The United Nations Convention on the Law of the Sea (UNCLOS) defined the areas beyond the limits of national jurisdiction by the High Seas, beyond the Exclusive Economic Zone (EEZ), or beyond the Territorial Sea where no EEZ has been declared, which, according to Article 86 'are open to all States, whether coastal or land-locked', and the 'Area' beyond the limits of the continental shelf, defined in Article 76, which 'means the seabed and ocean floor and subsoil thereof, beyond the limits of national jurisdiction' (Article 1). http://www.un.org/depts/los/convention_agreements/texts/unclos/UNCLOS-TOC.htm.

3 [27] Arvid Pardo, Maltese Ambassador to the UN, in a speech in November 1967 called to define the seabed beyond national jurisdiction as common heritage of mankind (www.oxfordbibliographies.com/view/document/obo-9780199796953/obo-9780199796953-0109.xml).

4 [115] Karen Barad, 'Getting Real: Technoscientific Practices and the Materialization of Reality', *Differences: A Journal of Feminist Cultural Studies,* vol. 10, no. 2 (1998) 93.

5 [116] Ibid.

6 [354] Elizabeth Grosz, *Architecture from the Outside: Essays on Virtual and Real Space* (Cambridge, MA: The MIT Press, 2001).

Stefanie Hessler, extracts from *Prospecting Ocean* (Cambridge MA and London: The MIT Press, 2019) 33–6, 76–7, 217, 219, 221.

Saskia Olde Wolbers
Pfui – Pish, Pshaw / Prr//2017

Pfui – Pish, Pshaw/Prr, (2017, 2 screen/2018 single screen, 20 min HD) deals with the urgent business of marine oil spills and fossil fuel's continuing threat to the environment. The film gives voice to Mr Theodosis Alifrangis, the longest-serving worker of a Greek toxic waste management company. Mr Alifrangis is an enigmatic oracle, who unofficially filmed over 20 years of emergency call outs on his camcorder.

The film's fictional script is loosely based on Alifrangis' anecdotes and reveals an oil responder's love for shipwrecks, recollections of heroic acts against the mundane everyday reality of cleaning heavy oils from the sea's surface and how his camera warded off the evil eye whilst tending to major emergencies. Until narrative time seemingly starts reversing, playing with ideas of toxic waste and permanence.

The work features an eclectic sample of Alifrangis' prolific VHS archive filmed in the 1980s and 90s, alongside imagery created in Olde Wolbers' studio, where model sets of cruise ship interiors, ferromagnetic mussels and molecular structures are covered in iridescently coloured dripping oils and filmed in tanks.

It also features sonar imaging attempts around the unsalvageable Sea Diamond, a cruise ship in Santorini that has commanded Alifrangis' daily care for the last 10 years, filmed by Olde Wolbers in collaboration with Alifrangis.

Script
I nearly got stuck to Sanopi as a child ...
we all fainted in our sleep.
The brazier smoked in the room.
Five in a bed, including mum and dad.
Someone found us.
We were lucky to escape that God of Tar ...
And his shadow sponges of carbon.
Aaaah ... Mr Lambros ... there isn't a better employer.
In the 35 years I was with the company,
never had my pay been late.
If the accountant made a mistake, they got the chop.
Since Polycrates found his wedding ring inside a fish,
the sea is no longer that ancient place of no return.
It spits up oil and all things filled with air.
Our first spill was in Pachis, Megara ...

I needed money to baptise my little one, so I went.
Before the Aktari, we'd hire 30 people for a clean up,
sometimes more.
Mr Lambros would stand on a crate in Piraeus
to pick casual ship hands. He wanted men who could stay off the bottle
and go without smoking for a day.
The ones that enjoyed sniffing the flowery fuels,
but wouldn't take a can home with them.
Oh yes, they do exist.
Naphthalene, crude, benzene, *petrelaio* fumes.
All sirens that call good men to madness.
I filmed it all. The men called me 'Camera Man'.
Unusual back then.
In the Pre-Cam-Era ...
Handling the murky business of separating oil from water,
makes you evil-eyed.
But my camera stared it in the face.
Gave me an armour of magnetic signal.
When we cleaned up, our eyes burned from the smell.
But the lens was always sober.
Some tapes got lost and others I fed to the incinerator.
That party at the end of time.
Every situation was different, we improvised.
Swimming through petrol, naked,
to reach the far side of a wreck.
Then diving back into the sea,
our bodies covered in dispersant.
Oil should be magnetically charged,
so we can round up these flimsy membranes
into an accountable body.
Our policy was to leave no trace. But 'matter is never entirely spirited away'.
It made it hard for people to stay on the job:
no gain, just the undoing of actions.
Still, I love wrecks.
Donkey's years ago, there was a decommissioned cruise ship,
back in Piraeus, and I ran aboard when I saw a fire in the stern.
The captain, clutching a jittery chicken doused in petrol,
fixed me with one eye. What business was it of mine?
The fire brigade put it out.
A day later the boat was on fire again.

It burned for a week.
Our company was the first to go in.
All these ships have chapels,
and inside the cupboard with its melted aluminium door,
12 volumes of the bible.
Intact …
I'm not so religious but I took them.
Yes I did, and how I have needed those.
This pen I am writing with
I found while diving many years ago.
87 dead. The Perses of Hecate. We couldn't sleep for the grief.
The captain, the first mate,
I would never let them out of jail.
The dead …
They're always there in the corner of your eye,
like a shark's fin.
The only way not to go mad on the job
is to enjoy the small details.
The bird we rescued,
The rat –
the proverbial rat – leaving the ship,
The wads of dollar notes stacked in the safe of a wreck,
clouding to powder around my diving glove.
Accidents happen mostly around Christmas and Easter.
We always waited for that phone call,
knowing it would mean double pay.
One Christmas Eve,
an 80,000 tonne tanker loaded with oil
was pulling into the port of Pylos when there was an explosion.
This captain's screw-over had put petrol in the floating tanks
where the drinking water should go.
There's no shortage of stupidity in the universe ….
my wife used to say.
The anchor chain rushing through the hawse pipe caused the spark.
And imagine, the people were saved by a ships boy,
Kouvelios, as we knew him.
The last 9 years I have been mopping up old news on this island.
The Ananke Express, a cruise ship.
She ran into the rocks in the port and sank,
landing 150 metres below sea level.

Perfectly upright, her propellers wedged in the seabed.
She's a sailor's tattoo leaking ink on a pristine stretch of coast.
All this time after those two fuel tanks imploded,
a tongue of balmy Mazut still licks her innards:
372 cabins, 5 restaurants, a swimming pool and multiple casinos.
There was a big team at first,
but only me and Kyrios Nikos, my partner on site, have stuck around.
He joined me 2 years to the day after she sank.
A slightly moody but reliable man,
unannounced by the head office.
The Express has cried neatly into a boom for 9 whole years –
just a few drops a day,
We circle that tail-eating worm,
with oil-loving pads.
We play Russian roulette with mascaras, mini bar bottles,
tennis balls, vibrators, light bulbs,
lipsticks, ready meals,
dolls' heads, piano keys, coffee too.
What floats on the surface becomes a missile 150 metres deep.
Empty barrels, they can kill you.
If one of those comes up, you stand no chance.
But Nikos is never worried about that.
He seems more concerned with arguments he starts
in the port's only café.
Slapping his wedding ring on the table, he insists –
for the benefit of the waitress and me – that;
'Oil is not your fern juice or dinosaur skeleton mousse,
but an infinite mineral hidden by the "petrarchy".'
Conspiracy theories. Chemtrails, flat earth …
Ask me anything about the seabed.
'Niko, the earth cannot be full of oil!
– says the waitress
Oil might be both fossil and mineral
But we are no scientists
Let's think of it as formed from animals and plants
that are millions of years old.
It's more poetic and, for our sake, hopefully finite'
After years of blindly servicing the Ananke,
we abandon the optical and go sonar.
Our baby…. Chains through her mouth,

leaning against the volcanic cliff,
between the ebb and flow of tourists.
There *were* plans to salvage her,
pump her full of Ping-Pong balls or something,
but it's difficult.
She's going to break in half…
salvaged or not, and plunge to 300 m deep
and our job will repeat itself…
Lately her flow is heavier,
oils are again dissolving outside the boom.
The ship no longer appears on the returning echoes
translated inside my fish finder,
but then sonar is only a tiny torch
illuminating a world of shiny black plastic.
Kyria Chimera, our actuary,
an accident predictor of sorts, is sent from Piraeus.
Her lab creates scale models in tanks
to estimate dripping times.
'Remember, nature reacts when observed'
'Now the sea has rebelled against this new sonar clarity.
Test mussels might have invaded,
a hundred thousand per square metre
and covered the wreck and even the walls of Atlantis.
They bio filter those hi-fi donkey bells of yours
with a chorus of hot air … '
I loved fishing around the wreck, until I overdid it …
Went free-diving for 5 hours and had a heart attack.
'Fish have their own intelligence,' the doctor said –
and my mind has not been my own since.
Now I see a sea snake hugging a gull.
And tar clumps fat as tennis balls are back on the beach.
Then the bridge appears,
followed by the aft side …
Like out of the sea in Solaris that throws up shapes.
When the Ananke's passenger list re-appears,
close on a decade later,
Nikos circles the names of the two deceased –
the couple that was never found.
Kyria and Kyrios something or other …
He's got this idea into his head that they were on their honeymoon.

Fuelled by 8 bottles of Amstel, he makes our shipping-container
ring out with the sound of the bride's name.
These waters are dumping grounds;
toilet waste, white goods, company accounts,
even statues of useless politicians – the full body, mind you,
not just the head, like the frugal Romans …
Beneath the trash lie polluted sagas,
people don't wish to deal with again.
So what's got Nikos' goat?
Is it the deceased couple…
stand-ins for his own history, played out years ago on land…?
The lens never lies, but this Camera Man
can't vouch for what he's seeing any more…
A man in full captain's uniform on the small beach!
Is that Nikos wading into the sea?
Ignoring the oil and pumice-stones
that follow him to the lopsided boat.
They close the port and I close my eyes.
A captain who chose to leave the ship
rather than take care of his passengers?
The irresponsibility of those responsible.
Next thing I know…The Ananke is gone.
Mist hangs around the empty port like a tired cliché.
All is terrifyingly clean…
Has god pressed undo?

Saskia Olde Wolbers, *Pfui – Pish, Pshaw / Prr* (2017), script for video work commissioned by Polyeco's
Contemporary Art Initiative (PCAI) Greece and Invisible Dust UK.

Stacy Alaimo
Your Shell on Acid: Material Immersion, Anthropocene Dissolves//2016

[…] Notwithstanding the lively and generative thinking with stones, geologic
life and petrocultures, by [Jeffrey J.] Cohen, [Katherine] Yusoff, [Stephanie]
LeMenager, and others, I would like to contribute another sort of figuration
of the anthropocene, which is aquatic rather than terrestrial. It is vital to

contemplate the anthropocene seas, not only because marine ecosystems are gravely imperilled but also because the synchronic depth and breadth of the oceans present a kind of incomprehensible immensity that parallels the diachronic scale of anthropogenic effects. The deep seas, once thought to house 'living fossils' that terrestrial time left behind, are in fact home to sea creatures who live at a slower pace, within the cold, dark and heavy waters. Oceanic depths, especially, resist the sort of flat mapping of the globe that assumes a 'God's-eye view'. The view of the earth from space reveals merely the surface of the seas, a vast horizontal expanse that is rendered utterly negligible when one considers the unfathomable depths and three-dimensional volume of the rest of the ocean. To begin to glimpse the seas, one must descend, rather than transcend,[1] be immersed in highly mediated environments that suggest the entanglements of knowledge, science, economics and power. While the human alterations of the geophysical landmasses of the planet can be portrayed as a spectacle, the warming and acidifying oceans, like the atmospheric levels of CO_2, cannot be directly portrayed in images but must be scientifically captured and creatively depicted. The depths of the ocean resist flat terrestrial maps that position humans as disengaged spectators. Marine scientists must, through modes of mediation, become submerged, even as persistent Western models of objectivity and mastery pull in the opposite direction.[2] The substance of the water itself insists on submersion, not separation. Even in the sunlit, clear, shallow waters that divers explore, visibility is never taken for granted, nor does distance grant optimal vision. The oceans proffer a sense of the planet as a place where multiple species live as part of their material environs. As human activities change the chemical composition, the temperature, and the alkalinity of the waters, marine creatures also change. [...]

The Tasmanian artist Melissa Smith, who creates art about the effects of climate change, has made several works featuring the pteropod within her *Dissolve* and *Dissolve II* series, including *Dispel*, a stunning 2:30 video [...]. The name, *Dispel*, suggesting both dispersion and vanishing, shows a milky and translucent shell against a vibrant red background. Smith describes the video: 'This work is emotively charged both visually and aurally. The cascading image of an X-ray micro-CT-scanned pteropod shell, rotates and reveals its beauty before falling away to its demise. The soundtrack extends the viewer's perception of the visual to evoke an even deeper sense of loss.'[3] The video begins with the shell gently falling into the frame of the camera and slowly, hypnotically rolling across the screen. Then it gets closer to the viewer, both encompassing the viewer, pulling her gaze in and through the spiral, but also allowing her to see through the transparency. The shell's extraordinary fragility is accompanied by mournful cello and piano music. In the end, revolving

still, it disappears, white vanishing into red, as the shell spirals into smaller dimensions. The red background, signalling urgency, collides with the sombre music and slow, mesmerising rotations. The viewer's experience shifts from being a spectator, to being ensconced, to being part of the dissolve, left hovering within the red.

These shells, bereft of their fleshy creatures, without a face, nonetheless evoke concern, connection, empathy. While a gory scene depicting the living creature meeting its demise would separate the human spectator from this already distant form of marine life by sensationalising it or rendering it abject, the elegant minimalist aesthetic of the shell lures us into a pleasurable encounter that nonetheless gestures toward the apocalyptic. Within the contemporary digital landscape in which ocean creatures are posed in highly aesthetic ways, by environmental organisations, scientists and popular media, the shells take up their place in the virtual gallery of aesthetic marine pleasures, haunted by the missing fleshy life.[4] To say they call us to contemplate our own 'shells' – or bodily and psychic boundaries – on acid, suggests something akin to a psychedelic experience. The spiral shells, especially when they are spinning around in the video versions, do, in fact, suggest the spiral as the icon of altered states. This mode of engagement, this type of attention, often involves a 'dissolution between' the human and the 'outside world', as Wikipedia tells us: 'Some psychological effects may include an experience of radiant colors, objects and surfaces appearing to ripple or "breathe", colored patterns behind the closed eyelids (eidetic imagery), an altered sense of time (time seems to be stretching, repeating itself, changing speed or stopping), crawling geometric patterns overlaying walls and other objects, morphing objects, a sense that one's thoughts are spiraling into themselves, loss of a sense of identity or the ego (known as "ego death"), and other powerful psycho-physical reactions. Many users experience a dissolution between themselves and the "outside world".'[5] Intrepid viewers may dis/identify in the dissolve, simultaneously identifying with the shelled creature and contemplating the dissolution of boundaries that shore up human exceptionalism, imagining this particular creature's life and how extinction will ripple through the seas.

This dissolution between the human self and the world suggests what Richard M. Doyle, in *Darwin's Pharmacy: Sex, Plants, and the Evolution of the Noösphere*, defines as an 'ecodelic insight', 'the sudden and absolute conviction that the psychonaut is involved in a densely interconnected ecosystem for which contemporary tactics of human identity are insufficient'.[6] Although Doyle is not writing about the question of scale in terms of the anthropocene, his conception of the ecodelic may be useful for forging environmentally oriented conceptions of the anthropos, not as a bounded entity, nor as an abstract force, but as manifestation: 'And in awe we forget ourselves, becoming aware of our

context at much larger – and qualitatively distinct – scales of space and time. And over and over again we can read in ecodelic testimony that these encounters with immanence render the ego into a non sequitur, the self becoming tangibly a gift manifested by a much larger dissipative structure – the planet, the galaxy, the cosmos.'[7] I am interested in how the ecodelic erodes the outlines of the individual self in 'encounters with immanence' that provoke alluring modes of scale shifting. The problem here, however, is that contemplative or psychedelic practices have an association, in Western culture at least, with a navel-gazing, spiritual transcendence – the exact opposite of the sort of materially immersed subjectivity I think is necessary for environmentalism. Recasting Doyle's scenario by imagining the anthropogenically altered, acidified seas, rather than the perfect, ethereal expanses of the cosmos (descending, rather than transcending), may provoke a recognition of life as always immersed in substances and chemistries, that are, within the anthropocene especially, neither solid nor eternal. More difficult to contend with, however, is that the ecodelic figuration of the dissolve may be useless in terms of social justice and climate justice, in that it does not provoke consideration of differential human culpabilities and vulnerabilities. And yet, as a vivid image of slow violence, it could be taken up as a mode of dis/identification and alliance for particular groups of people who are contending with other sorts of invisible environmental harm. [...]

As one figuration of the anthropocene among many others that are possible, the exquisite photographs and videos of dissolving shells may perform cultural work, portraying the shift in alkalinity as a vivid threat to delicate yet essential living creatures. Whereas the predominant sense of the anthropocene subject, en masse, is that of a safely abstracted force, the call to contemplate your shell on acid cultivates a fleshy posthumanist vulnerability that denies the possibility of any living creature existing in a state of separation from its environs. The image of the diminutive creature, with its delicate shell dissolving, provokes an intimacy, a desire to hold and protect, even as we recognise that such beings hover as part of the unfathomable seas. The scene of the dissolve demands an engaged, even fearsome activity of scale shifting from the tiny creature to the vast seas. In *The Posthuman*, Rosi Braidotti challenges us to imagine a vital notion of death: 'The experiment of de-familiarisation consists in trying to think to infinity, against the horror of the void, in the wilderness of non-human mental landscapes, with the shadow of death dangling in front of our eyes.'[8] Arguing not for transcendence but instead for 'radical empirical immanence', she contends that 'what we humans truly yearn for is to disappear by merging into this generative flow of becoming, the precondition for which is the loss, disappearance and disruption of the atomised, individual self'.[9] Envisioning the dissolve, then, can be an immanent, inhuman or posthuman practice.

In the era of the sixth great extinction, it is not difficult to discern the shadow of death. Marine life faces many other threats in addition to acidification, including warming waters and the ravages of mining, drilling, ghost nets, shark finning and industrial overfishing. Marine habitats are riddled with radioactive waste, toxic chemicals, plastics and microplastics, all of which become part of the sea creatures that, not unlike [Ulrich] Beck's citizen in risk society, lack the means to discern danger, and the impermeability that would exclude it. Contemplating your shell on acid is a mode of posthumanist trans-corporeality that insists all creatures of the anthropocene dwell at the crossroads of body and place, where nothing is natural or safe or contained. To ignore the invisible threats of acidity or toxins or radioactivity is to imagine we are less permeable than we are and to take refuge in an epistemological and ontological zone that is somehow outside the time and space of the anthropocene. Those humans most responsible for carbon emissions, extraction and pollution must contemplate our shells on acid. This is a call for scale shifting that is intrepidly – even psychedelically – empathetic, rather than safely ensconced. Contemplating your shell on acid dissolves individualist, consumerist subjectivity in which the world consists primarily of externalised entities, objects for human consumption. It means dwelling in the dissolve, a dangerous pleasure, a paradoxical ecodelic expansion and dissolution of the human, an aesthetic incitement to extend and connect with vulnerable creaturely life and with the inhuman, unfathomable expanses of the seas. It is to expose oneself as a political act, to shift toward a particularly feminist mode of ethical and political engagement.

1 [Footnote 61 in source] See Stacy Alaimo, 'New Materialisms, Old Humanisms; or, Following the Submersible', NORA: Nordic Journal of Feminist and Gender Research, vol. 19, no. 4 (2011) 280–84.

2 [62] Take, for example, James Cameron's Aliens of the Deep (2005), a documentary about deep-sea exploration that repeatedly supplants the seas with the planets. The deep seas are cast as the perfect practice arena for space explorers, marine biology is said to be a good starting point for astrobiology, and the samples from the ocean are the 'next best thing' for the planetary scientist to examine. The ethereal trumps the aqueous, the transcendent transcends the immanent. Marine biologist Dijanna Figuero's compelling and informative discussion of symbiosis in riftia (giant tube worms), for example, is followed by a cut to Cameron telling a scientist, 'The real question is, can you imagine a colony of these on [Jupiter's moon] Europa?' Stacy Alaimo, 'Dispersing Disaster: The Deepwater Horizon, Ocean Conservation, and the Immateriality of Aliens', in Disasters, Environmentalism, and Knowledge, eds. Sylvia Mayer and Christof Mauch (Heidelberg: Universitätsverlag, 2012) 175– 92.

3 [73] Melissa Smith, 'Climate Change as Art', Australian Antarctic Magazine, no. 25 (December 2013) (www.antarctica.gov.au/about-us/publications/australian-antarctic-magazine/2011-2015/issue-25-december-2013/art/climate-change-as-art).

4 [74] Jellyfish and other gelatinous creatures, for example, have been portrayed as 'art' in museum exhibits, coffee table books, videos for relaxation, and scientific and popular websites. See Stacy Alaimo, 'Jellyfish Science, Jelly-fish Aesthetics: Posthuman Reconfigurations of the Sensible', in *Thinking with Water*, eds. Janine MacLeod, Cecilia Chen and Astrida Neimanis (Kingston, ON: McGill-Queen's University Press, 2013) 139–64.

5 [75] Wikipedia, 'Lysergic acid diethylamide', n.d., http://en.wikipedia.org/wiki/Lysergic_acid_diethylamide.

6 [76] Richard M. Doyle, *Darwin's Pharmacy: Sex, Plants, and the Evolution of the Noösphere* (Seattle: University of Washington Press, 2011) 20.

7 [77] Ibid., 21.

8 [79] Rosi Braidotti, *The Posthuman* (Cambridge: Polity, 2013) 134.

9 [80] Ibid., 136.

Stacy Alaimo, extracts from *Exposed: Environmental Politics and Pleasures in Posthuman Times* (Minneapolis: University of Minnesota Press, 2016) 161, 164–8.

Sarah Wade
Amorous Anthropomorphism, Marine Conservation and the Wonder of Wildlife Film in Isabella Rossellini's *Green Porno//2020*

It is a well-worn slogan that 'sex sells', but can it save species? At a time when the anthropogenic threats facing wildlife are numerous, and species are disappearing from the wild at an increasingly accelerating rate, the actress and model Isabella Rossellini's *Green Porno* (2008–9) short films suggest this very possibility. Wearing well-crafted yet comical costumes made from colourful Lycra and cardboard, in these films Rossellini performs the reproductive acts of various kinds of wildlife such as insects, fish, marine invertebrates and marine mammals, whose physiology is far from human and whose sexual behaviours appear to be particularly curious from a human perspective. As the series of *Green Porno* progress, the ecological imperative of the films becomes increasingly explicit. Series three is entitled 'Bon Appétit!' and tackles the detrimental effects that human activities have on the lives and habitats of marine wildlife, particularly overfishing. After Rossellini has performed the sex acts of sea creatures, the marine biologist Claudio Campagna appears on screen to inform viewers about the threats they face at human hands. In the episode 'Anchovy' Rossellini is shown dressed as a fish. She 'swims' amongst a shoal of puppets and uses human-centric

language to describe anchovy mass spawning events as 'orgies'. The film ends with Campagna explaining that anchovies are overfished, impacting the food chains of other wildlife. In 'Shrimp', Rossellini performs a comic strip tease in which she transitions from male to female shrimp. After mating, Rossellini-as-shrimp is captured in a net along with various paper marine creatures and Campagna informs viewers that fishing for shrimp produces large quantities of wasted by-catch. The last film in the series is longer and features footage of live elephant seals, a puppet show and an animation. Rather than performing elephant seal sex, Rossellini resides on the shoreline with Campagna observing this wildlife in action. The film closes by highlighting the perils faced by these seals as a result of human activities, including fishing and dumping rubbish.

[...] Initially appearing to be bizarre web-based curiosities, on closer viewing *Green Porno*'s educational and entertaining screen-based format readily invites links to wildlife film, parodying many conventions of the genre. The series defies typical tropes of so-called 'blue chip' wildlife film and television programming by presenting viewers with a 'handmade aesthetic' and a humorous tone, which through its playful approach and overt artificiality contravenes the genre's usual reverent presentation of an 'untouched' natural world.[1] Despite this visual and performative irreverence, series three of *Green Porno* has serious ecological intent, exhibiting what the environmental humanities scholar Nicole Seymour has termed 'bad environmentalism'. Here, the playful, the absurd, the frivolous and the camp provide alternatives to the sensibilities more typically activated through environmentalism, which Seymour lists as including guilt, shame, seriousness and wonder.[2] Yet in series three of *Green Porno*, wonder is integral, rather than oppositional, to a light-hearted approach to ecology.[3]

Through *Green Porno*, Rossellini claimed that she wanted 'to give people a sense of wonder about the natural world [...] to make them fall in love with it and want to protect it'.[4] Considering Rossellini's aim, it is notable that in recent years a number of scholars have argued that a sense of wonder can generate ethical and compassionate responses towards others.[5] For the political theorist Jane Bennett, moments of enchantment, or what she describes as 'wonder-at-the-world', can induce a generous disposition where one feels compelled to act in the interest of other lifeforms.[6] Wonder here becomes a mobilising force for prompting action.[7] [...]

Promoting the protection of marine wildlife can pose challenges. The radically different physiology and lifeworlds (*umwelten*) of sea creatures can make it hard for humans to relate to them, which has typically impacted the ways relationships with these creatures are configured and the degree to which marine wildlife is treated with respect and a sense of responsibility. For instance, the animal rights philosopher Peter Singer noted that there exists 'no

humane slaughter requirement' for fish caught in the wild, nor in many cases for fish that are farmed.[8] Yet it is well known that even Singer himself once used sea creatures to determine the line where rights to nonhuman animals should be curtailed, positioning it 'somewhere between a shrimp and an oyster', since he believed that their experiences of pain could not be confirmed.[9] The welfare and protection of ocean life is therefore arguably harder to promote than it is for the cuddly charismatic species that have been traditionally favoured by wildlife conservation campaigns. Wonder can hold out promise in this regard. [...]

[...] *Green Porno* evokes a specific category of wildlife film that the environmental geographer Jamie Lorimer classified as 'awe' when assessing the different affects such films could elicit.[10] If 'awe' is taken in the sense of feeling wonderstruck, then harnessing this 'awesome' tendency of wildlife film is clearly a strategic move given the widely acknowledged ethical potential of wonder and Rossellini's desire to promote marine wildlife protection through these films. According to Lorimer, wildlife films falling into this category 'evoke the overwhelming [...] alterity of nature to provoke admiration' and focus on presenting 'alien ecologies, unfamiliar anatomies, and inhuman behaviors'.[11] *Green Porno* focuses on just this kind of wildlife. In series three alone viewers are shown how shrimp change sex before they shed their shells to mate, how anchovies reproduce through mass spawning events and how female elephant seals can stall their pregnancies. [...]

According to Lorimer, in the category of 'awe' the behaviour of wildlife is exaggerated to produce thrilling footage and is marked by a tendency 'to drift toward the pornographic', in which viewers 'are presented with an improbable feast of [...] exotic animals, which are forever fighting, fucking, eating, migrating, and dying for their impatient channel-surfing audiences'.[12] The wildlife filmmaker and scholar Derek Bousé also observed this 'pornographic' impulse, equating kill scenes in wildlife films to 'the obligatory "cum-shot"'[13] in X-rated adult films, arguing that both act as markers of authenticity and provide the filmic climax sought out by viewers.[14] *Green Porno* reflects this trend, similarly equating the awesome 'pornographic' qualities of wildlife film with pornography's 'principle of maximum visibility'[15] in a humorous and deliberate way: viewers are presented with close-ups of penetration performed by puppetry or appendages attached to costumes ('Squid') and even a Silly String 'money shot' ('Anchovy'), before these creatures meet their death at human hands. In this way *Green Porno* provides an alternative to the eco porno fiction that pervades 'blue chip' wildlife films, in which nonhuman animal sex is frequently romanticised, sanitised and where anything relating to pleasure, the bodily or the abject is often overlooked or simply ignored.[16] Instead, Rossellini presents the sex lives of sea creatures in an unabashed way, responding exuberantly to the novelist Lydia Millet's (2004)

concern that eco porn's 'soft aesthetic produces soft results', as well as providing a new mode of environmentalism that visually has 'the guts to assault us with the ugly effects of our own appetites'.[17] [...]

Performing nonhuman animals in this way is almost hyperbolic in its anthropomorphism. Yet it is through recourse to anthropomorphism that Rossellini is able to render this marine wildlife closer to humans and therefore easier to relate to, empathise with, and as a result, extend compassion towards. This tactic is enhanced through the childlike appearance of Green Porno's paper and puppet protagonists, which renders sea creatures cute so that they might benefit from care and compassion induced by cuddly charisma – something that the small, slimy and scaly creatures of the sea are often perceived to lack. While anthropomorphism might be criticised for being reductive and failing to take nonhuman animals into account on their own terms, Rossellini exhibits a form of 'critical anthropomorphism' as defined by the animal studies scholar Kari Weil, in which 'we open ourselves to touch and to be touched by others as fellow subjects and may imagine their pain, pleasure, and need in anthropomorphic terms, but stop short of believing that we can know their experience'.[18] [...] Anthropomorphism is here neither reductive towards wildlife, nor should it reduce the capacity for wonder if it retains respect for and recognition of difference, making it a strategic tool in pursuit of raising awareness about marine wildlife conservation in Green Porno. [...]

1 Nicole Seymour, *Bad Environmentalism: Irony and Irreverence in the Ecological Age* (Minneapolis: University of Minnesota Press, 2018) 74–5.

2 Ibid., 4–5.

3 Ibid., 106.

4 John Bohannon, 'Do Scientists Like Green Porno?' *Science*, vol. 325, no. 5948 (2009) 1, 620.

5 See for instance Jane Bennett, *The Enchantment of Modern Life: Attachments, Crossings, and Ethics* (Princeton: Princeton University Press, 2001); Marion Endt-Jones, 'Coral Fishing and Pearl Diving: Curatorial Approaches to Doubt and Wonder', in *Wonder in Contemporary Artistic Practice*, ed. Christian Mieves and Irene Brown (Abingdon: Routledge, 2017) 179; Luce Irigaray, 'Wonder: A Reading of Descartes, The Passions of the Soul', in *An Ethics of Sexual Difference*, ed. and trans. Carolyn Burke and Gillian C. Gill. (London: The Athlone Press, 1993) 72–82; Runette Kruger, 'Wonder, Subversion and Newness', in *Wonder in Contemporary Artistic Practice*, ed. Christian Mieves and Irene Brown (Abingdon: Routledge, 2017) 73–88; Marguerite La Caze, *Wonder and Generosity: Their Role in Ethics and Politics* (Albany: Suny Press, 2013); and Marguerite La Caze, 'The Encounter Between Wonder and Generosity', *Hypatia*, vol. 17, no. 3 (2002) 1–19.

6 Bennett, op. cit., 32 and 156.

7 Sophia Vasalou, *Wonder: A Grammar* (New York: State University of New York Press, 2015) 20–21.

8 Peter Singer, 'Fish: The Forgotten Victims on our Plate', *The Guardian* (14 September 2010).

9 Peter Singer, *Animal Liberation*, (London: Pimlico, 1995) 174.

10 Jamie Lorimer, *Wildlife in the Anthropocene: Conservation After Nature* (Minneapolis: University of Minnesota Press, 2015), 130–133.

11 Ibid, 131–2.

12 Ibid., 132.

13 Derek Bousé, *Wildlife Films* (Philadelphia: University of Pennsylvania Press, 2000) 43.

14 Ibid., 182

15 Linda Williams, *Hard Core: Power, Pleasure, and the 'Frenzy of the Visible'* (Berkeley: University of California Press, 1999) 49.

16 Cynthia Chris, *Watching Wildlife* (Minneapolis: University of Minnesota Press, 2006) 132.

17 Lydia Millet, 'Ecoporn Exposed', *Utne Reader*, (2004) (www.utne.com/community/ecopornexposed).

18 Kari Weil, *Thinking Animals: Why Animal Studies Now* (New York: Columbia University Press, 2012) 31.

Sarah Wade, extracts from 'Amorous Anthropomorphism, Marine Conservation and the Wonder of Wildlife Film in Isabella Rossellini's *Green Porno*', *Animal Studies Journal*, vol. 9 no. 2 (2020) 192, 193, 194, 197–9, 203–4.

Donna Haraway
Sym-chthonic Tentacular Worldings: An SF Story for the Crochet Coral Reef//2015

The *Crochet Coral Reef* is an SF story of string figures, science fact, science fiction, stitched fantasies and speculative fabulation. This hyperbolic reef is material, figurative, collaborative, tentacular, worldly, dispersed within the tissues and across the surfaces of terra, playful, serious, mathematical, artistic, scientific, fabulous, feminist, exceeding gender, and multispeciesist. Its story is brave; the *Crochet Coral Reef* risks making – actually making – real and fabulated things together in order to open up still possible times for flourishing on a diverse earth. The time for this story is now; and without overturning the old prick stories, the time could be too short. The threads of the stitched figures made by the tentacular ones could be cut; or, just possibly, the human and more than human beings of the planet could loop and knot and tie and braid in generative play tanks and open matrices for still possible ongoingness.

The *Crochet Coral Reef* takes shape in *terran holobiomes* inhabited by myriad tentacular ones in a time of response-ability that we yearn to name the Chthulucene. The Reef holobiome is the whole assemblage of diverse species,

whose robust living and dying, in ongoing generations and lateral weavings, depend on the health of the symbiotic animal cnidarians and algae-like zooxanthellae of the coral. Now cannot continue to be the age of two-armed, radiant-visioned, exterminationist, plastic-saturated, fossil-burning, fossil-making prickmen. Now is already the surging, hyperbolic, non-Euclidean time of many-and-snaky-armed ones entangled in the collaborative work and play of caring for and with other earthlings amidst hot and acid seas laced with every kind of toxin. This is the time for overthrowing both the over-reaching Anthropocene and the petro-dollar-ensorcelled Capitalocene in order to nurture still possible flourishing, still possible recuperation, still possible arts for living in multispecies sympoiesis on a damaged planet. This is the time of Consequences.

The Chthulucene draws its name from the aweful chthonic ones, the abyssal entities of the underworld, those ongoing generative and destructive powers beneath seas and airs and lands, those who erupt into the affairs of the well-ordered, upward-gazing, progress-stunned and star-besotted ones, who forget and so dismember their multispecies tangled flesh. The Gorgons, especially mortal and snaky-headed Medusa, whose blood from her severed head gave rise to the corals of the Western sea, are tentacular chthonic powers. They are not finished. The gorgeous sea whips and sea fans of the reefs – the Gorgonia of modern biology – remind terrans of their collaborative mortal lives that are at risk to each other. The chthonic ones empower the symbiotic coral reefs and all the other holobiomes of a thriving earth. These are the powers that the makers of the *Crochet Coral Reef* stitch in non-Euclidean yearning and solidarity.

Sym- means 'with'; *poiesis* means 'making', *sympoiesis*, making-with. Nothing makes itself; nothing assembles itself; living and dying well as mortal terrans must be sym-chthonic, or they are not at all. The *Crochet Coral Reef* is symchthonic. It is for and with the multispecies critters, including human people, of the deep and ongoing earth. The *Crochet Coral Reef* is palpable, polymorphous, terrifying and inspiring stitchery done with every sort of fibre and strand, looped by thousands of people in dozens of nations, who come together to stitch care, beauty and response-ability in play tanks. This SF worlding is enabled by Margaret and Christine Wertheim's outrageous chthonic symbiosis of science, mathematics, art, activism, women's fibre arts, environmentalism, fabulation and sheer love of the critters of terra. This is truly an Institute For Figuring.

Donna Haraway, 'Foreword: Sym-chthonic Tentacular Worldings: An SF Story for the Crochet Coral Reef', in *Crochet Coral Reef,* eds. Christine Wertheim and Margaret Wertheim, (Los Angeles: The Institute for Figuring, 2015) 11.

Manthia Diawara
The Environment, Édouard Glissant, and the Poetics of Solidarity//2021

When I bought my house in 2010 in Yène, a small fishing village on the Atlantic coast of Senegal, I didn't have any idea that it would turn me into an activist on behalf of the environment, or the ecology, or, as Édouard Glissant put it, the natural 'surroundings'. What drew me first to the house was its marginal position near the outskirts of the village, which has a mosque standing at its entrance like a guardian against intruders. Then there was the fact that the house stood on a savage beach with no tourists, only fishermen throwing nets into the ocean; some women smoking fish not far from the brightly painted pirogues [boats] that spend the night at sea; and other women combing the beach for shells, sand gravel, and multi-sized pebbles used in the construction and embellishment of second homes, like mine, owned mostly by well-to-do Dakarois and immigrants.

In the rainy season, the house is often cut off from the village by an estuary where waters from the rain and the sea meet and form a stream in the back, extending for more than three miles. During that time, from the windows upstairs I can see hundreds of pelicans that have landed in the stream to breed. They fly over the house, back and forth, from the stream to the ocean, to bring fish to their young. In the dry season, soon after the ground sucks up the rain and saltwater, the village women come to dig the ground for crabs and mussels that they dry and smoke as condiments for two of my favourite Senegalese dishes: Chebu Jen and Soup Kandjan.

It is easy to see why I like my house and Yène, with its fishermen, pebble collectors and migrant pelicans, all of whom depend on the generosity of the ocean for their livelihood. But there are other reasons to stand and fight for the house and its surroundings. For the last ten years, I have seen rapid development in the area, including people buying and building houses in the path of the stream, and a new port being built just three miles north of Yène. Now, the rainy seasons don't just bring back pelicans. They have become notorious for annual, fatal floods all over Senegal, clearly the effect of climate change.

Another apocalyptic scene the rains have been bringing us lately, besides the inundations and floods, is the rubbish that the ocean throws back on the beach, for miles and miles. It's frightening to wake up in the morning and find various consumer items spread on the beach, like a kitsch installation. One day, I was looking in awe at the scene of plastics of all colours mingled with sea coral, used clothes, and other fibres from fishing nets, when I heard behind me the voice of Alou Diouf, a fisherman I have befriended:

Yes, it's the fault of man! We say here that you should be aware that if you throw a ball against the wall, it will bounce back at you. Everything you throw at the sea it throws back at you. We have to realize that we are undermining ourselves and our humanity by treating the ocean so cheaply, like a garbage dump. Our governments in Africa allow multinational industries to rid themselves of their rubbish in our ocean. It will kill us today, but tomorrow it will be their turn.

Alou, to me, was like a primordial fisherman, the last hero of traditional techniques in Yène, when the ocean is invaded by modern fishing boats from France, Italy, China, and even boats that are licensed under the names of African countries. Another charismatic person in Yène who taught me about the ecology of the ocean is Mati Ngom. A lean and tall woman who walks back and forth on the beach, Mati rarely acknowledges my presence as she's focused on the pebbles, shells and sand gravel deposited by the waves in different spots at different moments of the day and night. At times, she reminds me of the immigrants in the US and Europe who are hired, with the lowest wages, to pick fruit.

When I was finally able to talk to Mati, I asked her if she knew that collecting pebbles (that I, myself, have used on my walls) was bad for the sea, eroding the coastline? She replied that others coming from Dakar and Europe have told her this, but she had not paid attention to them because they just talk.

The sea has always been generous to us. First it gave us fish. Now that fish are rare, it gives us sand and pebbles that patrons like you buy from us. No one has been as generous to us as the sea. We don't make enough money collecting pebbles, but it helps us to survive. If you want me to stop, don't talk to me about the sea, just give me money for my time and I'll stop.

Worlds apart: in America where I work, environmental debates divide us. On the one side, religious and conservative groups, capitalists who want to homogenise consumption and taste to drive more production and profit, private and individual rights groups who put nationalist interests above scientific evidence. On the other side, those who put the rights of communities above private property and individualism, believe in science, and fight to prevent or at least delay catastrophic climate change. These are the progressives, who believe that human beings are responsible for the degradation of nature and that we will destroy ourselves if we don't do something about it; and finally that we need an equitable distribution of wealth to bring an equilibrium to the environment.

Here in Yène, people are forced to abandon their traditional production and consumption habits because of climate change and the colonisation of their taste in food and clothes, cheaply imported from the West and Asia. Alou Diouf comes

to the same place every day to fish for lotte, red snapper, capitaine, sea bream and even lobsters between the rocks. But he does not see fishing as a viable job for his children. He thinks they should learn a trade that's in demand, like mechanics, construction work, electronics and computer sciences, or try their luck at emigration. Mati Ngom has already traded fish mongering for pebble collecting.

How do I share with them my concerns about global warming; and they, with me, the everyday hustle to earn a living, without dignity? It is at this point that I find Glissant's call for a poetics of the ecology essential. In his critique of how land was rendered barren in Martinique by the use of chemicals to boost banana plantations, and how the population was dependent on the importation of all their products from France, Glissant asserted that what was urgently needed was a renewed sensibility toward land, not as sacred fatherland and a nationalist territory that excluded others, but as a rhizomic land that's 'a driving force for the relational interdependence of all lands, of the whole Earth. It is this interdependence that forms the basis for entitlement'.[1]

A reconnection with land, or as Glissant put it, a renewed aesthetic relation to land, is also a move to subvert and undermine our current consumption of standardised and packaged products from supermarkets; a homogenisation of taste everywhere at the expense of local products. A love and poetics of land is a recognition of the unique value of every land and the solidarity between all lands. To celebrate the changing identities of each land, according to seasons, is to enter into complicity and admit that all lands are equal, small or large, iceberg or landmass; and each must be protected for the survival of the planet's biodiversity.

The new politics of land concerns itself with the other of Thought, as Glissant calls it, the unthought, or unintended products coming from contact zones and the confluence of cultures, after theory in dominant countries has invented and fixed the identity of people, things, or lands. The other of Thought pushes us to act against the grain of mainstream thought. 'If, thus, we allow that an aesthetics is an art of conceiving, imagining, and acting, the other of Thought is the aesthetics implemented by me and by you to join the dynamics to which we are all to contribute.'[2] It is also what Glissant calls an anti-violence violence against the oppressor; it's where the whole world enters together into consciousness of land poetics, aesthetics and politics.

To return to Alou Diouf, the fisherman, and Mati Ngom, the pebble collector, and me, in my roles as homeowner and artist, the first thing we each have to realise, as Glissant put it, is that

The suffering of human cultures does not confine us permanently within a mute actuality, mere presence grievously closed. Sometimes this suffering authorizes an absence that constitutes release, soaring over: thought rising

from the prisms of poverty, unfurling its own opaque violence, that gives-on-and-with every violence of contact between cultures.[3]

The lesson about opacity as generator of creative act and diversity is not only valid for poor countries with ruined and barren lands, but also for wealthy areas that only know one thing: get wealthier. After reading these lines from Glissant, I can no longer dismiss Mati's statement, 'Give me money and I will stop collecting pebbles now', as simply people from poor countries asking richer countries for money. Now her words sound in my ears like a church bell or the voice of a muezzin calling for prayer. I need the complicities of Mati and Alou, just as they need mine, to change our attitudes to the land, just as the wealthier countries that are primarily responsible for the degradation of lands need poorer countries to begin the healing together. We all need to give the planet its dignity back by not throwing our rubbish onto it. Mati and the children of Alou should have more opportunities than what the markets of homogenisation are throwing at them; they, too, deserve jobs that reconcile them with their dignity. That's the challenge Glissant has thrown to artists, with his poe-cept of the politics and poetics of land.

1 Édouard Glissant, *Poetics of Relation* (Ann Arbor: The University of Michigan Press, 1997) 146.

2 Ibid., 155.

3 Ibid., 156.

Manthia Diawara, 'The Environment, Édouard Glissant, and the Poetics of Solidarity', in *140 Artists' Ideas for Planet Earth,* eds. Hans Ulrich Obrist and Kostas Stasinopoulos (London and New York: Penguin Books, 2021) n.p.

T.J. Demos
Feeding the Ghost: John Akomfrah's *Vertigo Sea*//2020

Oblique tales on the aquatic sublime. The phrase, appearing as one of *Vertigo Sea*'s nine intertitles, is apt for this moving three-channel video installation, created by John Akomfrah in 2015.[1] Running at forty-eight minutes, the piece investigates the ocean as a multivalent site of geopolitical conflict, liquid nationality, and postnational uprooting, all set within still-unfolding histories of colonialism, migration, slavery and environmental transformation. In terms of affect, the ocean appears as locus of terror and beauty, providing a vast expanse

of resonant meanings and experiential sensations where incongruous narratives interact. Most notably these are of social injustice and environmental violence, a pairing not often joined in contemporary art but all the more important to do so to avoid the siloing of each, thereby minimising significance and impact, and to mobilise the power of their intersection. In Akomfrah's rendition that opposes any such narrow approach, startling seascapes provide colourful imagery as well as haunting backdrops for the routes of colonial exploration and the transatlantic slave trade, the latter referenced by seconds-long clips of shackled Black figures lying on the dank bunks of a ship's hold. In other scenes, stunning images of marine life, including dolphins and orcas, are interrupted by black-and-white passages of sailors killing whales and hunting polar bears. Gorgeous footage of mountainous Arctic icescapes competes with the brutal industrialisation and militarisation of nature, the sea serving as test site for nuclear bombs and extraction field for deepwater oil drilling, as well as sink for their leaks and backdrop for their fiery explosions. In this socioecological entanglement, oceanic signs of climate breakdown and global warming, appearing in footage of melting icebergs and calving glaciers, counterpoint shots of the sea as cemetery, where the bodies of countless Europe-bound migrants wash up on shore. [...]

Bringing these audiovisual elements together in conversation, including at times into painful conflict, Akomfrah offers a haunting meditation on fraught histories and visual cultures of Western modernity drawn from the perspective of the sea. At the same time, in defining a necessary historical ground for any future vision of emancipation and justice to be realised, any renewal to be initiated, it offers important lessons for how to live, perceive and think sensitively and deeply in the present, steering clear of any emotionally manipulative forms of social documentary. Focusing attention on the intervals between projections as much as their interior images, the triptych, in Akomfrah's hands, proposes a cinema of spatialised relationality as well as an archival work of temporal correspondences that resists providing any simple message, moral or partisan interpretation, even while it manifests an overdetermined space of what might be called the spectropoetics of colonial violence, slavery and multispecies death. While *Vertigo Sea* reveals unanticipated connections between narratives, none of them complete, and virtual openings that offer places where the unexpected appears and where discovery can occur, its drama is nonetheless devastating, implicating centuries of colonial conquest and slavery in the unfolding world-ending climate and environmental catastrophes of the present.[2]

[...] Rather than repeating familiar constructions of the sublime, Akomfrah's film locates and thereby updates its perception within our own cultural-

geological present, where modern society, no longer conceivable as separate from the natural world, has become a driver of disastrous environmental transformation over centuries of capitalist extraction and industry. [...] This complex reality is what *Vertigo Sea* depicts and dramatises. With natural and cultural zones now inextricable, and extractive industrialisation increasingly determining the course of the Earth's biophysical cycles – what some call the Anthropocene; others, the Capitalocene – the incongruous categories of the sublime formerly located in the nonhuman realm now cross over into the cultural one too, each vertiginously corrupting the other.[3] Indeed, Akomfrah's film shows how the beauty of maritime nature becomes terrible under the sign of Western modernity and our capitalist present, even as the latter's horror – dramatised in scenes of the industrial destruction of whales and the collapse of the Arctic ecosystem – is grotesquely aestheticised, transfigured as a sort of cinematic geology but in no way acritically. [...]

The film's recurring depictions of whale killing – a powerful and disturbing refrain, particularly at the present time of the sixth mass species extinction event, when we are losing some two hundred species a day at a rate one thousand times the historical average – figure as but one part of modernity's rampant colonisation and destruction of the world.[4] 'The way of killing men and beast is the same', reads another of *Vertigo Sea*'s intertitles, as images mix scenes of majestic humpback and blue whales dying in watery clouds of their own blood, with those of drowned, shackled slaves washed up on beaches. Nature programmes like *Blue Planet*, which can seemingly record every element of a whale's life and explore some of the most hidden spaces of the ocean, are here directly related to, and indicted in, the industrialisation of the seas, by harpoon and camera alike: as such, the visualisation of the aquatic sublime risks slipping into the socio-ecological grotesque, a case of human hubris asserting its dominance over human and nonhuman phenomena. Indeed, part of slavery's very horror resulted from the racial distinctions violently made between these two latter categories: between who is human and who animal. If aestheticisation designates here a matter of the control and appropriation of nature for human pleasure (as with one common definition of aesthetics), then it parallels our horror when scenes of destruction (shipwrecks, slavery's Atlantic passage, whaling and polar bear hunting, migrants drowning) become spectacularised as filmic images, to be witnessed from a safe, mediated distance of privilege and security. Part of the horror is our powerlessness to intervene, not only in the social and ecocidal violence but also in the seemingly unstoppable imaging of its visual compulsions, the oceanic, in conventional versions and perhaps to some degree in Akomfrah's, proposing an overwhelming force of seductive obliteration and complicity with intolerable realities and images. [...]

Within this multiplicity and relationality of temporalities, *Vertigo Sea* also projects what Akomfrah calls an 'afterlife of the image', according to which an image, any image, necessarily implies a future. This imaging and viewing-time-to-come define a utopian dimension intrinsic to image making, a virtual futurism embedded in cinema as a political ontology of endless materialisation and anticipation. As such, cinema, in Akomfrah's hands, manifests a protest against finitude, as well as against the idea that representation can totalise experience and colonise significance, as if the image can ever be(come) complete or self-sufficient (which, as we have seen, informs his recent postanthropocentric filmmaking, as much as *Vertigo Sea*'s triptych multiplicity). As Akomfrah contends, artists, as image makers who insist on emancipating the infinite, act as 'custodians of a possible future', implying a future of viewership too, a future reality impacted by the artwork, as well as a future context unanticipated by the filmmaker, which also reveals the present as necessarily incomplete and non-totalisable.[5] Developing the same line of thinking, can we not also say that remembering past tragedies and imaging present wrongs – on the world-historical levels of slavery and colonialism, species extinction, nuclear war, and anthropogenic climate disruption – can also, in fact must, entail proposing, even cultivating, alternate futures? If so, perhaps what *Vertigo Sea* offers is, ultimately, optimism, if not without its cruelties: where past injustices have failed to utterly destroy their aftermath, we can maintain hope, despite all, of a different time to come. If that time will not necessarily redeem what has been, then at least, as dramatised by Akomfrah, it insists on holding historical failings within the realm of visibility – so that they will not ever be forgotten in the creation of future alternatives.

1 The piece was commissioned for the 2015 Venice Biennale, and also shown at the New Museum in New York, for which this chapter appeared in an earlier version as a catalogue essay. See Thea Ballard and Dana Kopel (eds.), *John Akomfrah: Signs of Empire* (New York: New Museum, 2018).

2 [Footnote 5 in source] Akomfrah discusses his aesthetic approach to history in an online interview accompanying a 2015 exhibition at the Bildmuseet, Umeå University (www.bildmuseet. umu.se/en/exhibition/john-akomfrah-vertigo-sea/20548).

3 [18] For my own critical analysis of Anthropocene discourse, see T.J. Demos, *Against the Anthropocene: Visual Culture and Environment Today* (Berlin: Sternberg, 2017).

4 [20] See Elizabeth Kolbert, *The Sixth Extinction: An Unnatural History* (New York: Henry Holt, 2014); and Elizabeth Kolbert, 'The Darkening Sea', *New Yorker* (20 November 2006).

5 [38] Akomfrah quoted in Bildmuseet interview op. cit.

T.J. Demos, extracts from *Beyond the World's End: Arts of Living at a Crossing* (Durham, NC and London: Duke University Press, 2020) 23–4, 26, 34–5, 42.

Erika Balsom
An Oceanic Feeling: Cinema and the Sea//2018

[...] In *The Order of Things*, Michel Foucault turns to the ocean in search of a metaphor for the end of philosophical humanism, looking forward to the day when the concept of 'man would be erased, like a face drawn in sand at the edge of the sea'.[1] Did his dream come true? Yes and no. When the world system is viewed through the lens of the container ship, a very different erasure of man than the one Foucault hoped for becomes visible, namely, the total subsumption of life under capital. In mainstream narrative cinema, meanwhile, the concept of man remains alive and well, the centre of the universe: in *Deepwater Horizon* (2016), a dramatisation of the 2010 catastrophe that killed eleven people and released almost five million barrels of oil into the Gulf of Mexico, constituting perhaps the worst environmental disaster in US history, there is no mention of ecological devastation. The film offers a drama of personalities, of human heroism and cowardice. The flight of a panicked, oil-slicked bird into the control room stands as the only reminder of the tremendous damage to nonhuman life, damage that remains ongoing.

Both of these phenomena – the unchecked dominance of capital and the spurious ideology of individualism – have contributed to the ecological emergencies now facing our planet. Ocean dead zones without oxygen have quadrupled since the 1950s, while the so-called 'Great Pacific Garbage Patch' is twice the size of France and contains some 79,000 tonnes of plastic. In [Peggy] Ahwesh's *The Blackest Sea*, computer-animated fish die en masse, floating to the surface. One team of researchers claims that their living counterparts will be gone from the seas by 2048. The Earth is heating up. In this age of what many call the Anthropocene, Foucault's metaphor takes on resonances he perhaps never anticipated, as rising water levels and calls for environmental justice put new pressure on the autonomy of 'man'.

In G. Anthony Svatek's *.TV* (2017), climate change and the global circulation of data come together in Tuvalu, the small Pacific nation particularly vulnerable to rising water levels. Svatek crosscuts between landscape images of the island sourced from YouTube and digital devices in unknown locations playing videos hosted on websites ending in .tv, a national domain name that constitutes big business for Tuvalu's government owing to its evocation of television. A voiceover frames the film's images as relics of the past, narrating from a future time when Tuvalu has vanished beneath the water. 'Perhaps', he intones, 'it was too abstract to imagine that Earth, too, had a right to rest.' Like the global supply chain, climate change partakes of an immense scale that challenges our powers

of conceptualisation. The narrator of *.TV* has now retreated to cyberspace, where he claims that rising waters can never reach him. This fable of dematerialisation is darkly dystopian, asking the viewer to imagine the disappearance of Tuvalu and to inhabit a time when humans have definitively abandoned the phenomenal world. Hints of this dystopia are already here.

Most have already begun their partial retreats into cyberspace; Svatek, like his narrator, has never visited Tuvalu but encounters it only through the fibre optic cables that carry the bulk of internet traffic beneath the oceans. More troublingly, many remain wilfully blind to the precarity of the planet. Perhaps this science fiction is not so fictional after all.

.TV suggests that though dematerialised images circulate around the globe, consuming tremendous amounts of electricity as they distance us from the immediacy of experience, such images can perhaps also enable an encounter with the enduring material fragility of the world. Amitav Ghosh has speculated that our age may be looked back upon as 'the time of the Great Derangement', since so little literature reckons with climate change, tied as it is to the temporalities of bourgeois life.[2] The same could be said of the cinema. But if the task is, as Ghosh suggests later, 'to recognize something we had turned away from: that is to say, the presence and proximity of nonhuman interlocutors', then the lens-based image, with its grounding in physical reality, seems especially well poised to intervene.[3] To recognise the presence and proximity of nonhuman interlocutors, to take account of the interdependence of human and nonhuman life, is to court oceanic feeling. Out of this world we cannot fall.

1 [Footnote 4 in source] Michel Foucault, *The Order of Things: An Archaeology of the Human Sciences* (1966) (London: Routledge, 2002) 422.

2 [5] Amitav Ghosh, *The Great Derangement: Climate Change and the Unthinkable* (Chicago: University of Chicago Press, 2017) 11.

3 [6] Ibid., 30.

Erika Balsom, extract from *An Oceanic Feeling: Cinema and the Sea* (New Plymouth: Govett-Brewster Art Gallery, 2018) 72–5.

Biographical Notes

Eileen Agar (1899–1991) was a British-Argentinian painter and photographer.

Stacy Alaimo is Associate Professor of English at the University of Texas at Arlington.

Heba Y. Amin is a visual artist and Professor of Digital and Time-Based Art at ABK-Stuttgart.

Michelle Antoinette is a Senior Lecturer and Researcher in Art History and Theory at Monash University, Melbourne.

Bergit Arends is a curator and researcher working on art and the environment.

Erika Balsom is a Reader in Film Studies at King's College London.

Karen Barad is Professor of Feminist Studies, Philosophy, and History of Consciousness at the University of California, Santa Cruz.

Betty Beaumont is a Canadian-American site-specific installation artist, sculptor and photographer.

Louis Bec (1936–2018) was a biologist and zoosystematician born in Algeria and settled in France.

Ron Broglio is Associate Professor of English and Senior Scholar in the Julie Ann Wrigley Global Institute of Sustainability at Arizona State University.

Rachel Carson (1907–1964) was an American marine biologist, writer and conservationist.

Mel Y. Chen is Associate Professor of Gender and Women's Studies and Director of the Center for the Study of Sexual Culture at University of California, Berkeley.

Tacita Dean is a British-German visual artist who works primarily in film.

Elizabeth DeLoughrey is Professor at UCLA in both the English Department and the Institute for the Environment and Sustainability.

T.J. Demos is Professor and Patricia and Rowland Rebele Endowed Chair in Art History and Visual Culture at University of California, Santa Cruz.

Manthia Diawara is a Malian writer, filmmaker, cultural theorist, scholar, art historian and is a Professor in the Department of Cinema Studies at New York University's Tisch School of the Arts.

Chris Dobrowolski is an artist and writer.

Tarralik Duffy is a writer, artist and jeweller from Salliq (Coral Harbour), Canada, and based in Saskatoon.

Ann Elias is Associate Professor of the History and Theory of Contemporary Global Art at the University of Sydney, Australia.

Marion Endt-Jones is a teacher, researcher, writer, translator and curator based in Manchester, UK.

Léuli Eshrāghi is an artist and curator of Chinese, Sāmoan and Persian heritage working across Australia, Hawai'i, Canada and Europe.

Kodwo Eshun is a British-Ghanaian writer, theorist, filmmaker and Lecturer in Aural and Visual Culture at Goldsmiths, University of London.

Tatiana Flores is a curator, art critic and Professor of Latino and Caribbean Studies and Art History at Rutgers University New Brunswick.

Vilém Flusser (1920–1991) was a Brazilian Czech-born philosopher, writer and journalist.

Marietta Franke is a German art historian and author.

Paul Gilroy is an English sociologist and cultural studies scholar and the founding Director of the Sarah Parker Remond Centre for the Study of Race and Racism at University College London.

John K. Grande is an writer focusing on art and ecology.

Ayesha Hameed is an artist and Senior Lecturer in Visual Cultures at Goldsmiths University of London.

Donna Haraway is American Professor Emerita in the History of Consciousness Department and Feminist Studies Department at the University of California, Santa Cruz.

Stefano Harney is an American activist and scholar based in Brazil.

Epeli Hau'ofa (1939–2009) was a Tongan and Fijian writer and anthropologist.

Eva Hayward is an anti-disciplinary scholar and Assistant Professor of Media and Culture Studies at Utrecht University.

Stefan Helmreich is a Professor of Cultural Anthropology at the Massachusetts Institute of Technology.

Barbara Hepworth (1903–1975) was an English artist and sculptor.

Stefanie Hessler is a German-born contemporary art curator, an art writer, and the current Director of Swiss Institute in New York.

Klara Hobza is a Berlin-based artist.

Luce Irigaray is a Belgian-born French feminist, philosopher, linguist, psycholinguist, psychoanalyst and cultural theorist.

ISUMA is a collective of Inuit artists founded by Zacharias Kunuk, Paul Apak Angilirq and Norman Cohn, based in Nunavut and Montreal, Canada.

Zakiyyah Iman Jackson is Associate Professor of English and Director of the Center for Feminist Research at the University of Southern California.

Celina Jeffery is an art historian, curator, educator and Associate Professor of Art History and Theory at the University of Ottawa, Canada.

Melody Jue is an Associate Professor of English at the University of California, Santa Barbara.

Brian Jungen is an artist of Dane-zaa and Swiss ancestry living and working in the North Okanagan of British Columbia, Canada.

Robin D.G. Kelley is an American historian, academic and the Gary B. Nash Professor of American History at UCLA.

Tania Kovats is a visual artist, best known for her sculpture, installation art and drawing.

Barbara Kutis is Associate Professor of Fine Arts at Indiana University Southeast, United States.

Sonia Levy is a French artist whose research-led practice considers new forms of engagements with nonhuman life forms.

Max Liboiron is a Métis researcher, designer, an Associate Professor in Geography and is formerly the Associate Vice-President (Indigenous Research) at Memorial University in St. John's, Newfoundland and Labrador, Canada.

Lana Lopesi is an author, art critic, editor and Assistant Professor in the Department of Indigenous Race and Ethnic Studies, University of Oregon.

Janine Marchessault is a Professor in Cinema and Media Arts at York University and holds a York Research Chair in Media Art and Social Engagement.

Chus Martínez is a Spanish curator, art historian and writer.

Ana Mendieta (1948–1985) was a Cuban-American performance artist, sculptor, painter and video artist.

Jules Michelet (1798–1874) was a French historian and writer.

Kasia Molga is a design fusionist, artist, environmentalist, creative coder and founder and Director of Studio Molga Ltd, in Kent, UK.

Eleanor Morgan is an artist and lecturer in Fine Art at Loughborough University.

Fred Moten is an American cultural theorist, philosopher, essayist and poet.

Astrida Neimanis is a cultural historian and Lecturer in the Department of Gender and Cultural Studies at the University of Sydney Australia.

Saskia Olde Wolbers is a Dutch video artist who lives and works in London.

Celeste Olalquiaga is a Venezuelan-born cultural historian, creative thinker and author.

Ralph Rugoff is an American-born curator and is the Director of London's Hayward Gallery.

John Ruskin (1819–1900) was an English writer, philosopher, art critic and polymath.

Shimabuku is a Japanese artist based in Okinawa.

Allan Sekula (1951–2013) was an American photographer, writer, critic and filmmaker.

Heather Anne Swanson is a Professor at the School of Culture and Society in the Department of Anthropology at Aarhus University.

Jan Verwoert is a writer and Guest Professor of Contemporary Art and Theory at the Academy of Umeå.

Ahren Warner is a British writer, filmmaker and photographer.

Marina Warner is an English historian, mythographer, art critic, novelist and short story writer.

Alberta Whittle is a Barbadian-Scottish multidisciplinary artist, based in Glasgow.

Bibliography

Abberley, Will (ed.), *Underwater Worlds: Submerged Visions in Science and Culture* (Cambridge: Cambridge Scholars Publishing, 2018)

Alaimo, Stacy (ed.), *Science Studies and the Blue Humanities*, special issue of *Configurations*, vol. 27, no. 4 (2019)

Bastian, Tairone, Candice Hopkins and Katie Lawson (eds.), *Water, Kinship, Belief* (Toronto: Toronto Biennial of Art and Art Metropole, 2022)

Bauer, Ute Meta (ed.), *Joan Jonas: Moving Off the Land* (Vienna: Verlag der Buchhandlung Walther Konig, 2022)

Blackmore, Lisa and Liliana Gómez (eds.), *Liquid Ecologies in Latin American and Caribbean Art* (Abingdon and New York: Routledge, 2020)

Blum, Hester, 'The Prospect of Oceanic Studies', *PMLA*, vol. 125, no. 3 (2010) 670–7

Bode, Steven, Coline Milliard, Hans Ulrich Obrist and Erik Verhagen. *Zineb Sedira: Beneath the Surface* (exh. cat) (Paris: kamel mennour, 2011)

Brown, William and David H. Fleming, *The Squid Cinema from Hell: Kinoteuthis Infernalis and the Emergence of Chthulumedia* (Edinburgh: Edinburgh University Press, 2020)

Buckland, David, Ali MacGlip and Siôn Parkinson (eds.), *Burning Ice: Art and Climate Change* (exh. cat) (London: Cape Farewell, 2006)

Cahill, James, *Zoological Surrealism: The Nonhuman Cinema of Jean Painlevé* (Minneapolis and London: University of Minnesota Press, 2019)

Cao, Maggie M., 'The Entropic History of Ice' in *Ecologies, Agents, Terrains*, eds. Christopher P. Heuer and Rebecca Zorach (Williamstown, MA: Clark Art Institute, 2018) 266–91

Caycedo, Carolina, *One Body of Water*, ed. Brynn Saito (performance text, Bowtie Project LA, produced by Clockshop in collaboration with CA State Parks, 2015) (available at http://carolinacaycedo. com/wp-content/uploads/2015/11/OBOW_Final1.pdf)

Chambers, Iain, 'Maritime Criticism and Lessons from the Sea', *Insights* vol 3., no. 9 (2010) (available at http://www.iasdurham.org/wp-content/uploads/2021/03/Chambers_Maritime-Criticism-and-Lessons-from-the-Sea.pdf)

Chen, Cecilia, Janine MacLeod and Astrida Neimanis (eds.), *Thinking With Water* (Montreal and Kingston: McGill-Queen's Press, 2013)

Christov-Bakargiev, Carolyn & Süreyya Evren (eds.), *SALTWATER: A Theory of Thought Forms* (exh. cat.) (Istanbul: Istanbul Foundation for Culture and Arts, 2015)

Cousteau, Jacques-Yves with Frédéric Dumas, *The Silent World* (London: The Reprint Society, 1954)

Cusack, Tricia (ed.), *Framing the Ocean, 1700 to the Present: Envisaging the Sea as Social Space* (Abingdon: Ashgate, 2014)

DeLoughrey, Elizabeth M., *Allegories of the Anthropocene* (Durham, NC: Duke University Press, 2019)

Dion, Mark (ed.), *Oceanomania: Souvenirs of Mysterious Seas: From the Expedition to the Aquarium* (exh. cat.) (London: Mack, 2011).

Endt-Jones, Marion, 'Coral Fishing and Pearl Diving: Curatorial Approaches to Doubt and Wonder', in

Wonder in Contemporary Artistic Practice, eds. Christian Mieves and Irene Brown (London and New York: Routledge, 2017) 177–93

Farquharson, Alex and Martin Clark (eds.), *Aquatopia: The Imaginary of the Ocean Deep* (exh. cat) (Nottingham and London: Nottingham Contemporary and Tate Publishing, 2013)

Feigel, Lara and Alexandra Harris (eds.), *Modernism on Sea: Art and Culture at the British Seaside* (Witney: Peter Lang, 2009)

Feldman, Alaina Claire (ed.), *The Ocean After Nature* (exh. cat) (New York: Independent Curators International, 2016)

Fend, Peter, *Ocean Earth: 1980-Today* (Stuttgart: Oktagon Verlag, 1999)

Flores, Tatiana and Michelle Ann Stephens (eds.), *Relational Undercurrents: Contemporary Art of the Caribbean Archipelago* (exh. cat) (Los Angeles: Museum of Latin American Art, 2017)

Gaskins, Nettrice, 'Deep Sea Dwellers: Drexciya and the Sonic Third Space', *Shima*, vol. 10, no. 2 (2016) 68–80

Glissant, Édouard, *Poetics of Relation* (1990), trans. Betsy Wing (Ann Arbor: University of Michigan Press, 2010)

Godfrey-Smith, Peter, *Other Minds: The Octopus and the Evolution of Intelligent Life* (London: William Collins, 2018)

Hartman, Saidiya, 2021, *Lose Your Mother: A Journey Along the Atlantic Slave Route* (London: Serpent's Tail, 2021)

Harvell, Drew, *A Sea of Glass: Searching for the Blaschkas' Fragile Legacy in an Ocean at Risk* (Oakland: University of California Press, 2016)

Hayward, Eva, 'Enfolded Vision: Refracting the Love Life of the Octopus', *Octopus: A Journal of Visual Studies*, no. 1 (2005) 29–44

Hayward, Eva, 'Fingeryeyes: Impressions of Cup Corals', *Cultural Anthropology*, vol. 4 no. 25 (2010) 577–99

Hessler, Stefanie (ed.), *Tidalectics: Imagining an Oceanic Worldview Through Art and Science* (Cambridge MA: The MIT Press, 2018)

Hine, Simone and Kyle Weise, *Sediment* (exh. cat) (Brisbane: Metro Arts, 2021)

Hoare, Philip, *Leviathan or, the Whale* (London: Fourth Estate, 2009)

Horden, Peregrine and Nicholas Purcell, 'The Mediterranean and "the New Thalassology"', *The American Historical Review*, vol. 111, no. 3 (2006) 722–40

Ingersoll, Karin Amimoto, *Waves of Knowing: A Seascape Epistemology* (Durham NC: Duke University Press, 2016)

Jacobs, Karen, '*Bottled Ocean 2120*: George Nuku, the Ocean, Plastic and the Role of Artists in discussing Climate Change', *World Art*, vol. 12 no. 3 (2022) 213–38

Jeffery, Celina (ed.), *Ephemeral Coast: Visualizing Coastal Climate Change* (Wilmington and Malaga: Vernon Press, 2022)

Jeffery, Celina (ed.), *Junk Ocean*, special issue of *Drain*, vol. 13, no. 1 (2016)

Jue, Melody, *Wild Blue Media: Thinking Through Seawater* (Durham NC: Duke University Press, 2020)

Jung, Julia et al., 'Doubling Down on Wicked Problems: Ocean Art Science Collaborations for a

Sustainable Future', *Frontiers in Marine Science*, vol. 9 (2022) (available at www.frontiersin.org/articles/10.3389/fmars.2022.873990/full)

Kouoh, Koyo and Dirk Luckow (eds.), *Streamlines: Oceans, Global Trade and Migration* (exh. cat) (Cologne: mbH, 2015)

Lee, Rona, *That Oceanic Feeling* (exh. cat) (Southampton: John Hansard Gallery, 2012)

Sophie Lewis, 'Amniotechnics', in *Full Surrogacy Now: Feminism Against Family* (London and New York: Verso, 2019) 160–6

Mack, John, *The Sea: A Cultural History* (London: Reaktion, 2011)

Masaki Bellows, Andy and Marina McDougall (eds.), *Science is Fiction: The Films of Jean Painlevé* (Cambridge, MA and London: The MIT Press and San Francisco: Brico Press, 2000)

Mentz, Steve, *Ocean* (New York and London: Bloomsbury Academic, 2020)

Nicolov, Sophia, *Whale Encounters* (Leeds: East Street Arts, 2019)

Ocean Archive, https://ocean-archive.org

Parthasarathi, Prasannan (ed.), *Indian Ocean Current: Six Artistic Narratives* (exh. cat) (Boston: McMullen Museum of Art, 2020)

Rossellini, Isabella, *Green Porno: A Book and Short Films by Isabella Rossellini* (New York: harperstudio, 2009)

Ramos, Filipa (ed.), *Flows: Bodies of Water – A Reader* (Dijon: Les Presses du Réel, 2021)

Reichle, Ingeborg (ed.), *Plastic Ocean: Art and Science Responses to Marine Pollution* (Berlin: De Gruyter, 2021)

Roberts, Emma, *Art and the Sea* (Liverpool: Liverpool University Press, 2022)

Rozwadowski, Helen, *Vast Expanses: A History of the Oceans* (London: Reaktion, 2018)

Scozzari, Cory and Daniela Zyman (eds.), *Allan Sekula – OKEANOS* (London: Sternberg Press, 2017)

Sharp, Alice, 'Going Into the Dark: The Deep Sea', in ed. Greer Crawley, *Mariele Neudecker: Sediment* (London: Anomie, 2021)

Sharpe, Cristina, *In the Wake: On Blackness and Being* (Durham NC and London: Duke University Press, 2016)

Steinberg, Philip E., *The Social Construction of the Ocean* (Cambridge: Cambridge University Press, 2001)

Stout, Katharine (ed.), *New Visions of the Sea: Contemporary Art at the National Maritime Museum* (exh. cat) (London: National Maritime Museum, 1999)

Susik, Abigail, 'Convergence Zone: The Aesthetics and Politics of the Ocean in Contemporary Art and Photography', *Drain Magazine*, vol. 7, no. 2 (2012)

Syperek, Pandora and Sarah Wade (eds.), Curating the Sea, special issue of *Journal of Curatorial Studies*, vol. 9, no. .2 (2020)

Wainwright, Jean (ed.), *Ship to Shore: Art & the Lure of the Sea* (exh. cat) (Southampton: John Hansard Gallery, 2018)

Wallace, Robert K., 'Ben-Ner's *Moby Dick* and Melville's Mechanism of Projection', *Leviathan*, vol. 9, no. 1 (2007) 43–59

Watt, Yvette, Toby Juliff, Anne Hölck and André Krebber, *Oktolab: Laboratory for Octopus Aesthetics*,

www.okto-lab.org

Wertheim, Margaret and Christine Wertheim (eds), *Crochet Coral Reef* (Los Angeles: Institute for Figuring, 2015)

Williams, Heathcote, *Whale Nation* (London: Jonathan Cape, 1988)

Williams, Linda, *Ocean Imaginaries* (exh. cat) (Melbourne: RMIT Gallery/RMIT University, 2017)

Zyman, Daniela and Eva Ebersberger (eds.), *Thyssen-Bornemisza Art Contemporary: The Commissions Book* (London: Sternberg Press, 2020)

Zyman, Daniela (ed.), *Oceans Rising: A Companion to Territorial Agency: Oceans in Transformation* (London: Sternberg Press, 2021)

ACKNOWLEDGEMENTS

Editor's acknowledgements

Our heartfelt thanks to all the authors and artists who have contributed to *Oceans*, particularly those whose texts are published here for the first time – Klara Hobza and Bergit Arends, Kasia Molga, Eleanor Morgan and Alberta Whittle – and to Sonia Levy and Shimabuku, who along with Kasia, Klara and Bergit gave talks for our Artists/Oceans series, hosted and funded by University of East Anglia and formative to this volume. Further thanks to those who provided helpful insights, including Asinnajaq, Erling Björgvinsson, Marcus Coates, Léuli Eshrāghi, Kelly Freeman, Thomas Hughes, Celina Jeffery, Petra Lange-Berndt, Tau Lewis, Marsha Meskimmon, Alice Sharp, Lou Sheppard, Katharine Stout and colleagues from Art History and World Art Studies at University of East Anglia and Loughborough University. This volume arose out of our ongoing research project Curating the Sea, and we are grateful to all who have contributed along the way, and to those undertaking adjacent inspiring oceanic research. Deepest gratitude to James Nomico and Ben Judd. Finally, massive thanks to Francesca Vinter, Evie Tarr, Justine Hucker, the editorial board at Whitechapel Gallery and commissioning editor Anthony Iles, whose astute commentary and feedback was invaluable, and who like us bears a surname with watery etymology – a testament to our shared oceanic origins.

Aspects of this research were funded by the Leverhulme Trust.

Publisher's acknowledgements

Whitechapel Gallery is grateful to all those who gave their generous permission to reproduce the listed material. Every effort has been made to secure all permissions and we apologise for any inadvertent errors or omissions. If notified, we will endeavour to correct these at the earliest opportunity.

Whitechapel Gallery

whitechapelgallery.org

Supported using public funding by
**ARTS COUNCIL
ENGLAND**